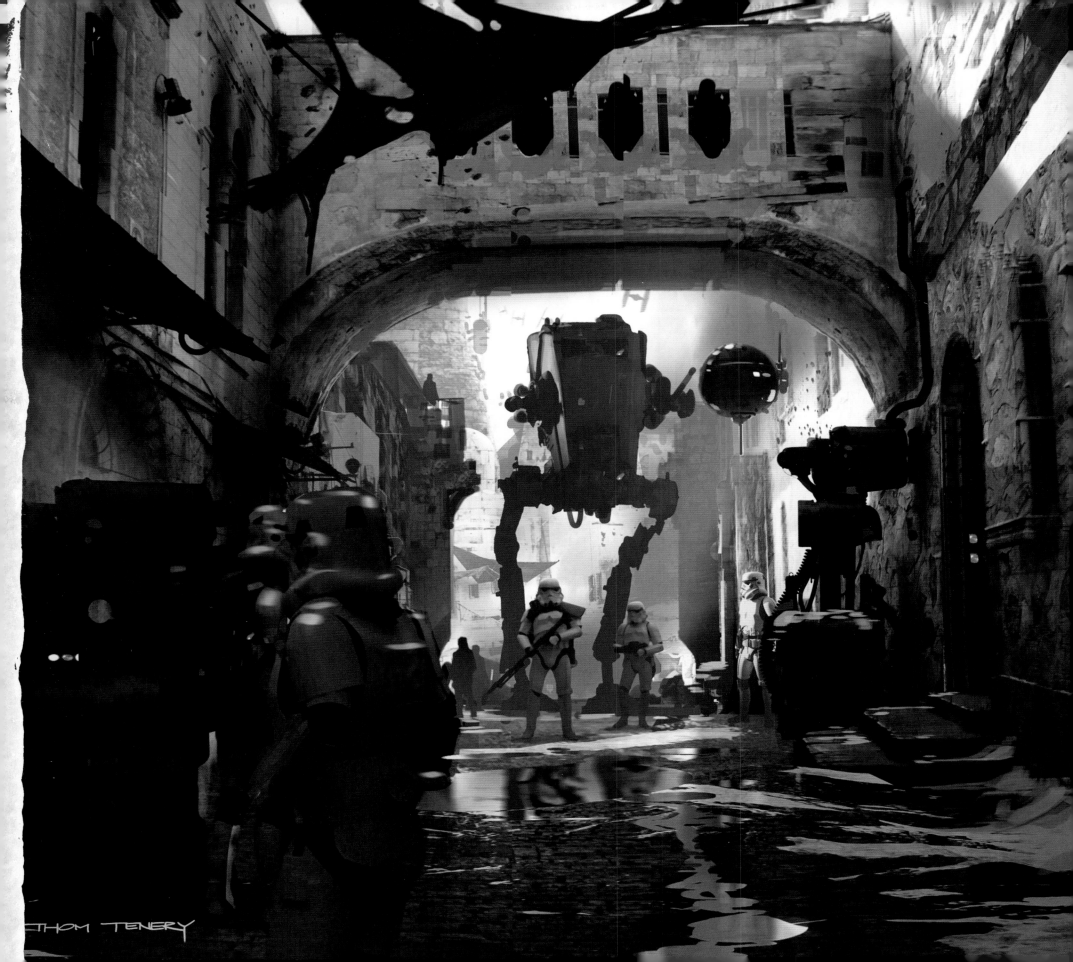
THOM TENERY

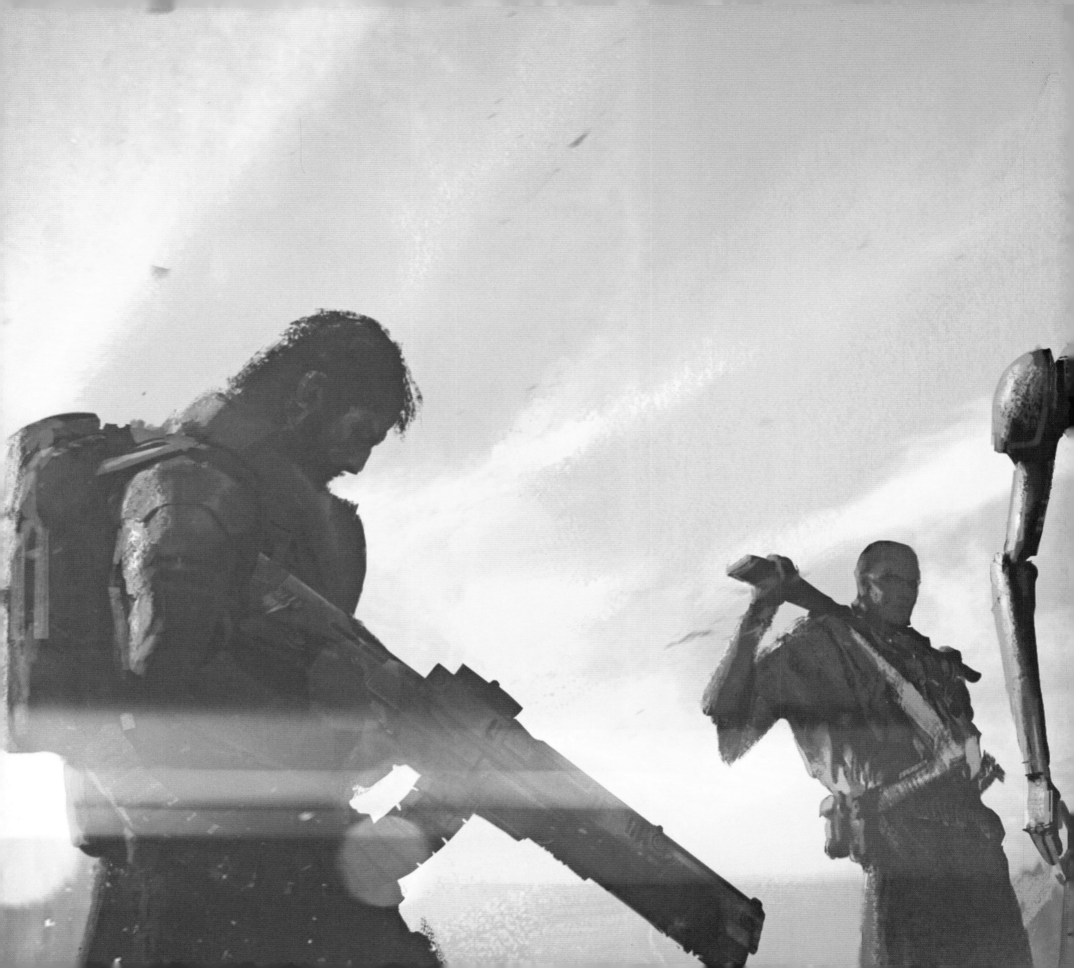

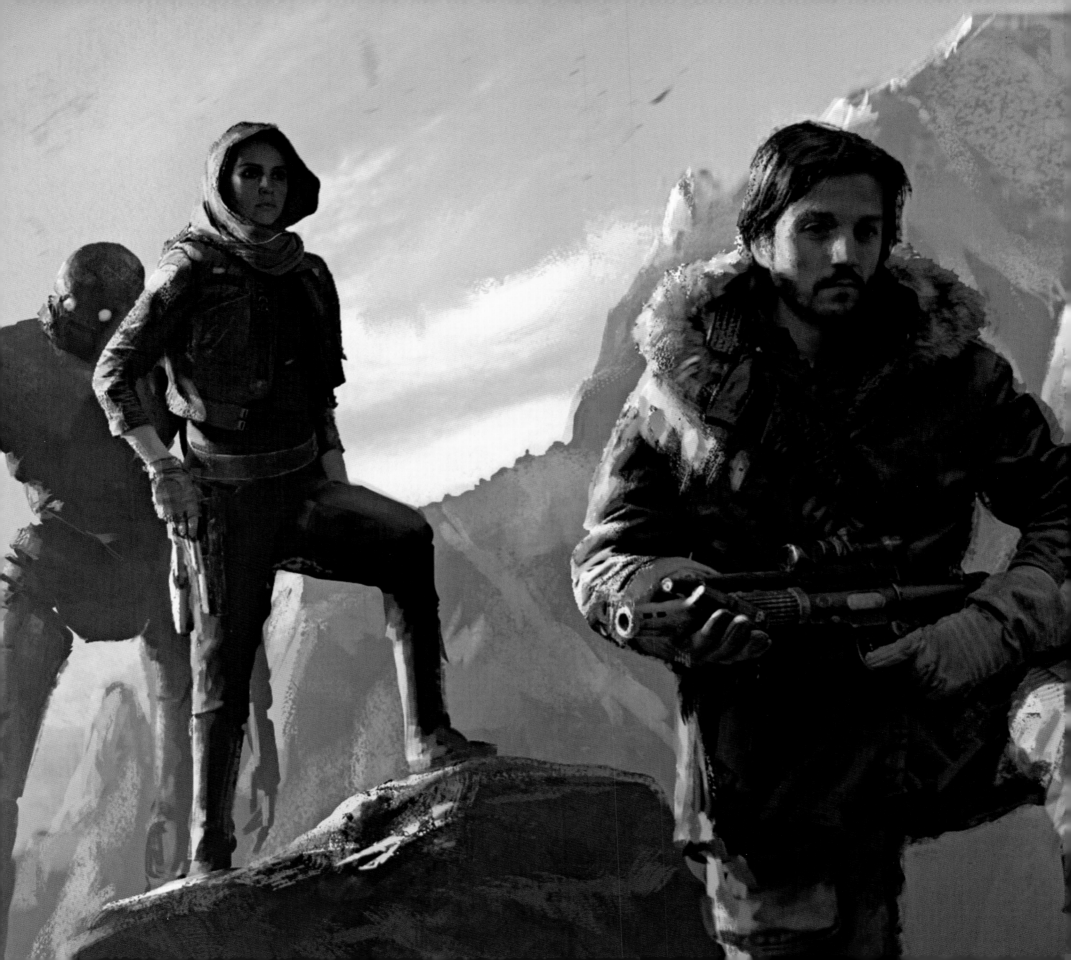

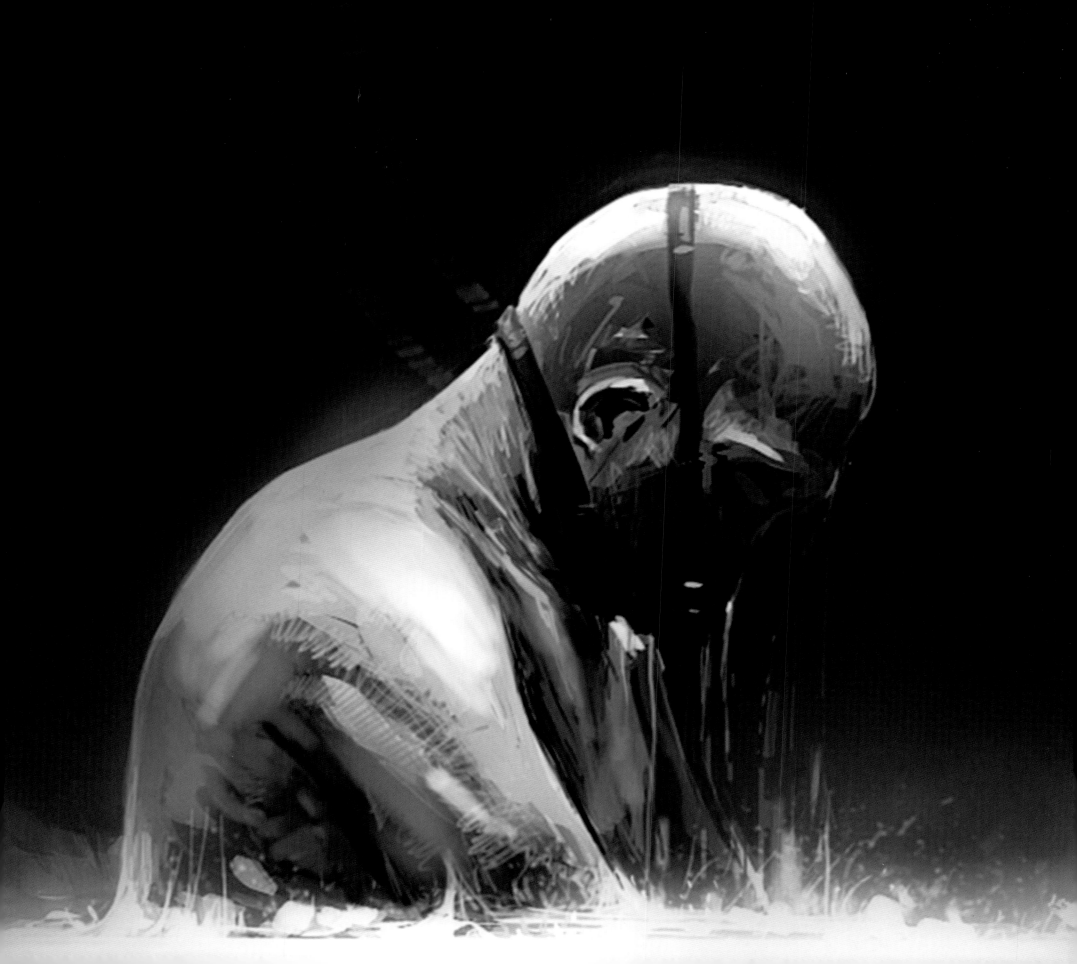

ROGUE ONE
A **STAR WARS** STORY

WRITTEN BY JOSH KUSHINS

Forewords by Doug Chiang, Neil Lamont, and Gareth Edwards

ABRAMS, NEW YORK

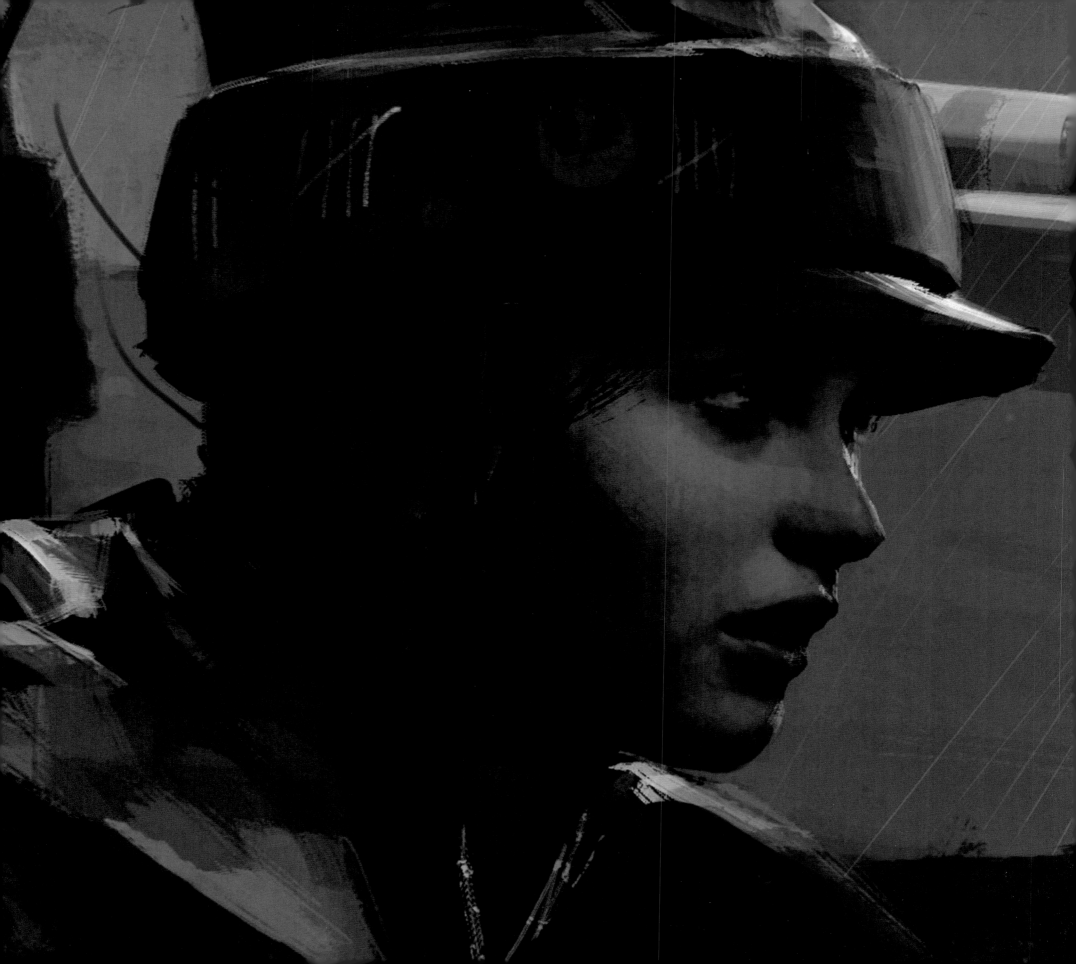

CONTENTS

10 Foreword by Doug Chiang
11 Foreword by Neil Lamont
14 Foreword by Gareth Edwards
17 Who's Who

19 Prologue: "Let's Tell *That* Story"
21 Blue-Sky Development
30 Rogue Team

34 **LAH'MU**
36 Home Is Where the Hero Is
48 Troopers
54 Concept Boards

58 **YAVIN 4**
61 The Mission Briefing
68 K-2SO
78 "A Million Ships": Evolution of the U-Wing
93 A Tactical Approach to Period Sci-Fi

94 **JEDHA**
97 Followers of the Force
143 Chirrut Îmwe and Baze Malbus
148 Bor Gullet

152 **EADU**
155 Imperial Installations
169 Close Encounter on Eadu

172 **MUSTAFAR**
175 Vader's Lair

190 **SCARIF**
193 The Final Battle

246 "How You Remember It . . ."

248 Index
251 Acknowledgments

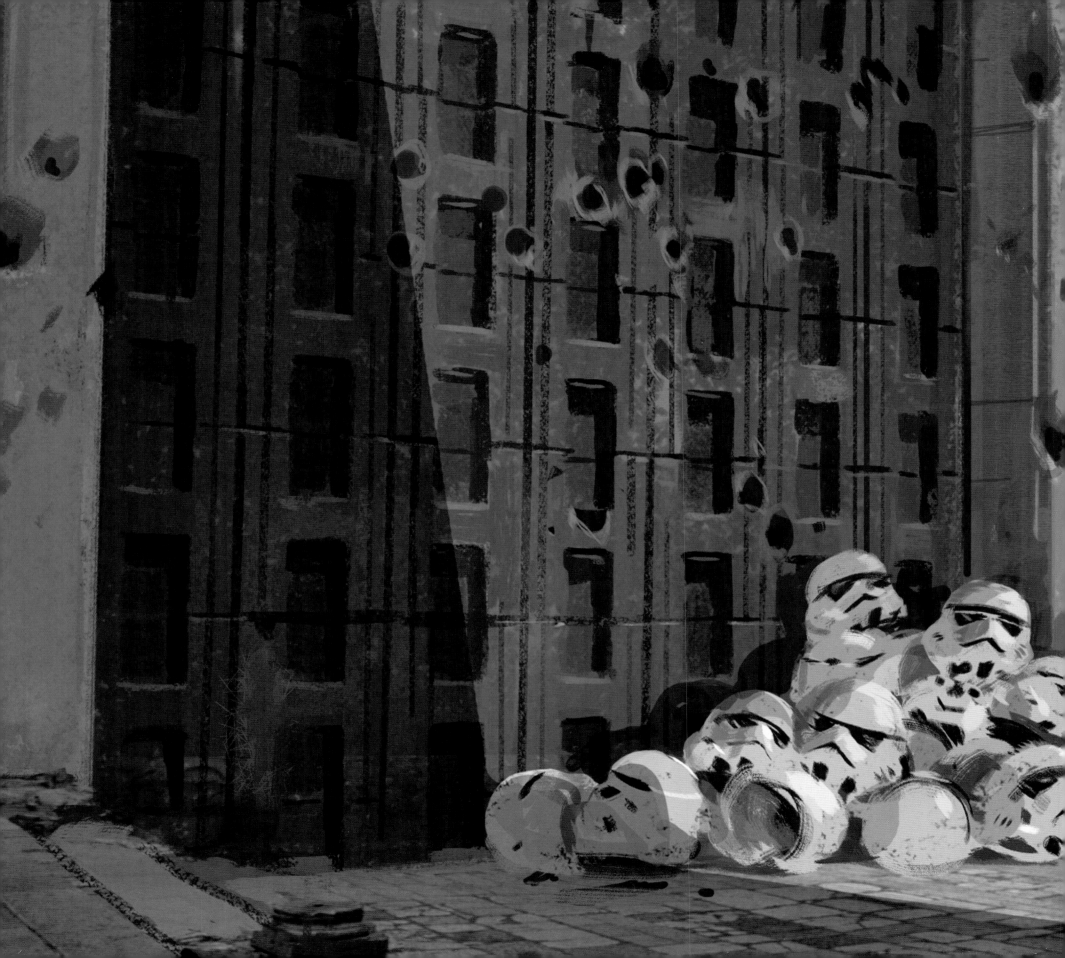

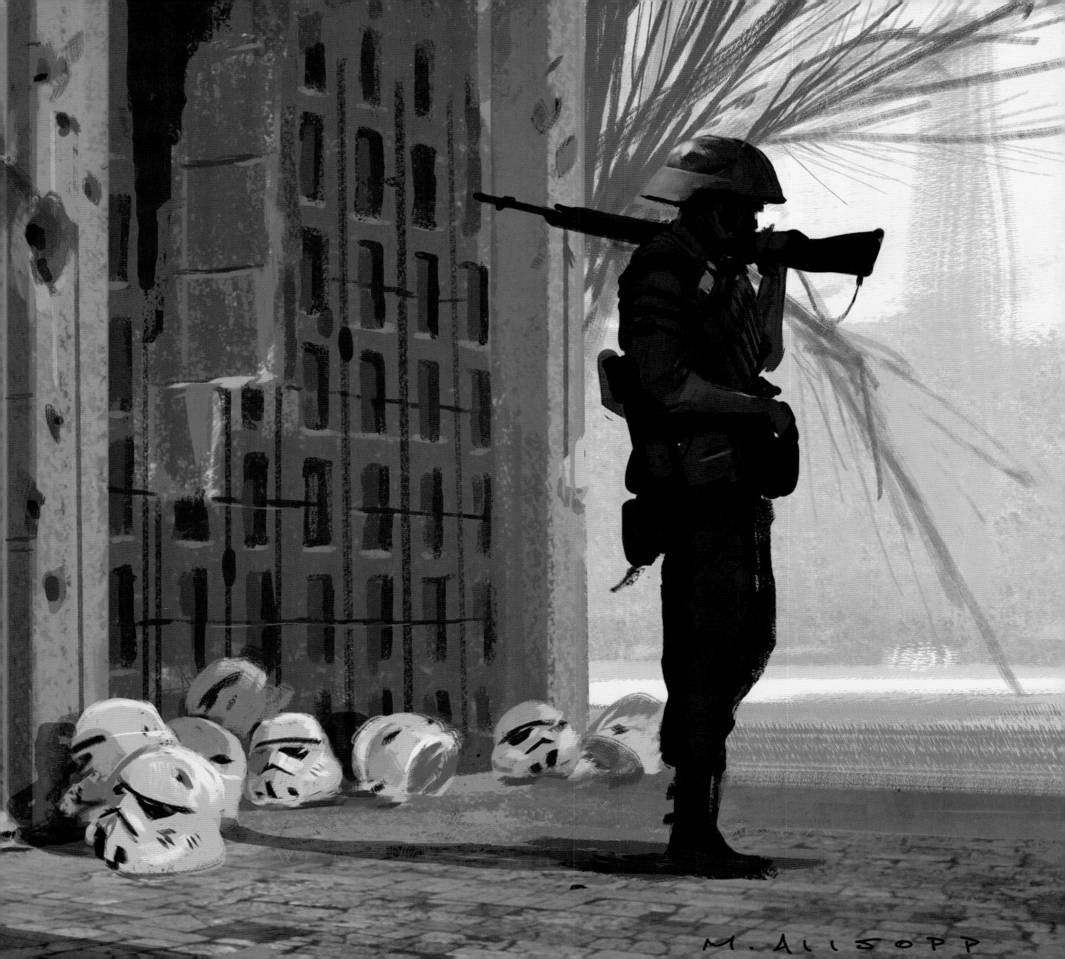

Foreword by Doug Chiang

In the fall of 1979, popular interest in concept art exploded—and a subgenre of book publishing was pioneered—with the release of *The Art of Star Wars*. Over the years, that book has remained the gold standard for documenting film design. Gracing those pages were beautiful illustrations by Ralph McQuarrie, Joe Johnston, and many other talented artists who helped bring the *Star Wars* universe to life. Their artwork was sublime. George Lucas had assembled an amazing team of artists who would inspire him, as well as be inspired by him. Seeing their vivid visions, full of wonder and color, with memorable characters surrounded by magnificent environments, profoundly affected me as a fifteen-year-old. Like many young aspiring artists, my career path was cemented from that moment. I knew then that I wanted to create artwork like that. Now, nearly thirty-five years later, "artwork like that" would be the same high bar we set for ourselves as we embarked on designing *Rogue One: A Star Wars Story*.

As co-production designer for *Rogue One*, I eagerly embraced the challenge. I knew it would be a journey full of surprise and excitement—one that would push me to my limits. This collection of art from *Rogue One* is a behind-the-scenes immersion into that process, and presents the best artwork we created to realize director Gareth Edwards's vision of *Star Wars*. More than just a collection of beautiful paintings and drawings, it is also a record of the passion that each artist brought to the table, as well as a snapshot of our extensive, and sometimes circuitous, path to find the ideal design.

The process, for me, actually started back in 1995—a week after I was hired to head up the Lucasfilm art department for the *Star Wars* prequels—when I first met George Lucas. It was clear from that first meeting that we were all guests of honor in his sandbox. He set the rules, and we played within them. Nevertheless, his sandbox was quite vast. The key to successful collaboration was to understand that the boundary between "what is *Star Wars* and what is not" can be obscure. That gray area was for us to play in. George often encouraged us to explore this boundary, because he knew that was where we would find the most exciting ideas. He pushed us forward into unexpected places. And when we strayed too far, he would pull us back to try another direction. From this philosophy, I learned to embrace risk to find bold new ideas.

Every new idea begins with concept art. But who or what are concept artists? Concept artists are visual storytellers, as well as designers: They initiate broad story ideas while creating specific designs. Their art form encompasses a wide range of skills that can be hard to label under a single title. Concept artists not only have to be industrial designers, character artists, painters, costume designers, set decorators, architects, and cinematographers, but also researchers and historians—as well as futurists. It is a very personal art form, but also immensely collaborative.

When I first met Gareth Edwards in January 2014, I found a fellow concept artist at heart. His confidence and clarity of vision was similar to George's. Gareth intuitively understands the power of great designs and how they can inform and inspire the story. During our early meetings, I discovered that he knew as much about *Star Wars* design, and its technical aspects, as I did.

Like myself, he held *Star Wars: A New Hope* as the benchmark of excellence for cinematic design. And because the story of *Rogue One* takes place before the events of *A New Hope*, and in fact directly links to George's original film, we knew our new designs had to dovetail seamlessly with it. This made our design mission even more daunting. Over a year and a half, we produced more than six thousand pieces of concept art. Discovering Jyn's ship alone took nearly five hundred drawings. This spoke to the thoroughness that Gareth demanded.

To anchor us, we all looked to Ralph McQuarrie. His genius was his uncanny ability to create iconic cinematic shapes. Stripped of details, his forms were always graphically simple but striking. He designed vehicles, sets, and environments almost as if they were logos. Details, after all, embellish the form but don't define it. The best ideas often seem simple and obvious in hindsight, but finding that simple idea can be very elusive and arduous. Design is rarely a straight path.

In our early brainstorming sessions, we asked ourselves one simple question: "As fans ourselves, what would we want to see in a *Star Wars* film?" That simple question set the tone and became the measure for our work ahead. We discussed where we have been and where we could go—or where we *should* go. It was important to find the bold ideas that would capture our collective imagination. The ideas needed to start big to set the aspiration bar as high as possible. From there, we knew that the vision would only get smaller as the limitations of time, budget, and resources eventually set in.

As we explored that gray boundary area, sometimes we would go too far. Other times we would find something interesting that would spark a new direction for someone else to expand further. Or someone would misinterpret someone else's drawing and create something entirely new. There were no

Page 1
IMPERIAL-OCCUPIED JEDHA Thom Tenery

Pages 2–3
***ROGUE ONE* ENSEMBLE: BAZE MALBUS, CHIRRUT ÎMWE, K-2SO, JYN ERSO, CASSIAN ANDOR** Jon McCoy

Pages 4–5
VADER EMERGING FROM BACTA Luke Fisher

Pages 6–7
MOUNTAIN LANDING—JYN ERSO McCoy

Pages 8–9
JEDHA EXTERIOR VERSION 1A Matt Allsopp

egos. An idea would bounce from one artist to another, amplifying and growing with each iteration.

Filmmaking by its nature is a collaborative effort. By embracing the knowledge that there is no ownership in what we do—it's not about who designed what, or who came up with a particular idea first—we rely upon a highly collaborative process to attain the best designs possible.

This book epitomizes what can be born out of that team effort, when everyone's focus becomes a singular vision. Our vision for *Rogue One* is inevitably different than *A New Hope*, but it is one we hope is worthy of being called a *Star Wars* film.

Doug Chiang is an Academy Award®-winning artist, author, and production designer. As creative director for Industrial Light & Magic, he served as visual effects art director on films such as *Terminator 2*, *The Mask*, and *Forrest Gump*. In 1995, George Lucas personally selected Chiang to serve as head of the Lucasfilm art department for seven years on *Star Wars*: Episodes I and II. He left Lucasfilm in 2002 to form his own design studio, IceBlink Studios. Chiang returned to Lucasfilm in 2013 to work on *Star Wars: The Force Awakens* and currently serves as Lucasfilm VP creative director. He served as co-production designer on *Rogue One: A Star Wars Story*.

Foreword by Neil Lamont

By May of 2014, the art department was deeply immersed in creating sets and locations for *Star Wars: The Force Awakens*. The telephone rang in my office at Pinewood Studios, UK and a voice on the other end asked if I would like to meet Gareth Edwards and Doug Chiang. *Well*, I thought to myself, *they must be looking for a supervising art director. Nothing ventured . . .* But, as it turned out, they asked me to partner with Doug as co-production designer for *Rogue One: A Star Wars Story*.

The concept art you see here in this book is the realization of Gareth's vision. It shows his knowledge of *Star Wars*, and how he wants to translate memories of his first experience viewing *A New Hope* into his vision for *Rogue One*. This book is the wonderful product of hard work by the San Francisco and United Kingdom art departments, creature FX, the costume department, as well as artists working remotely from all around the world.

Our challenge has been to create and transition the design concepts (including art direction, set decoration, creature FX, costume design, prop making and construction) in a way that they seamlessly span the two films. This is a collaborative process—ideas are pooled, explored, and developed, while always pushing boundaries.

The concept art is vital to *Rogue One* because it informs many design departments, from environment to lighting and mood. However, there are times when we do not have enough exploration time for concept art to be fully developed. So we sometimes rely on drawn plans and elevations that allow us to quickly produce a model. The model, with the aid of a "lipstick camera," provides an accurate view of the intended built set. This is an "old school" method. *Rogue One* has a great balance of both techniques.

In addition to concept, set decoration research and mood boards allow the director to become immersed in the layering of the set. The addition to the decoration, the tone and texture enhance the production design. In the case of the city of Jedha, set decoration referred to combinations of historic bazaars of the Far East and ancient marketplaces, becoming the basis on which the decorations were designed. The result complimented the architecture of these inspiring places.

The construction department manufactured life-size examples of set finishes. In the case of the interior homestead, for example, faux laser-cut rock was chosen as a theme. A sample was sculpted and, with further collaboration, slipped sections of rock were added, then painted—first as a base tone, then multiple layers of hues. Next, peat and sawdust were added for texture; and finally a top finish of waxes and aging. The set decoration department and the drapes department then continued the process, applying buttoning and webbing to rolls of manufactured padded insulation. This is an ongoing collective process throughout the production, where everyone's thoughts are gathered into one place, creating physical concepts for all to see, touch, and interact with.

As set designers, we tell a story with scenery—from the concept art to the art direction, set decoration, and the final build—to ultimately immerse the audience in a place and time, in a galaxy far, far away.

Neil Lamont served as supervising art director for *GoldenEye*, *Harry Potter and the Sorcerer's Stone*, *Harry Potter and the Deathly Hallows: Part 2*, *War Horse*, *Edge of Tomorrow*, and *Star Wars: The Force Awakens*. He was co-production designer on *Rogue One: A Star Wars Story*.

▶ ▶ **PRISONER TRANSPORT** Allsopp

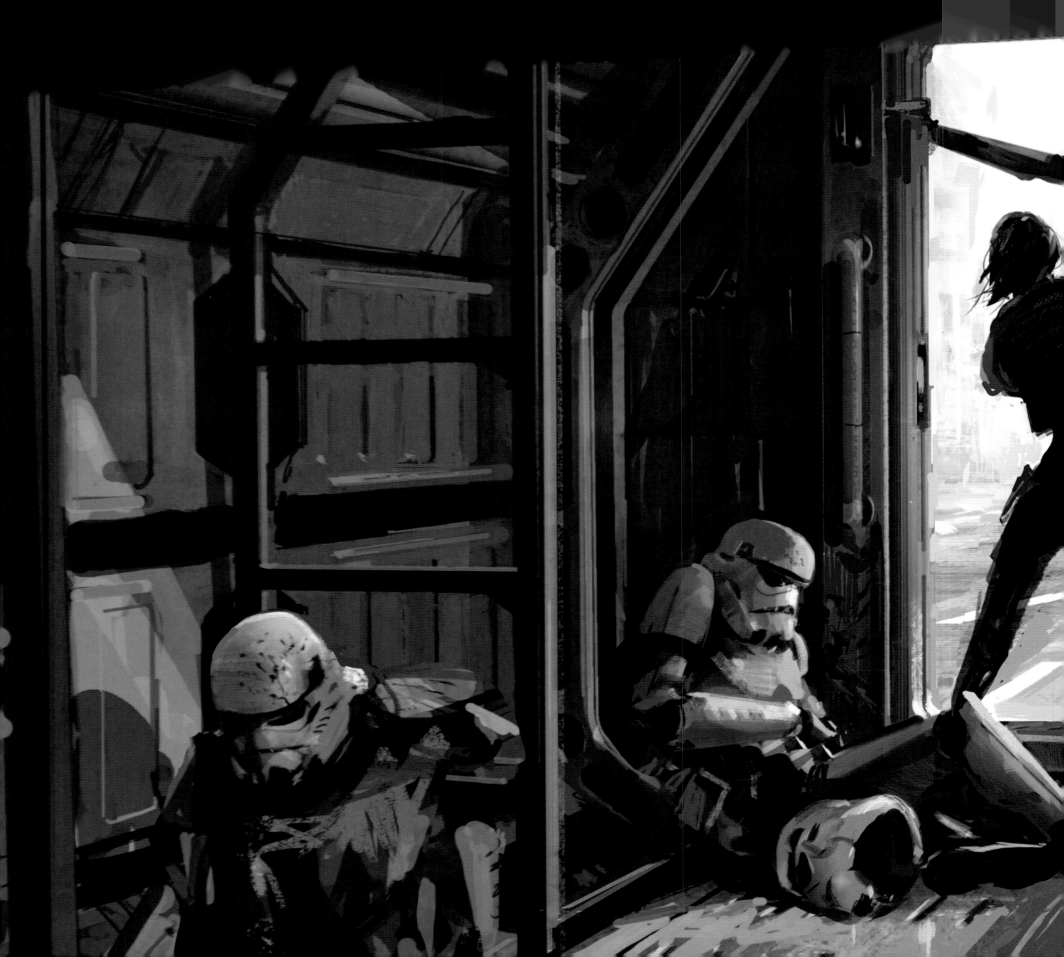

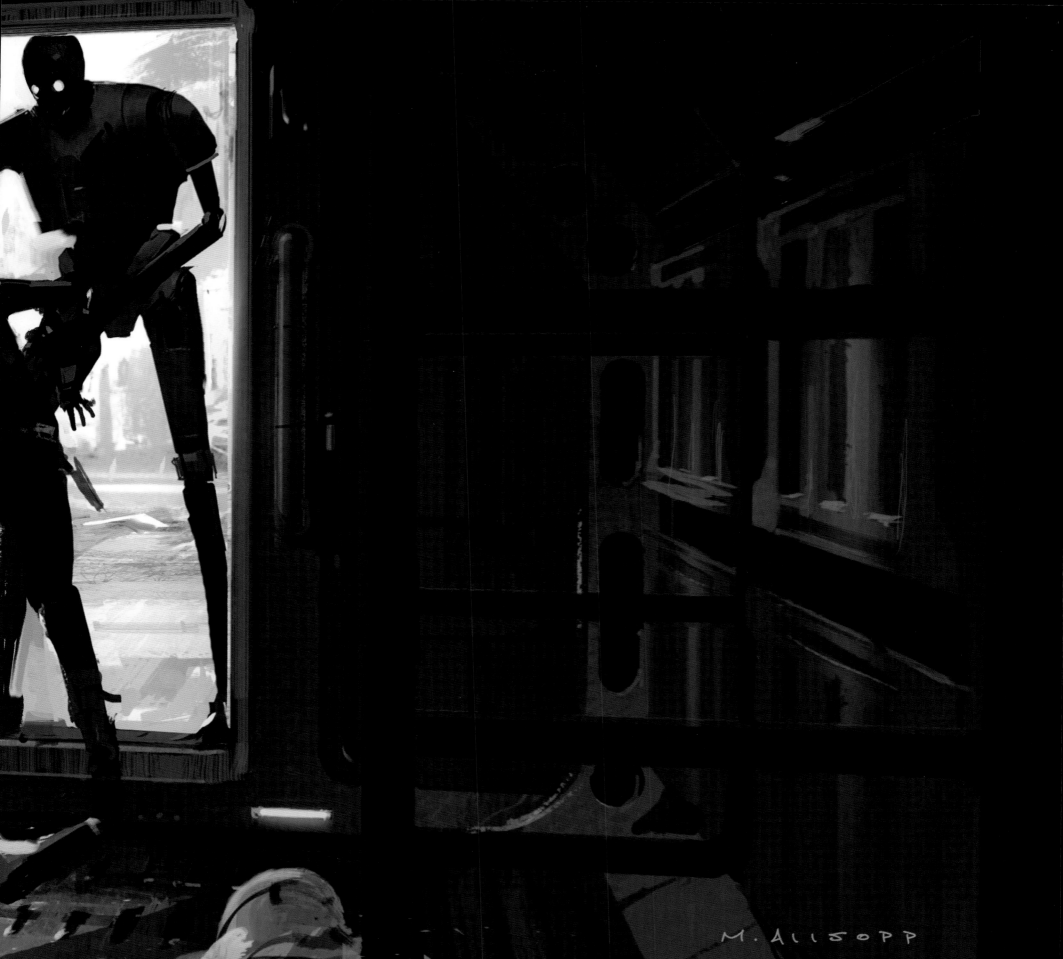

Foreword by Gareth Edwards

I don't actually remember seeing *Star Wars* for the first time. I was two years old when it came out in the cinemas, so it was just always there, part of the world. In fact, if you'd asked me what I wanted to do when I grew up, I'd have probably said, "Join the Rebel Alliance and blow up the Death Star." Then, slowly over time, I started to learn that *Star Wars* wasn't, in fact, real. These people and places didn't actually exist. The whole thing was one giant lie, made by adults, called a "film." I eventually figured, well, if I couldn't fly an X-wing, then I'd do the next best thing: I'd grow up and become one of these "liars" and make films, too!

Apparently, after a bit of research, all you had to do to be a filmmaker is go to film school, make a short film, and then wait until you got a call from either George Lucas, or perhaps Steven Spielberg, inviting you to shoot a giant Hollywood movie. Sadly, they must have lost my number or something, because after I graduated, the phone never rang. But, as it turned out, film school wasn't a complete waste of time. My flatmate was studying this new thing called "computer graphics," a tool that was clearly going to become the future of filmmaking. If no one ever gave you the chance to make a film, it didn't matter; all you had to do was learn the software and then there was nothing stopping you from going off and making your own.

So that was the plan: spend six months figuring out how to use Photoshop, and the next six making a film. Turns out I wasn't as talented as I'd thought, and it took me closer to a decade to get good enough to try and make something. Throughout that time I bought every "Art of" book I could find, desperately studying each image in search of inspiration. I wondered, *How did they paint that so well? How did they find that composition? Why doesn't my work look as good as that?*

The "Art of" books I picked up from my shelf the most were my *Star Wars* ones, from both the original trilogy and the prequels. It seems the more you try to make films, the more you realize how special *Star Wars* really is. The planets aligned back in 1977 in a way that might not ever happen again. First, you had George Lucas—one of the greatest filmmakers of a generation—at the height of his creative powers. Then, add to that John Williams—arguably the greatest film composer that has ever lived—composing one of the best soundtracks of his career. Next, the formation of a little company called Industrial Light & Magic, the employees of which are a who's who of the godfathers of visual effects. Not to mention the "discovery" of a relatively unknown actor called Harrison Ford. Perhaps the least known, and possibly most important, of all these ingredients

was George's collaboration with a quiet, humble, visionary artist named Ralph McQuarrie.

When I packed up my life to move to San Francisco to start development on *Rogue One*, I didn't have much room left in my bag, so I packed only one book. That book was, for me, the visual bible of *Star Wars*: a large coffee table publication simply called *The Art of Ralph McQuarrie*. McQuarrie was to some extent doing the same with his designs as George was doing with story: taking ideas grounded in history and mythology and adding just enough futurism to make them feel fresh—unrecognizable from their origins. But I learned pretty quickly that this was a very simplistic view of what is truly a delicate balance. If you take things slightly too far, it just isn't *Star Wars* anymore; not far enough and you are just copying what Ralph and George had already done.

Fortunately for me, I was in the safest of hands. Joined by Doug Chiang and Neil Lamont, I got to work with my artistic heroes, whose names you will see beside the great designs and iconic visuals in this book. I personally feel that concept artists are perhaps the most underrated contributors to modern Hollywood filmmaking. Their work is where cinematic alchemy happens. These are the people who seem to pluck great visuals from thin air and turn them into inspiring new worlds and memorable characters. I can't help but feel that if a lot of the great painters and masters of the past were alive today, and still wanted to inspire the world with their visual ideas, then they might well have become concept artists, too.

One of the things I do at the start of a project is put together a collection of reference images for each section of the film. For *Rogue One*, I gathered a couple thousand images, and it soon became clear (and a little embarrassing) that some of the artists whose work I had stolen—including Erik Tiemens, Doug Chiang, and Ryan Church—were actually working on the movie. It was pretty cool to be in meetings and point at my favorite images and say, "Can you draw something like this?" only to hear someone respond, "I hope so, that's my painting."

A great highlight of working at Lucasfilm is that, at some point, you get to visit the archives: a large warehouse full of what can only be described as every fanboy's dream. You name it, it's there: the *Millennium Falcon*, Luke Skywalker's lightsaber, Darth Vader's helmet, Han Solo frozen in carbonite. But the objects that gave me the most goosebumps were the ones toward the back, in horizontal drawers—the place that is home to the very paintings that started it all. I had studied these images for hours and hours in books as a child, but here they

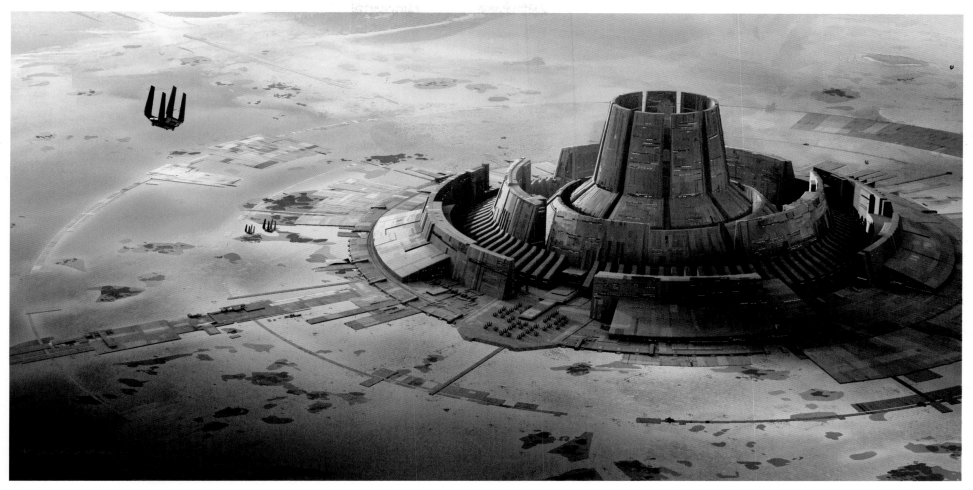

▲ **SCARIF TOWER AERIAL EXTERIOR VERSION 1A** Ryan Church and Tenery

were, in real life. It felt like looking at the original Dead Sea Scrolls, or the Ten Commandments. This was the genesis of *Star Wars*. This was where it all began.

The great thing about the concept artists and designers on *Rogue One* is that they tend to be incredibly collaborative. There were so many occasions where we would take one artist's work and give it to another, just to see if there was anything that could be tweaked or improved with fresh eyes. And, rather than being protective, they would all actively encourage it, feeding off each other, constantly doing paint-overs on top of one another's images. As a result, many of the designs in this book don't have one single parent, but have, instead, evolved through a series of experiments and collaborations void of egos or barriers, just a desire to create the best concept possible.

As I feared when I started this process, this book is full of great images and ideas that never made it into the final film. This was due to many different reasons. Sometimes the story changes, sometimes the budget, and sometimes it's just bad luck, but never because the art wasn't good enough. When someone's brilliant work wouldn't make it into the final film, we'd try and make ourselves feel better by saying, "That's why God created 'Art of' books"—half joking, but half serious. This is where great ideas come, not to die, but to live forever in our childlike imaginations.

Enjoy.

Gareth Edwards acted as writer, director, and cinematographer—and completed the creature design and visual effects shots single-handedly—for the BAFTA-nominated film *Monsters* (2010). His work drew the attention of Hollywood, where he was given the opportunity to direct Legendary Pictures's epic rebirth of *Godzilla* (2014).

Edwards's creative flair and intimate storytelling did not go unnoticed. In May 2014, he was offered the chance to direct for the very same film franchise that so heavily influenced him as a child—*Star Wars*—with *Rogue One: A Star Wars Story*.

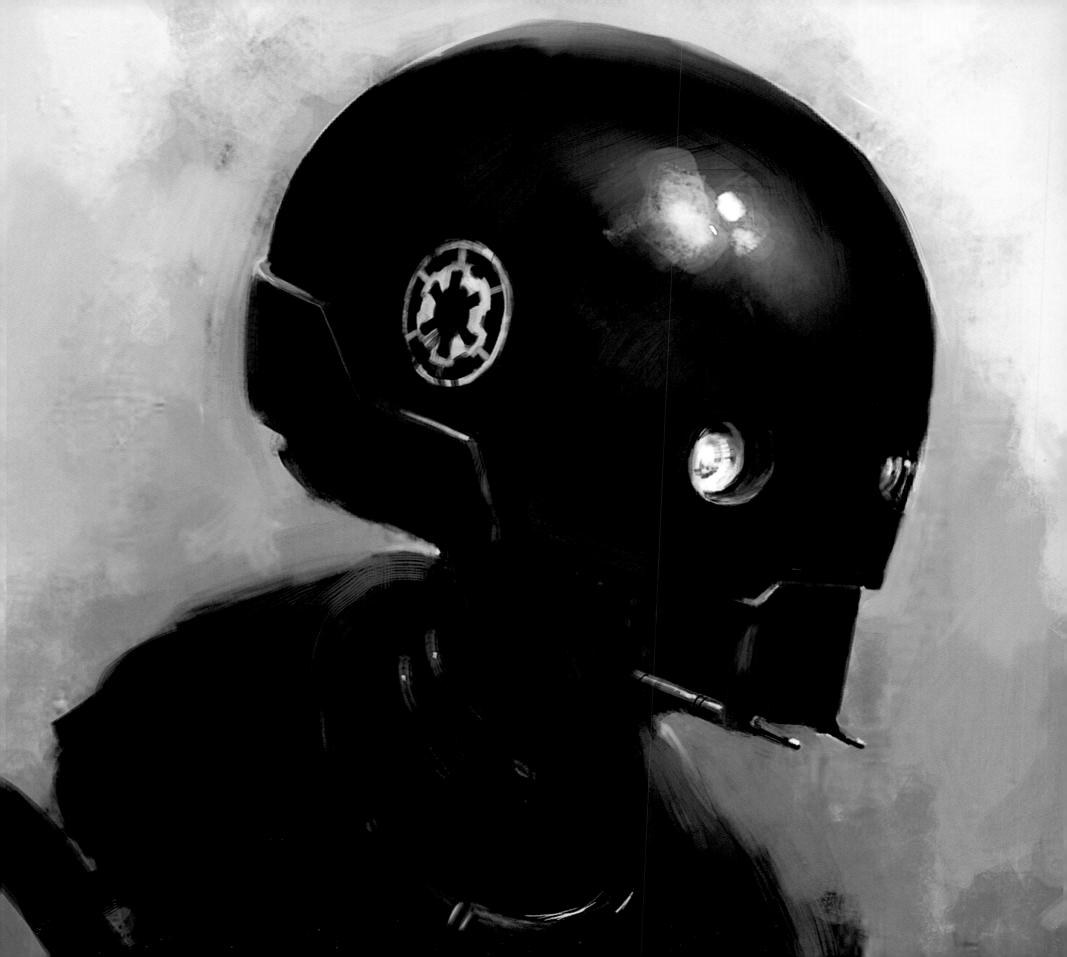

WHO'S WHO

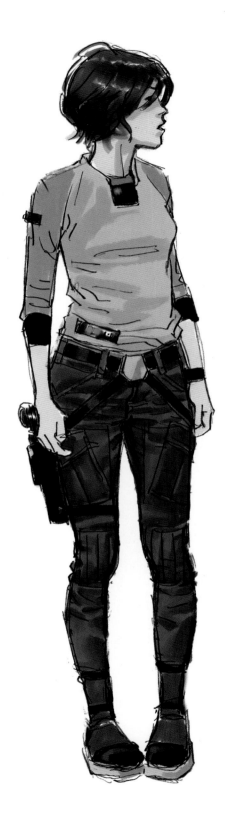

MATT ALLSOPP
Lead concept artist

CHRISTIAN ALZMANN
Concept artist

ALEX BAILY
Art director

JOHN BELL
Concept artist

CHRIS BONURA
Concept artist

ANDREW BOOTH
Computer graphics
supervisor: BLIND LTD.

ADAM BROCKBANK
Costume concept artist

AL BULLOCK
Supervising art director

CHRIS CALDOW
Concept artist

JULIAN CALDOW
Concept artist

KINMAN CHAN
Concept artist

DOUG CHIANG
Lucasfilm VP creative
director
Co-production designer

RYAN CHURCH
Concept artist

JAMES CLYNE
Concept artist

DAVID CROSSMAN
Co-costume designer

GLYN DILLON
Co-costume designer

YANICK DUSSEAULT
Art director

GARETH EDWARDS
Director

JORDANA FINKEL
Art director

LUKE FISHER
Creature concept designer
Senior sculptor

RENE GARCIA
CG concept modeler

JOHN GIANG
Concept artist

CHRISTIAN HALEY
Concept artist

KIRI HART
Lucasfilm senior vice
president of development
Co-producer

TOBY HEFFERMAN
Associate producer
First assistant director

DAVID HOBBINS
Concept artist

GUSTAV HOEGEN
Animatronic design
supervisor

MUNGO HOREY
Screen graphics designer

WILL HTAY
Concept artist

ALEX HUTCHINGS
Art department model
maker

KEVIN JENKINS
Concept artist

VINCENT JENKINS
Concept artist

FELICITY JONES
Actor (Jyn Erso)

KATHLEEN KENNEDY
Lucasfilm president
Producer

JOHN KNOLL
Industrial Light & Magic
chief creative officer
Executive producer

NEIL LAMONT
Co-production designer

KHANG LE
Concept artist

THANG LE
Concept artist

NICOLE LETAW
Lucasfilm art production
manager

KARL LINDBERG
Concept artist

GEORGE LUCAS
Star Wars creator

JAKE LUNT DAVIES
Creature concept designer

IVAN MANZELLA
Creature concept designer
Senior sculptor

AARON McBRIDE
Concept artist

JON McCOY
Storyboard artist

JASON McGATLIN
Lucasfilm senior vice
president of production
Executive producer

BRETT NORTHCUTT
Concept artist

KARLA ORTIZ
Concept artist

MARTIN REZARD
Creature concept designer
Senior sculptor

RAYNE ROBERTS
Lucasfilm creative
executive

LEE SANDALES
Set decorator

MATTHEW SAVAGE
Concept artist

NEAL SCANLAN
Special creature effects
supervisor

TYLER SCARLET
Jr. concept artist

ALLISON SHEARMUR
Producer

JOHN SWARTZ
Lucasfilm director
of development and
production
Co-producer

KRISTEN SWARTZ
Franchise production
supervisor

STEPHEN TAPPIN
Concept artist

THOM TENERY
Concept artist

ERIK TIEMENS
Concept artist

ANDRÉE WALLIN
Concept artist

CHRIS WEITZ
Screenwriter

COLIE WERTZ
Digital effects artist

GARY WHITTA
Screenwriter

JAMIE WILKINSON
Prop master

SAM WILLIAMS
Costume concept modeler

DONNIE YEN
Actor (Chirrut Îmwe)

SHAUN YUE
Screen graphics designer

▲ **JYN ERSO IN COMBAT GEAR (NO JACKET) VERSION 3** Glyn Dillon

◄ **K-2SO HEAD STUDY** Fisher

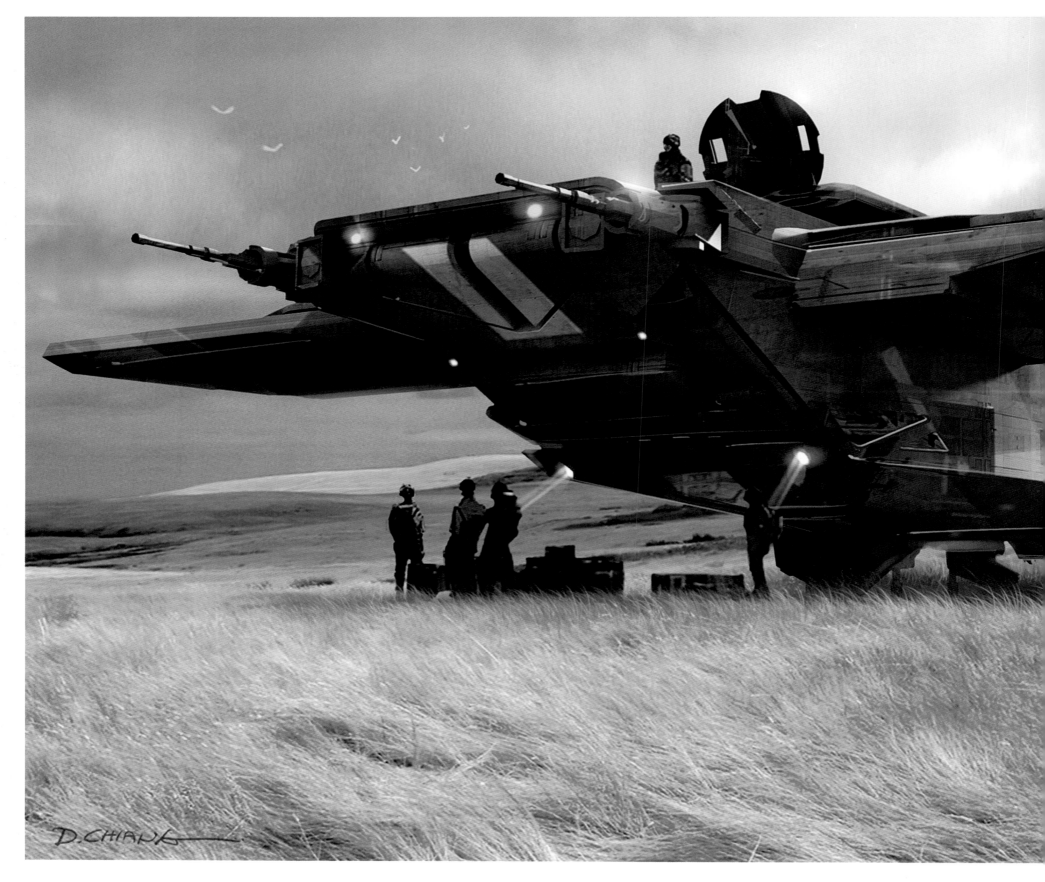

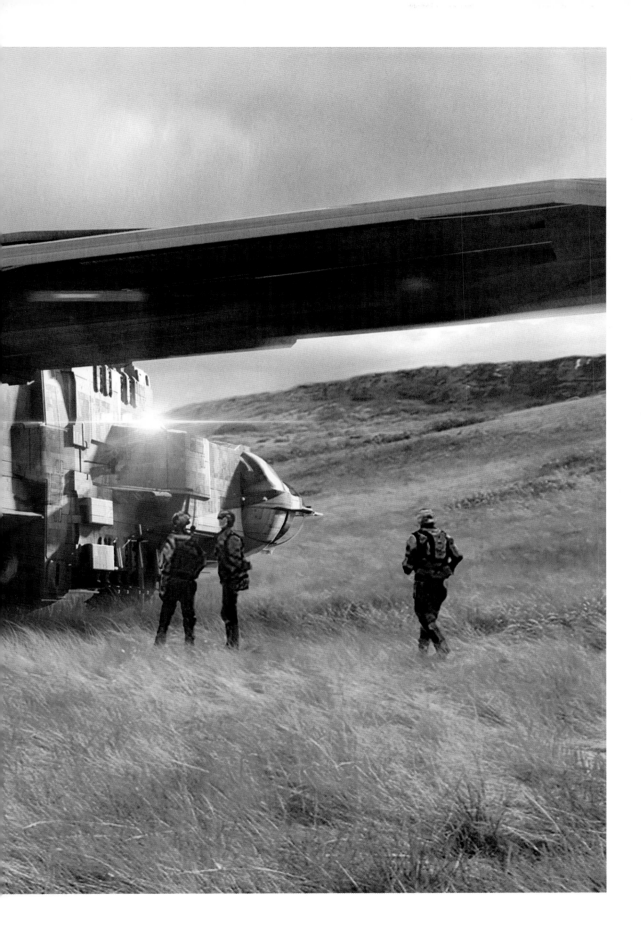

PROLOGUE:
"LET'S TELL *THAT* STORY"

In late 2012, The Walt Disney Company publicly announced that it had acquired Lucasfilm Ltd.—and with it, the rights to produce new *Star Wars* films.

This return to the *Star Wars* galaxy portended even more than just the promised continuation—and eventual conclusion—of the Skywalker saga, as originally chronicled in Episodes I through VI. With an entire "galaxy far, far away" before them, the creative caretakers of the expansive *Star Wars* universe made a bold decision early on to look *beyond* that evolving saga, enriching its narrative with adjacent tales of all-new heroes in all-new scenarios. In February 2013, Lucasfilm announced that it would develop *Star Wars* features independent of the established Episodes but within the same fictional universe. The first of these standalone films, *Rogue One*, marks the origin of not just a new *Star Wars* film, but of the *Star Wars Story* brand, as well as an entirely novel approach to *Star Wars* itself.

Stepping in for *Star Wars* creator George Lucas after his retirement, new Lucasfilm president Kathleen Kennedy saw the potential of a galaxy alive and in motion, bursting with stories unfolding *alongside* the Episodes—existing organically just beyond the frame. These new features would provide opportunities to explore parts unknown—to not only peer around the corners of the existing movie mythology, but also to shine a light on otherwise unseen areas and unsung heroes of *Star Wars*.

Unhindered by the trilogy format, here was a chance to survey the full expanse and history of the galaxy from entirely new angles, and to allow visionary filmmakers to bring fresh perspectives to *Star Wars*.

"It's interesting to think about what sets *Star Wars* apart. A lot of people wonder what that magic formula is, if there is one; I think it comes from an authenticity and a genuine feeling of aspiration that embody who George was when he started making films," Kennedy said. "George loves movies—anything from John Ford westerns to Kurosawa films to World War II movies—and I think that's something we as filmmakers can draw on. So what we're doing is following along the lines of that genre filmmaking. The fascinating thing with these new films is that anything can happen—and this is the kind of cinematic history that inspired *Star Wars*."

◄ **ASSAULT SHIP VERSION 1** Doug Chiang

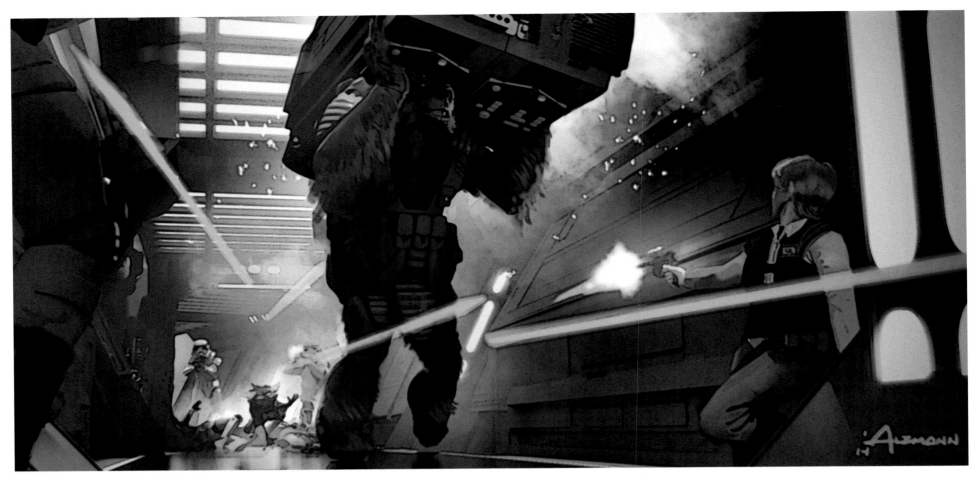

In the spirit of "anything can happen," the idea for the first of these standalone stories came from an unlikely source: a relatively modest genre pitch by Industrial Light & Magic's soft-spoken chief creative officer, John Knoll (*Star Wars*: Episode II *Attack of the Clones*, *Star Wars*: Episode III *Revenge of the Sith*, *Pirates of the Caribbean: Dead Man's Chest*).

"For a lot of us, the first thought was, *John Knoll's writing a story?*" said concept artist Ryan Church (*Attack of the Clones*, *Revenge of the Sith*, *Star Wars: The Force Awakens*), who was among the initial pool of artists brought in to work on *Rogue One*. "For a long time, we'd thought of him strictly as an executive at Industrial Light & Magic; it's easy to forget that he's a genius and one of the leading experts on *Star Wars*. If anyone was going to be able to come up with a story like this one, it was going to be John."

Knoll's pitch was short and sweet—a seven-page treatment titled *Destroyer of Worlds*, which also included corresponding character biographies. The story was simple, promising to flesh out the heroics of those rebel spies so famously referenced in the opening crawl to the original *Star Wars*:

. . . Rebel spaceships, striking from a hidden base, have won their first victory against the evil Galactic Empire. During the battle, Rebel spies managed to steal secret plans to the Empire's ultimate weapon, the DEATH STAR . . .

"It's what's described in the *A New Hope* crawl—the story of a mission to steal the Death Star plans," said Knoll. "That's the core of the idea. I thought, *Let's tell* that *story*."

After sharing his idea with Kennedy and Lucasfilm senior vice president of development and co-producer Kiri Hart (*The Force Awakens*) in May 2013, Knoll got a green light for his idea in the room, jumping the line of *Star Wars Story* prospects to take first position in the production queue, right after *The Force Awakens*.

"Kathy and Kiri came out of that meeting just glowing, and they'd pretty much told John then and there that his idea was the next thing we were going to do," said co-producer and Lucasfilm director of development and production John Swartz (*The Force Awakens*). "It was exciting and, in terms of figuring out what the first standalone movie would be, it was a perfect idea. As soon as we heard it, it just clicked."

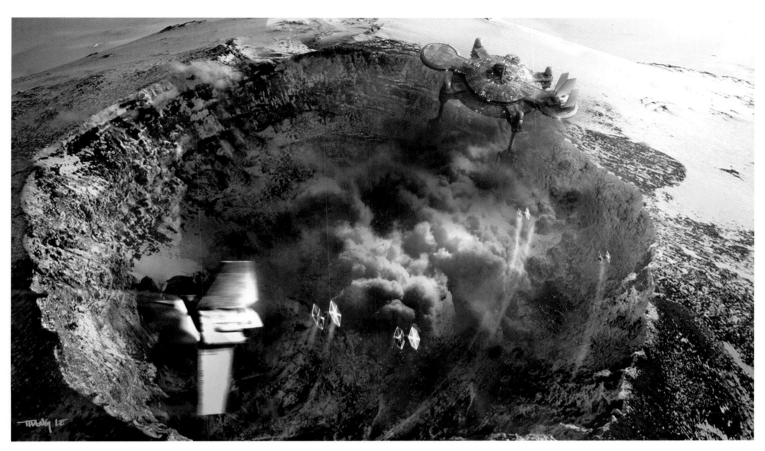

Blue-Sky Development

Within a few short months of the initial pitch—under Knoll's guidance, but without a director or writer yet attached—concept art development got underway.

"Our policy is that as soon as there's an idea, there can be concept art. We have this embarrassment of riches, with so many crazily talented artists at our disposal. They all know *Star Wars* and are already at Lucasfilm and ILM. So we just started having them work on stuff," said Hart. "In John's case, we knew he was going to be the executive producer and the visual effects supervisor as well—so we thought that if he wanted to play around a little bit and start generating some ideas, it couldn't hurt. Anything that doesn't get used, we just put into the archive, because someday we may find a use for it somewhere else."

Coming to the project after transitioning off *The Force Awakens* in February 2014, Church recalled, "John showed us his treatment, along with something he'd cut together—a sizzle reel—for reference and inspiration. He wanted to give us a sense of what was in his head, so he gave it to us and said, 'Watch this. It's the tone of the movie.' And it really was; it was a heist thing,

kind of *Mission: Impossible* meets *The Hunt for Red October*, and it was filled with film clips and references like that. Very militaristic, streamlined, and self-contained."

This narrative economy was to function both as an appropriate story structure for a wartime tale and as a proof-of-concept to justify consideration for the project itself—an implicit argument that the idea could be made more efficiently and more cost-effectively than the large-scale Episodes.

"What was really interesting was that, at the time, John had a number in his head that he wanted to be able to make it for, and it was a low, low number—a really low budget," said Church. "John just wanted to get something going, and he wanted to show how his idea could get made—so that's why he'd pitched this neat, lean thing with limited characters. Coming off *The Force Awakens*, we were all blown away, because it was the complete opposite of that. He even pitched reusing sets from *TFA*, just to prove it could be done. John is very left-brained, and so everything about his approach was from a very left-brained perspective."

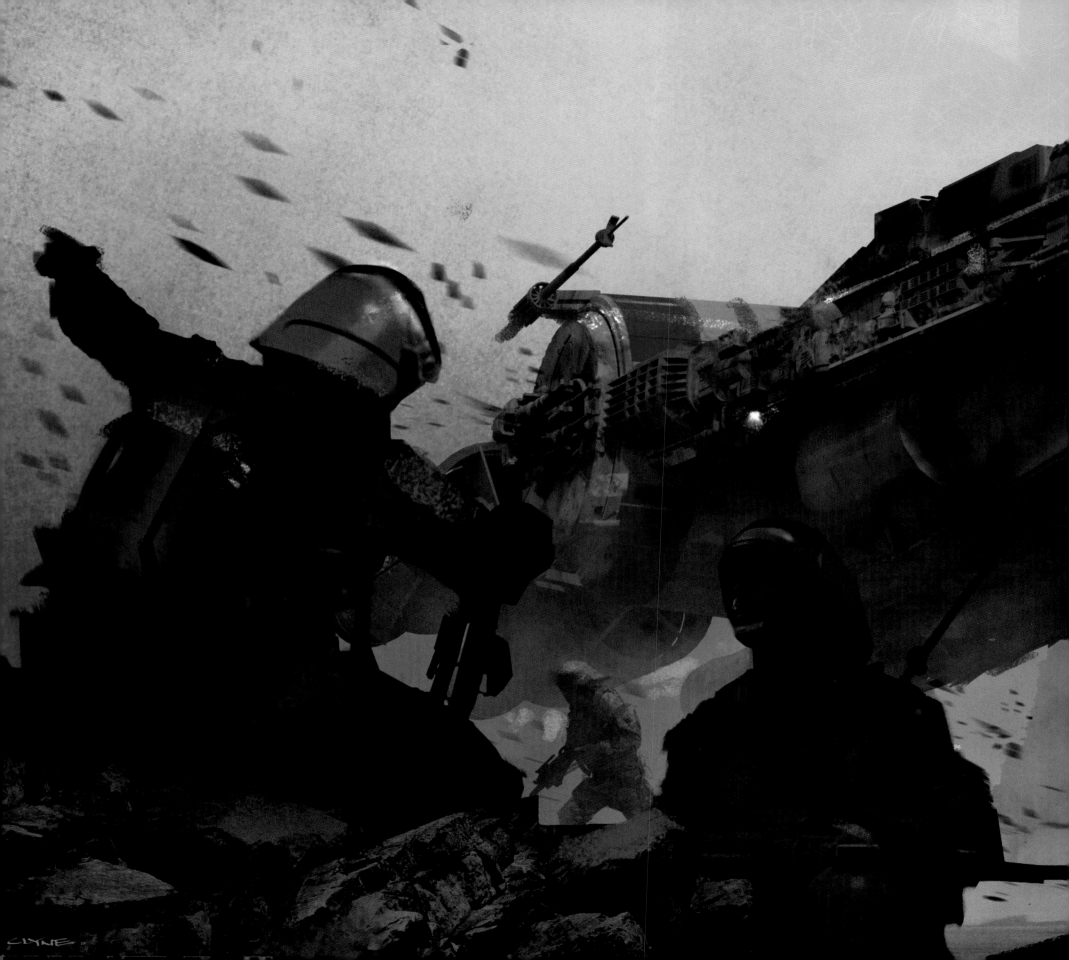

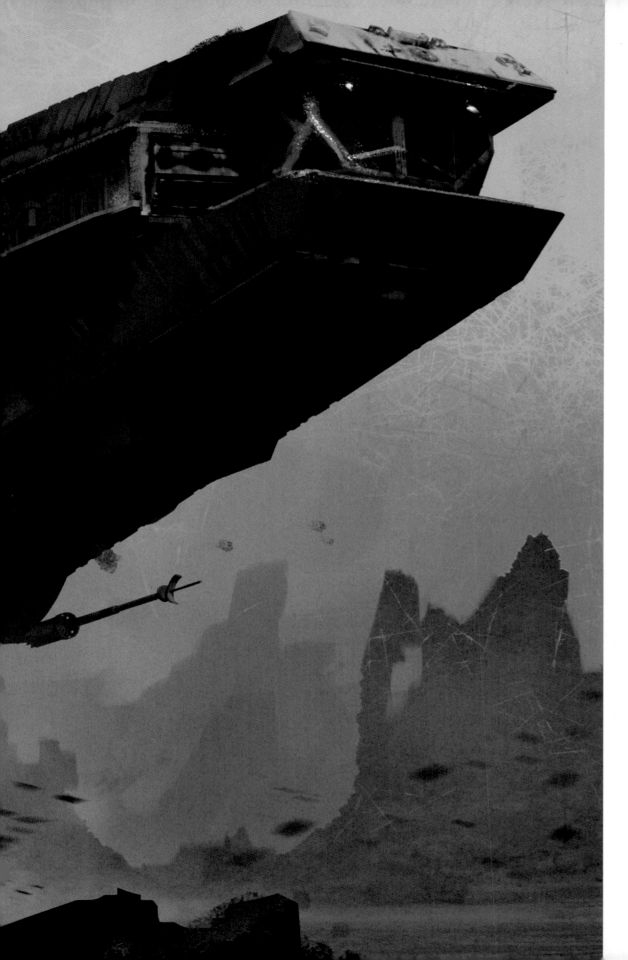

Tight and economical in its telling, Knoll's pitch also envisioned a streamlined cast of characters to drive the story—leaning on tropes and conventions from his own childhood cinematic inspirations.

"It's sort of a well-known story of where *A New Hope* came from—that George drew elements from a lot of material that he liked, synthesizing them in a way that felt fresh and different," said Knoll. "I was drawing from a lot of things that I loved when I was a kid: movies with a small group of experts working together as a team, caper movies, commando movies, intelligence procedurals, detective dramas with a cat-and-mouse component. So, that's what I was trying to do—to come up with something in the same way that George wrote *A New Hope*."

Among the unusual suspects populating Knoll's cast of characters were rebel commando Jyn Erso, rebel pilot Ria Talla, protocol droid K-2SO, and team members Dray Nevis and Jerris Kestal, along with aliens Lunak and Senna—all engaged in a series of breathless set pieces in search of a means to destroy the Death Star. Knoll took them through covert infiltrations and intrigue, followed by requisite escapes and evasions. Confounding the heroes' journey was Krennic, an Imperial spy embedded within the team who would covertly report back to an Imperial Security Bureau intelligence officer always at their heels—Willix Cree.

"If we go all the way back, it was very much like *Force 10 from Navarone*—a ragtag commando team, which would allow us to play with a bunch of different character types and scales," said concept artist Christian Alzmann (*A.I. Artificial Intelligence*, *Attack of the Clones*, *War of the Worlds* [2005]).

With only a few pages outlining the basic story and a few more articulating the key characters, the teams tasked with bringing *Destroyer of Worlds* to life during this period were given creative license and allowed to default to "blue-sky" ideation as deeper story development progressed.

"You always have to look at *Star Wars*—at the history of the universe—to see what's been done in the past, to make it all fit," said lead concept artist Matt Allsopp (*Godzilla* [2014], *The Force Awakens*). "But another important part of *Star Wars* is showing audiences something completely new. I quite like the blue-sky stuff."

◄ **MOUNTAIN PLANET LANDING VERSION 2** James Clyne

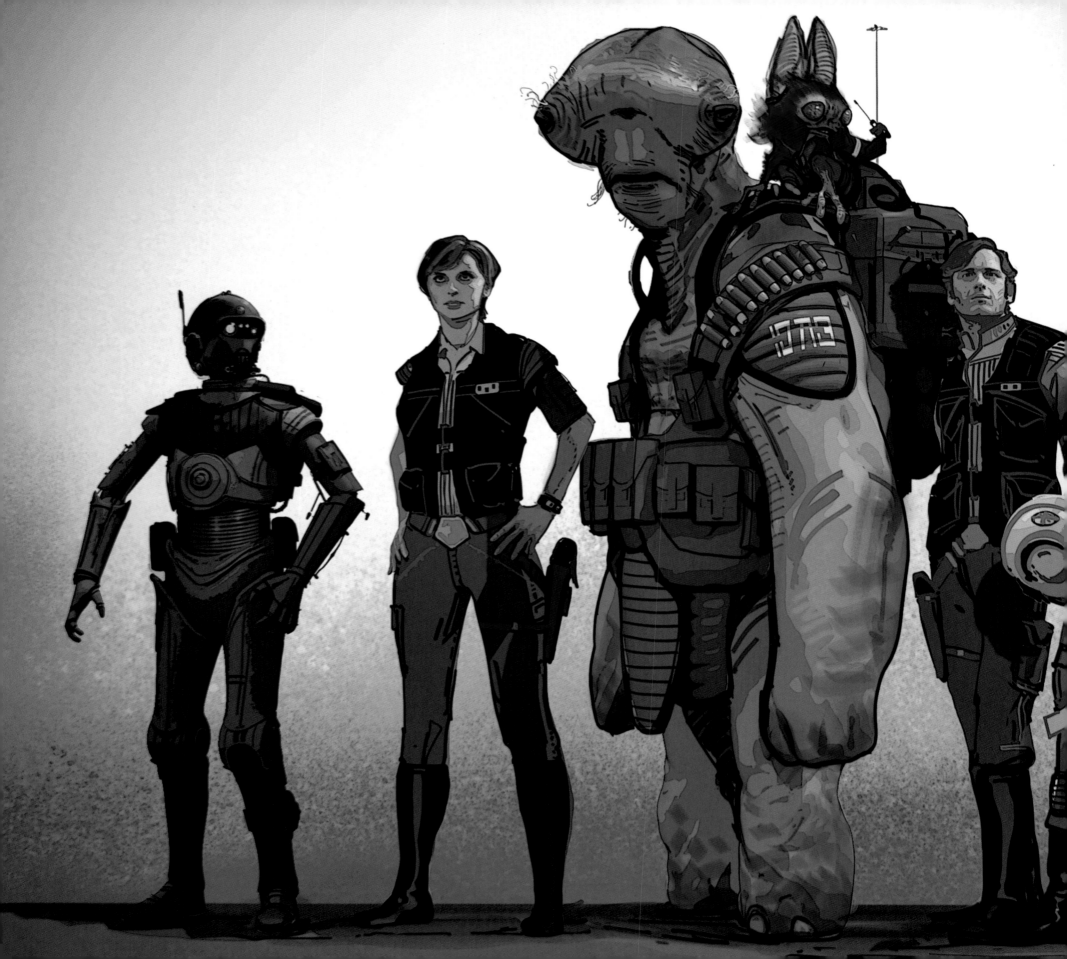

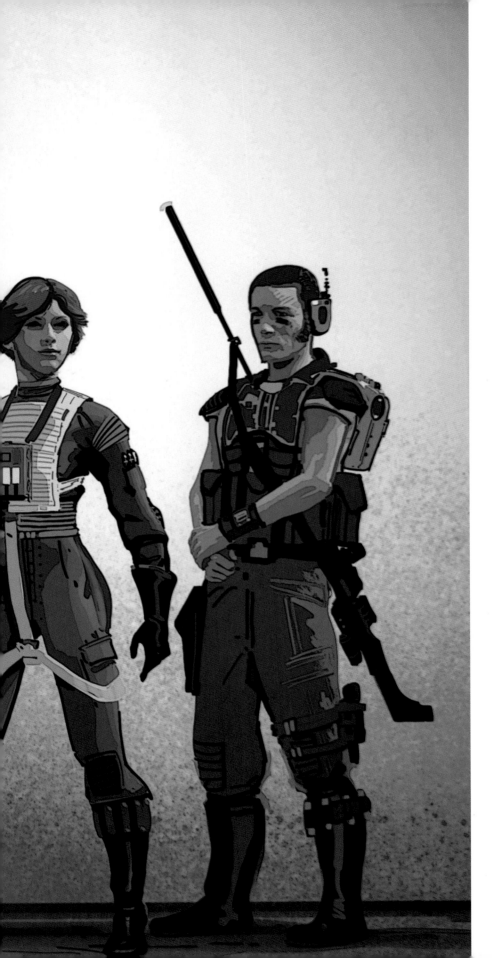

▲ **SENNA VERSION 2** Karl Lindberg

◄ **THE ORIGINAL LINEUP: K-2SO, JYN ERSO, SENNA, LUNAK, DRAY NEVIS, RIA TALLA, JERRIS KESTAL** "Senna and Lunak were going to be our two aliens. I imagined Senna would be just massive—a Chewie type, but even bigger. And Lunak would be something that could skitter into an air duct, almost like a little thief." Alzmann

▲ **SENNA CONCEPT** Lindberg

▲ **SENNA VERSION 2** Alzmann

▶ **K-2SO VERSION 1A** Ivan Manzella

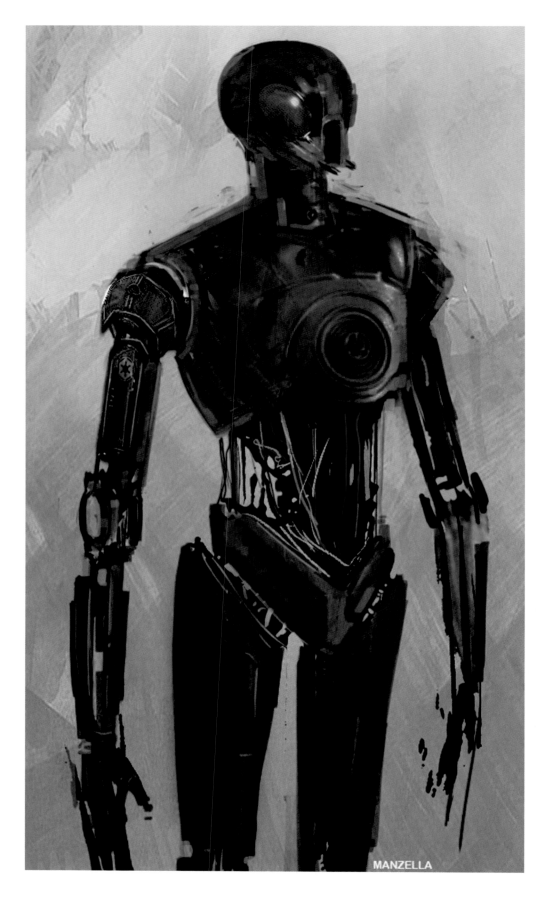

MANZELLA

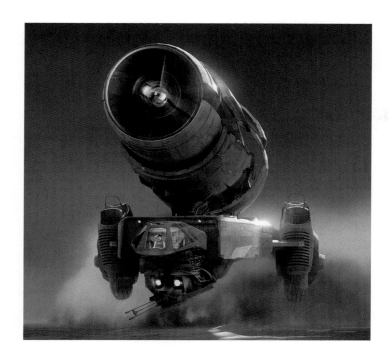

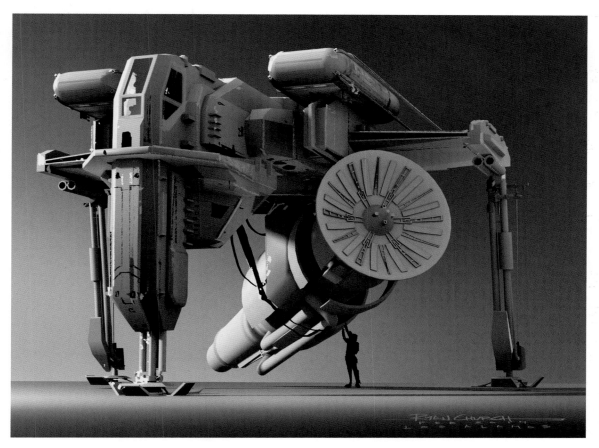

▲ **RECONNAISSANCE SHIP/MARINE FIGHTER VERSION 1** Chiang

▶ **TELESCOPE SHIP** "John had something specific in mind for a new ship. It had a telescope, but he made it clear that it wasn't an *optical* telescope. It used radio imagery, and the way he saw it, the rebels would have taken an old cargo ship and jerry-rigged the radio antenna onto that. Ugly, awkward, gawky—this thing is just something they threw together, and it's a mess." **Church**

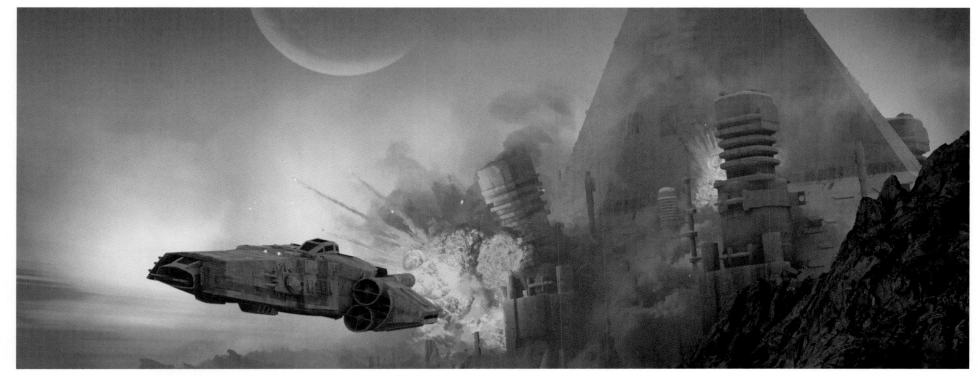

▲ **ESCAPE FROM MOUNTAIN PLANET VERSION 1** Yanick Dusseault

▶ ▶ **TIE FIGHTER CHASE VERSION 1** Clyne

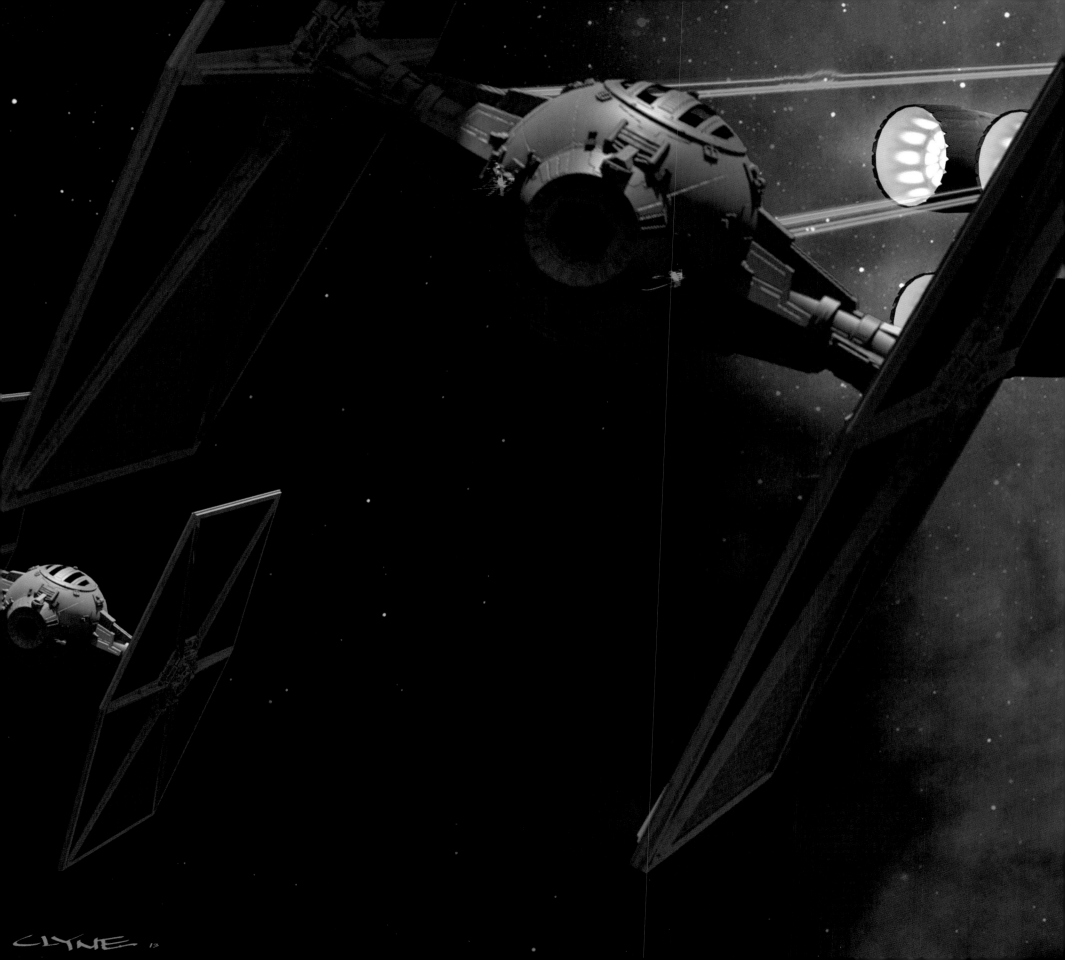

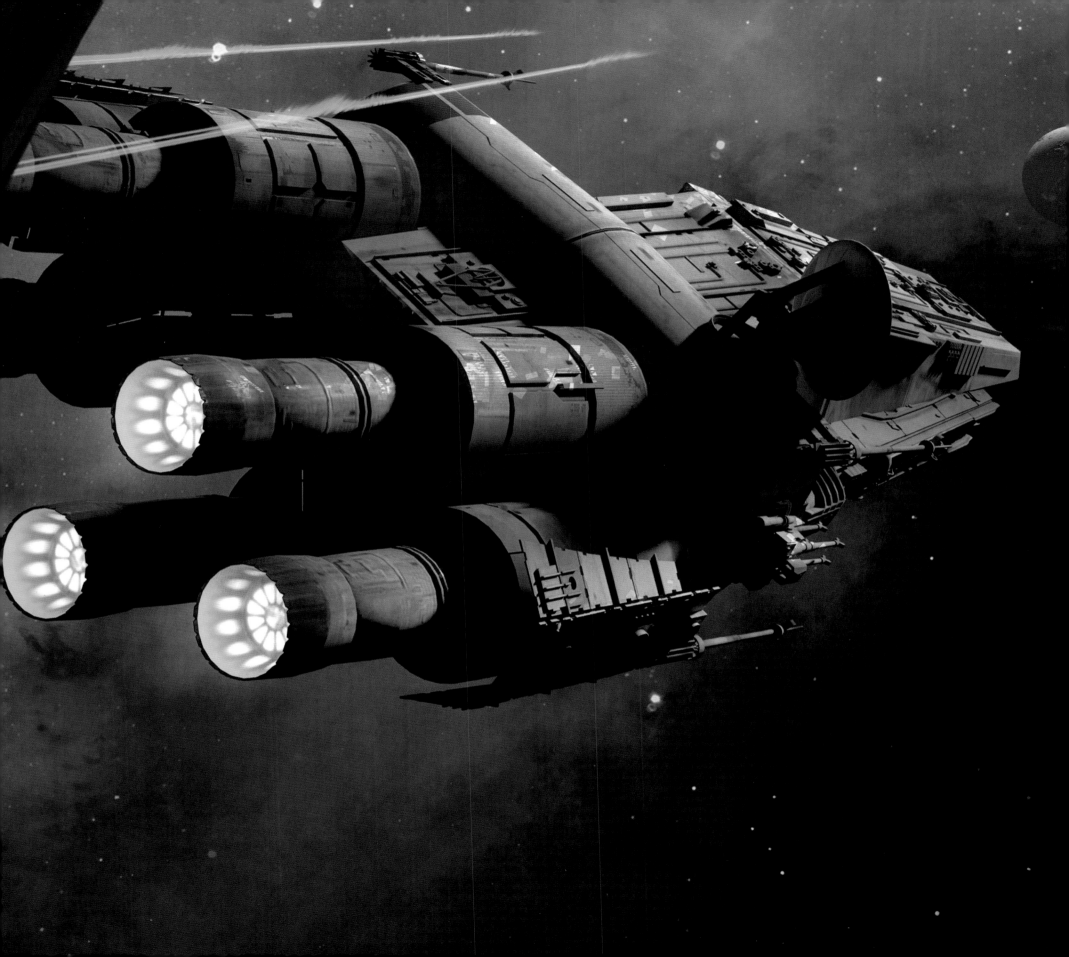

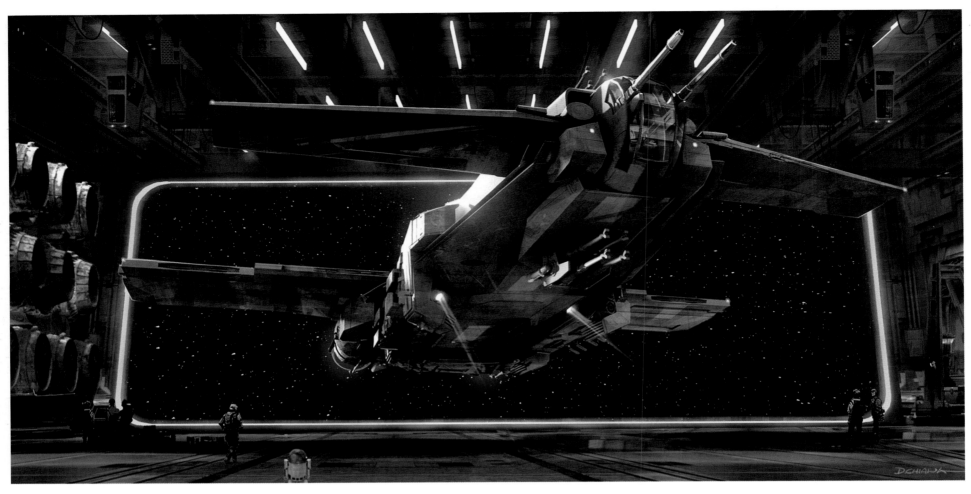

▲ **HERO SHIP VERSION 1** Chiang

ROGUE TEAM

When, in May 2014, Gareth Edwards was announced as director for the yet-untitled film that would become *Rogue One*, he was still a relatively unknown quantity. Legendary Pictures's *Godzilla*—which he directed—wasn't set to release for another few days, leaving him with just a single completed film under his belt (the 2010 independent film *Monsters*, his only other feature directorial credit). But his additional experience as writer, cinematographer, and visual effects artist for *Monsters*, where he led a skeleton cast and crew as they wandered through Central America picking up shots, meant he was uniquely suited to marry story and image during *Rogue One*'s development process.

"We didn't hire Gareth because of *Godzilla*; we hired Gareth because of *Monsters*," said executive producer and Lucasfilm senior vice president of production Jason McGatlin (*The Adventures of Tintin, Strange Magic, The Force Awakens*). "It created a real-world experience in a fantasy zone populated by

these creatures; it was so different to see a monster movie that was about people and not about monsters. And that's what we wanted for *Rogue One*—a movie about people that takes place in *Star Wars*. Grounded and real."

Working to break *Rogue One*'s story with screenwriter Gary Whitta (*The Book of Eli, After Earth*), Edwards was able to express a clear vision for his take on *Star Wars*—an immersive *cinema verité* approach that would fully realize the "lived-in," realistic visual style that had been a signature of Lucas's original trilogy.

"I look at *Star Wars* as a real historical event that took place in the universe, and George Lucas was there with his crew to capture it," said Edwards. "And now we're there with our cameras and our crew, filming as it passes through us. There's something I really love about organic realism in movies. When you look like you've come in with a plan, it can feel too prescribed and a bit

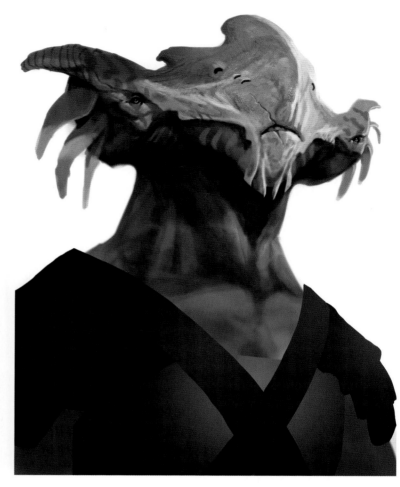

false—but when it looks like you're capturing the images, like you're watching them unfold in real time, it just feels more real. I'm always trying to find that little thing that knocks you off your path—the idea or the ingredient that we didn't come in trying to create, the curveball that makes the story feel unique."

Bringing such levels of authenticity to a project as large-scale as *Star Wars*, however, is not as simple as picking up shots in existing real-world environments.

"'Guerilla' is probably the wrong term on a movie this big, but there's something really intimate in the way that Gareth approaches things," said John Swartz. "His goal is to shoot as naturalistically and as realistically as he possibly can, and that affects every department—everyone's supporting Gareth in creating as organic a process as possible, pouring their all into this universe in a way that feels real and true to what's come before. That's what is going to make this movie feel very special."

Leading the army of artists tasked with realizing and articulating *Rogue One*'s distinct visual vocabulary was co-production designer Doug Chiang (*Star Wars*: Episode I *The*

Phantom Menace, *War of the Worlds* [2005], *The Force Awakens*), a *Star Wars* veteran who'd been part of the saga's creative fabric for two decades—beginning initially as a design director for *The Phantom Menace* and working most recently as Lucasfilm's head of design for *The Force Awakens*.

"When I heard that Gareth wanted to approach *Rogue One* with that documentary sensibility, it reminded me a lot of how George had always approached *Star Wars*. I knew I had to sign on again," he said. "In my early days working with him on the prequels, I remember George saying that *Star Wars* was a documentary—and I think the magic of *Rogue One* is that it's carrying this design philosophy to the next level. You have to create a very immersive world in order for a director to do that, and I knew right away that in order to do what I wanted to do, I would need a partner."

He found one in co-production designer Neil Lamont (*War Horse*, *Edge of Tomorrow*, *The Force Awakens*). Lamont, promoted from his role as supervising art director on *The Force Awakens*, possessed a physical production sensibility that

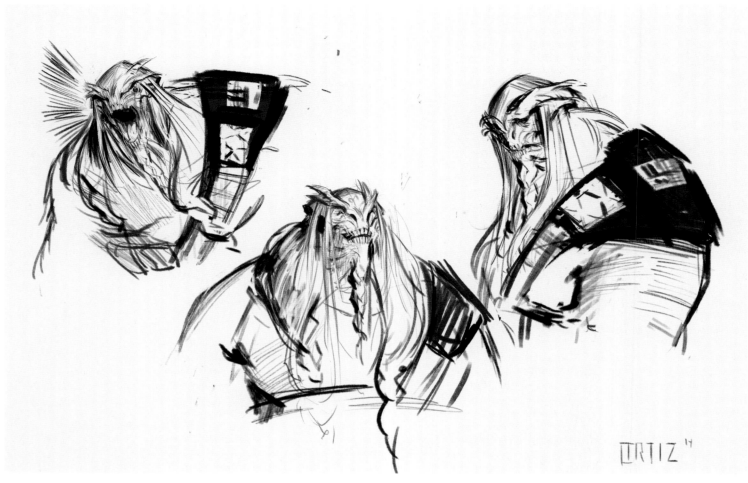

SENNA SKETCH—EXPRESSIONS 3 Karla Ortiz

would complement Chiang's conceptual background. And Lamont, too, had a history with *Star Wars* that informed his early career trajectory.

"It's going to date me terribly, but I was the art department assistant on *Return of the Jedi* in 1981. That was my second film, but from that point on, I've loved *Star Wars*," said Lamont, who would lead the UK art department while Chiang directed ILM's concept teams stateside. "Lo and behold, it came to pass with everybody's blessing and encouragement that Doug and I would enter into the contract of marriage on this one. It's worked out extremely well. Doug and the gang in San Francisco have an incredible number of talented artists, who've collaborated with our English concept artists and art directors—our supervising art director Al Bullock (*The Force Awakens*, *Edge of Tomorrow*)— to put together a docu-war film—rougher and tougher than the episodic *Star Wars* that everyone's used to."

Edwards's own design sensibility would inform not only the general documentary approach to developing *Rogue One*'s visual aesthetic, but also to breaking the story itself.

"I grew up watching Spielberg and Lucas, and that's where I learned the language of film. I always grew up picturing films like that, imagining that if I ever got to make a movie, it'd be with that vocabulary, in that style," said Edwards. "When I didn't get that opportunity, I had to go off and do what I could with a low budget—all handheld—and there was something that I really loved about the organic realism that I could get with that."

To capture such an organic sense of naturalistic immersion, Edwards embedded himself with the concept art teams, working exhaustively with artists in both the US and the UK to ensure that all aesthetic avenues were fully explored—both in terms of realizing what was laid out in Knoll's pitch and deviating from that treatment in creative ways informed by design.

"Of all the films I've worked on, this one probably has had the most art," said Chiang. "And that's all because of Gareth. I'm amazed that he can keep track of both the narrative and the visual design landscape, and how the art and design evolves with the story. It's hand in hand, because that's how he works."

▲ **SENNA (BACK) VERSION 00X** Fisher

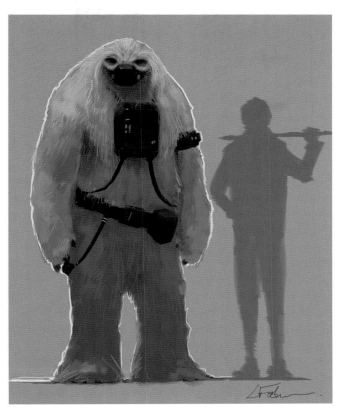

▲ **SENNA VERSION 1A** Fisher

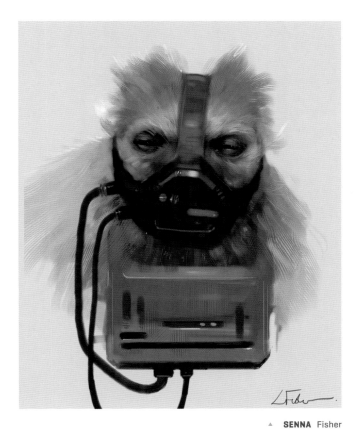

▲ **SENNA** Fisher

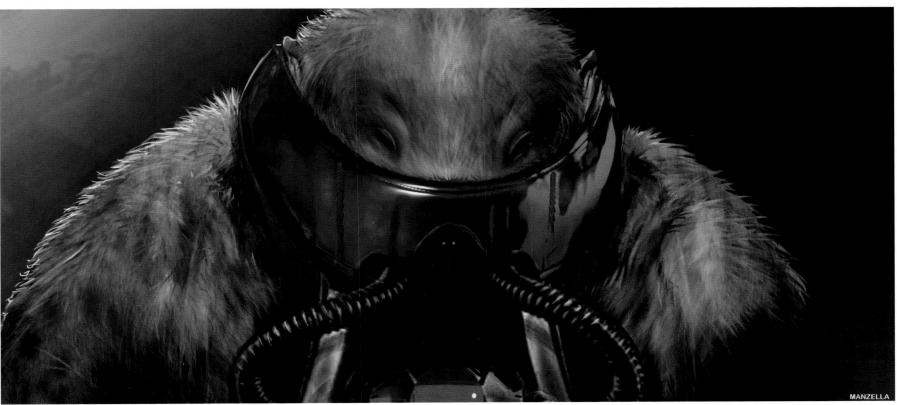

▲ **SENNA VERSION 3A** Manzella

▶▶ **GRASS PLANET EXTERIOR VERSION 4** Brett Northcutt

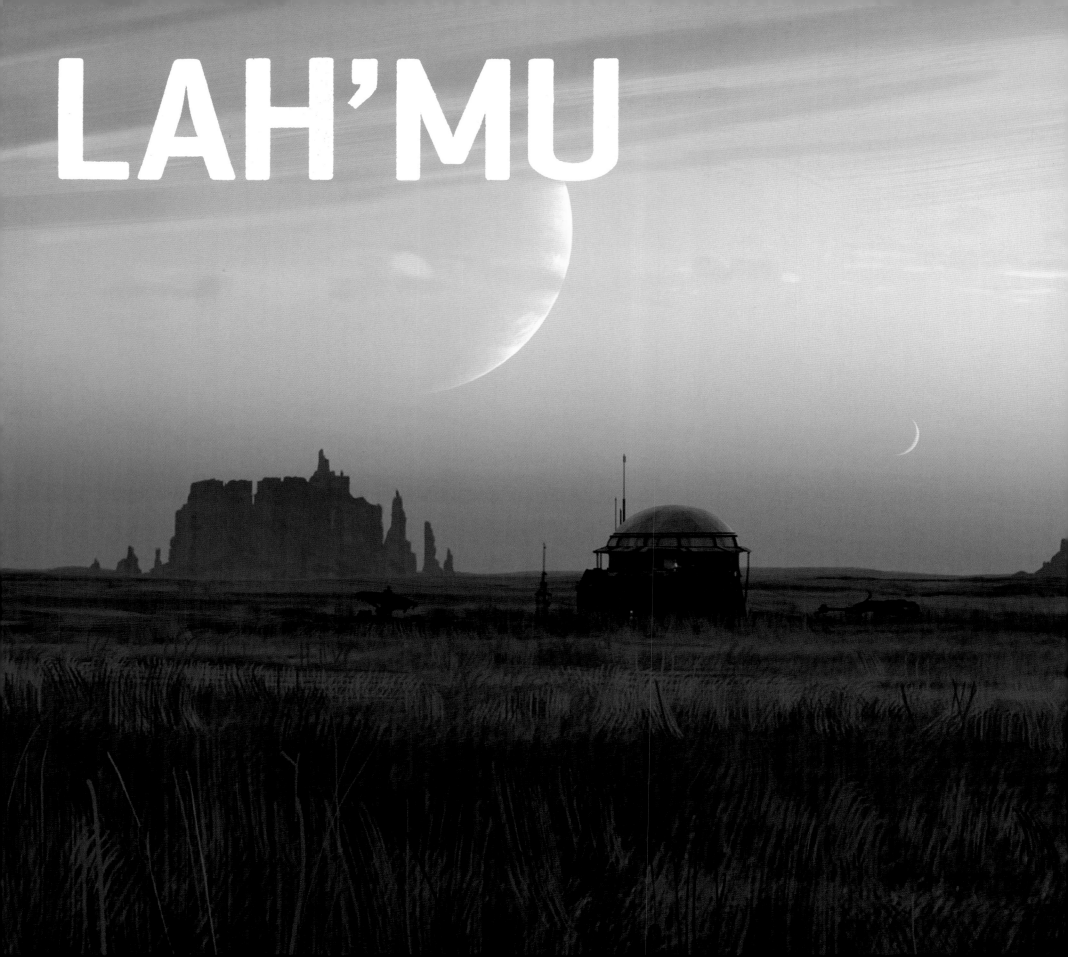

LAH'MU

HOME IS WHERE THE HERO IS

With the story taking shape on parallel paths with script development and concept boards, the narrative quickly evolved beyond its lean "mission" sensibility to embrace larger themes and explore characters that had previously existed only as rough sketches. As it moved away from its original focus on the mechanics of espionage, key elements began to shift.

"When I met Gareth [Edwards] for the first time, I remember him saying that he wanted to feel more of the character journey. It was the difference between a plot and an emotional, character-based story," said Gary Whitta. "A lot of the original characters and names were retained, but they went through the blender and came out the other side a little different. We took a lot of John [Knoll]'s elements apart and rebuilt them in a slightly different configuration."

Krennic and Willix swapped names, though the respective functions within the narrative remained intact: The former became the Imperial agent in pursuit of the heroes, and the latter a spy working undercover, under duress, while relaying information to the Imperials. The duo of Lunak and Senna was excised entirely—to be replaced later by another unlikely pairing. Protocol droid K-2SO remained, though not without undergoing some technical modifications of his own, moving further away from the image of the black, RA-7 model protocol droid glimpsed briefly on the Death Star in *Star Wars: A New Hope*. The most significant change, however, was to the character of Jyn. She was elevated from team leader to a far more prominent role: the story's emotional core.

"John's pitch was really an ensemble piece, focusing on this elite group of rebel spies—but the shape of his story was very different," said Lucasfilm creative executive Rayne Roberts (*The Force Awakens*). "The emotional components were spread out among more of the characters—all very well thought-out—but when Gareth came in, he became very interested in telling a much more personal story about a singular protagonist. The hero was always a girl named Jyn, but Gareth wanted to explore her origins as the driving emotional engine for why she is completing this mission *now*."

In early iterations of the script, Jyn was given a family history—a Jedi mother in hiding from the Empire, a young brother she had to protect, and a father, introduced as Galen, who had been the Imperial engineer responsible for designing

▶ **HOMESTEAD WORKSHOP EXTERIOR VERSION 10A** Vincent Jenkins

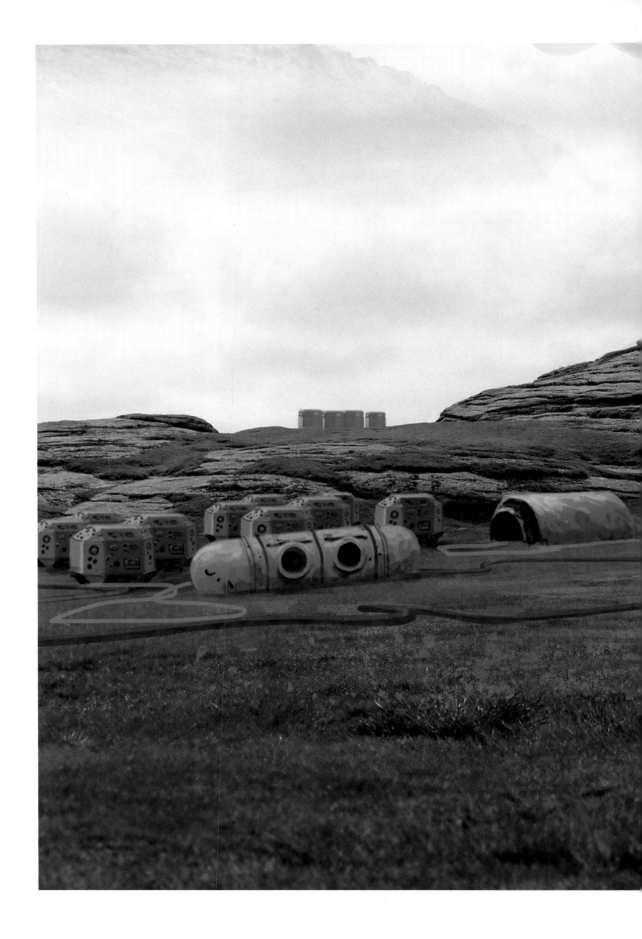

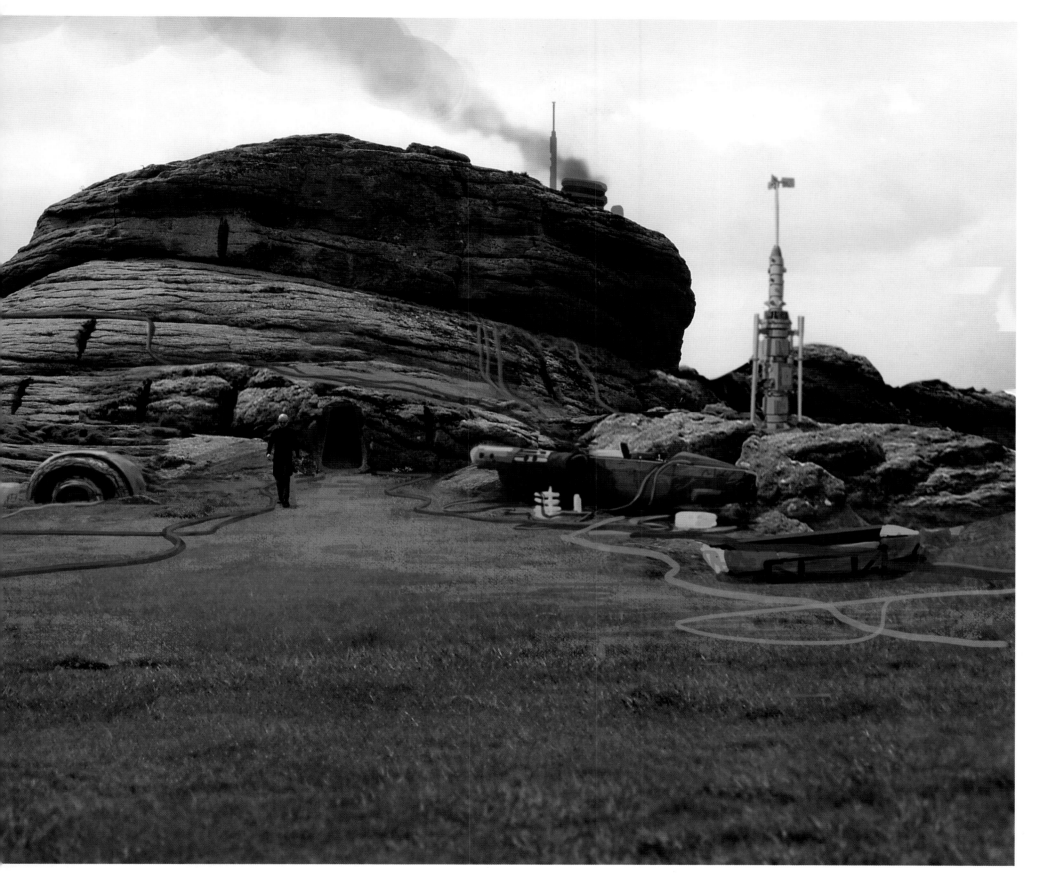

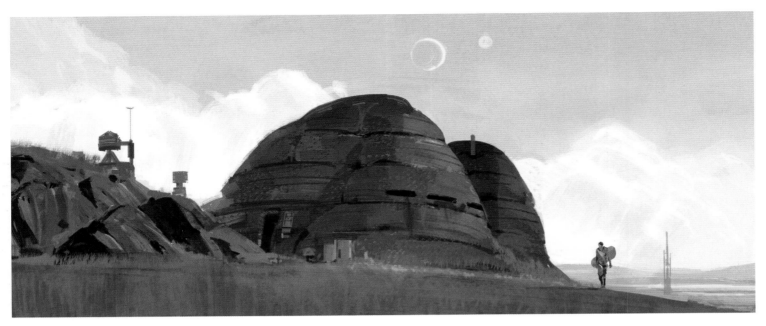

and developing a key component of the Death Star's super-weapon. This was a story not only with stakes for the fate of the galaxy, but also for its hero.

In addition to the intensive, sequestered brainstorming sessions among the director, the writers, and key creatives within Lucasfilm's vaunted Story Group to articulate Jyn's background and mission, the art department was included in early meetings to help define the movie's tone—not just as a visual exercise, but in service of determining the narrative itself.

"From our first meetings, Gareth had us drawing pie charts to break down the acts—the first act, the second act, the third act," said concept artist Erik Tiemens (*Revenge of the Sith*, *Journey to the Center of the Earth* [2008], *The Force Awakens*). "It was always a circle, from our hero's family home to an underworld to the rallying of the troops, and Gareth always wanted to get Jyn back home again; it starts with the home and ends with [a metaphorical] home. The charts helped us get the structure of the story in a way that was fun but also very ambitious. And, of course, the story is all about the Death Star plans, so I'd doodle the Death Star under them."

Jyn's return is not to the literal location of her childhood home, but to the clarity of purpose represented by the family she lost as a child, and has an opportunity to rediscover. For Edwards, it was a trajectory intended as a narrative rhyme with Luke Skywalker's origins in *A New Hope*—a thematic contrast to those classic aspirations of adventure, but embodying similarly archetypal truths.

"Luke's a boy who grew up out of the way and who dreams of joining the war, and Jyn is a girl who's grown up in war and wants to find a way back home," he said. "The essence of that is the same; it's the hero's journey—leaving home, finding the truth and facing the enemy, and returning [to a metaphorical] home."

With the story unfolding both visually and narratively, the artists looked to a precedent within the *Star Wars* aesthetic narrative—its strong sense of distinctive palettes, most notably in the "color tagging" of its planets.

"You can sum up each film by the color of its environments—orange desert for *A New Hope*, white and blue snowscapes followed by Bespin's orange clouds in *The Empire Strikes Back*, and the green forest of *Return of the Jedi*. Those color statements completely define those films," said Jon McCoy (*Thor: The Dark World*, *X-Men: Days of Future Past*, *Avengers: Age of Ultron*). "As a designer, it was the most basic thing to ask what colors should represent any new planets we're considering. It's kind of like a tree: The color of the planet would be the tree trunk, and out from it would be the detail. Refine and refine and refine into branches of design, where each leaf at the end of each branch could be a completely different design—but still harmonized into that same tree. When I was kid watching *Empire*, I understood Hoth as a snow planet; the snow could be any configuration and the landscape could be anything, but the most important thing was that it was easy to read as 'snow planet.' And that's the sort of way I try to look at the color-design process—the evolution of a tree from its trunk to its small branches."

The color palettes do more than just make each planet distinctive; a concerted effort was made to ensure that the progression of those colors would tell the same story as the script itself.

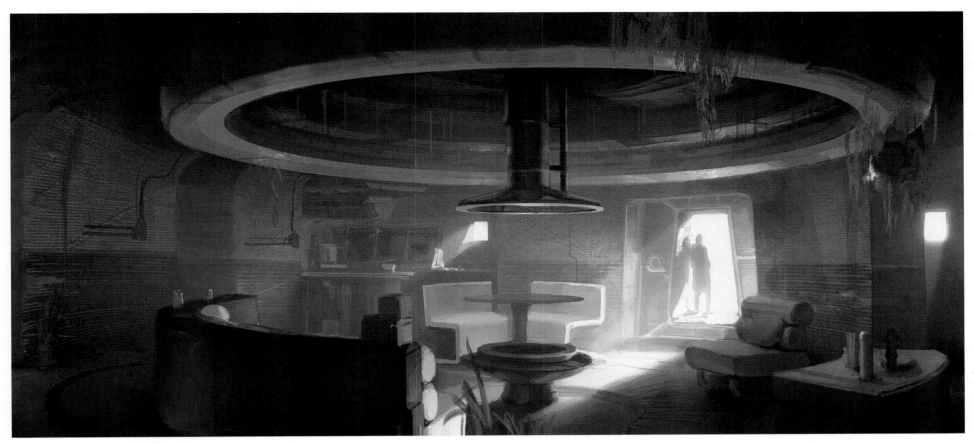

▲ **HOMESTEAD INTERIOR VERSION 4A** McCoy

"We tried as much as possible to parallel them and to marry them," said Doug Chiang. "In designing the overall look of the movie, we knew that it was going to begin with our heroine's story arc from a perfect memory of home, and that a trauma would shift the tone of the movie, taking her to a dark place—so we designed it to be murky. It parallels what's going on in her mind at the time. As she progresses and her purpose becomes clearer, the settings themselves become brighter—until the very end is staged in another idyllic environment, because her mind is clear. What we do is not just sets and vehicles and props and creatures; when it's done well, good production design will always help tell a really good story. We're designing the emotional arc as a color palette—with the philosophy that what we're doing here is only going to make the film feel more real."

Jyn's story would begin with a memory, of sorts—presented as a prologue, set in her childhood home when she's just a little girl. Originally represented in concept art by bright, clear colors, the homestead planet of Lah'mu would characterize the expansive potential of *Rogue One*'s would-be protagonist—showcasing an uncomplicated life prior to the encroaching influence of the Empire. It was a visual representation beautifully embodied by locations found in Iceland by the film's production

scouts, matching both the spirit of Jyn's trajectory and the art imagined by *Rogue One*'s concept teams. When the film crew ultimately arrived at the Nordic grasslands location, however, they were met with persistent cloud cover that undermined the idyllic glow essential to the tone—necessitating on-site troubleshooting and a serendipitous last-minute production pivot.

"The homestead location we found was great, but we had also looked at this other location—a splinter location on the edge of a glacier with all this black sand about two hours away. It was this massive contrast, which only Iceland could provide," said associate producer and first assistant director Toby Hefferman (*World War Z, Gravity, Mission: Impossible—Rogue Nation*). "When we got to our grassy location, Gareth looked at it and I looked at him: *Should we get back to the helicopter?* So we flew back to the black sand location—this amazing landscape which is what's now in the movie. You couldn't go anywhere else in the world and get what we got."

It is when Jyn's family is first visited by an Imperial agent—Krennic, a former colleague of her father's—that the idyllic life of peace and harmony is shattered by violence. Her family torn asunder and her father Galen's ties to the Empire revealed, Jyn's world implodes—and her story is set in motion.

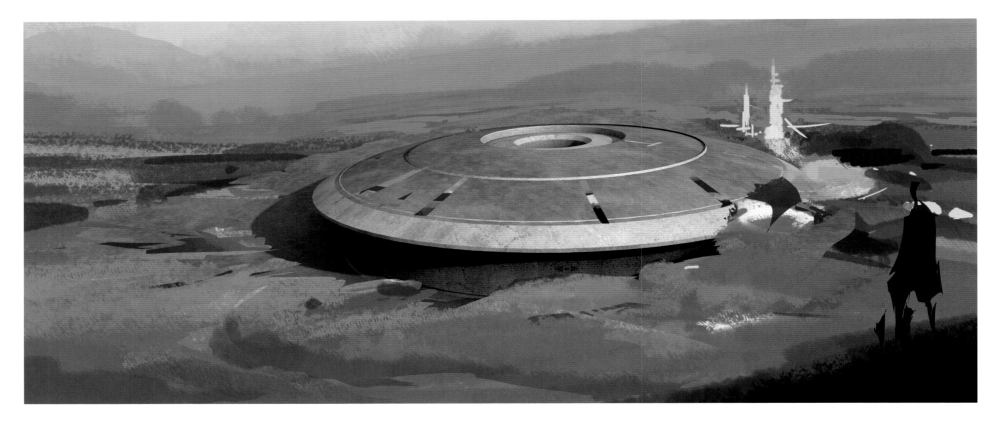

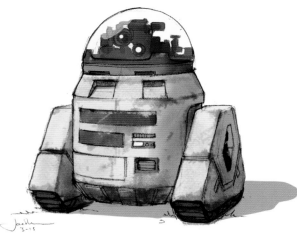

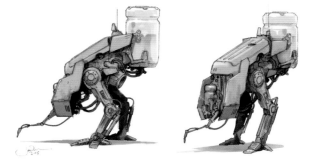

▲ **AGRICULTURAL DROID VERSION 15B** Lunt Davies

▲ **HOMESTEAD FIELD EXTERIOR VERSION 1—STRUCTURE CONCEPT**
Erik Tiemens

◄ **AGRICULTURAL DROID VERSION 00X** "On Jyn's homestead,
Gareth [Edwards] wanted to see some agricultural droids, so we
came up with an astromech—something Artoo-esque, but a bit
wider, a bit stumpier. He's dirty and dusty, his dome fogged and
yellow from the sun." Jake Lunt Davies

▼ **HOMESTEAD DROID VERSION 9A** Lunt Davies

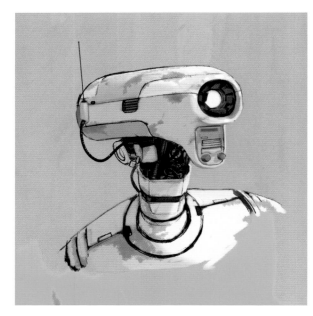

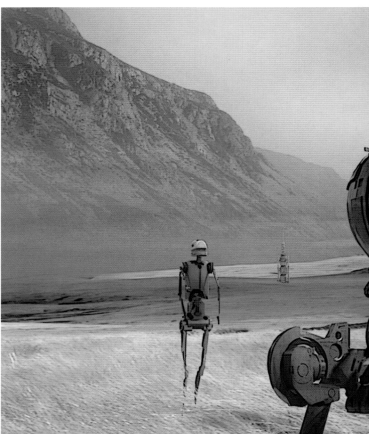

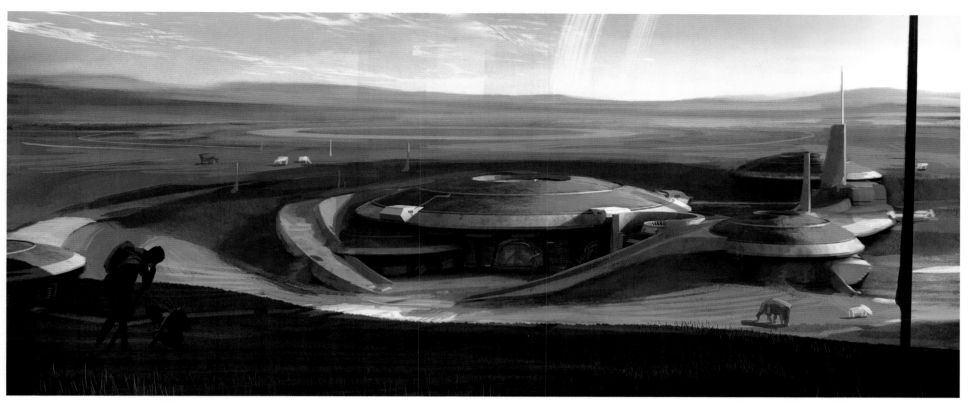

▲ **HOMESTEAD FIELD EXTERIOR VERSION 1** McCoy

▼ **HOMESTEAD EXTERIOR—GRASSLAND ARRIVAL VERSION 1** Chiang

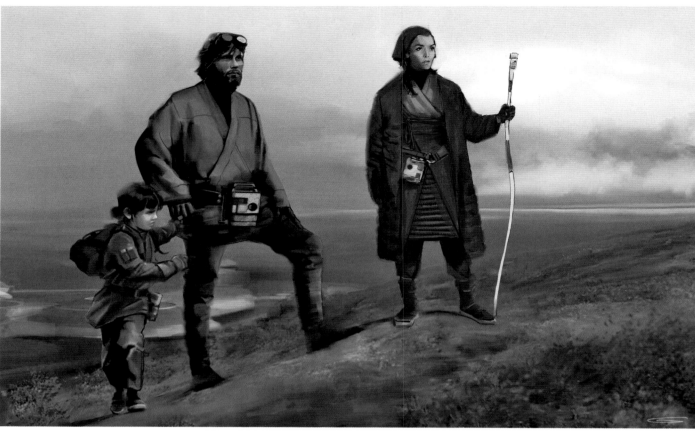

▲ YOUNG JYN VERSION 2A Dillon

▲ ERSO FAMILY (JYN, GALEN, LYRA) VERSION 2A Dillon

▼ HOMESTEAD FIELD EXTERIOR VERSION 6B Allsopp

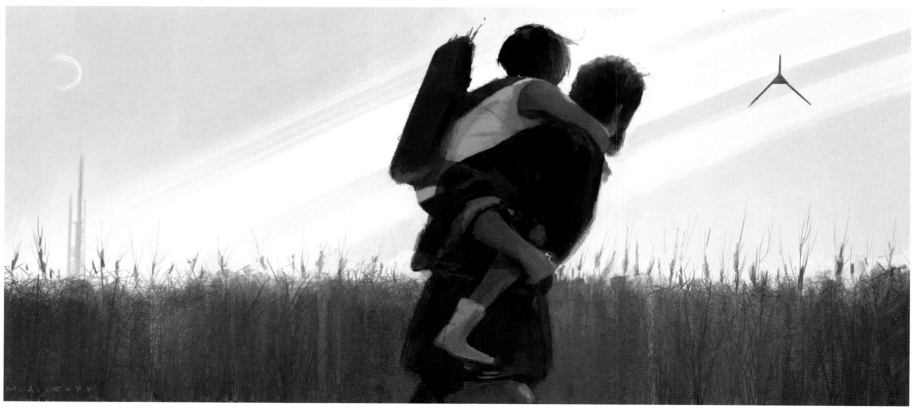

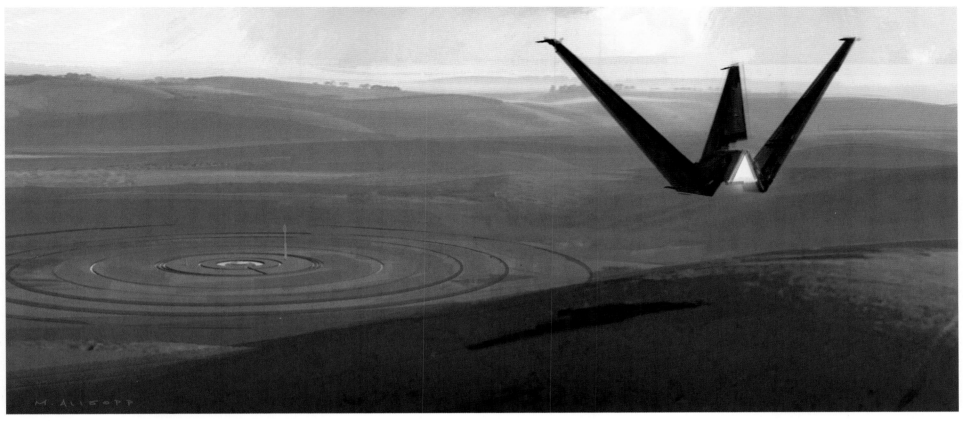

▲ **HOMESTEAD FIELD EXTERIOR VERSION 1** Allsopp

▼ **GRASS PLANET AERIAL VIEW VERSION 7** Northcutt

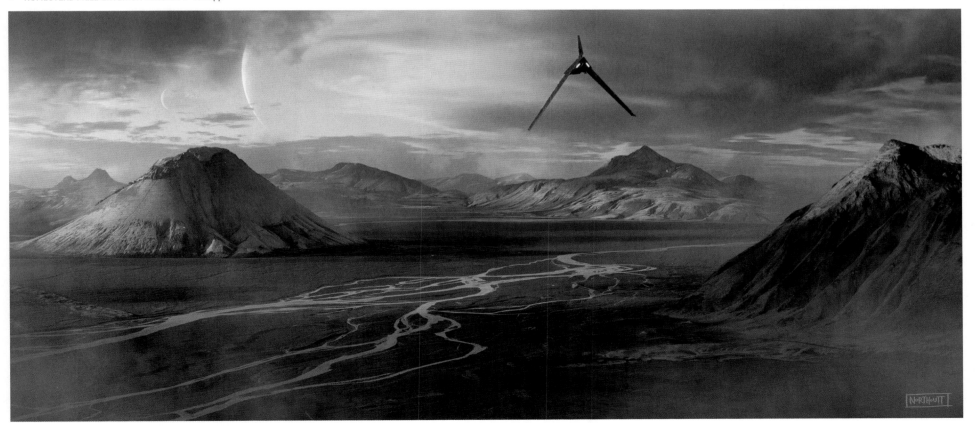

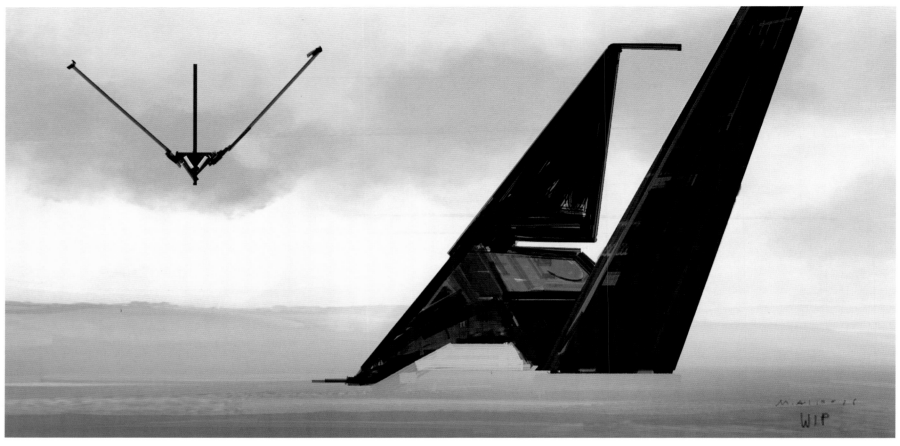

KRENNIC SHUTTLE—BLACKBIRD VERSION 1 Allsopp ▼ KRENNIC SHUTTLE VERSION 1B—TRI-WING Tenery ▶ KRENNIC SHUTTLE DETAILS VERSION 1 Church

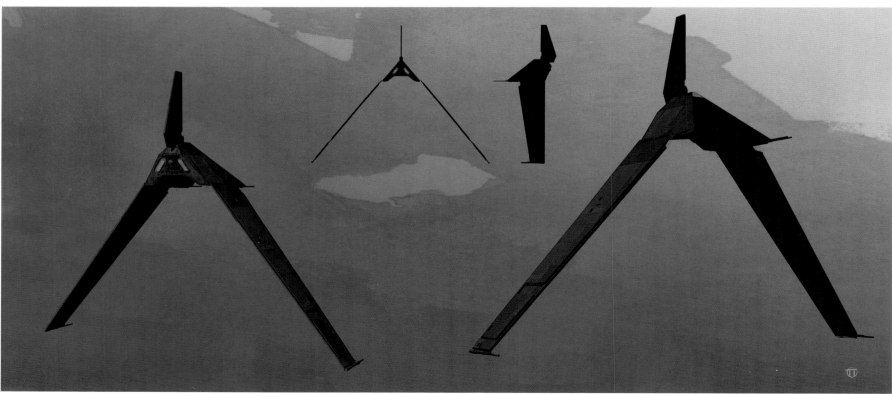

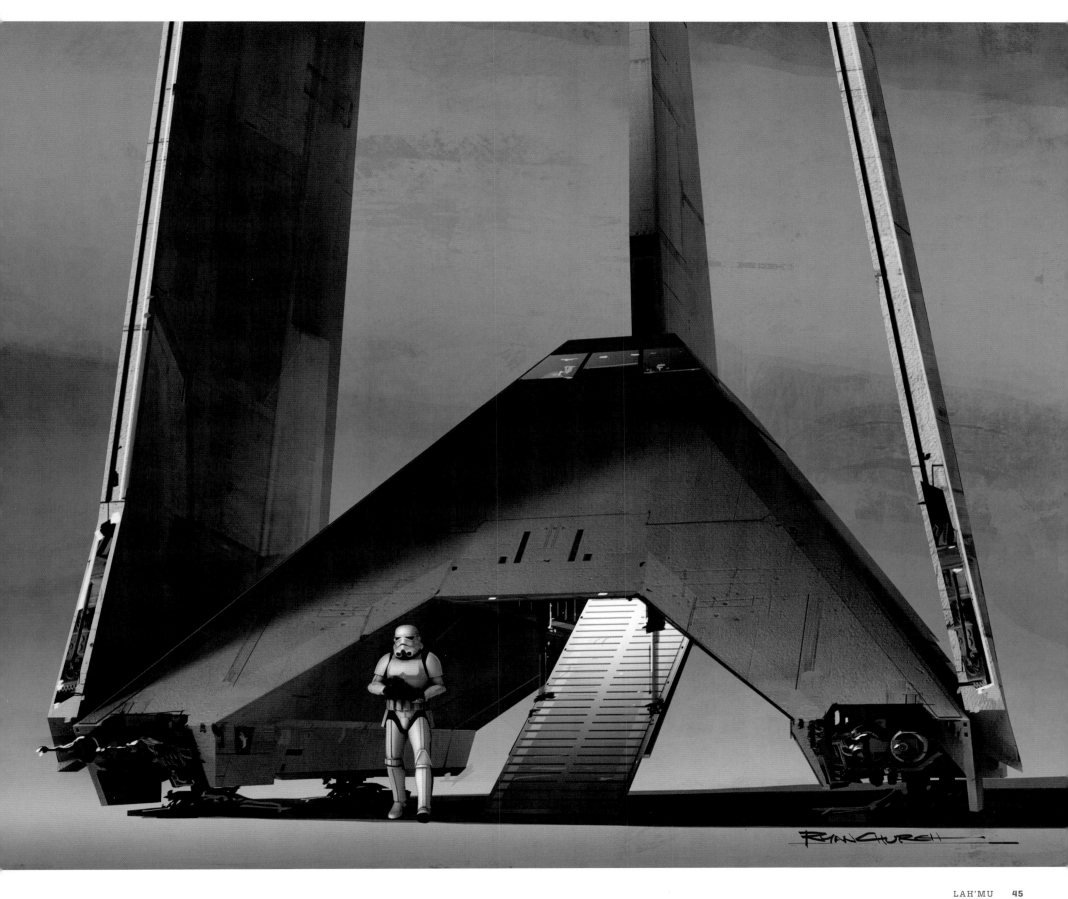

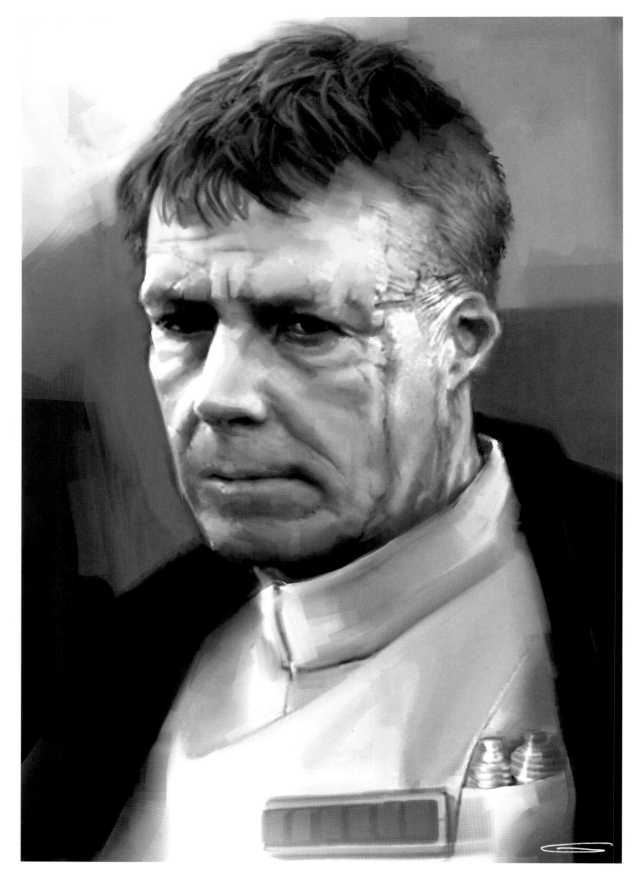

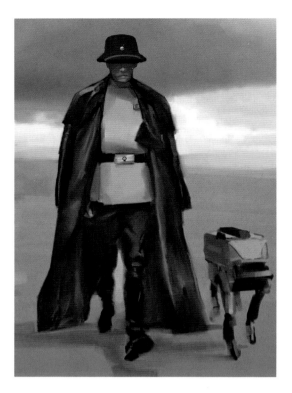

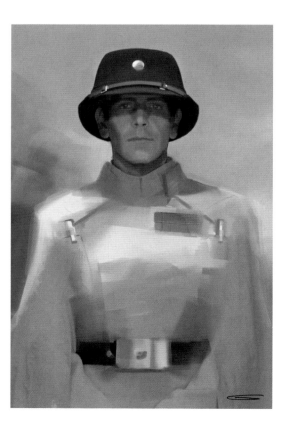

▲ **KRENNIC COSTUME WITH HAT VERSION 1** Dillon

◄ **KRENNIC COSTUME VERSION 3** Dillon

▼ **KRENNIC WITH HAT VERSION 1A** Dillon

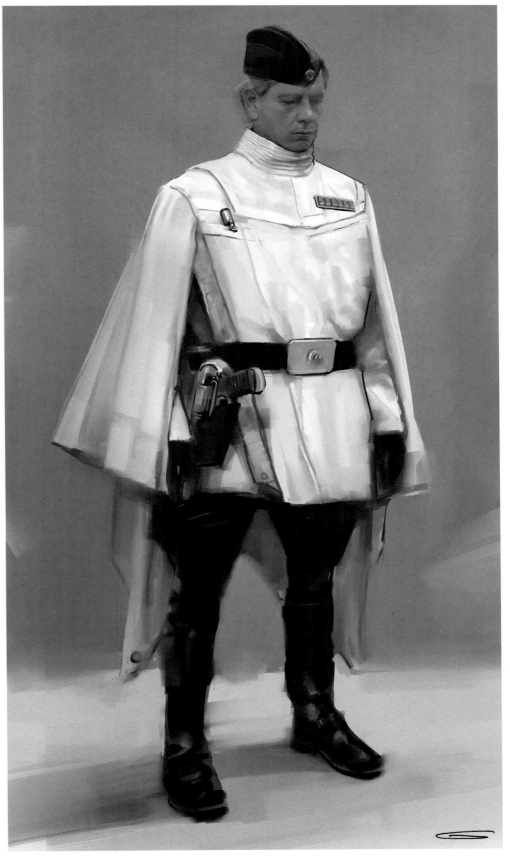

▲ **KRENNIC VERSION 1** Dillon

▶ **KRENNIC WET-WEATHER COSTUME** "If you blink you'll miss it, but there's a character on the Death Star in the original film who's sitting alongside Tarkin. He's got a really fine mustache, slicked-back hair, and a *great* white tunic. We thought that tunic would be a perfect look for the villain of this piece. We've got a cape on him, as well, because capes are very *Star Wars*." Dillon

▼ **KRENNIC'S SIDEARM VERSION 16A** Matthew Savage

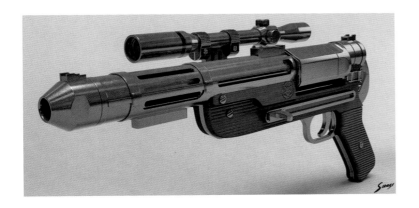

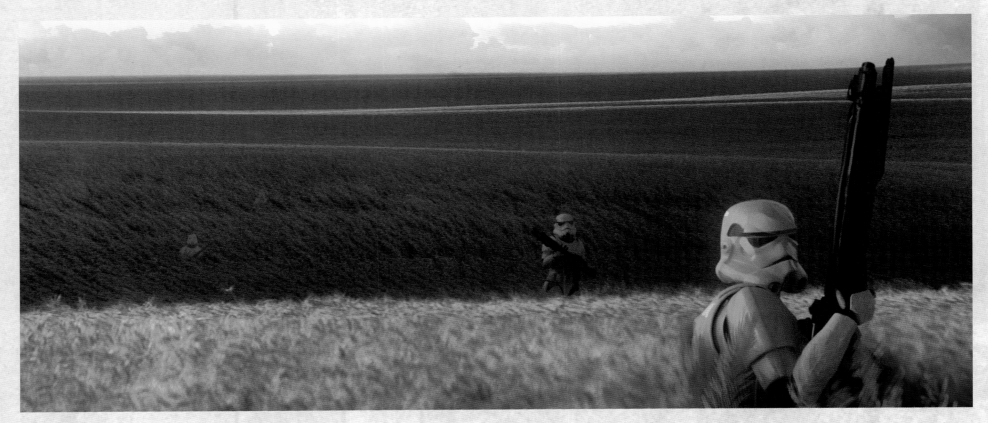

TROOPERS

With variations seen across the saga's seven films—including stormtroopers, sandtroopers, snowtroopers, scout troopers, clone troopers, and, most recently, the several different iterations of troopers serving the First Order—it seemed reasonable, to the *Rogue One* filmmakers, to assume the existence of other unseen trooper types, even within the established aesthetic of *Star Wars: A New Hope*. The opportunity to explore new trooper visuals offered a chance to expand the mystique of the Empire's soldiers—and to distinguish *Rogue One* from the very beginning of its narrative.

"Audiences are so familiar with stormtroopers. They've been around since the first film, and they're even among the very first characters we see on screen," said co-costume designer David Crossman (*Saving Private Ryan, Lincoln, The Force Awakens*). "So our goal was to introduce something different at the beginning of *Rogue One*, to create a sense of fear of what might happen."

Concept artist Christian Alzmann agreed, noting both the limitations established by *Rogue One*'s placement in the timeline and the opportunities afforded by a universe as expansive as *Star Wars*.

"We knew that we had to use an early *Star Wars* aesthetic for the troopers, because we're set so closely to Episode IV, but

Gareth [Edwards] was keen on looking at what opportunities we could explore," said Alzmann. "He was initially thinking there could be a middle version, something between a soldier and a droid—a special detachment belonging to Krennic that was a mix of organic and mechanical. He wanted to make it clear through the design—to show that the brain was gone by giving them helmets that no human could actually wear. Red lights under the dome. They'd be like Lobot from Cloud City and could be controlled."

Scaling back on the visible machinery with the eventual death trooper design did nothing to lessen their chilling visual impact—which fits within the previously established trooper design sensibilities but modifies those expectations in subtle ways.

"Gareth wanted something really intimidating right at the beginning of the film, and it was good fun doing the elite troopers—Krennic's death troopers. They're much taller, skinnier; everything's tighter and black is always just a good, fierce look," said co-costume designer Glyn Dillon (*Kingsman: The Secret Service, Jupiter Ascending, The Force Awakens*). "They're in the same style as the traditional stormtroopers, existing in the same time frame, but they represent parts of the Empire we haven't seen."

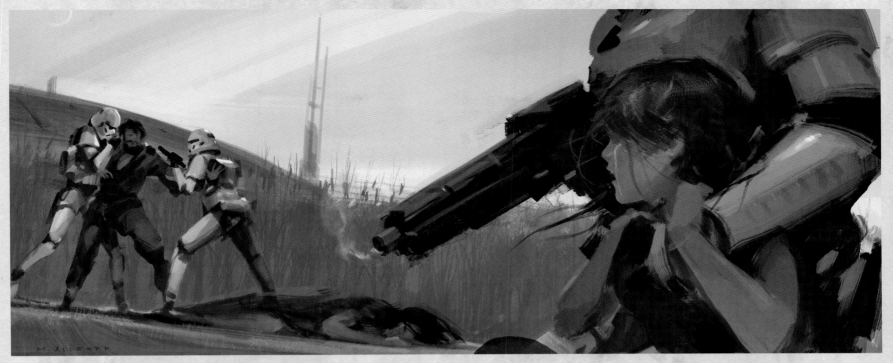

▲ HOMESTEAD FIELD EXTERIOR VERSION 1A—EMOTIONAL BOARDS FRAME 12 Allsopp

▼ DEATH TROOPER WHITE VERSION 3 Dillon

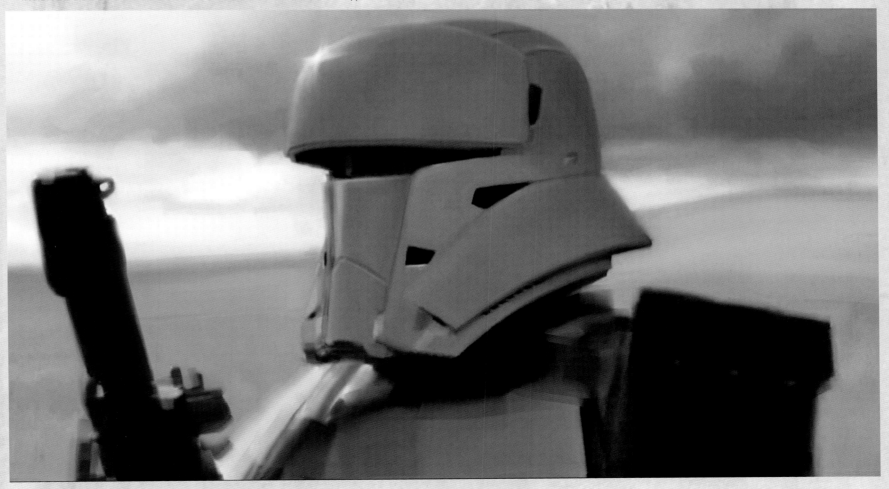

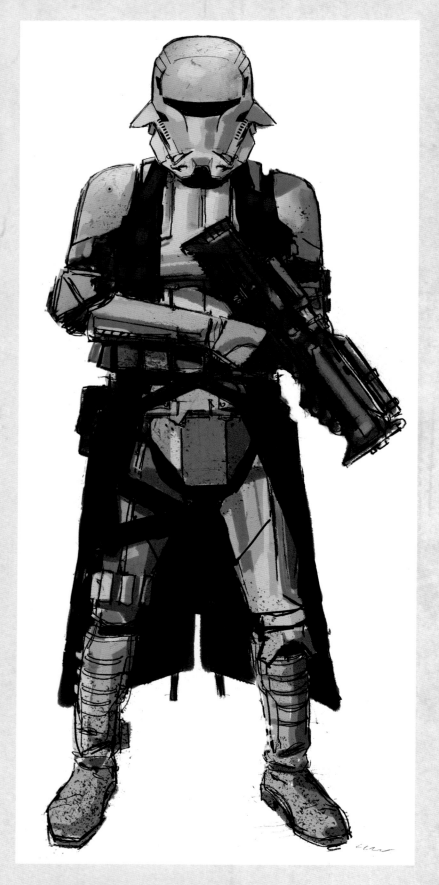

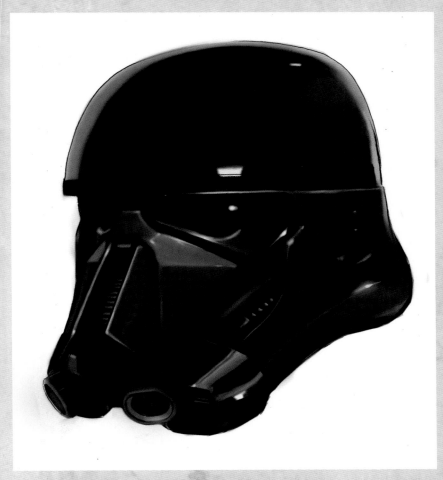

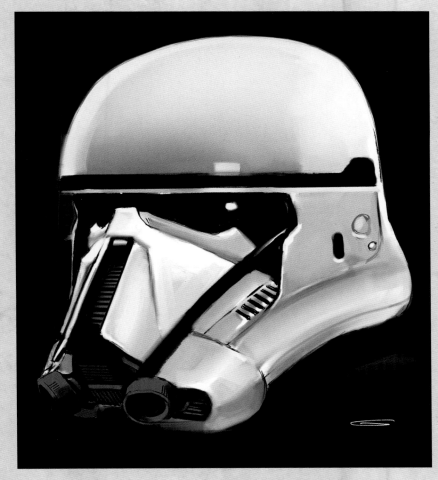

▲ **DEATH TROOPER HELMET GREEN LIGHTS VERSION 7** Dillon ▼ **DEATH TROOPER HELMET** Dillon and Williams ▲ **DEATH TROOPER STRAIGHT BROW WHITE VERSION 5** Dillon

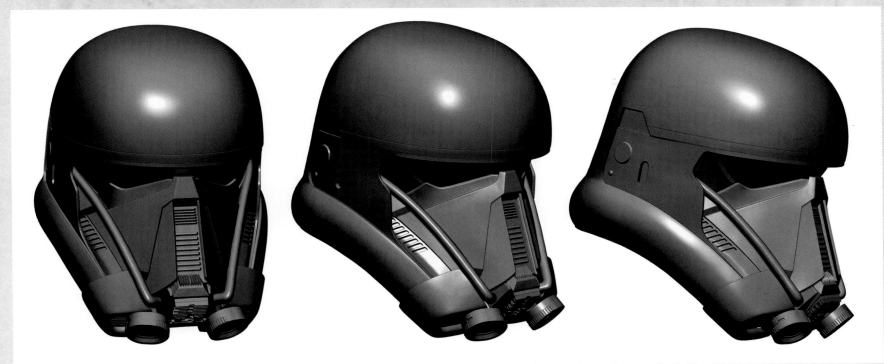

▲ **STORMTROOPER WITH BOMB DROID PACK VERSION 2** Tenery

▼ **DEATH TROOPER IDEAS—DEATH SQUAD MACHINE GUN VERSION 5A** Savage

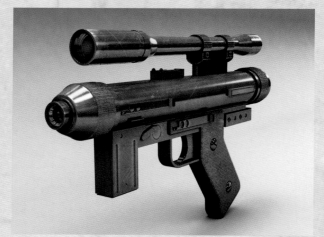

✪ DEATH SQUAD BLASTER

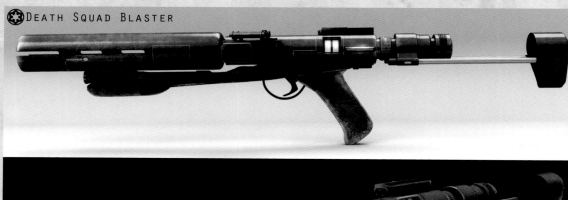

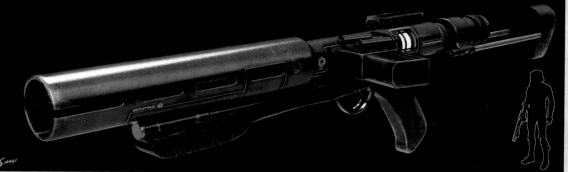

▲ **TROOPER PISTOL VERSION 1A** Savage

"We've come full circle, stripping down and fixing airsoft guns in our shop, because they've got some heft and a mechanism inside that gives them a bit of a recoil, but they're a lot lighter than what they would have used before." Jamie Wilkinson

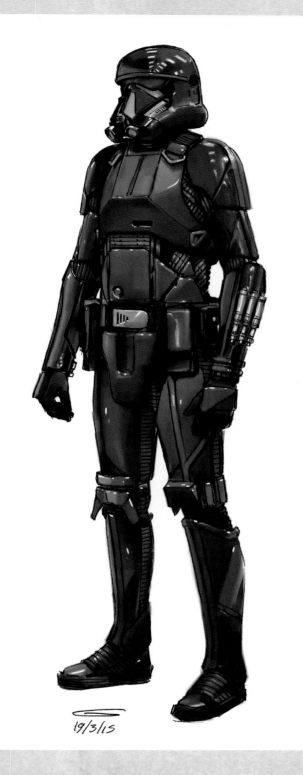

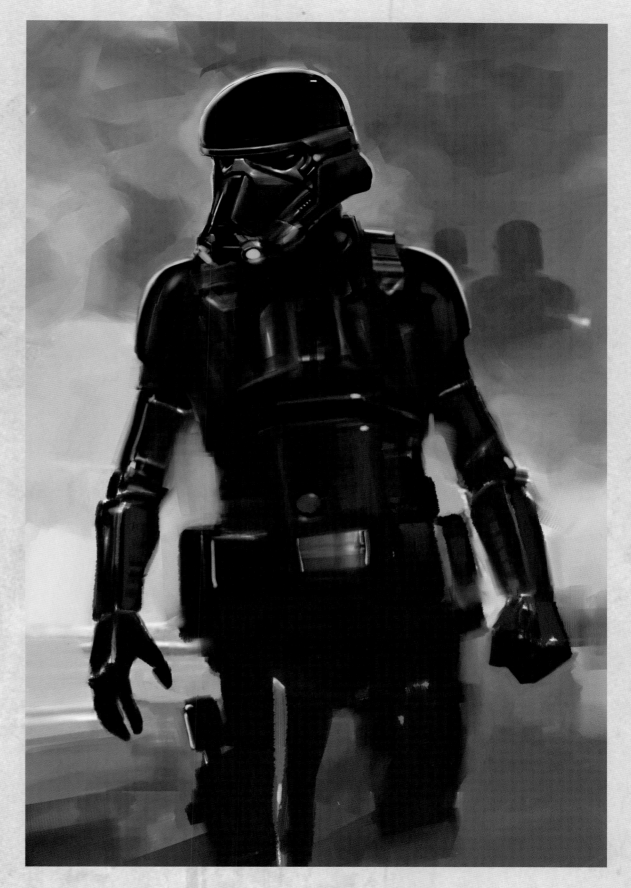

▲ **DEATH TROOPER VERSION 1** Dillon

▶ **DEATH TROOPER FULL LENGTH VERSION 1A—NO SENSOR LIGHTS** Dillon

"We're able to bring something new to the stormtroopers in this film. You'll actually see them doing their job and see them take out some rebels in the process. They're dangerous, and that was very important to us." John Swartz

Concept Boards

Whereas the art of storyboarding is common to most large-scale productions, Edwards encouraged *Rogue One*'s artists to approach the process differently—even eschewing the traditional term itself in favor of what the designers ultimately called "concept boarding."

"Other directors stage action, but Gareth [Edwards] stages composition," said co-production designer Doug Chiang. "It's not action flowing from one panel to the next, like most directors use storyboards, and it's not worrying about close-ups and wide shots and reverse shots; Gareth knows he'll get all that in editing, so he focuses on planning out the best compositions in advance. One of the early things Gareth said was that he wanted somebody to be able to stop on every scene and find an iconic frame. That was the mandate. It's very cinematic, planning for the iconic images that he wants to include; they could all be turned into beautiful paintings."

For Edwards, the approach was driven by the visuals, but was also conducive to discovering the essential truths of the story as it developed—a means of marrying aesthetics with narrative functionality in such a way that benefited both.

"I've often felt that instead of doing concept art—designing the world and then finding the shots—that it would make more sense to do the boards first," Edwards said. "Then you can design the world based on the imagery you want. There are shapes and ideas suggested here that are really informative to what the concept art should be. We called it 'story art.'"

The unique process reunited Edwards with lead concept artist Matt Allsopp, with whom he'd worked previously on *Godzilla*. It had been Allsopp who'd first imagined that film's signature HALO jump sequence—which saw the massive monster starkly illuminated by the red flares of soldiers freefalling around him.

"He needed someone to storyboard a sequence on *Godzilla*, and I was free right then so he sat with me and we ended up working out really well," said Allsopp. "Now, we'll be storyboarding and concepting at the same time as the writing. It allows us is to run with ideas, to experiment and to try things out. We'll sit together, draw things, do sketches. And with Gareth, a lot of the time, that feeds back into the story."

For his part, Edwards recognized a kindred spirit in Allsopp—and a valuable creative collaborator integral to *Rogue One*'s visual, thematic, and narrative development.

"I'm so lucky to have met Matt," Edwards said. "He's on such a similar wavelength, aesthetically, and we work together so well that it just becomes a very fun experience. And he's so good that I steal all his ideas."

Allsopp then brought storyboard artist Jon McCoy into the fold—though their work together on *Rogue One* wouldn't be the first time McCoy's and Edwards's paths had crossed. They'd met several years earlier following an early promotional screening of *Monsters*—after which McCoy found himself so starstruck that he'd offered to work on the director's next project for free.

"My friend told me I should show him my artwork, but I felt like there was no way I was just going to walk up to *Gareth Edwards* and start showing him samples. But I did and I gave him my e-mail—and a few months later, he e-mailed me out of the blue to say that he liked my work. What's funny is that when *Rogue One* came around, that wasn't even a factor at all. Gareth had asked Matt if he knew anybody and Matt just put my name forward."

McCoy found himself entrenched in the director's most intimate creative processes—holed up with Allsopp in Edwards's flat, working with both to articulate the story's visual vocabulary and lay out its emotional narrative. There were no barriers to the discussions; all three would throw ideas into the mix, often accompanied by quick, gestural sketches. McCoy was floored by the flow of ideas—and humbled to be able to work so closely with both Edwards and Allsopp.

"Gareth loves art, loves drafting the same way we do, loves seeing things being drawn in front of his face. He's always looking for the best possible version of every single scene—using the visual medium itself to illustrate the subtexts, the emotions, and sometimes the story itself. It's world-building that might not ever even make it into the script, but it's massively important to not only the emotional overtone of the film, but also to how the story is told."

Allsopp found the process invigorating and fresh—a departure from conventional approaches to storyboarding, affording him the unique opportunity to engage his aesthetic sensibilities and apply them fully to the art of narrative development.

"I hadn't done much storyboarding myself, but the way Gareth likes to do it wasn't really like traditional storyboarding. We just take the main beats and we draw them—almost like keyframes. What's the most interesting moment? What's the most ideal shot you would get for this moment? How do you make this really interesting?" said Allsopp. "They're a lot like concepts in a way, but they're black and white and a little bit simpler. We just plan the block beats of a sequence and then, when we're happy, we try and start connecting it; we fill out all the pieces in between. When you've got to get from beat to beat, then what's the beat in between? And we also know that if we run out of time, we get the main shots we want, and Gareth gets what's most important for the scene."

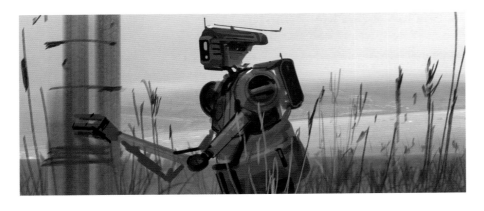

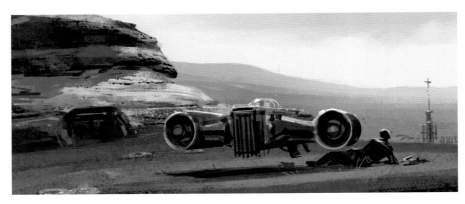

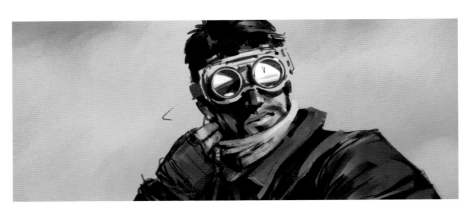

OPENING SEQUENCE CONCEPT BOARDS Allsop, McCoy, and Tappin

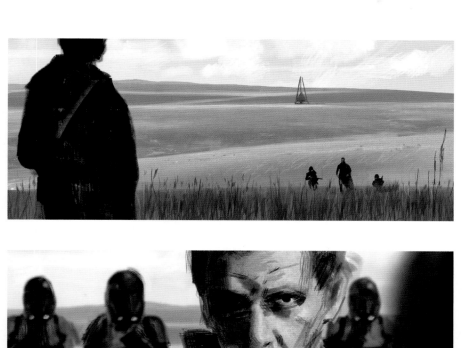
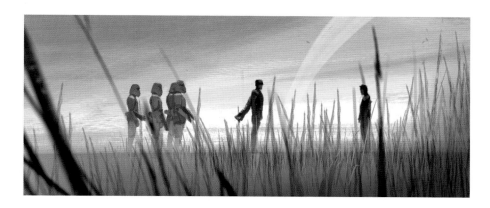
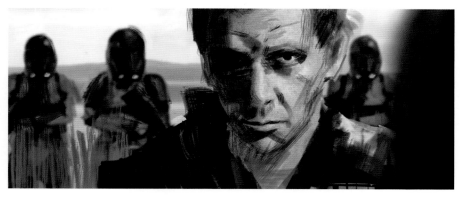

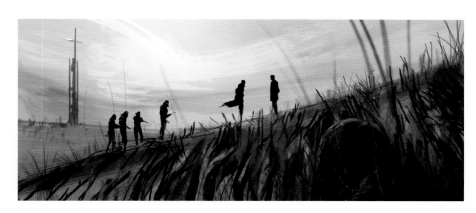

▶▶ **YAVIN EXTERIOR VERSION 11** Christian Haley

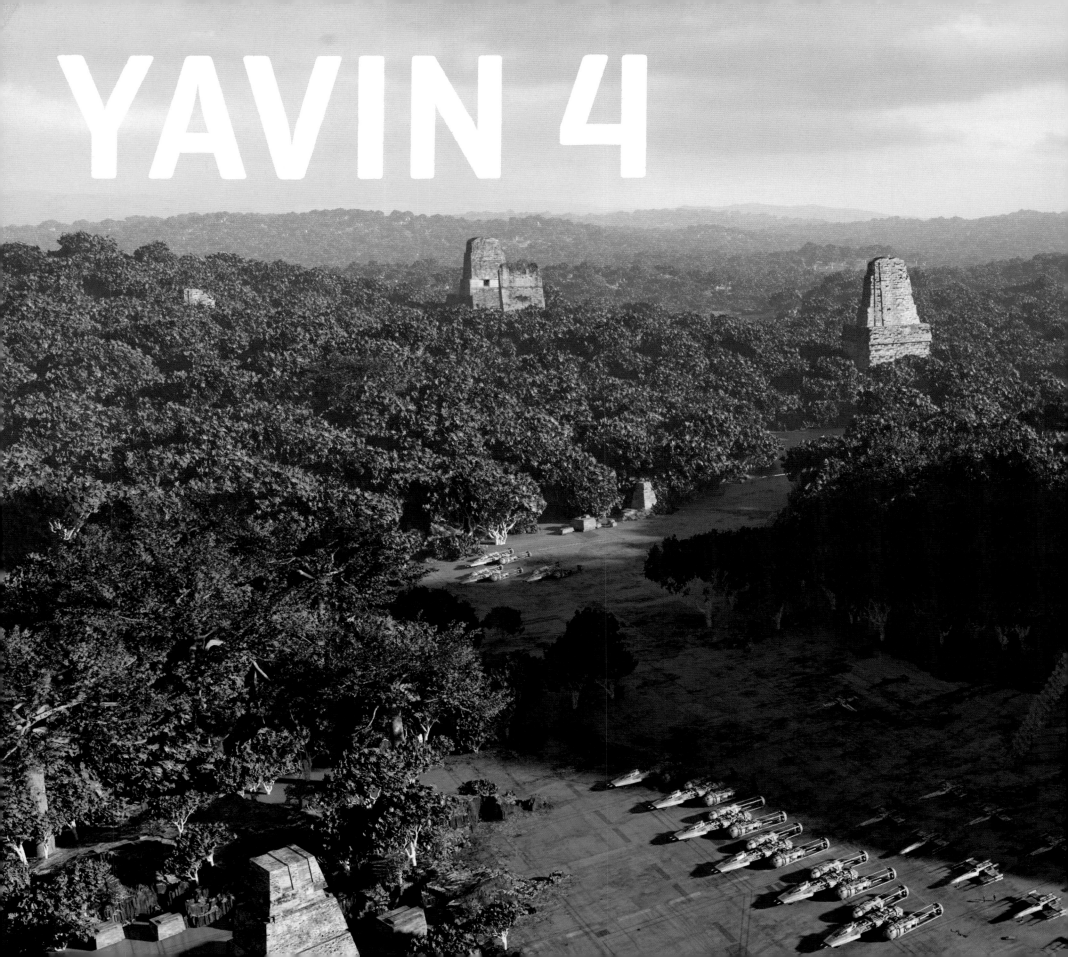

YAVIN 4

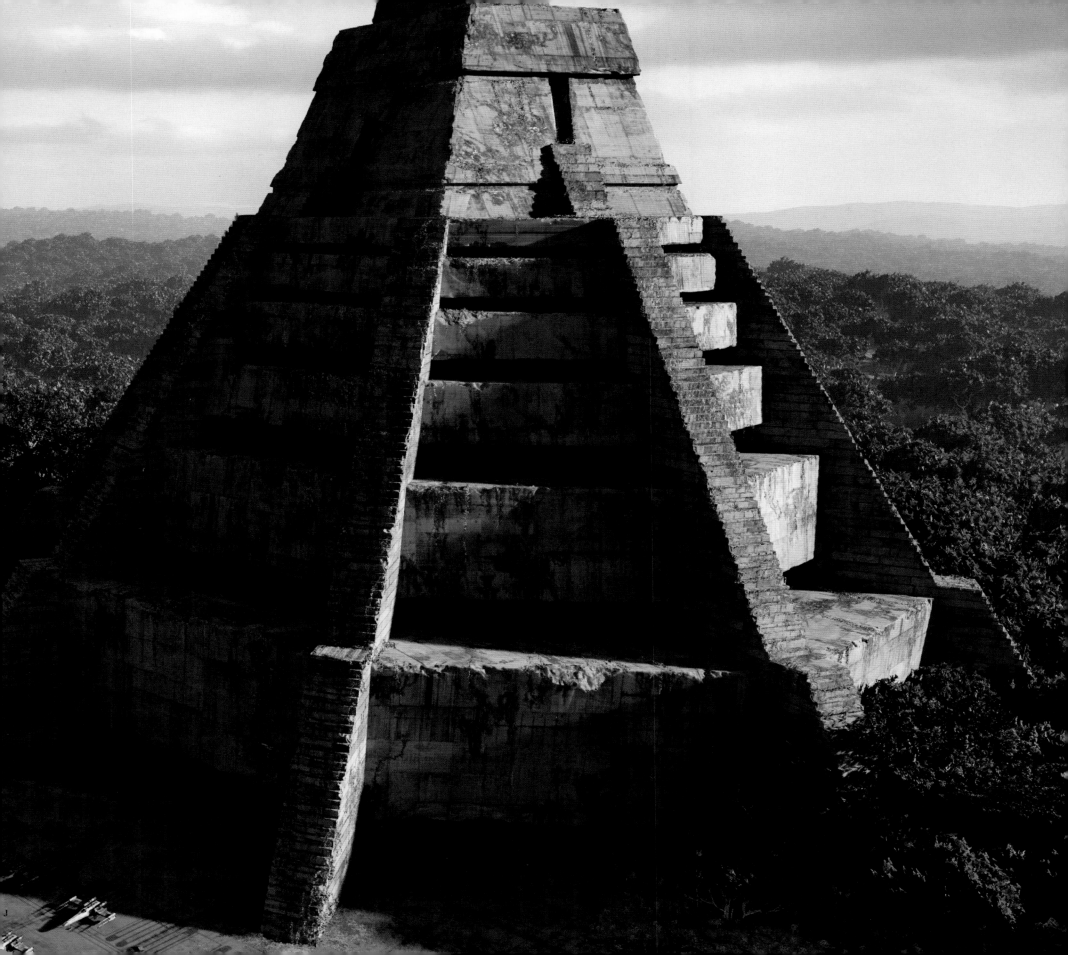

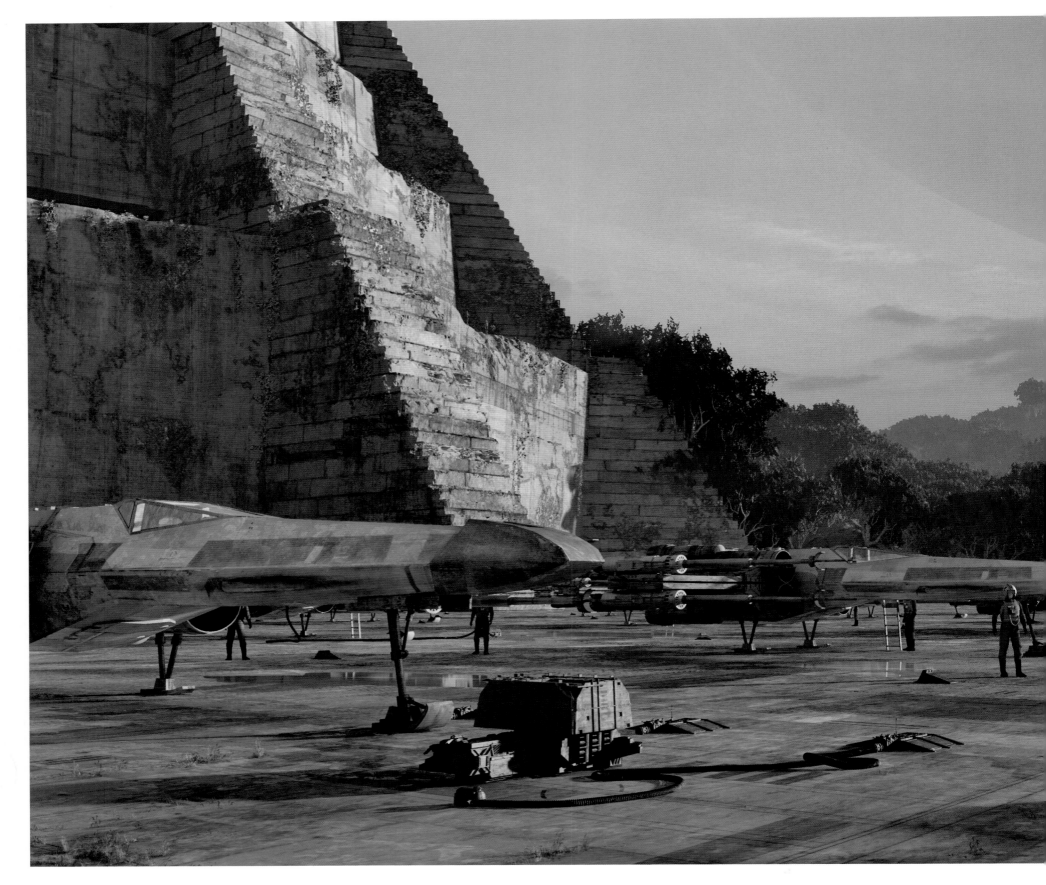

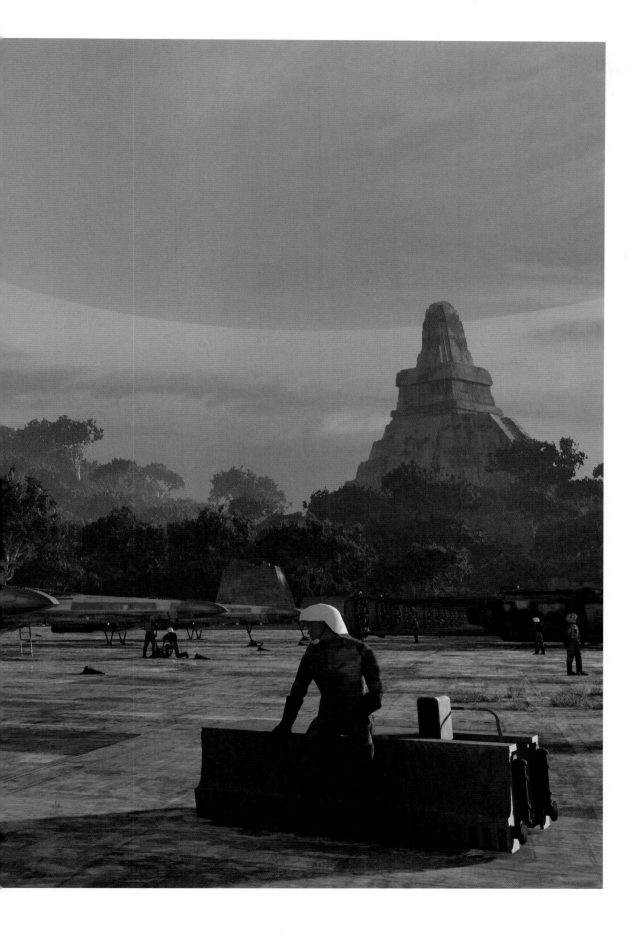

The Mission Briefing

The story flashes forward to a darker time—for both the galaxy at large and for Jyn herself. It is a time well-known to fans of the saga, who will recognize visual markers and aesthetic identifiers that characterize the iconic "period of civil war" referenced in the opening crawl of *A New Hope*. Notable among these indicators is the rebel base on Yavin 4, first seen as the launching point for the rebels' triumphant attack on the Death Star in the original *Star Wars* film—but in *Rogue One*, the base is not visited as a place of refuge from the raging storm of galactic conflict, nor are its rebels denizens waging a war with any hope of success. Here and now, futility and desperation creep like vines on the ancient walls of the monolithic Massassi Temple—and it is here that audiences learn what kind of woman young Jyn has become in the years following her childhood trauma.

She is hardened and alone, flawed and adrift—too unpredictable even for the rebels who recruit her. But desperate times call for desperate measures, and those resisting the Empire must seek aid where they can. Jyn is brought before Alliance leadership (including *Return of the Jedi*'s Mon Mothma) to receive an impossible assignment: to help the Alliance locate an instrumental piece of intelligence which points to a dangerous new weapon created by the Emperor. The source of the intelligence has ties to her father. It's a task integral to the survival of hope in the galaxy, but also one quintessentially personal to the heroine—her history writ large across the stars, her strength and frailty informing a story with sweeping stakes.

"What I love so much about Jyn Erso is that she's an imperfect female warrior—authentic and genuine, truthful and humble, strong and modern without feeling contemporary," said producer Allison Shearmur (*Cinderella* [2015], *The Hunger Games: Mockingjay—Parts 1* and *2*). "Oftentimes, Hollywood wants to see a strong woman apologize for not appreciating her life, or dedicate herself to figuring out why she's a certain way. What I love about Jyn is that hers isn't a story of wishing she'd made other life choices. This isn't an apology. She's equal parts Joan of Arc and Sigourney Weaver's Ripley—a pure hero, independent of gender. Someone who sets out to do something impossible and does it."

The complexity of the character and the notable distinction of being such a nuanced female protagonist was something that excited the art department about Jyn, as well—allowing them

◂ **YAVIN EXTERIOR VERSION 9** Haley

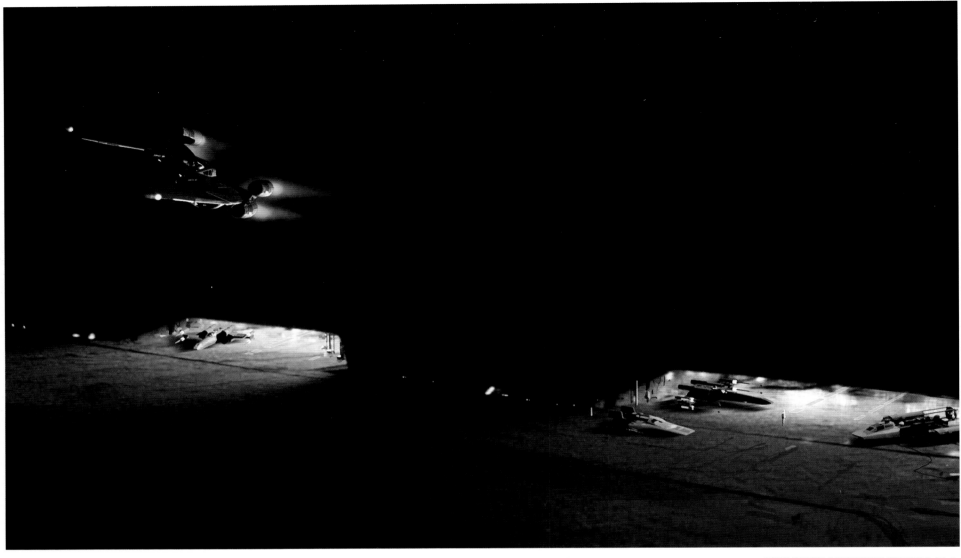

▲ **YAVIN HANGAR BAY VERSION 1A** Chiang ▼ **YAVIN BASE INTERIOR AMPHITHEATER VERSION 1** Colie Wertz ▼ **YAVIN HANGAR BAY INTERIOR VERSION 1** Wertz

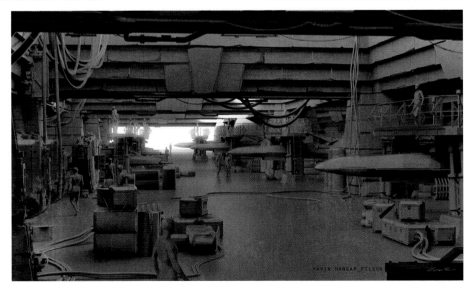

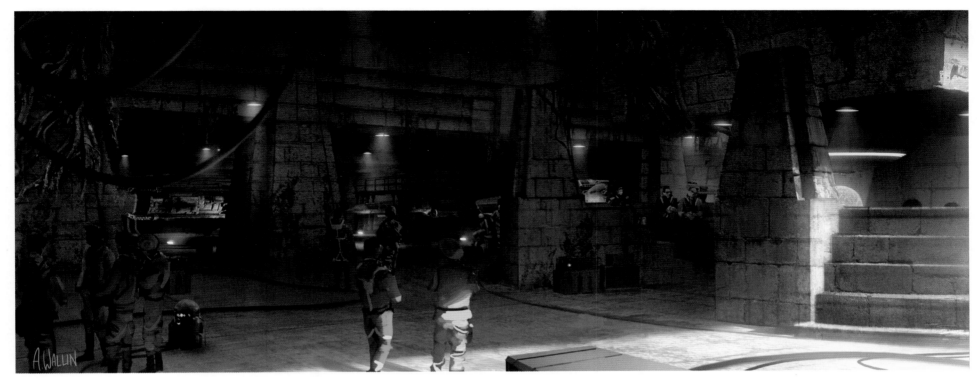

to reframe conventional thinking about a galaxy so familiar to audiences. *Rogue One* would depict a galaxy with a gender balance more reflective of *Star Wars*'s real-world audiences and fans, showcasing a wider population as evenly diverse as the beloved property deserves.

"That's the amazing thing about *Star Wars*—that it appeals to different people of different ages, as if it had been made for them specifically. And *Star Wars* has always appealed to women," said Doug Chiang. "There have always been strong women, starting with Princess Leia, but the fact that Jyn is now the lead in the story—that it's so completely about her—just expands the *Star Wars* universe that much further. Setting everything around her is so brilliant and so exciting—and lets us come at things from a female point of view."

Where *The Force Awakens* illustrated this perspective by placing Rey so front-and-center in the saga's unfolding future, *Rogue One* would retroactively repopulate previous points in the narrative; Jyn's present is the audience's past—making *Rogue One* something of a period piece, not just for its "a long time ago" setting, but because its narrative takes place at such a specific and recognizable point in the history of this galaxy in motion.

This presented one of the central challenges for the *Rogue One* production team, tasked with imagining a time period so iconic.

"The *Star Wars* universe is created as if it's real; there are laws that have to be observed—that certain characters go on

certain ships, that certain ships have certain functions, that certain events happened at certain points along the timeline," said franchise production supervisor Kristen Swartz. "Everything has a place and a rule, and whether it's in *Star Wars Rebels* or *Star Wars: The Clone Wars* or in the films or in video games or in comic books, we have to respect those rules. You wouldn't suddenly see Grand Moff Tarkin with a completely new look or style, or in a completely new costume. He has a uniform, and it's the uniform that he wears because it has been established as such—with a certain insignia to denote his rank based on where we are in the timeline. It's part of the job to make sure we adhere to our own rules, and that's especially true for *Rogue One* because of how it fits into the timeline, up against *A New Hope*."

But rather than limiting imagination, the restrictions of precedent only provided an opportunity for further exploration, a chance for the production to look beyond the familiar into the unknown corners of even *Star Wars*'s most iconic locales.

"The great thing is we all grew up loving *Star Wars*, and the appeal is that here we are tasked with being so true to the film that inspired us all," said Chiang. "*Rogue One* gives us the opportunity to expand the things we love, like the Yavin base—something that, as an audience, we only really glimpsed in *A New Hope*. Now we have a story to tell within that location, which demanded that we show more of it."

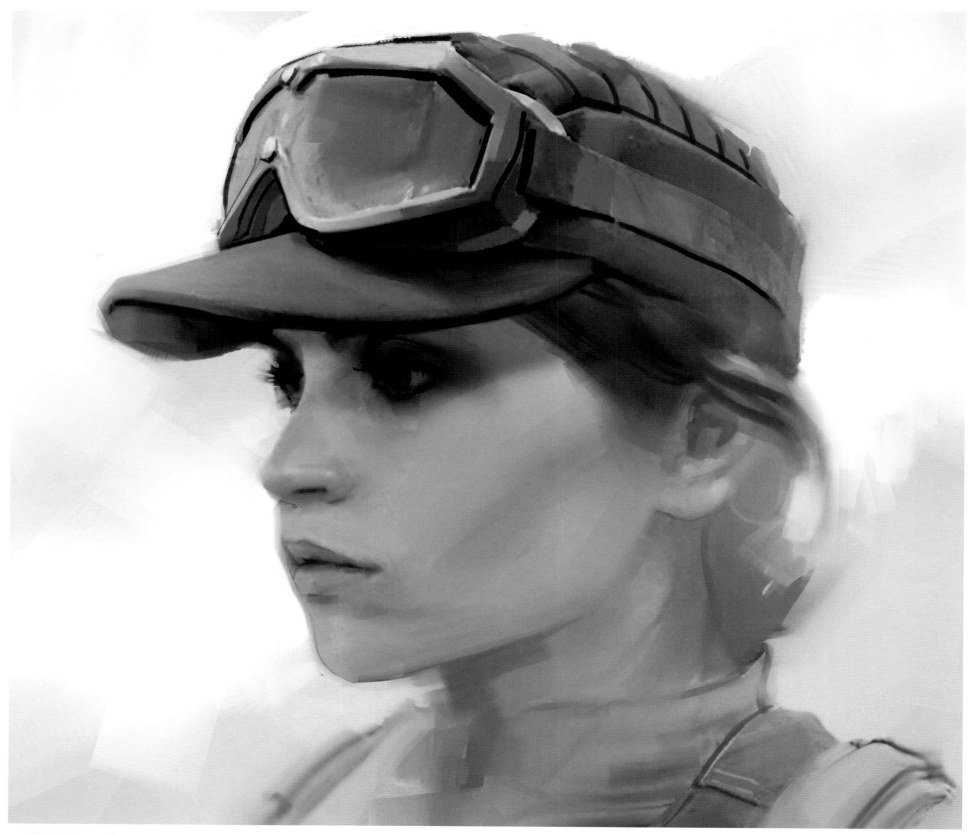

▲ **JYN (FELICITY JONES) IN CAP** Dillon

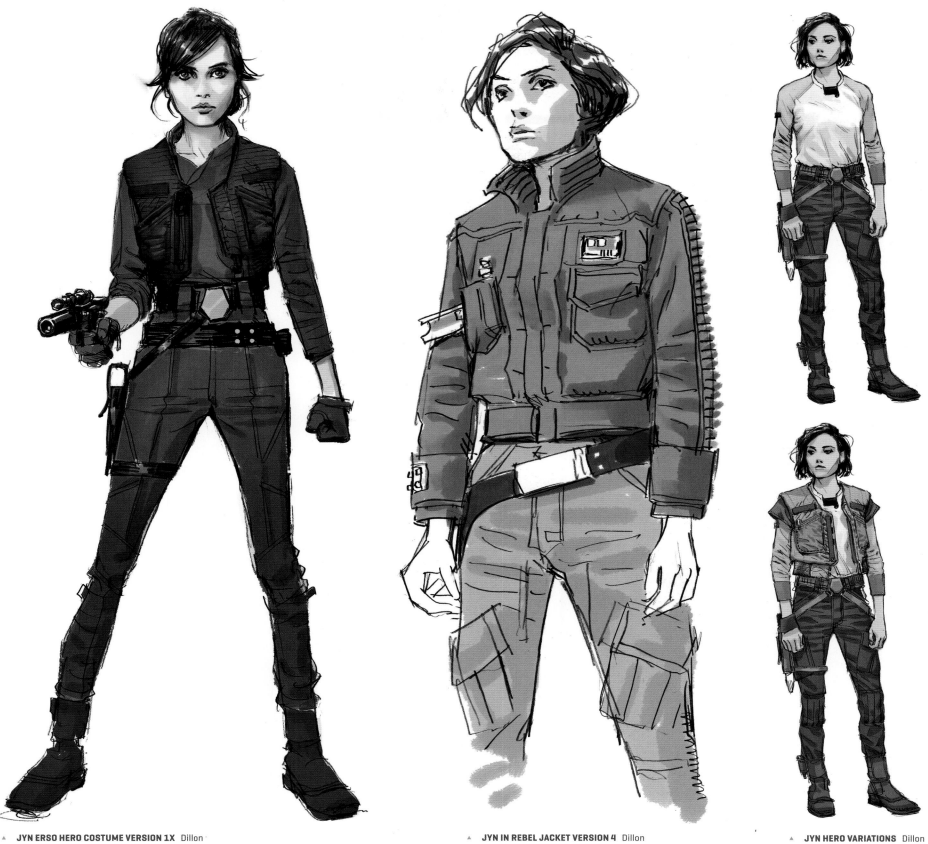

▲ **JYN ERSO HERO COSTUME VERSION 1X** Dillon

▲ **JYN IN REBEL JACKET VERSION 4** Dillon

▲ **JYN HERO VARIATIONS** Dillon

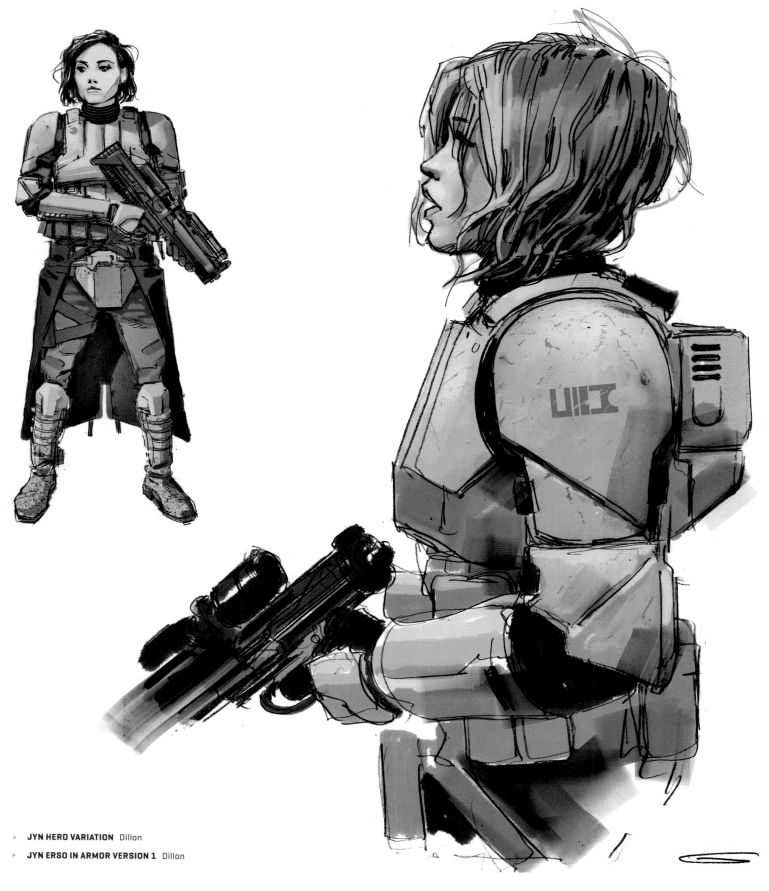

▲ **JYN HERO VARIATION** Dillon

▶ **JYN ERSO IN ARMOR VERSION 1** Dillon

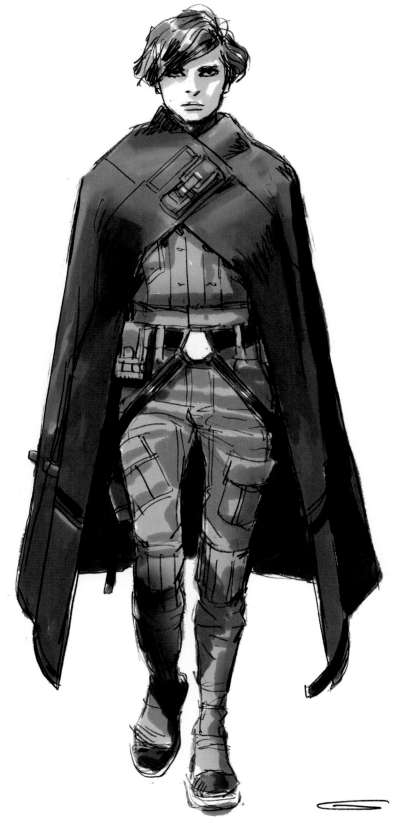

JYN IN COMBAT GEAR CAPE VERSION 1 Dillon

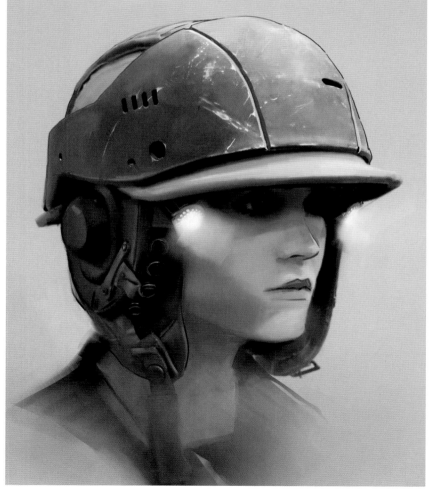

JYN'S SIDE ARM

BLASTER

RIFLE

▲ HERO BLASTER RIFLE VERSION 4A Savage ▼ JYN MARINE HELMET Dillon

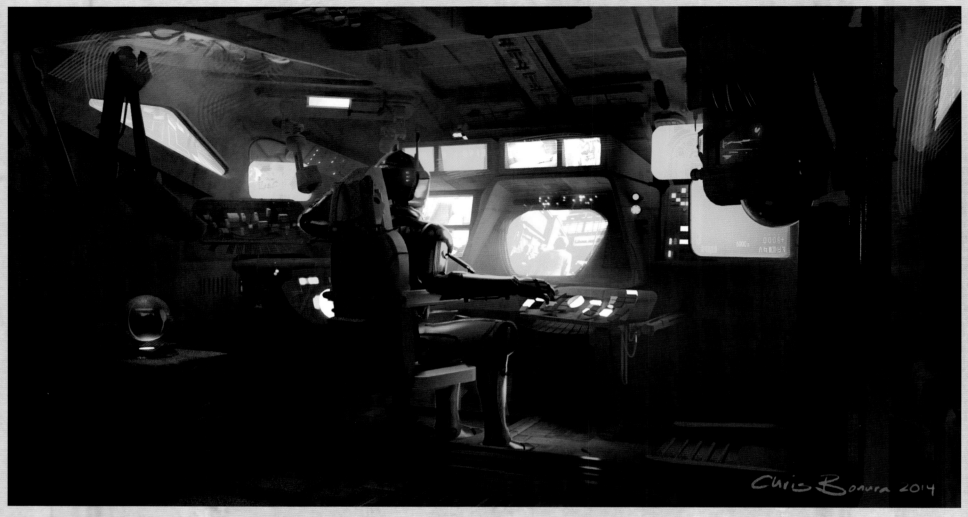

▲ **K-2SO SURVEILLANCE ROOM VERSION 1** Chris Bonura

K-2SO

Joining the ranks of iconic droids like R2-D2 and C-3PO—and, from *The Force Awakens*, breakout star BB-8—would be a new mechanical hero, companion to Cassian and among one of the key recruits essential to Jyn's ultimate mission. Originally imagined as an Imperial protocol droid, K-2 evolved through story and art development into something novel within the *Star Wars* stable.

"We all had a go at designing K-2SO in the beginning," said special creature effects supervisor Neal Scanlan (*Babe*, *Prometheus*, *The Force Awakens*), whose UK-based team remained in the shop established for *The Force Awakens* at Pinewood Studios. "Our concept artists were working on it. Doug [Chiang] was working on it, along with the guys back at Industrial Light & Magic in San Francisco. There's always a huge amount of work that goes into getting to the point where you begin to see the path ahead. And more than anything, it seemed that it was the

silhouette of the character. That's very important to the world of *Star Wars*; you can pretty well recognize any *Star Wars* character just from the silhouette. Yoda is Yoda, R2 is R2, Vader is Vader, and Jabba is Jabba because he's a big banana with a head on him. K-2 had to work the same way."

Beyond requiring a simple silhouette to immediately communicate identity, K-2SO's design was intended to convey not only foundational aspects of his personality, but also essential qualities recognizable as part of the canonical universe.

"Audiences can identify a *Star Wars* character pretty quickly, so I really wanted K-2SO to look like he fit into that world," said creature concept designer and senior sculptor Luke Fisher (*Children of Men*, *Prometheus*, *The Force Awakens*). "Even beyond the outline, he should feel like he'd come from the Imperial workshop, like he'd been built at the same factory that had built

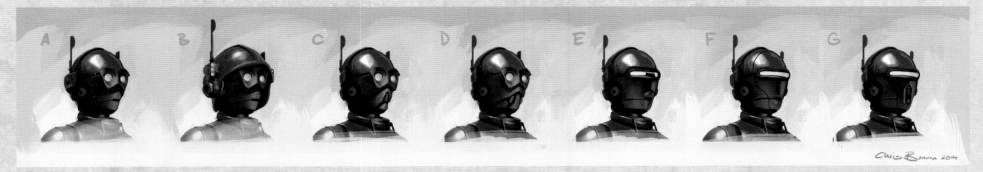

A B C D E F G

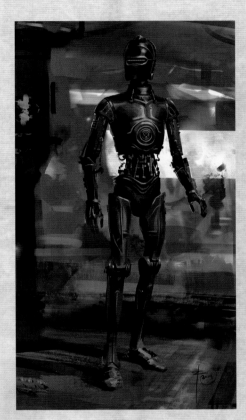

▲ K-2SO VERSION 1 Kinman Chan

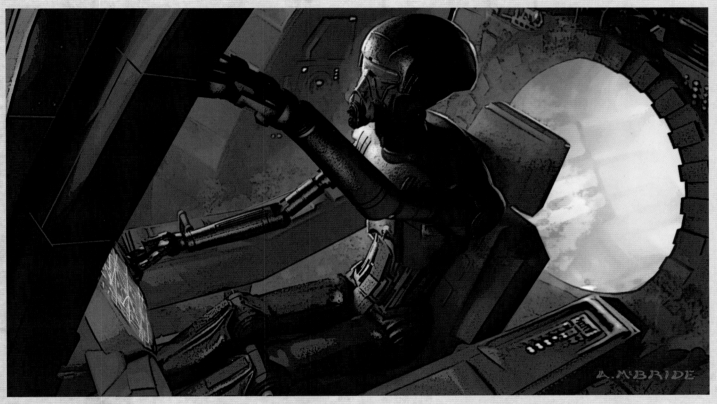

▲ K-2SO SEATED POSE VERSION 1 Aaron McBride

the torture droid for *Star Wars: A New Hope*. It's all part of a shared aesthetic that begins with the silhouette."

As the story continued to develop, so did the concept behind K-2SO. His ostensible Imperial affiliations were accentuated in subsequent drafts until, ultimately, it was decided that he would be a security droid—huge, imposing, once a tool of fear used by the Empire but now reprogrammed by Cassian Andor to aid the Rebellion. With his change of allegiance, however, came an essential change to his personality, which would provide a stark—and visually amusing—contrast to his towering, monolithic form.

"He's an imposing figure, but Gareth [Edwards] also wanted him to be appealing—for kids to be scared of him but also

kind of drawn to him. Gareth responded to some of the early sketches where there was a childlike quality to the head. It had the proportions of an infant skull, kind of large," said Fisher. "For Gareth, character was always the most important thing. I wanted to be able to convey that through the design. K-2SO's quite laid-back, with a casual kind of personality, so I designed him with a bit of a stoop. It's kind of built into him—it's part of his makeup that he looks like that. It was his attitude as much as anything. So I started drawing him leaning up against walls, chatting with people—always trying to find that personality. That was the key. Find his personality, and the rest of the aesthetic would follow."

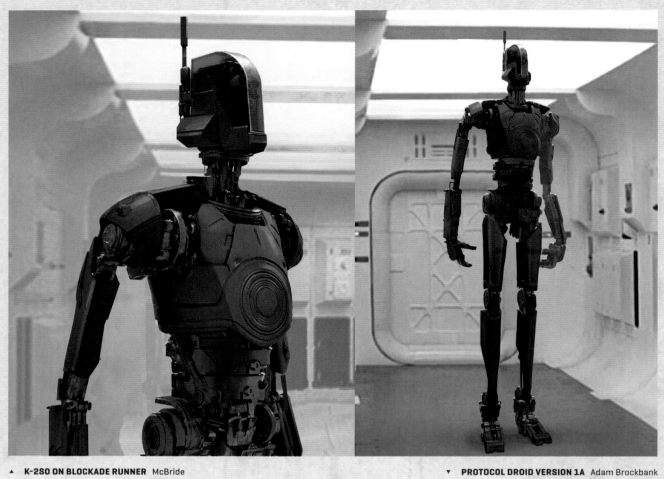

▲ **K-2SO ON BLOCKADE RUNNER** McBride

▼ **PROTOCOL DROID VERSION 1A** Adam Brockbank

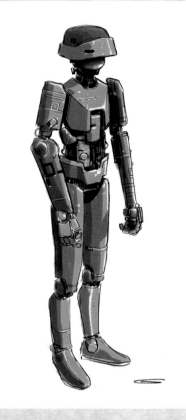

▲ **SENATOR DROID VERSION 2** Dillon

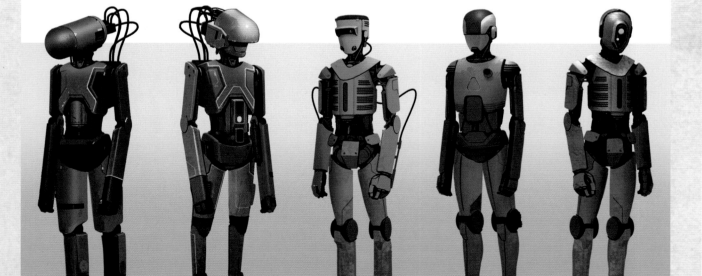

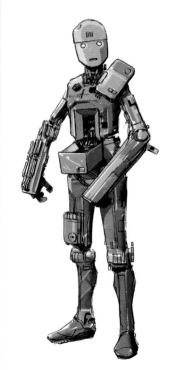

▲ **SENATOR DROID VERSION 6** Dillon

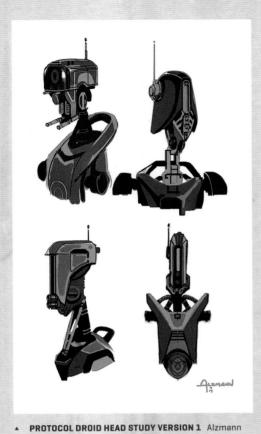

▲ **PROTOCOL DROID HEAD STUDY VERSION 1** Alzmann

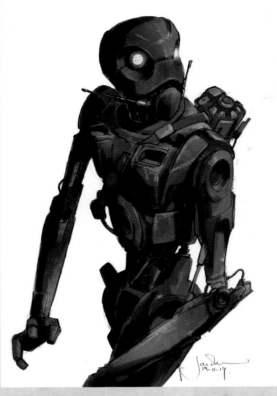

▲ **K-2SO FULL BODY/HEIGHT REFERENCE VERSION 7B** Lunt Davies

▲ **K-2SO VERSION 4A** Lunt Davies ▼ **K-2SO FIGURE VERSION 1A** Lunt Davies

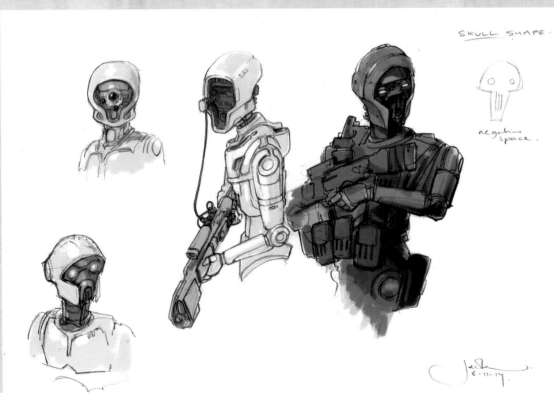

SKULL SHAPE.

negative space.

▲ **K-2SO SKETCHES VERSION 12** Lunt Davies

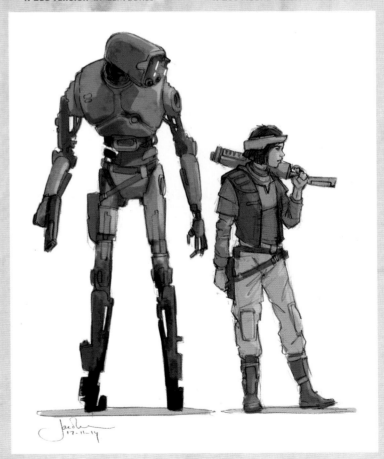

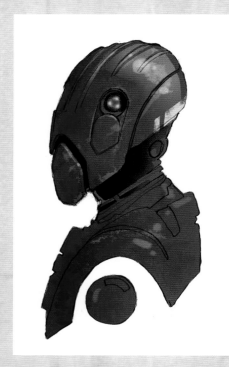

▲ **K-2SO HEAD VERSION 1G** Lunt Davies

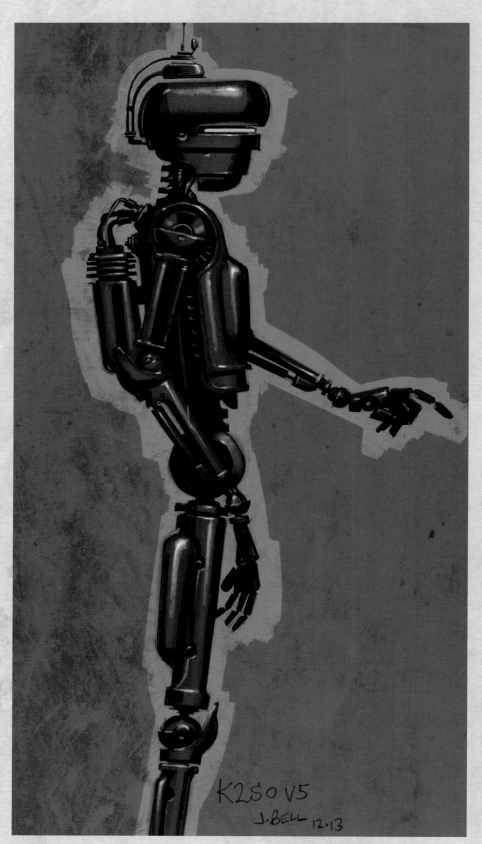

K2SO V5
J.BELL 12.13

▲ **K-2SO COLOR STUDY VERSION 1** John Bell

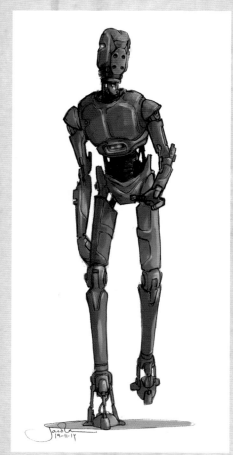

▲ **K-2SO FULL BODY/HEIGHT REFERENCE VERSION 6B** Lunt Davies

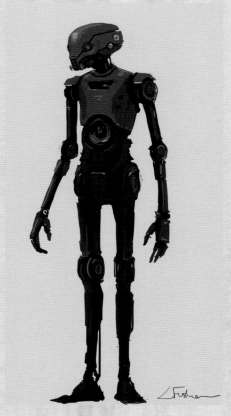

▲ **K-2SO FIGURE VERSION 2A** Fisher

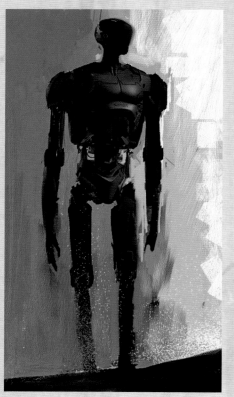

▲ **K-2SO STUDY** Manzella

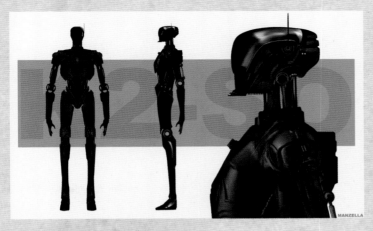

▲ **K-2SO VERSION 1A** Manzella

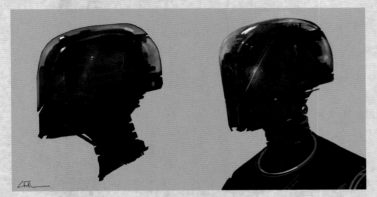

▲ **K-2SO HEAD VERSION 1A** Fisher

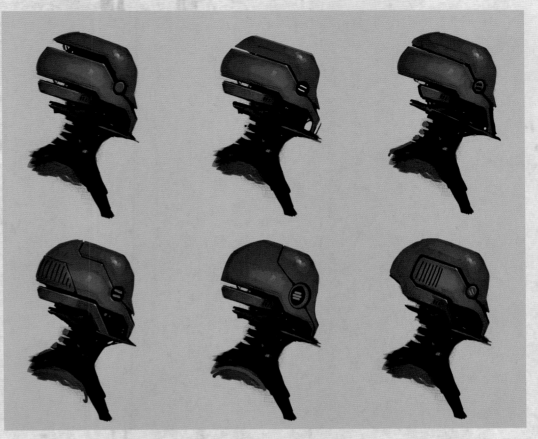

▲ **K-2SO PROFILE STUDY** Fisher

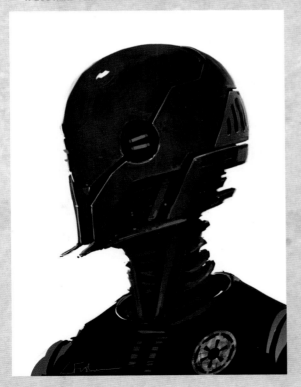

▲ **K-2SO HEAD VERSION 1A** Fisher

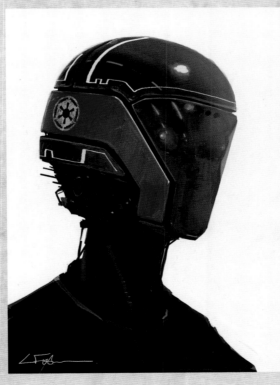

▲ **K-2SO HEAD VERSION 4A** Fisher

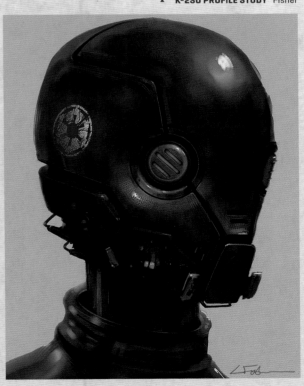

▲ **K-2SO HEAD VERSION 5A** Fisher

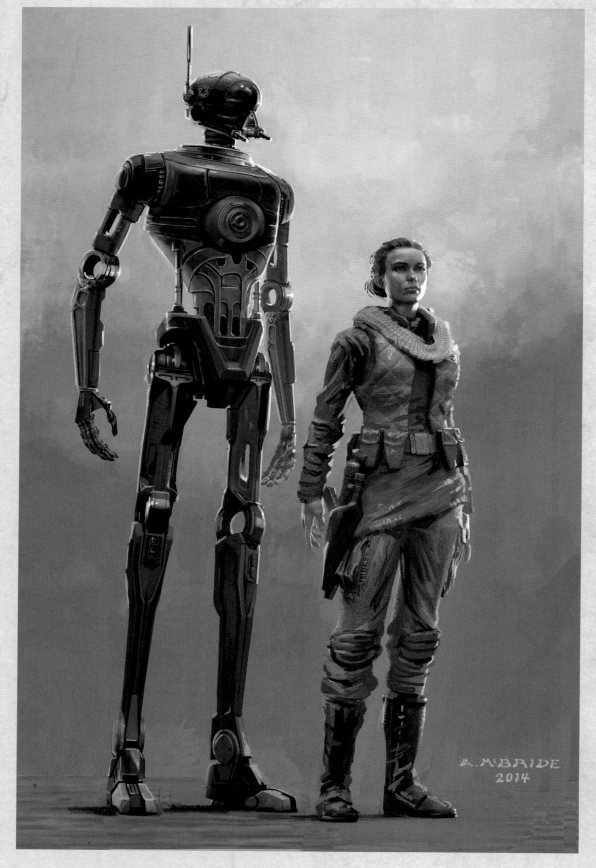

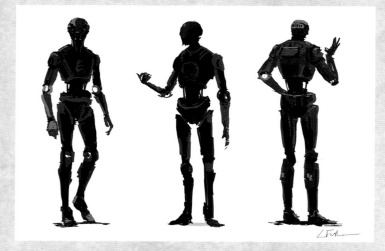

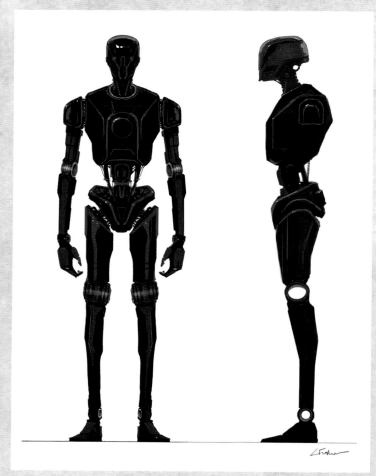

▲ K-2SO FULL BODY VERSION 2A Fisher ▼ K-2SO BODY VERSION 2A Lunt Davies

◄ K-2SO FULL BODY/HEIGHT REFERENCE VERSION 17 McBride

"Gareth was always very keen on this hip shape, and I've always liked the
contrast you get from it. It's in the head, too, where you have this outer
shell—this casing—but you can still see past it into the depths. You see
the mechanical side of the character." Fisher

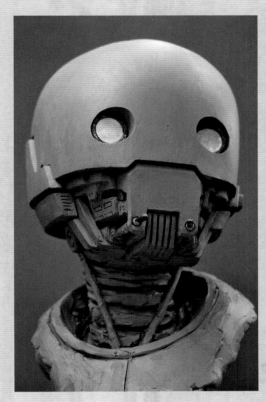

▲ **K-2SO HEAD MAQUETTE** Fisher

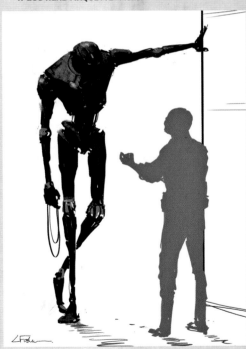

▲ **K-2SO LEANING VERSION 2A** Fisher

▶ **K-2SO MAQUETTE** "This was the first maquette, exploring his body language as much as his look. He's quite laid-back. Not lazy, but with an 'I don't really give a crap' kind of attitude." Fisher

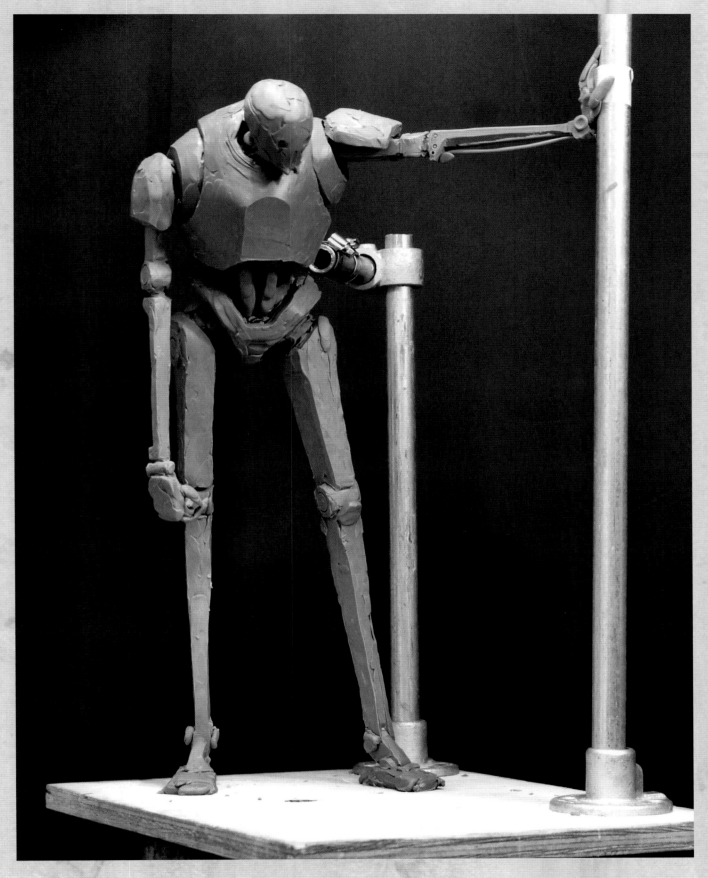

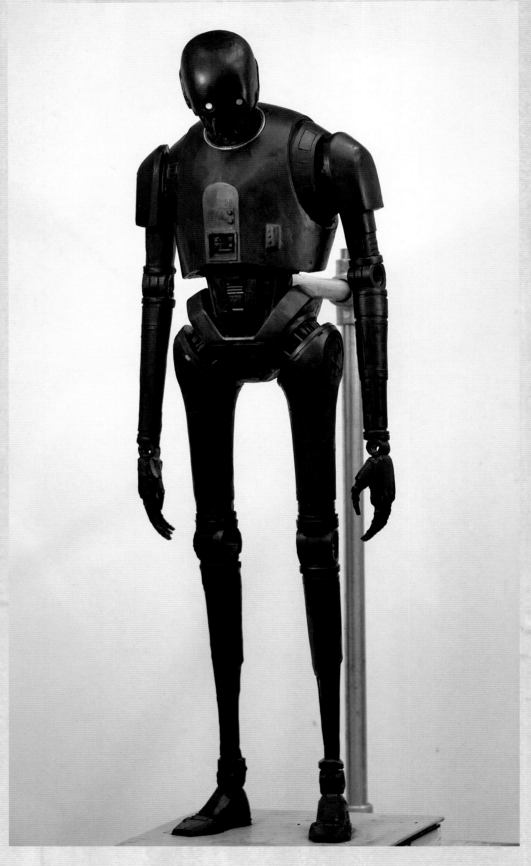

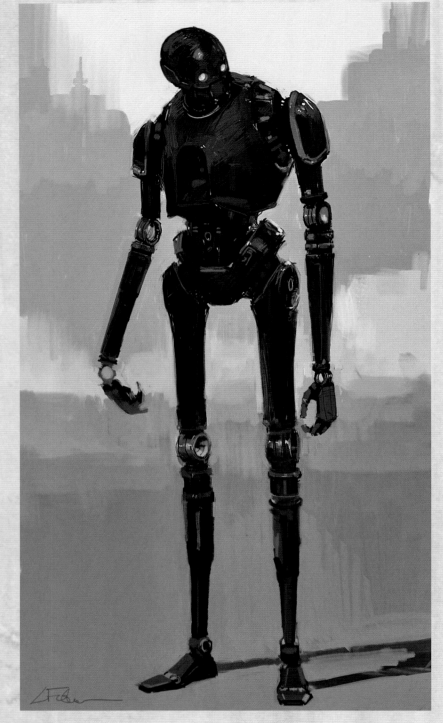

▲ **K-2SO CONCEPT VERSION 1A** Fisher

◄ **K-2SO MAQUETTE (PAINTED)** "I referenced a lot of existing Imperial design. His chest plate is based on the armor worn by the AT-AT commander in *The Empire Strikes Back*—which is also used on the snowtrooper." Fisher

▶ **K-2SO FINISHES VERSION 1C** "This is the second maquette. Here, he's quite relaxed. Gareth was more keen on this one, so this was the direction we took moving forward." Fisher

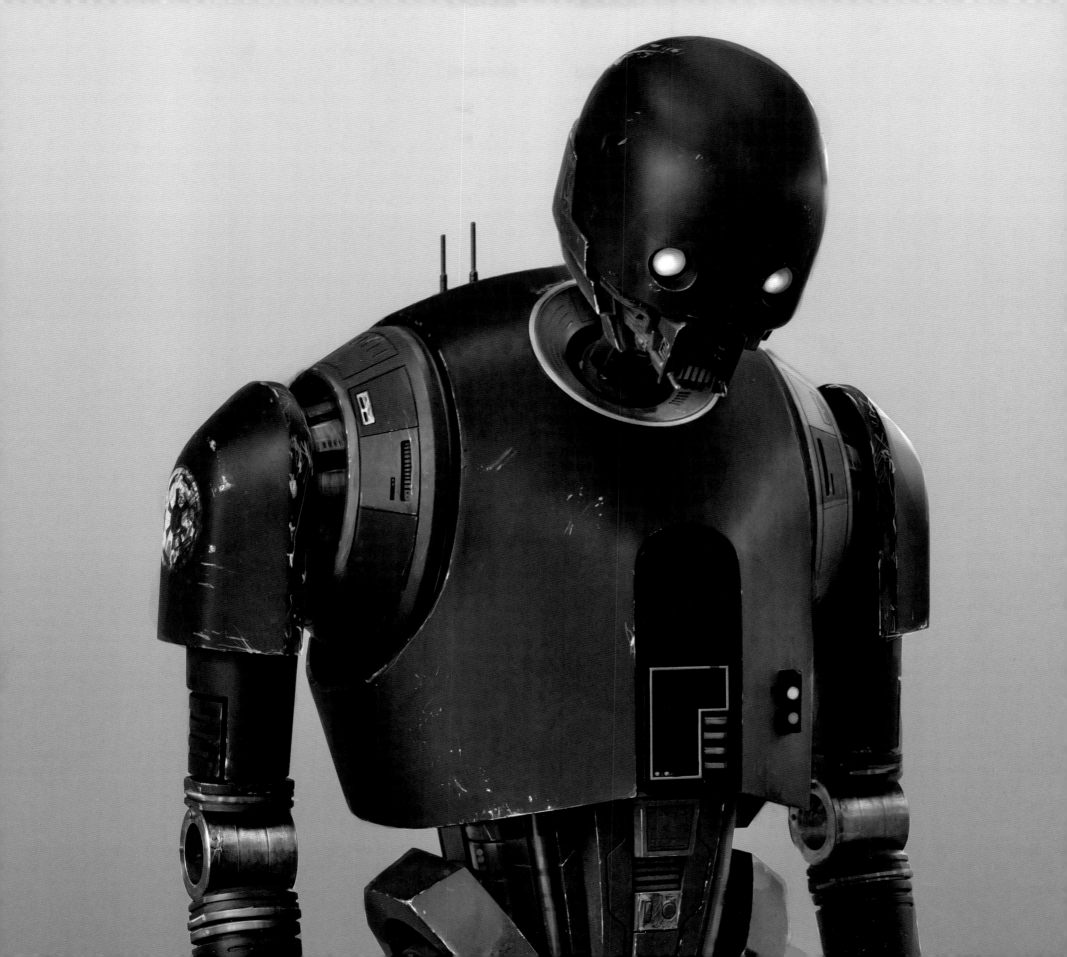

"A MILLION SHIPS": EVOLUTION OF THE U-WING

Leading as it does to the events of *Star Wars: A New Hope*, *Rogue One* is populated with all of the familiar ships and vehicles that generations of *Star Wars* fans have come to love. For the ship that Jyn and Cassian would use in service of their mission, one of the creative mandates was to envision something new, a hero ship that could stand alongside the rest of the legacy *Star Wars* fleet.

"We were all drawing a lot of ships. What's the new *Millennium Falcon* going to look like? Or rather, what's an old *Millennium Falcon* look like? We've done *every* shape. There were a lot of days where I was just sitting there—drag, click, expand, click—just pushing shapes together, looking for that icon. We did *a million* ships," said Ryan Church. "We had to be able to put it next to an X-wing, which is the coolest ship ever, and for a kid to grab ours. That is a high, high bar. In other words, we couldn't just do something that looks cool. It had to be iconic—absolutely iconic."

With the inclusion of X-wings, Y-wings, and the rest of the touchstones associated with the period, "Gareth [Edwards] also wanted to experiment and to deviate, to have some things that would be new for audiences," said Christian Alzmann. "It was an 80/20 approach, where 80 percent was the stuff that we'd seen and 20 percent was new, because you don't want the universe to feel static, and you want to give some new discoveries to people. But even with those things, we were always pushing for them to look like science fiction from 1977—or just before!"

The design of the U-wing ultimately bore much of that weight—requiring a delicate balance between the "period piece" sensibilities of a film set within such a distinct timeline and the necessity for visual revelations that could provide new thrills for sophisticated modern audiences. Church eventually took the lead on "hero ship" development and committed himself to the process, even as the narrative continued to evolve.

"It changed so much along the way—even more than the basic design elements," he said. "We envisioned the hero ship as a *Millennium Falcon*-sized thing that could fit a bunch of people. Cockpit, living quarters, that sort of thing. And then that changed, and it became this thing that could fit a smaller ship—which I thought of as helicopter-sized—inside of it. They could

▲ **HERO SHIP ONE-MINUTE SKETCHES** Church

take the smaller ship down to the planet, leaving the bigger one in orbit. Then we started asking if we really needed both, and we decided that we only needed the helicopter-sized thing—kind of like a transport version of an X-wing."

The decision was liberating, if somewhat frustrating.

"That meant that all the previous work was no longer valid for our needs. This wasn't a unique ship anymore; it was something you'd find out on the flight line next to all the X-wings and the other ships," said Church. "We see them parked at Yavin, a fleet of U-wings—just a ton of them along with X-wings and Y-wings. It was what the rebels were flying, and our guys just took one off the lot. A used lot, because they're older."

Ultimately, the development paid off with a concept that felt as fresh as it was familiar—which Church now attributes to a revelation made after the final design had been locked, loaded, and fully approved.

"We'd tried the Z-wing, the Q-wing, the R-wing. It was tough, and there were no eureka moments along the way—nothing until *after* we actually got the design," he said. "We kept coming back to a shape like a catamaran, with two parallel component parts. It was kind of forward-looking, and Gareth said it looked kind of like Superman with his arms outstretched as he's flying. He pointed out that, after everything, we'd just made an X-wing, but split down the middle. It's got the cockpit and the long nose, and we just split the nose into two air foils."

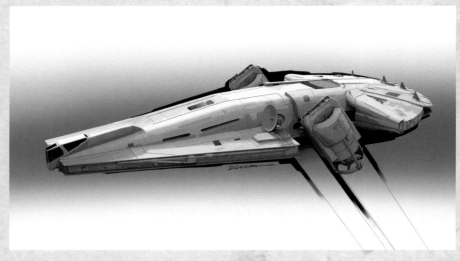

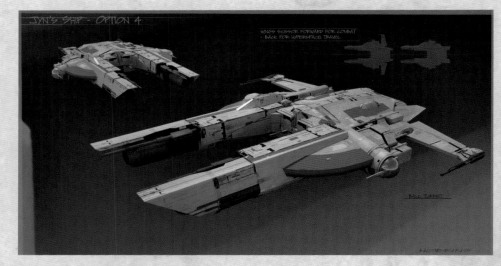

▲ **MARINE FIGHTER—COMMUNICATIONS SHIP VERSION 1** Chiang

▼ **REBEL FIGHTER—CATAMARAN 1** Church

▲ **JYN'S SHIP VERSION 6** David Hobbins

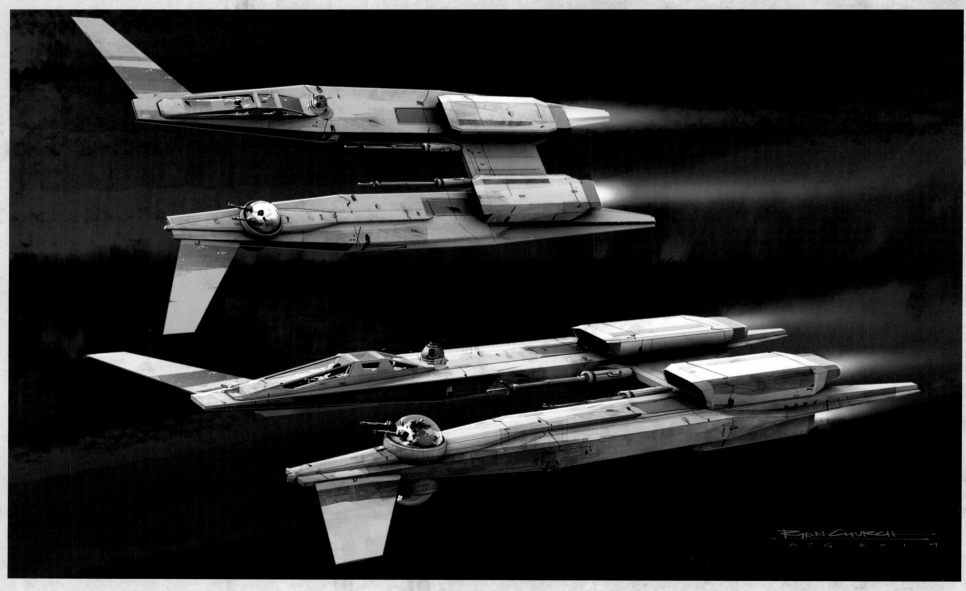

▲ **HERO SHIP INTERIOR—MAIN ROOM VERSION 2** Khang Le

▼ **SHIP TURRET VERSION 1** Khang Le

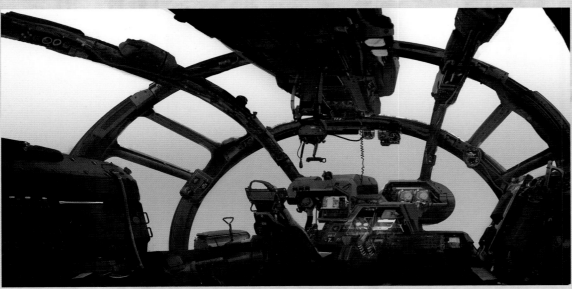

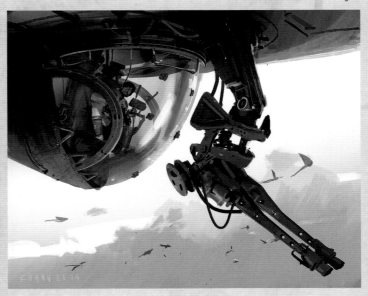

▲ **SHIP COCKPIT VERSION 3** Khang Le

▶▶ **JYN'S SHIP VIEW C VERSION 22** Hobbins

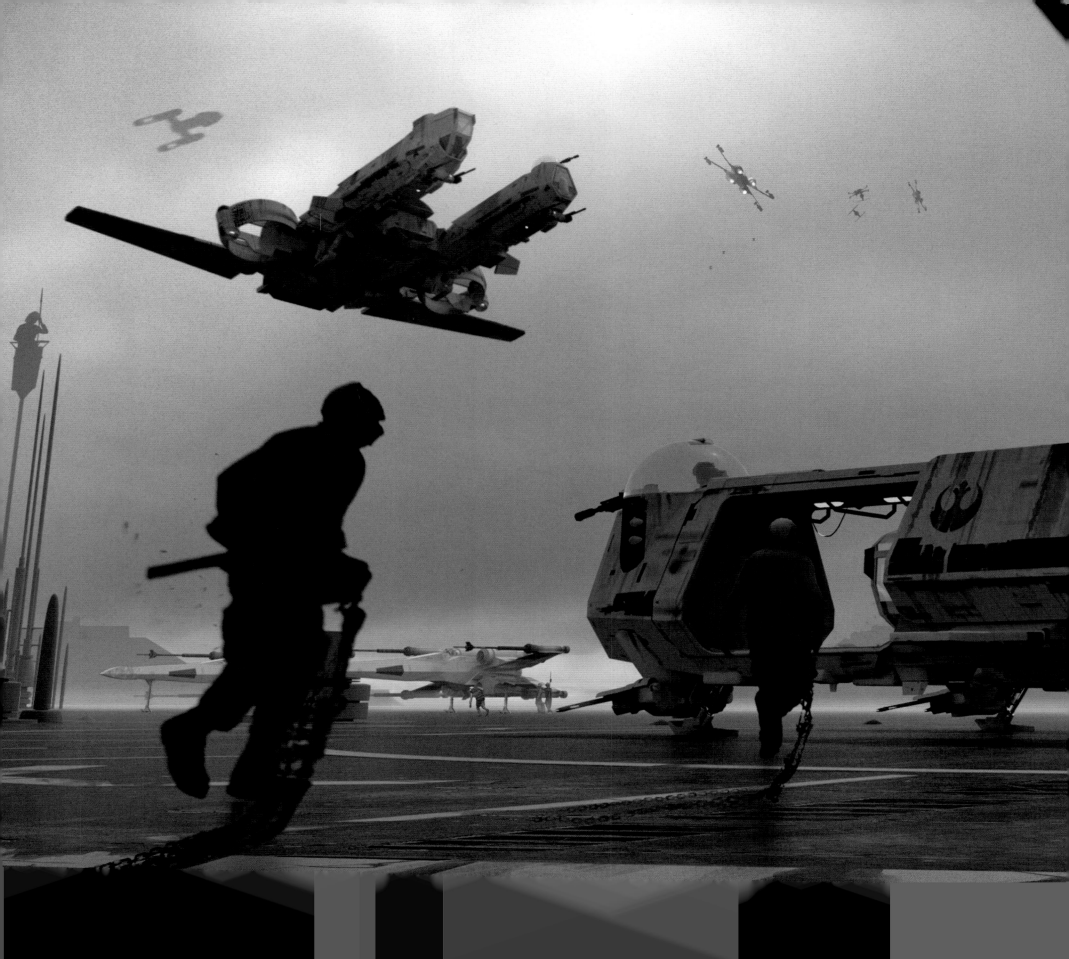

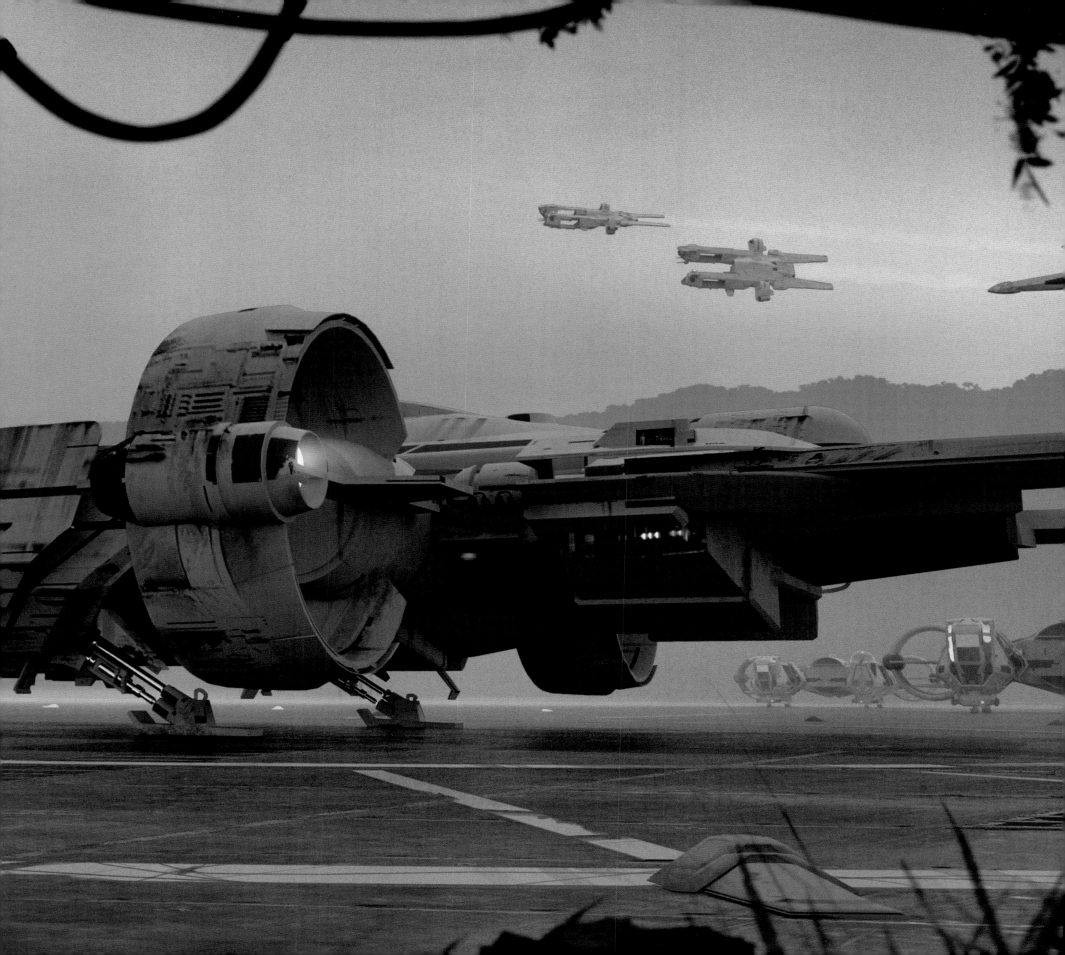

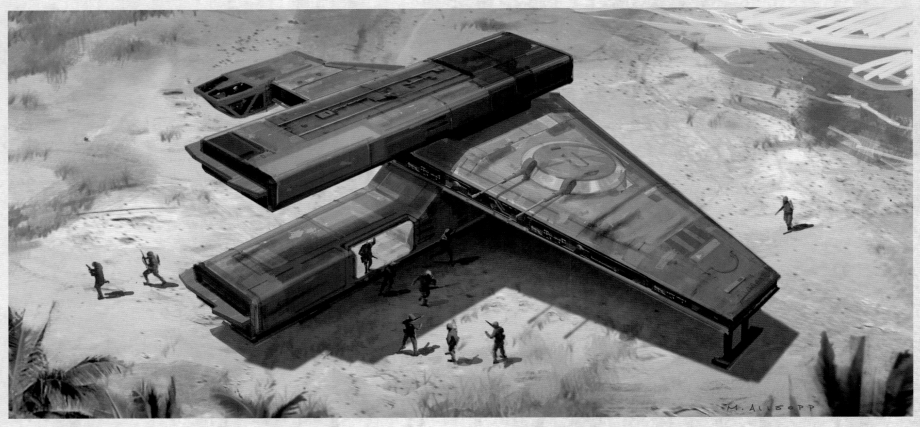

▲ **JYN'S SHIP VERSION 3** Allsopp

▼ **DROP SHIP, HOMESTEAD EXTERIOR** Allsopp

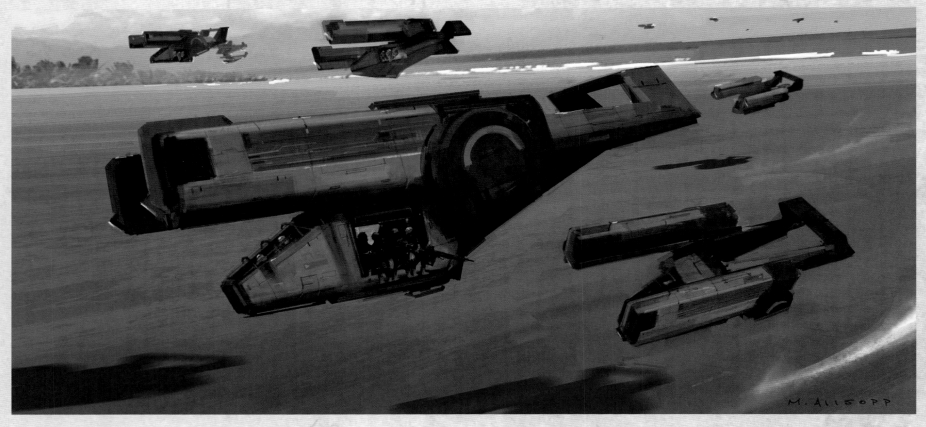

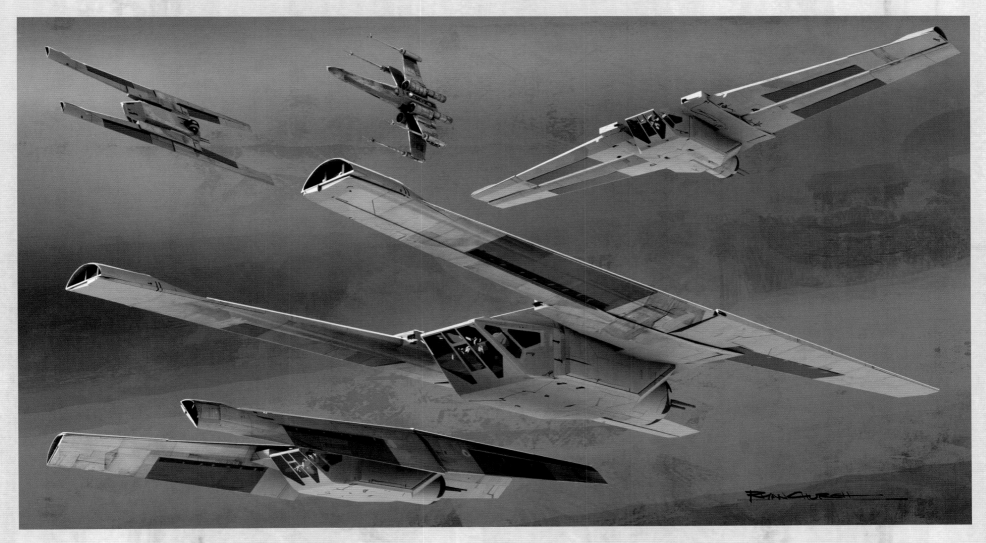

▲ **JYN'S SHIP VERSION 1** "Gareth always wanted something a kid could draw, just like we all drew X-wings and TIE fighters growing up." Church

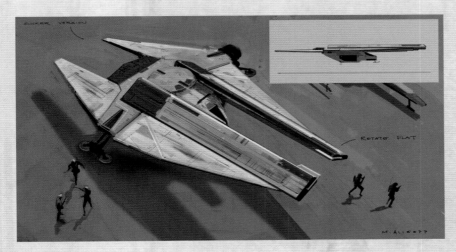

▲ **HERO SHIP VERSION 9** Allsopp

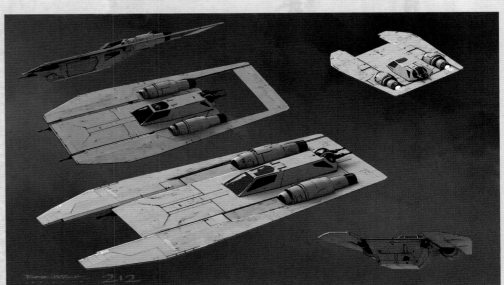

▲ **JYN'S SHIP 212 VERSION 1** Church

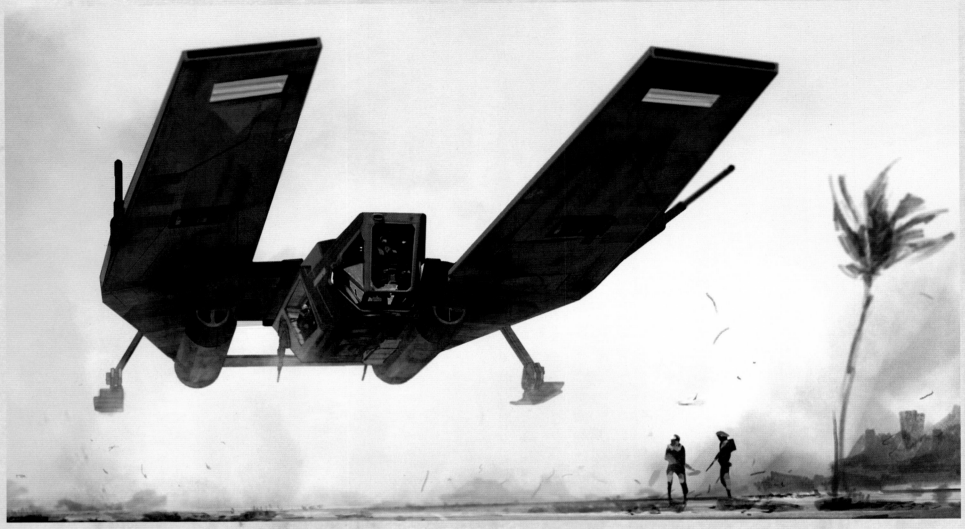

▲ **HERO SHIP VERSION 1** Allsopp

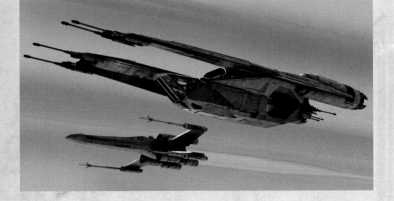

▼ **JYN'S SHIP VERSION 2—UPSHOT** Church

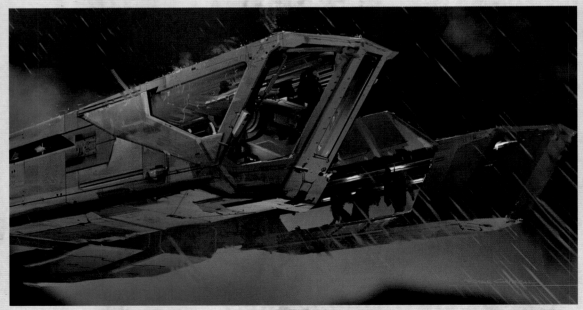

◄ **JYN'S SHIP VERSION 10—COCKPIT EXTERIOR** Church

"It was always Jyn's ship; that's what we called it. 'Jyn's ship.' After a thousand cracks at it, we'd finally gotten somewhere with the design. In fact, when our design finally got an approval, [Lucasfilm art production manager] Nicole Letaw made a cocktail called the Jyn's Ship—which was a gin drink, of course. And it was delicious." Church

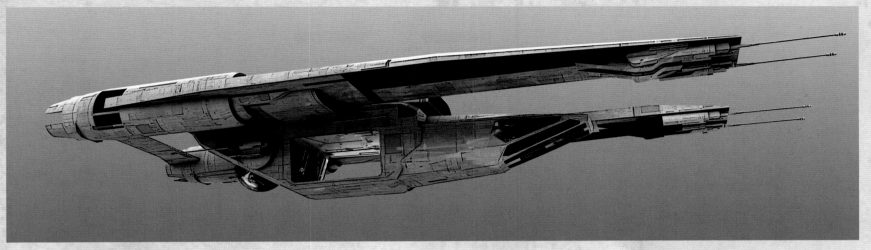

▲ **HERO SHIP VERSION 1** Chiang

▼ **HERO SHIP VERSION 1B—ANGLED WING** Tenery

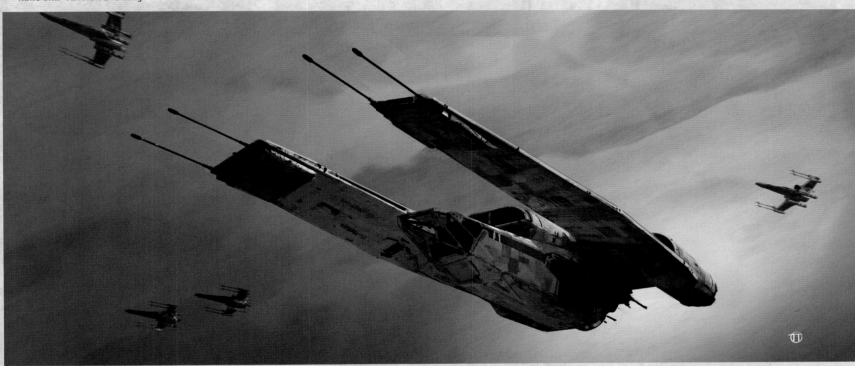

▼ **JYN'S SHIP VERSION 2** Chiang

▼ **JYN'S SHIP VERSION 6** Chiang

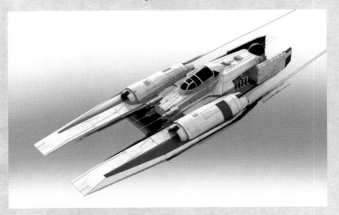

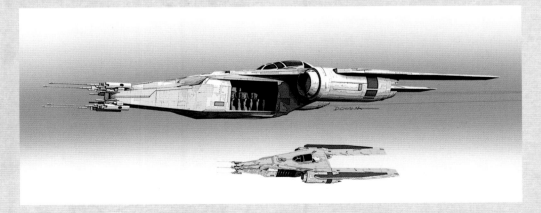

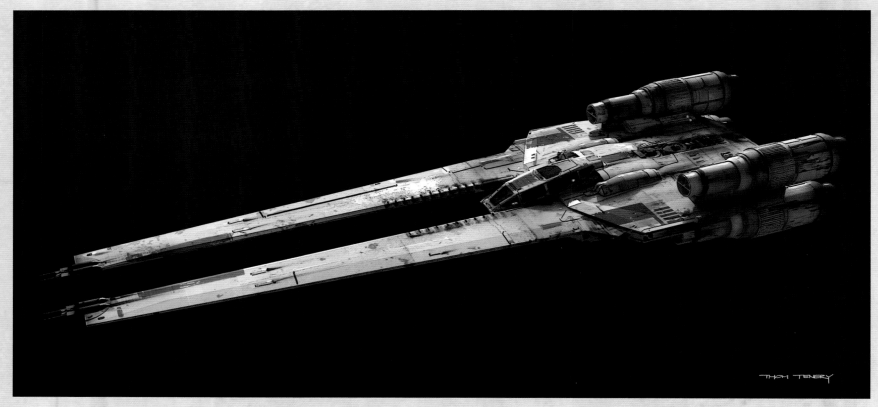

▲ **JYN'S SHIP VERSION 261** Tenery

▼ **JYN'S SHIP EXTERIOR FRONT QUARTER COLOR VERSION 3A** Church

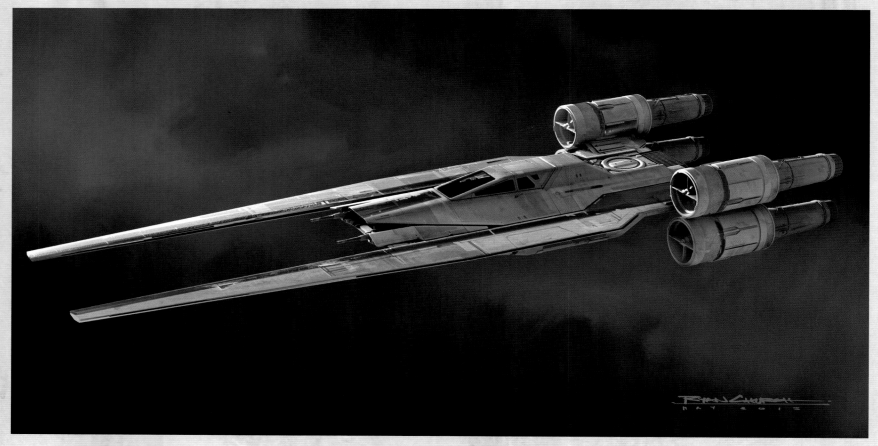

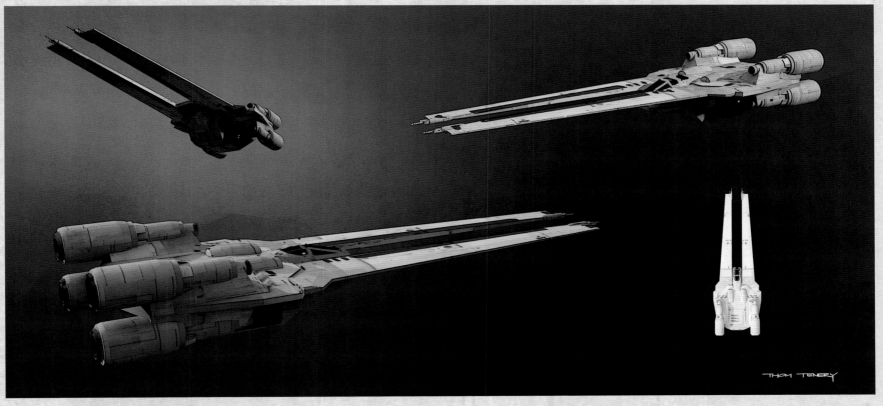

HERO SHIP/DROP SHIP VERSION 26D Tenery ▼ **JYN'S SHIP VERSION 2—CAB FORWARD** Church ▶▶ **JYN'S SHIP CHASE** Tenery

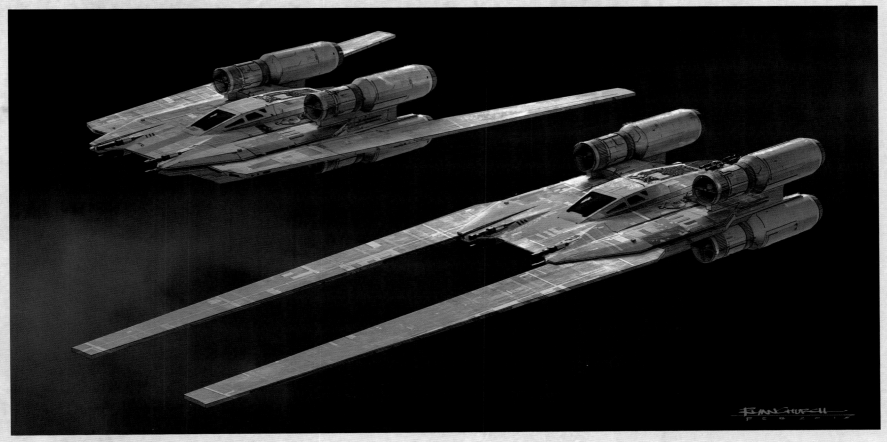

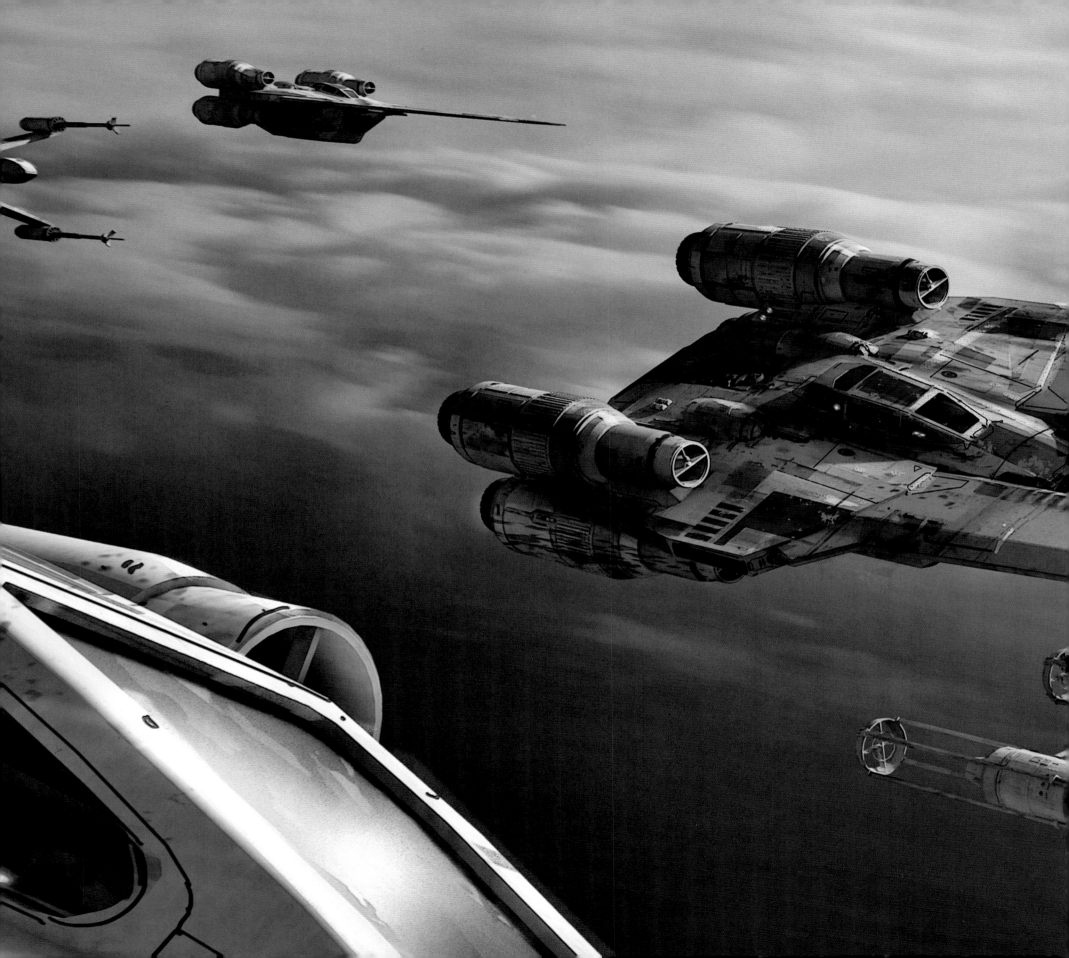

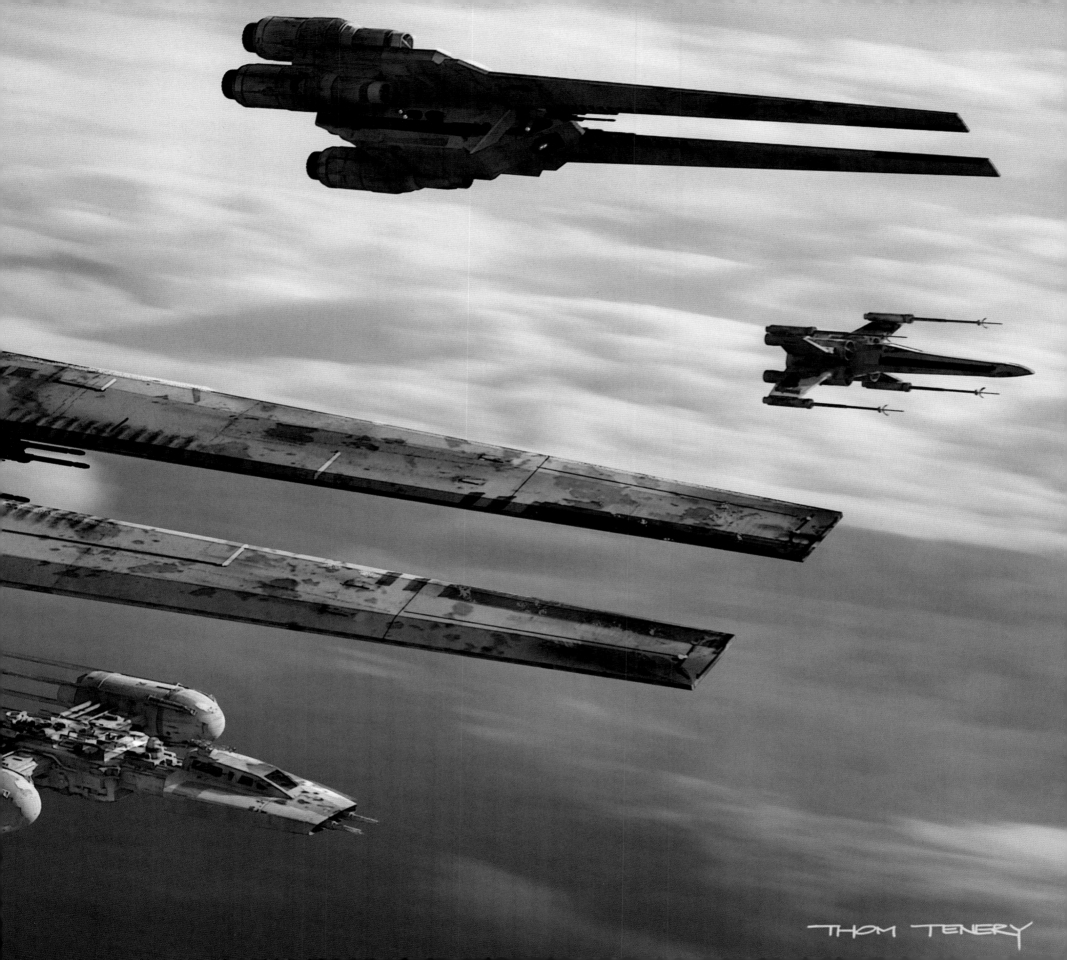

THOM TENERY

▲ **X-WING CONTROL PANEL** Andrew Booth and BLIND LTD.

▶ **DEATH STAR PLANS** Booth and BLIND LTD.

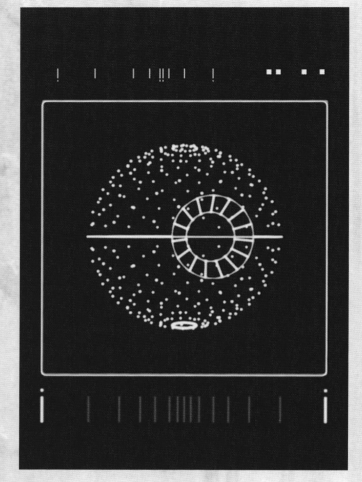

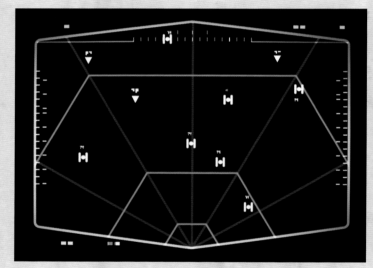

▲ **MINING VEHICLE RADAR** Booth and BLIND LTD.

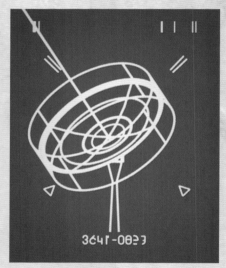

3641-0023

▶ **SCARIF DISH ALIGNMENT** Booth and BLIND LTD.

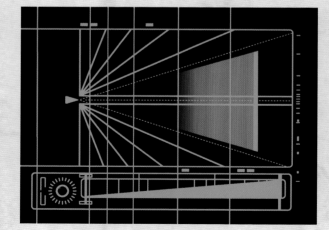

▲ **MINING VEHICLE TRACTOR BEAM** Booth and BLIND LTD.

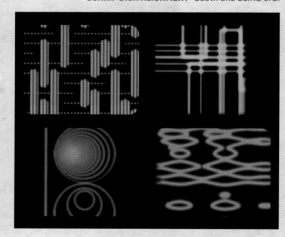

◀ **HOMESTEAD GRAPHIC** Booth and BLIND LTD.

"The shapes in *Star Wars* are all really quite simple. A TIE fighter or an X-wing or the Death Star or a Star Destroyer—they're all geometric. It's a great thing to fix on because they're identifiable, even in this space fantasy world. We are able to take it a step further—creating meaning from things like concentric circles just by turning them into a map or a star chart. They're impressionistic, but audiences can understand them because they're so universal." Andrew Booth

"We were trying to do computer displays from before personal computers existed, so it's very easy to fall back on what we expect computers to look like now. We had to get in that mindset of how they interpreted that future when graphic user interfaces for computers really didn't exist. I was looking at postmodernist graphic design as reference." Mungo Horey

"Sometimes we draw things by hand because they're not as perfect as a computer would create them, and getting that little texture and idiosyncrasy is part of trying to fit into that world. We tried to embrace that, because if you look closely, things aren't always perfect in the original. Just step back from it and let it be—which can be quite hard." Shaun Yue

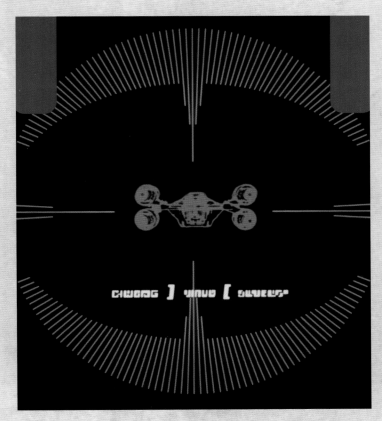

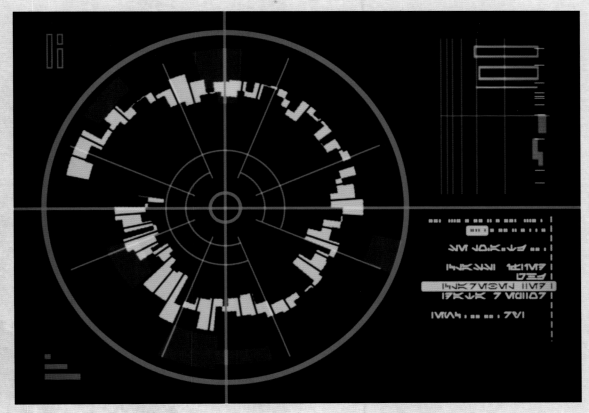

◄ **TIE FIGHTER TARGETING COMPUTER** Booth and BLIND LTD.　　　▲ **MINING SHUTTLE GRAPHIC** Booth and BLIND LTD.　　　▶▶ **STAR DESTROYER OVER JEDHA VERSION 2A** Wallin

A TACTICAL APPROACH TO PERIOD SCI-FI

Computer graphics supervisor Andrew Booth (*Batman Begins*, *Skyfall*, *The Force Awakens*) and his BLIND LTD. team were responsible for designing all of *Rogue One*'s monitors and display screens, working with set decoration to develop graphics that would effectively imply a fully functional world, realized by way of the interfaces and technologies it employs.

"It's a mix of on-set dressing and serving the story directly," said Booth. "When we talk about the ambient graphics, it's the sort of thing you'd see in the background—an oscilloscope turning around, bits of text floating up and down or just scrolling, abstract forms flashing. But there are also narrative beats that tie in with the actions of the actors or the dialogue, which becomes a very immersive thing. A classic example is the targeting computer on the *Millennium Falcon*—simple graphical forms that communicate the action of the scene."

The challenge for Booth and his team was in creating futuristic graphics that could align with the original *Star Wars*, a film released nearly forty years prior. *A New Hope* featured traditionally animated, cell-drawn tactical displays; rear-projection; oscilloscopes; and more, including one of the first instances of computer graphics being used in a movie. Larry Cuba designed the Death Star plans featured in the Yavin 4

briefing before the finale, which were recreated for *Rogue One* by John Knoll.

"Even on one set, they'd sometimes use three different techniques to create an image—and in the end, more variety in technique actually makes the world look bigger," said screen graphics designer Mungo Horey (*Kingsman: The Secret Service*, *The Force Awakens*). "Some movies these days, it looks like one designer made the entire movie, and it ends up feeling a bit small. Mixing it up and trying to keep it coherent—it feels like such a big world. It just increases the scale of everything."

To integrate new designs with the old, they scrutinized the original source material but also researched 1970s-era real-world print designs and other science-fiction films from the period—*The Andromeda Strain*, *Westworld*, *2001: A Space Odyssey*, and even Lucas's own *THX 1138*.

"We started with *Star Wars* and had to go even further back in time," said Booth. "We studied the graphics from the original film, took elements from those—whether it was targeting computers or a display showing the orbit of a planet—and then retrofitted them to create all-new graphics no one's ever actually seen before. The hope is that no one questions them, and that it feels right for the setting and the time in which it takes place."

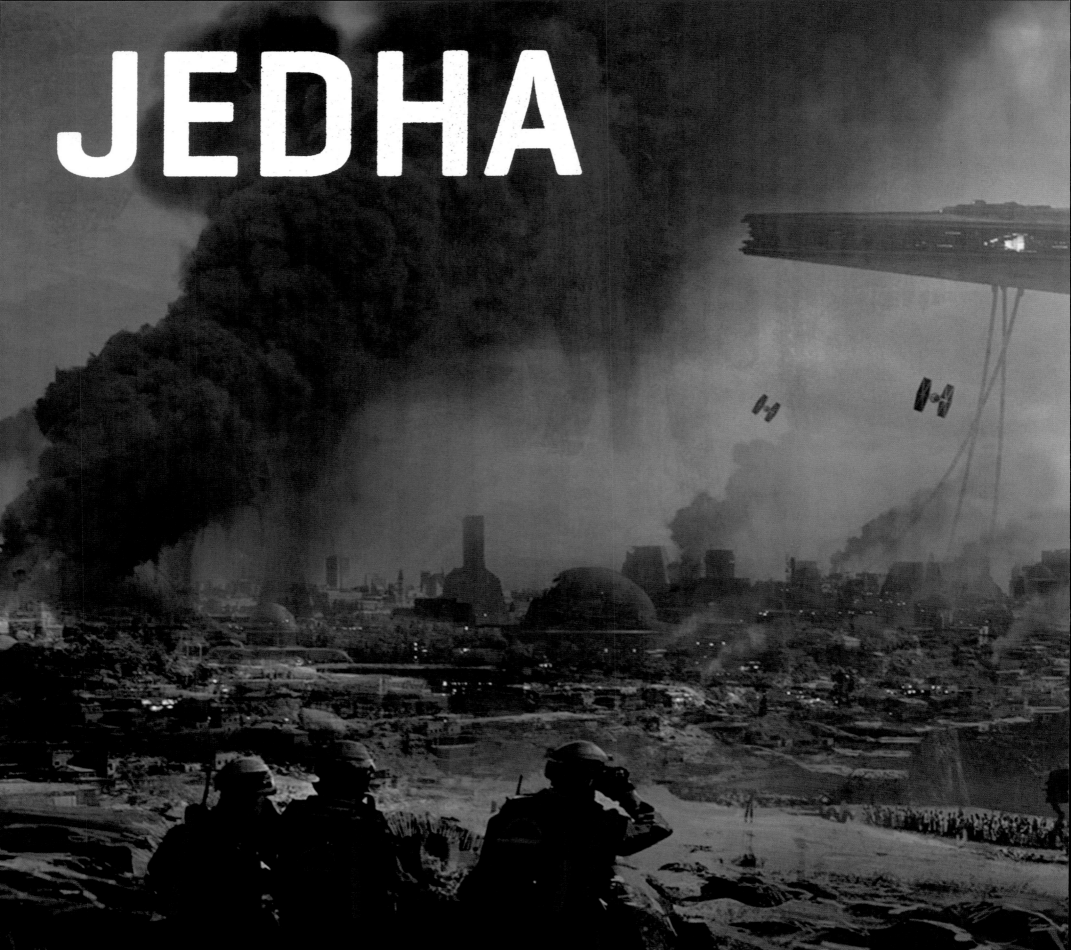

JEDHA

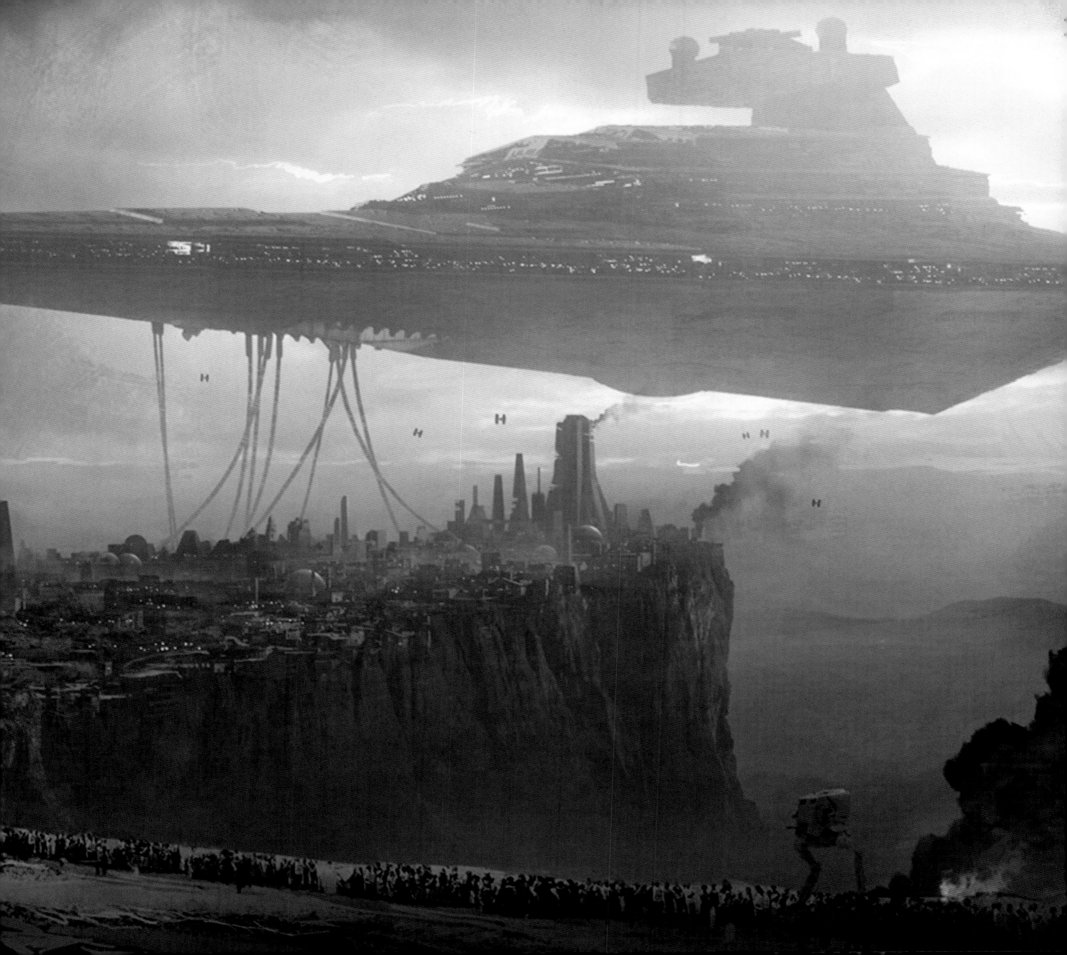

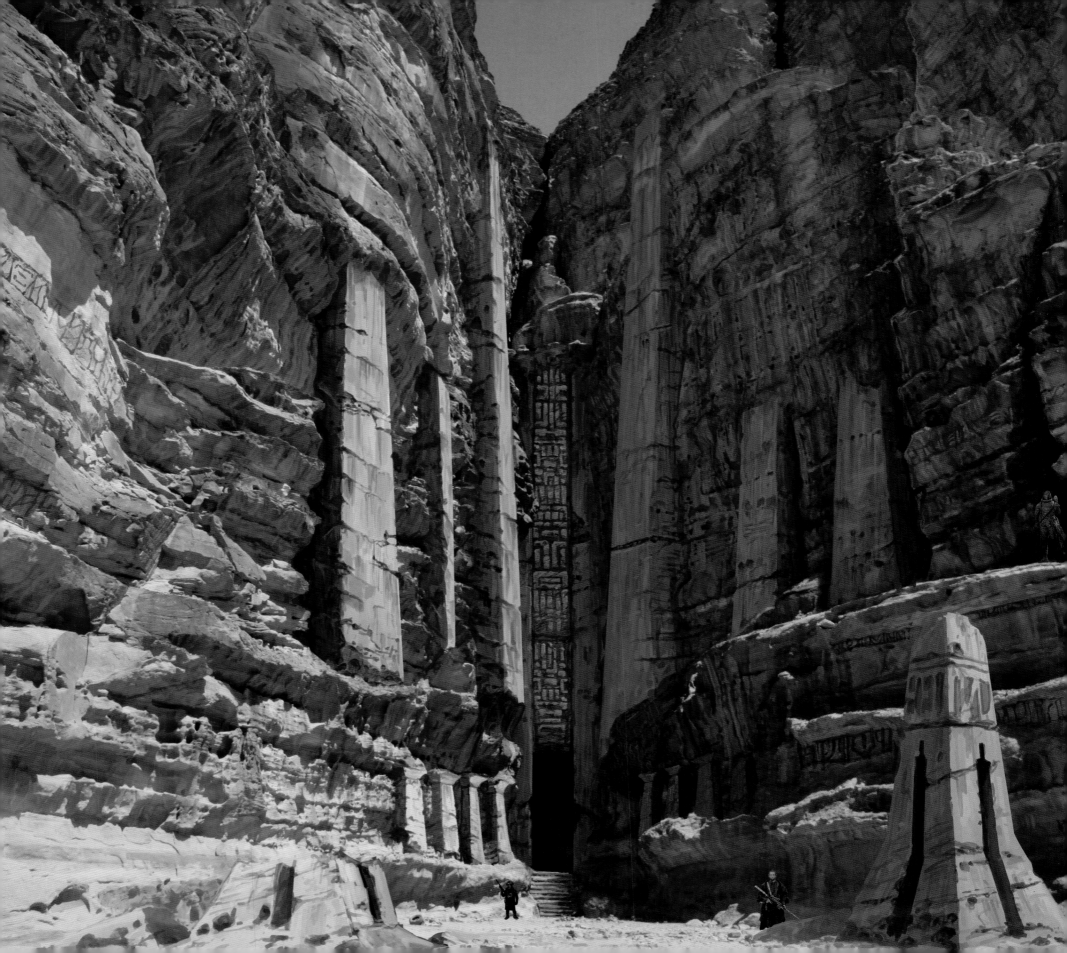

Followers of the Force

The first stop for Jyn, Cassian, and K-2SO after receiving their briefing on Yavin 4 is a location reflective of a major thematic departure from classic *Star Wars* storytelling—and a signature, singular characteristic that distinguishes *Rogue One* from the unfolding Skywalker saga.

"For a long time in the story, there were Jedi around, even if only in the background—Jyn's mother was a Jedi. But we thought that it would be more interesting to have a story without Force powers—without lightsabers," said screenwriter Chris Weitz (*About a Boy*, *The Golden Compass*, *Cinderella* [2015]). "We could explore a period of broken faith, a galaxy without hope. There's despair because the Jedi are gone—and with them, for many, even the memory of the Force. We know from *A New Hope* that Luke Skywalker hasn't even heard of the Force, out on distant Tatooine. That meant that our story could be about normal people pulling themselves up by their bootstraps."

According to co-producer John Swartz, the absence of Jedi—and the decision to move forward without those essential *Star Wars* avatars—is something that hangs over the entire film. "There's a piece missing from the *Star Wars*

universe—intentionally—because that's what makes our story different," he said. "Whereas Luke Skywalker realizes a destiny because of what makes him special, Jyn is special because she doesn't have a superpower or Force abilities. She's a normal person fighting a personal war—and she needs other people to help her."

The opportunities afforded by this absence were particularly exciting for the design teams, allowing them to explore representations of the *Star Wars* galaxy never before seen on film.

"The fact that there's no Jedi is what makes *Rogue One* so unique," said Doug Chiang. "There's beauty in empowering people and in not relying on magic or superpowers—and yet, there's the underlying mythology of the Force that's still pervasive throughout our story. We needed to find those things that could root *Rogue One* in the middle, because spirituality is such a huge part of *Star Wars*."

Even without Jedi to serve as audience conduits to the Force, it was essential that *Rogue One* find its own unique connection point to the universal power binding the galaxy together—and the solution that arose was planetary rather than personal. Without Jedi Force-practitioners among its heroes, *Rogue One* would

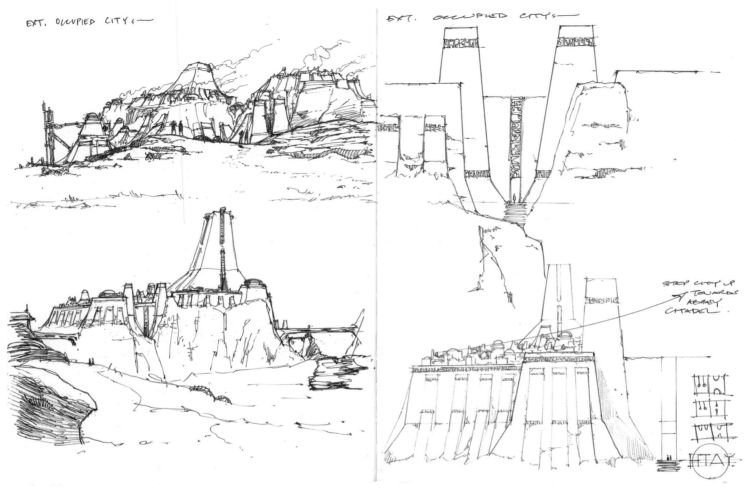

EXT. OCCUPIED CITY:—

EXT. OCCUPIED CITY:—

▲ **JEDHA CONCEPT SKETCHES VERSION 1D** Htay

instead highlight followers of the ancient religion—those unable to wield its power, but who make pilgrimage to a place recognized as a gathering point for true believers.

This is Jedha—a holy place unlike anything previously seen in *Star Wars*, and a key stop on the narrative journey of *Rogue One*'s heroes. But in addition to demonstrating the pervasiveness of the Force among the galaxy's less assuming citizens, the planet serves as a window into the hardships of living under Imperial rule.

"Obi-Wan Kenobi mentions the 'dark times' in *A New Hope*, and Jedha illustrates that part of the timeline," said set decorator Lee Sandales (*Casino Royale* [2006], *Maleficent*). "Its main city has been occupied by the Empire—pretty war-torn, but with a beauty to it. It perfectly describes *Star Wars*: very ancient, by way of the future. Neil Lamont and Doug Chiang set out the vision for Jedha with incredible sandstone buildings, arches, and ancient temples."

To better imbue the setting with a sense of scale and significance, artists found inspiration in human history—a resource rich with endless aesthetic potential and millennia of cultural associations that provided an inherent sense of underlying truth to the design process.

"Gareth [Edwards]'s approach paralleled George's thinking in terms of creating these worlds. They don't treat these movies like science fiction, but more like historical films," said Chiang. "We're creating universes, we're creating cities, we're creating worlds that aren't fantastic just to be fantastic—and that aren't so much fantastic as they are unfamiliar. We're trying to mine thousands of years of human culture to get these designs to work, and then we tweak it to set it apart, but it still looks real—because it comes from a place that is real. We're only adding just a little bit to take it into another realm. That's the start of the design process."

The process itself proved far more immersive than just the development of real-world anchoring points for design development—often requiring artists to look to specific moments in human history in order to capture not just their visual elements, but their emotion.

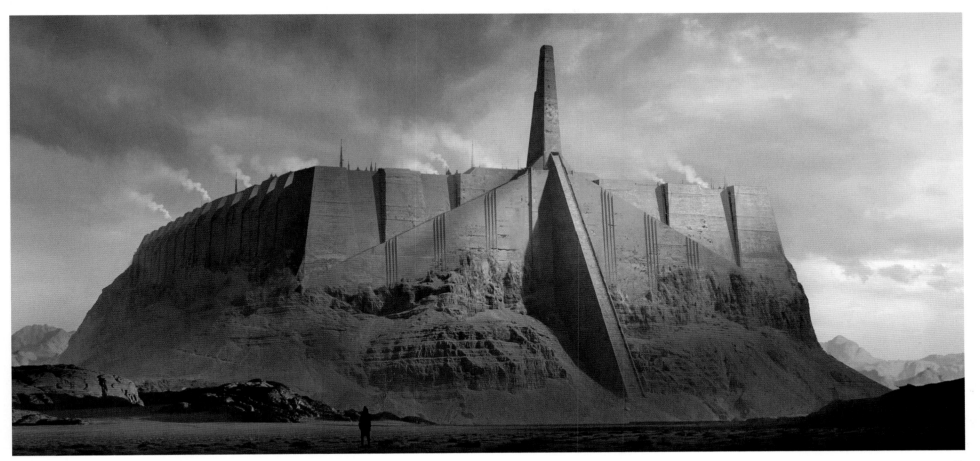

"Our work is built on a lot of research, and Gareth would direct us to moments in history that he envisioned as reference points for the images and the emotion of the story," said Jon McCoy. "In *Rogue One*, we see the iron fist of the Empire in ways we haven't seen in other *Star Wars* films—how it's affecting the galaxy. We looked to Vietnam for our final battle and to Paris during the German occupation in World War II for Jedha. Matt [Allsopp] and I would then dig up as much imagery as we could from those periods of time, in those locations."

"We'd find scenes in photography—things that happened in real life and that had been captured—that we'd never think to draw on our own," said McCoy. "People dragged through the streets while soldiers just sat drinking their tea. You start to paint that, from reality, and you start to infuse the story with those emotional tones—those horrible disparities that come from pure reference. *Rogue One* is fantasy, but its parallels are real—these real-world inspirations that tie our story into universal desires. Safety, freedom, peace—and everything that threatens those things."

Unlikely heroes tasked with protecting the galaxy against the menace of the Empire, Jyn and Cassian's mission leads them to Jedha not to pay tribute to the arcane power of an ancient religion, but in search of a man: Rebel extremist leader Saw Gerrera. Gerrera's extreme tactics have estranged him even from those sharing his hostility toward Imperial rule—marking him as a stark contrast to the measured approach of the burgeoning Alliance.

"It was Gareth's idea to include someone who represents that more militant mentality, almost like an extremist side of the Rebellion," said Gary Whitta. "Every political movement, every resistance movement, has its more militant, more radical tendencies. And Gareth liked the idea of seeing a rebel who was so much more extreme in his approach to fighting the Empire."

Kiri Hart suggested the use of Gerrera, a character originally created by George Lucas for the *Star Wars: The Clone Wars* animated series. Set nearly two decades prior to the events of *Rogue One*, *The Clone Wars* had seen Gerrera (whose name is a mnemonic riff on revolutionary leader Che Guevara's) already embittered by the galactic conflict that had killed his sister. *Rogue One* would follow that thread to discover what twenty years under Imperial rule would do to deepen his grudge.

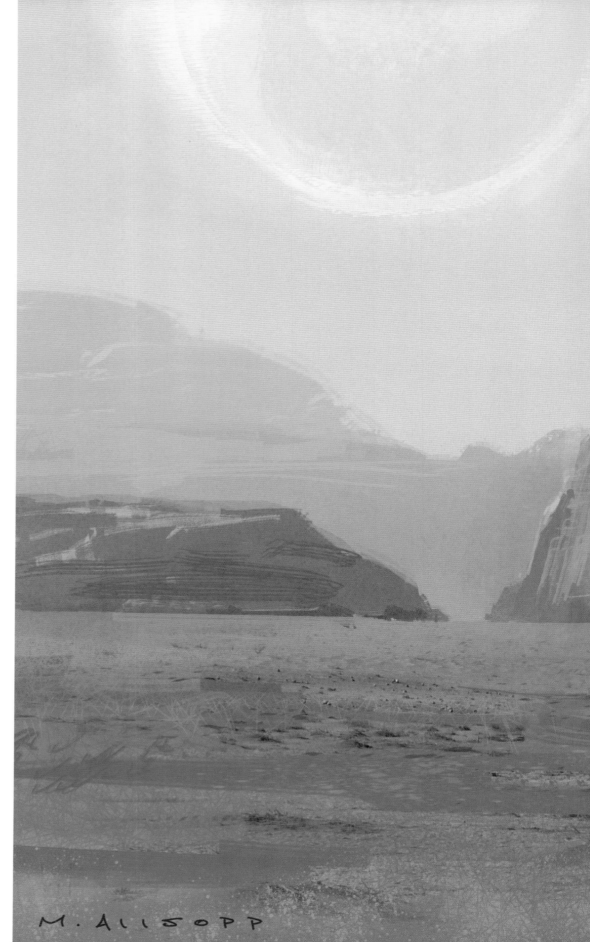

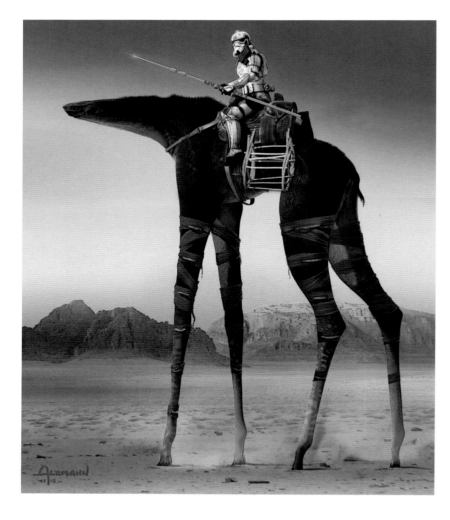

▲ **JEDHA "CAMEL" FULL BODY VERSION 55** Alzmann

▶ **JEDHA EXTERIOR VERSION 1A** Allsopp

"The planet Jedha is described in the script as a once-beautiful and ancient city, and it's a place of pilgrimage for people across the galaxy. We took that as our starting point, and then we drew from real-world places. One of them was Jerusalem. We looked at Morocco—and at the plateaus and Wadi rock of Jordan. You've always got to look at North Africa when you're developing these sorts of places for *Star Wars*." Jordana Finkel

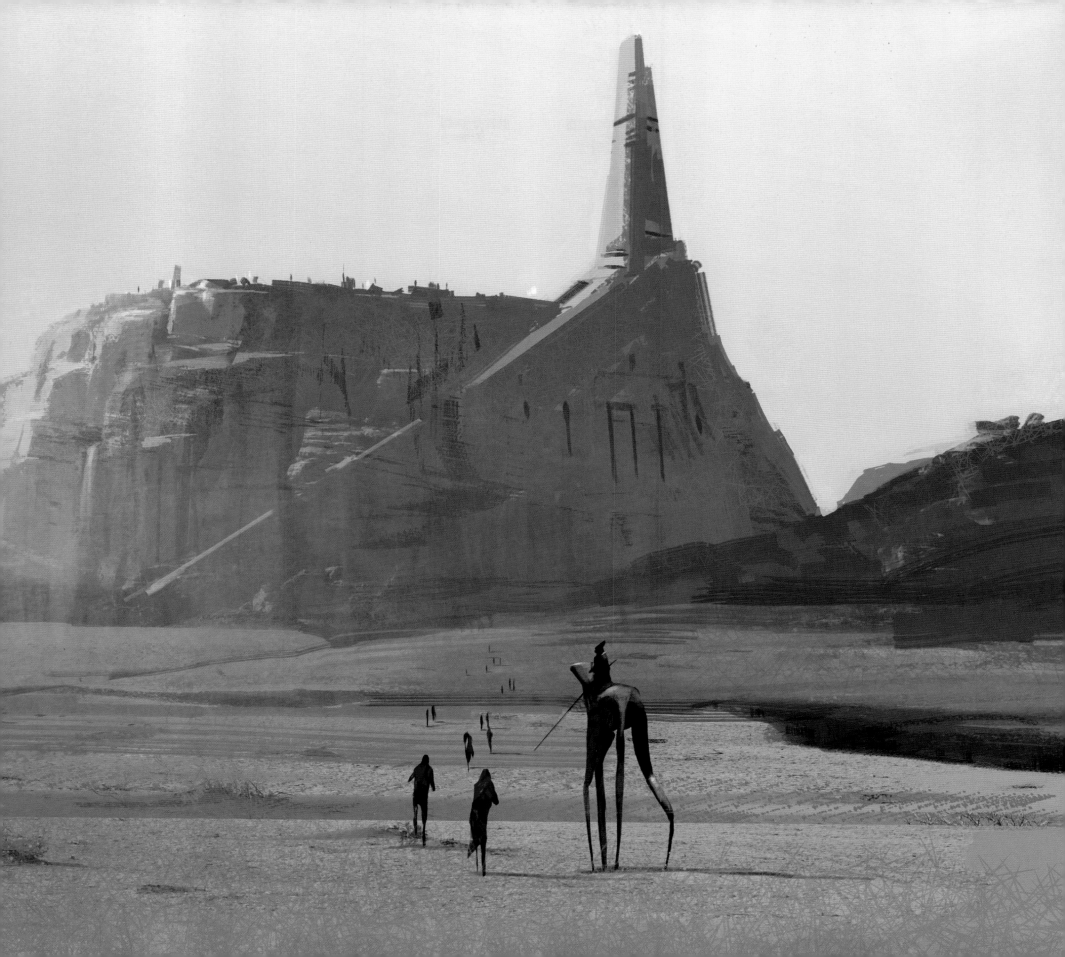

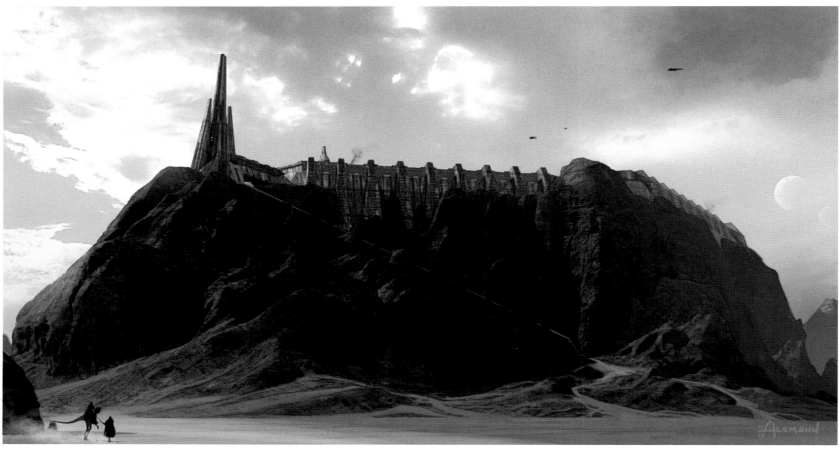

▲ **JEDHA EXTERIOR VERSION 1C** Alzmann

▼ **JEDHA DESIGNS VERSION 8A** Allsopp

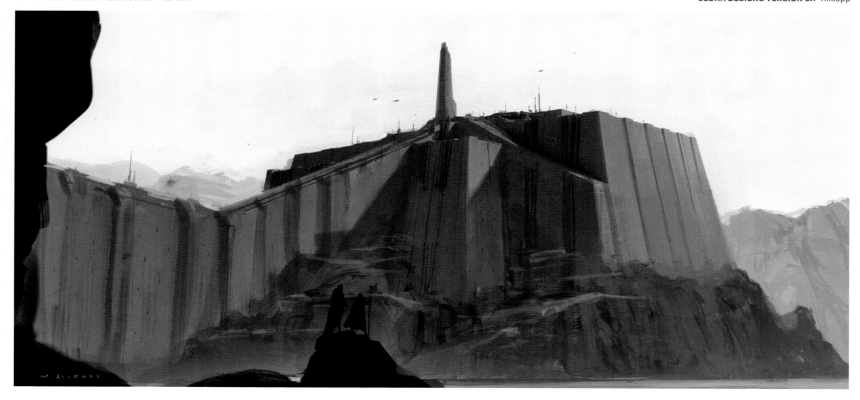

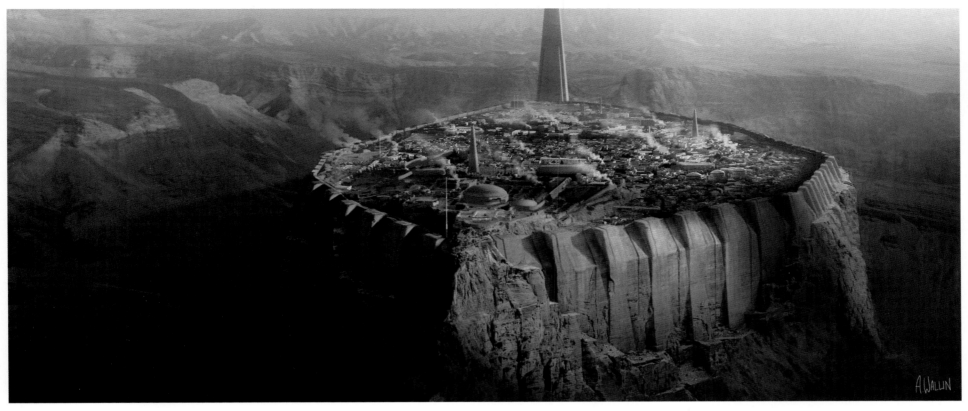

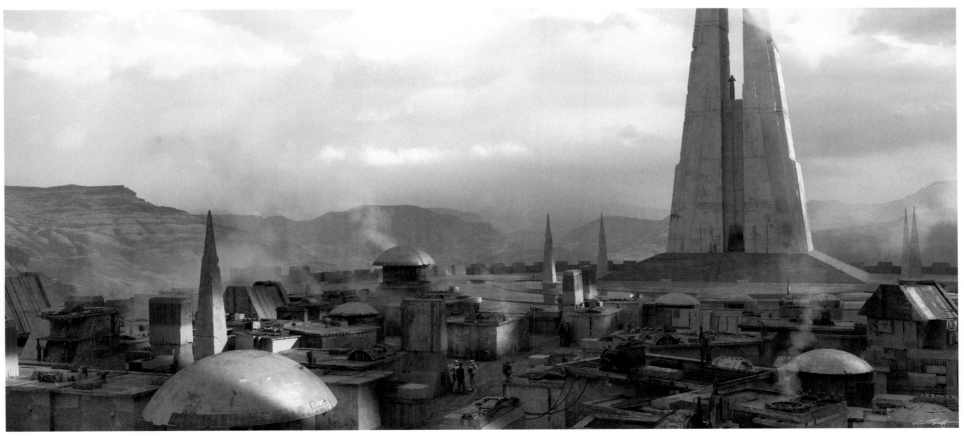

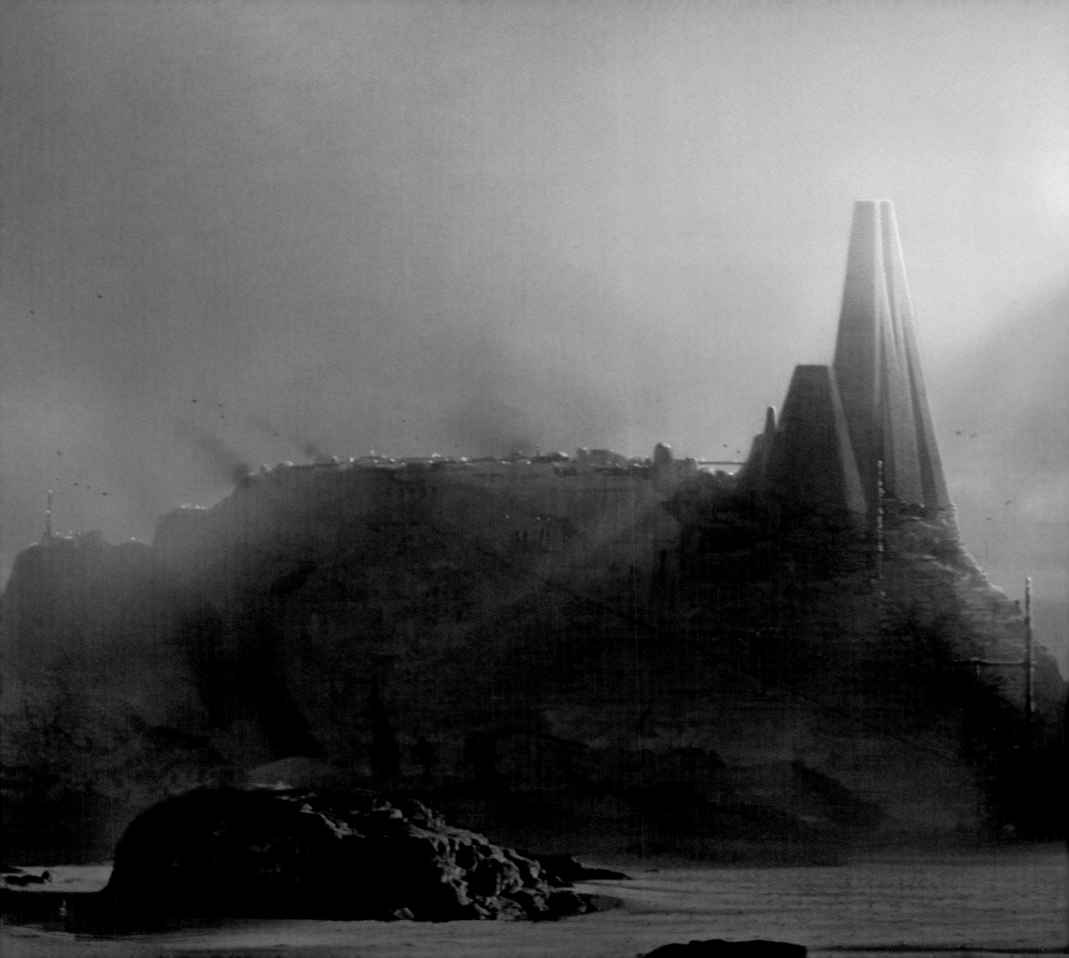

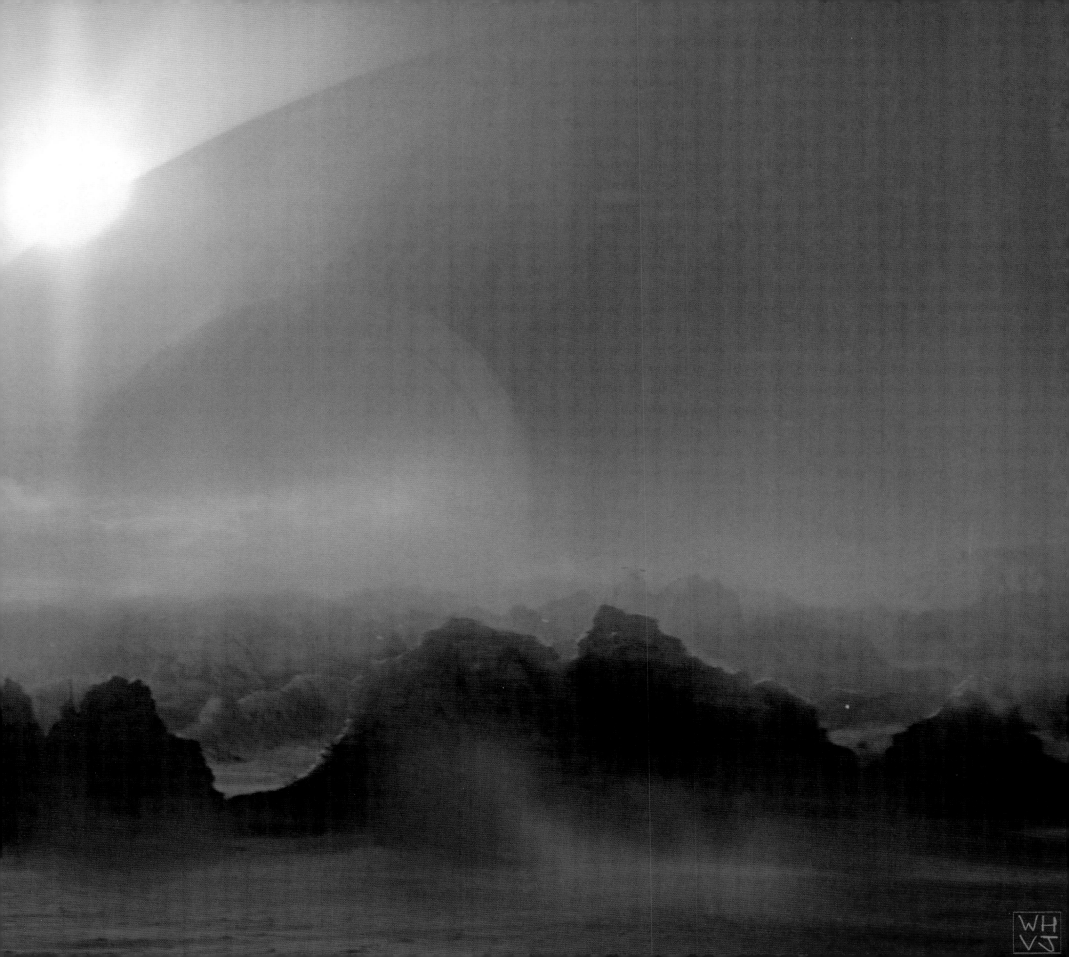

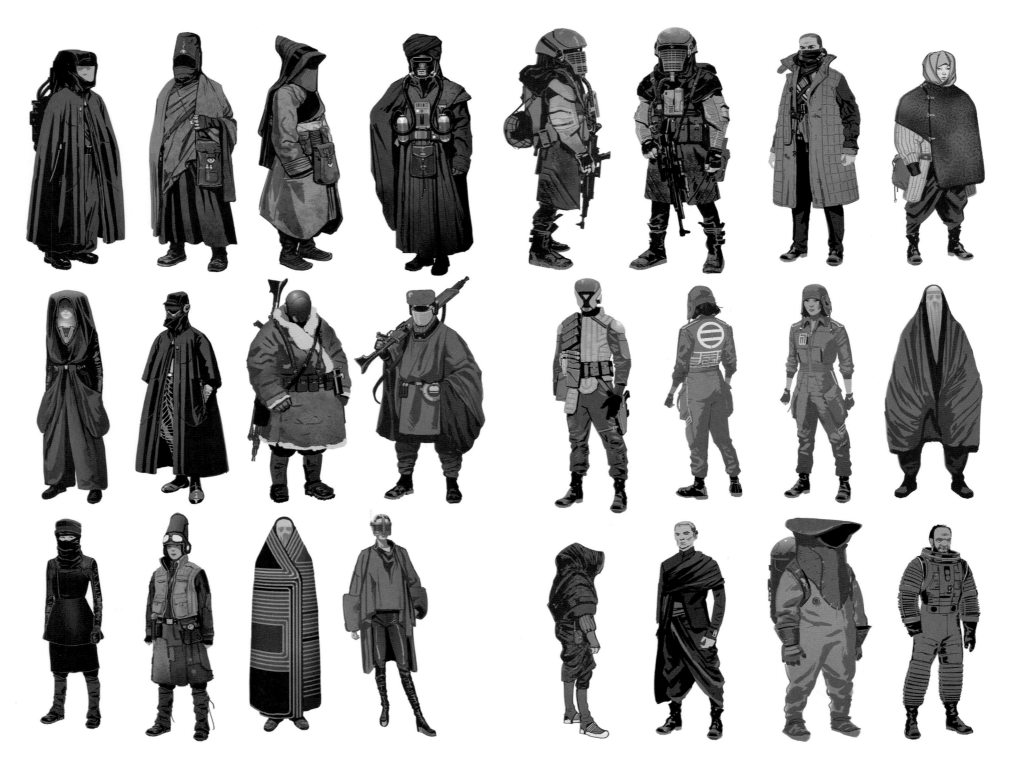

▲ **JEDHA EXTRAS SILHOUETTES 1** Brockbank

▲ **JEDHA EXTRAS SILHOUETTES 2** Brockbank

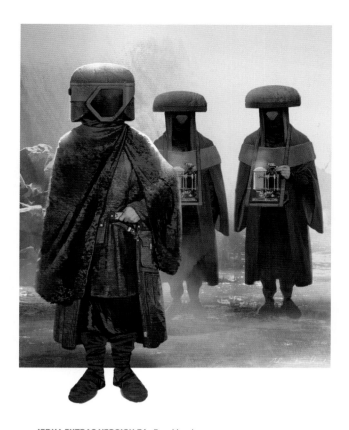
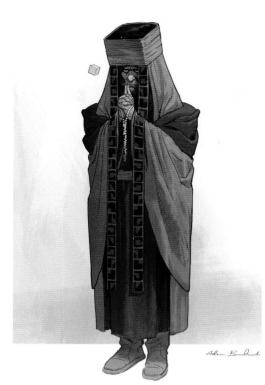
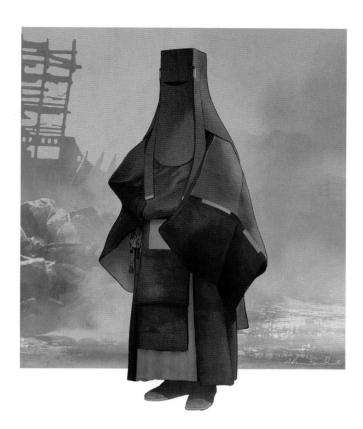

▲ **JEDHA EXTRAS VERSION 5A** Brockbank ▲ **JEDHA EXTRAS VERSION 1A** Brockbank ▲ **JEDHA EXTRA VERSION 7C** Brockbank

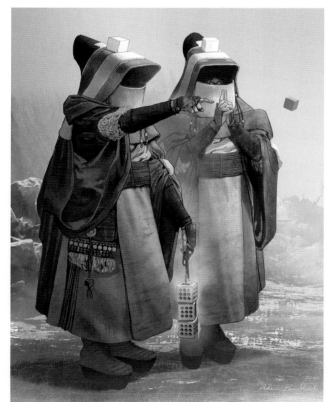
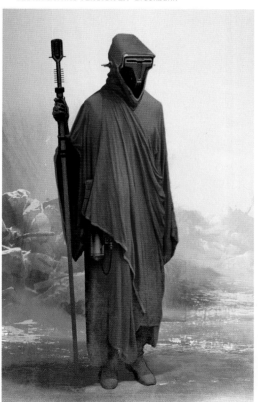

▲ **JEDHA EXTRAS VERSION 4A** Brockbank ▲ **MILITIA VERSION 1A** Brockbank ▲ **UNDERWORLD ALIEN VERSION 52A** Fisher

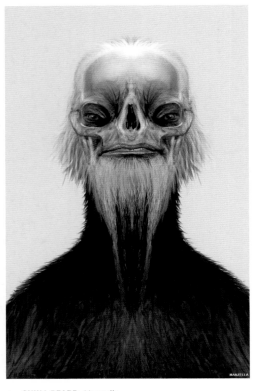

▲ **SKULL BEARD** Manzella

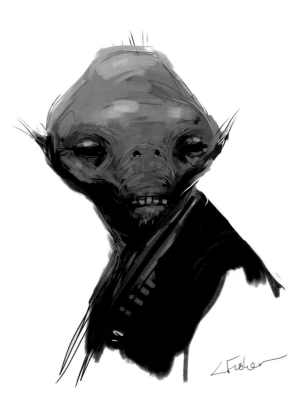

▲ **LV TEETH** Fisher

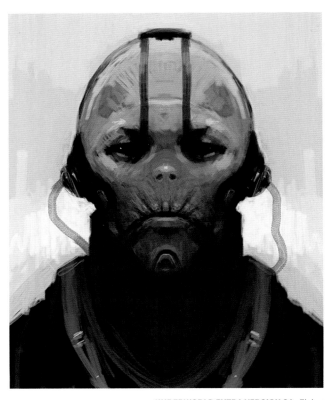

▲ **UNDERWORLD EXTRA VERSION 6A** Fisher

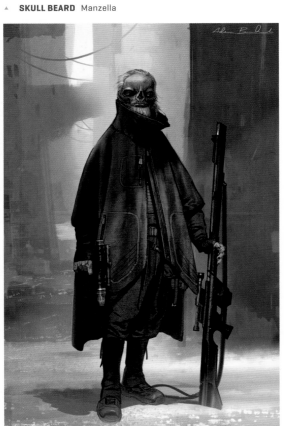

▲ **SKULL BEARD VERSION 1B** Brockbank

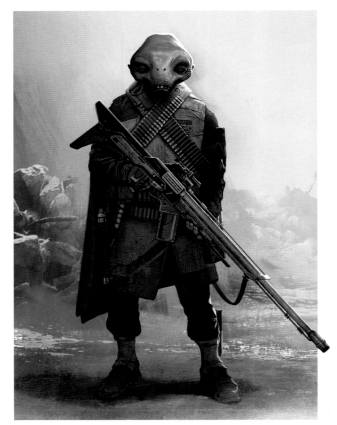

▲ **JEDHA EXTRA VERSION 1A** Brockbank

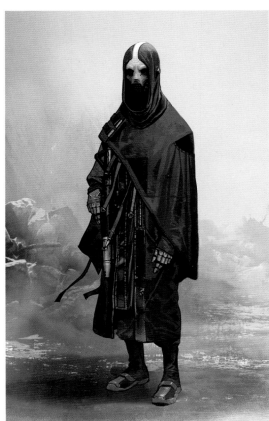

▲ **JEDHA ALIEN G0021** Brockbank

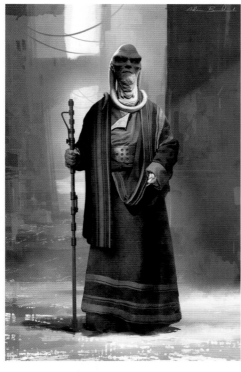

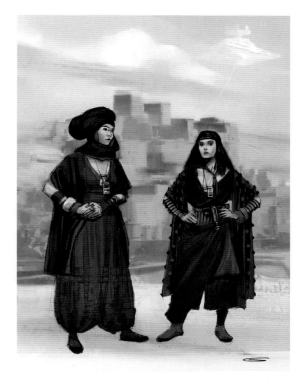

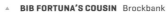
▲ **BIB FORTUNA'S COUSIN** Brockbank

▲ **TRIANGLE FACE (BOUNTY HUNTER)** Dillon

▲ **JEDHA EXTRAS VERSION 1A—DISREPUTABLE LADIES** Dillon

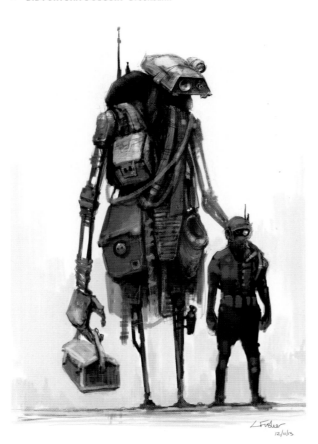

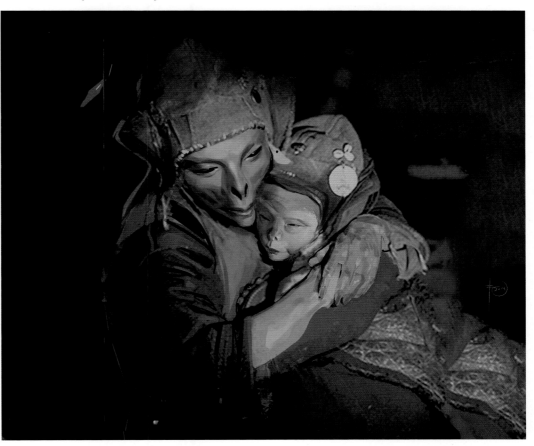

▲ **JEDHA DROID G027** Fisher

▲ **ALIEN PORTRAIT VERSION 5** Chan

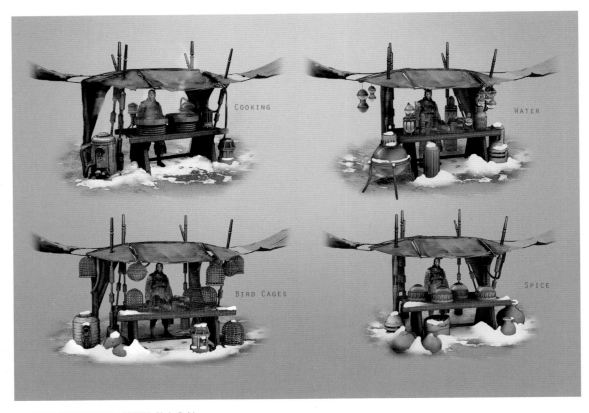

JEDHA MARKET STALL STUDY Chris Caldow

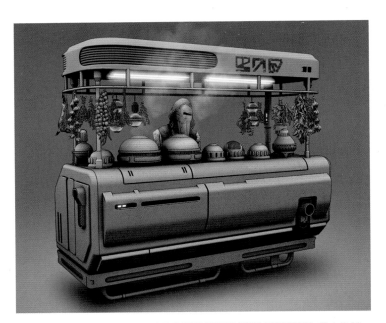

JEDHA MARKET COOKING STALL VERSION 5A Chris Caldow

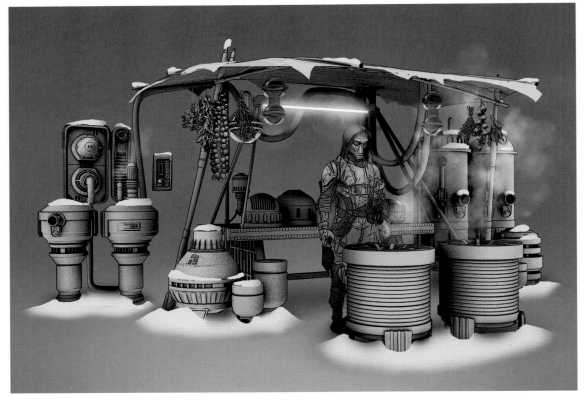

JEDHA MARKET COOKING STALL VERSION 3A Chris Caldow

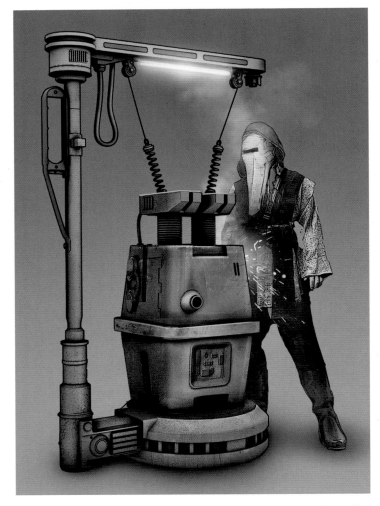

JEDHA DROID REPAIR STALL Chris Caldow

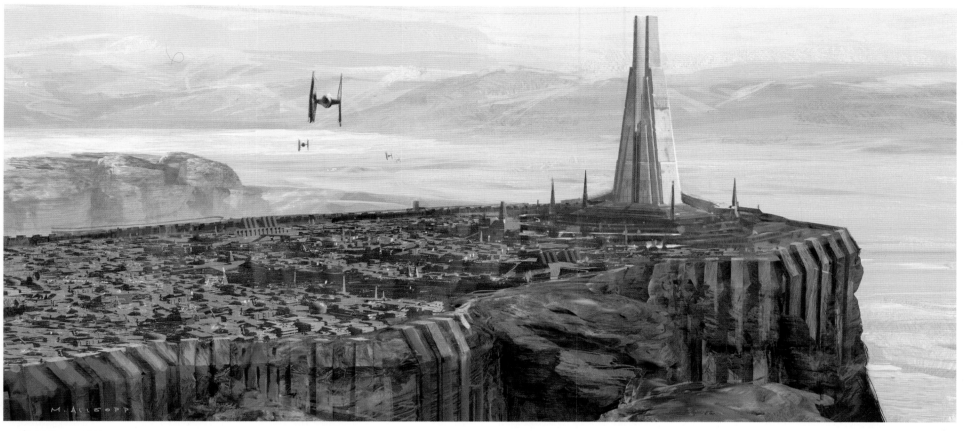

▲ **JEDHA TEMPLE VERSION 5B** Allsopp ▼ **JEDHA EXTERIOR VERSION 4** Kevin Jenkins ▶▶ **JEDHA COURTYARD** Allsopp

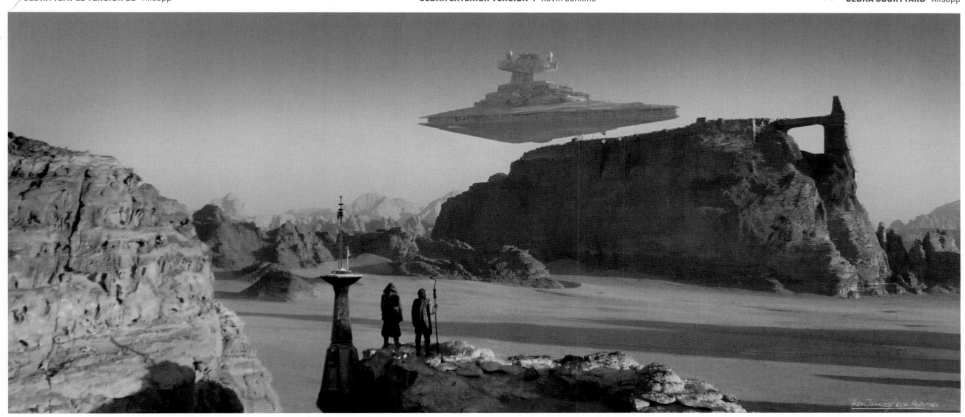

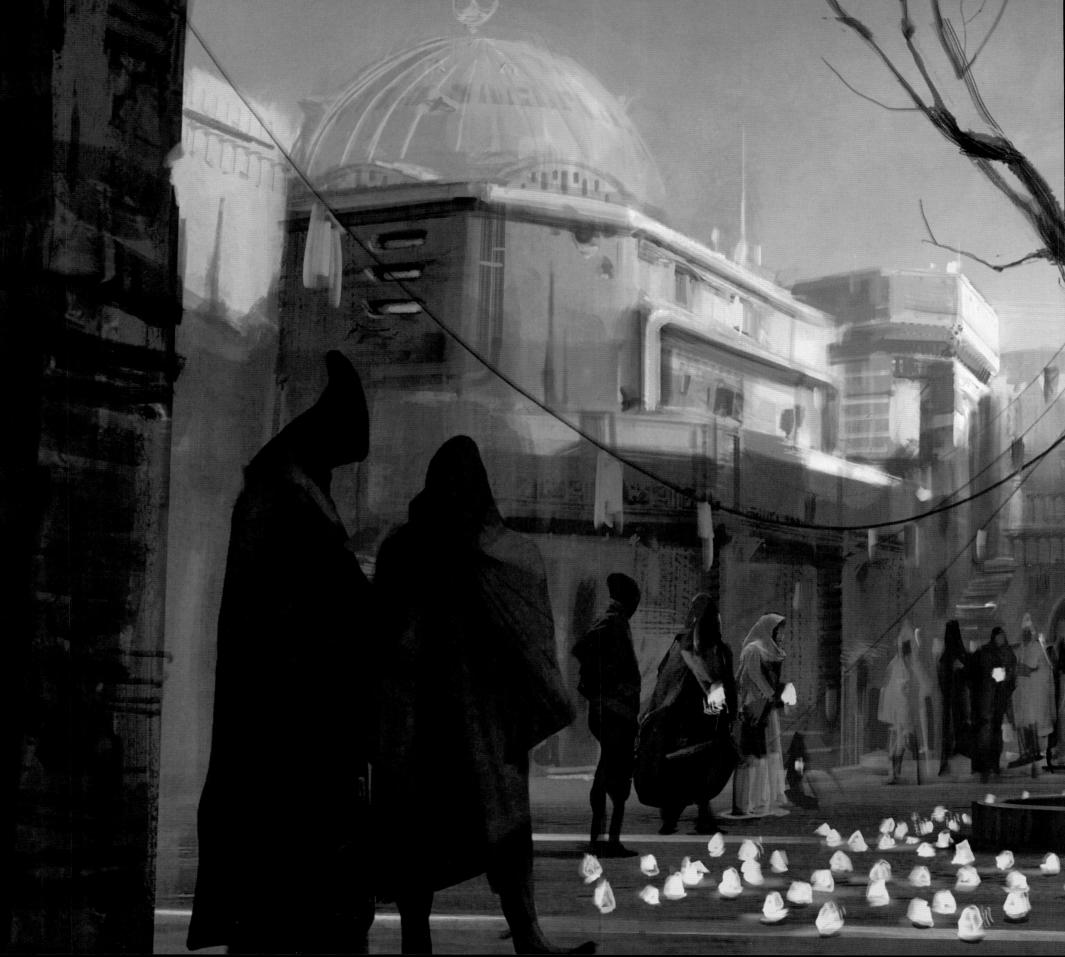

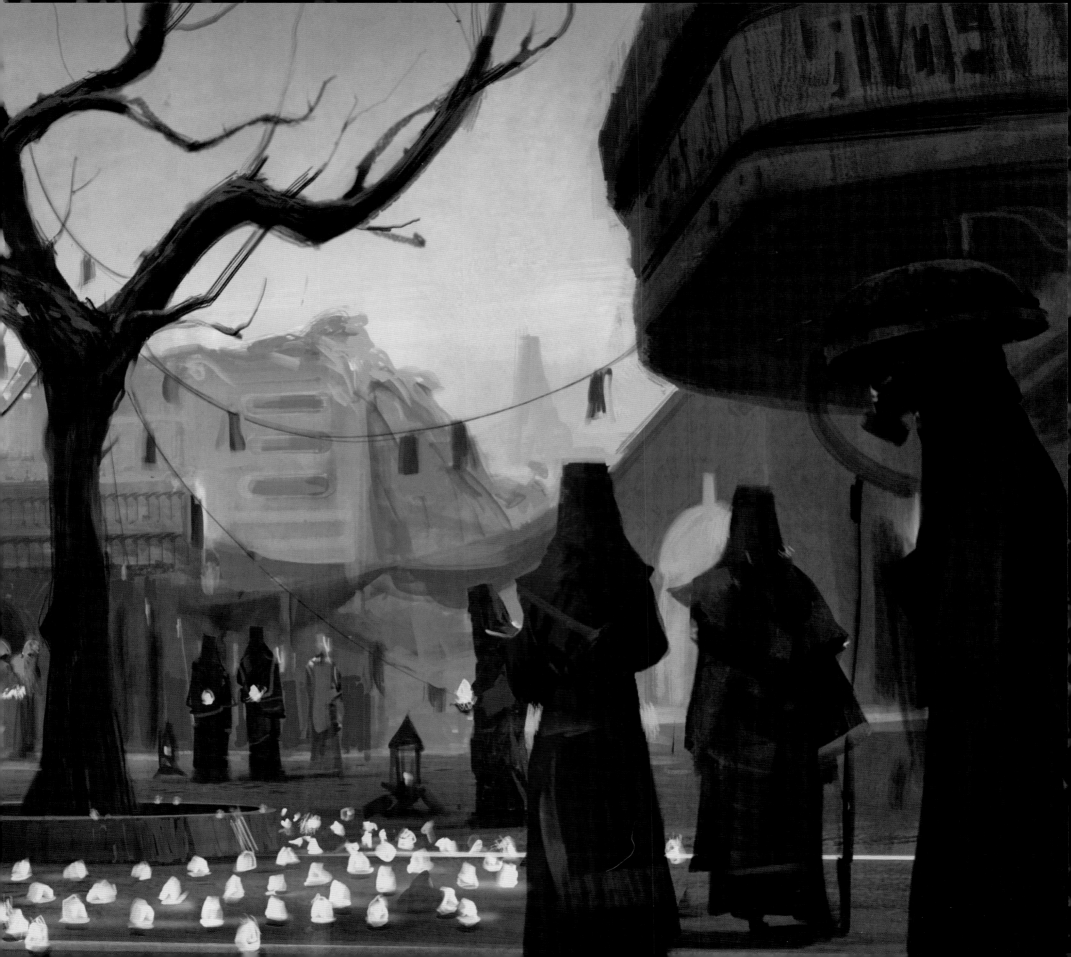

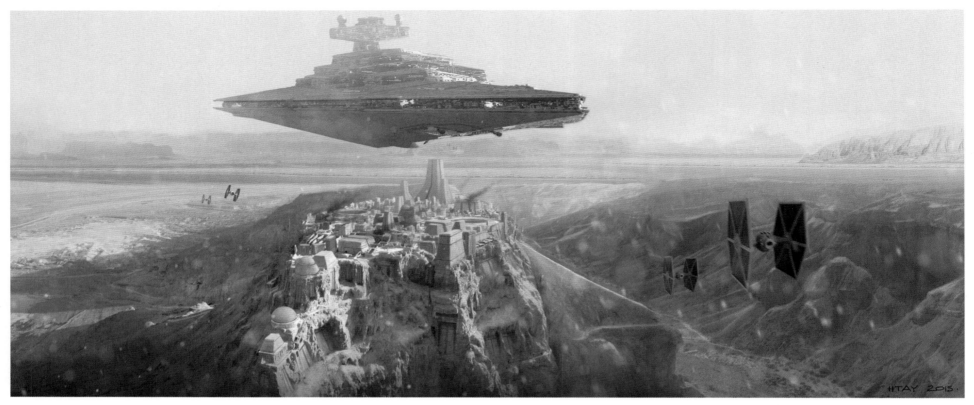

▲ **JEDHA WIDE OVERVIEW VERSION 3H** Htay

▼ **JEDHA EXTERIOR VERSION 4B** Htay

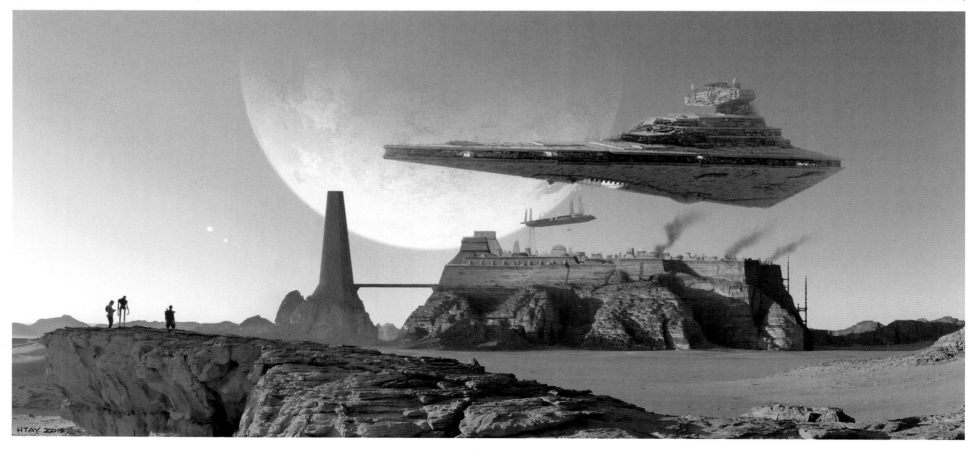

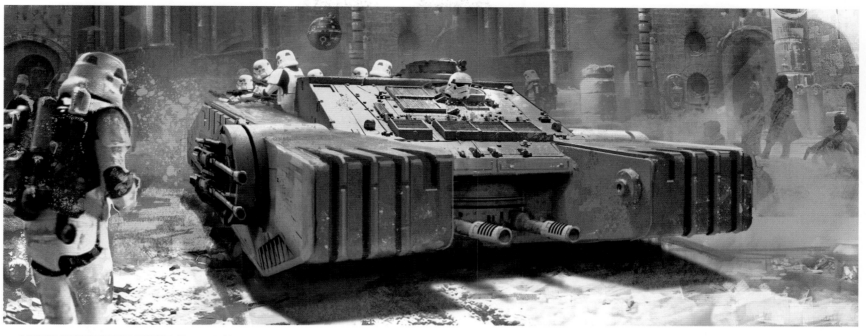

IMPERIAL HOVERCRAFT VERSION 24D Vincent Jenkins

IMPERIAL HOVERCRAFT VERSION 26A Vincent Jenkins

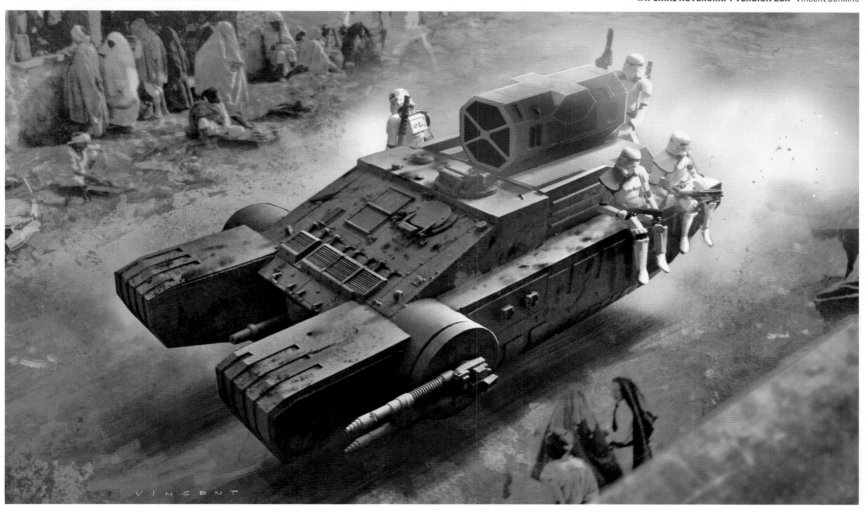

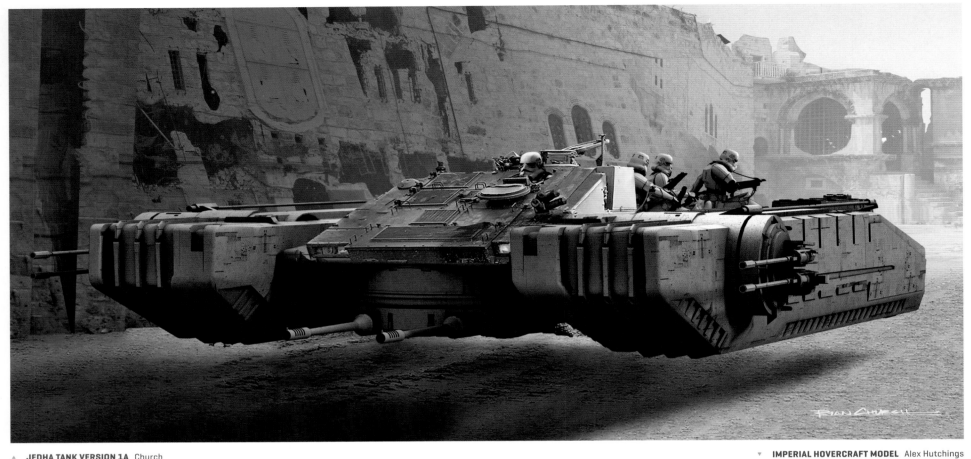

▲ **JEDHA TANK VERSION 1A** Church

▼ **IMPERIAL HOVERCRAFT MODEL** Alex Hutchings

▲ **JEDHA ALLEY EXTERIOR VERSION 7I** Htay

▼ **JEDHA EXTERIOR VERSION 9A** Allsopp

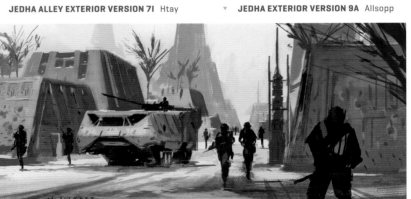

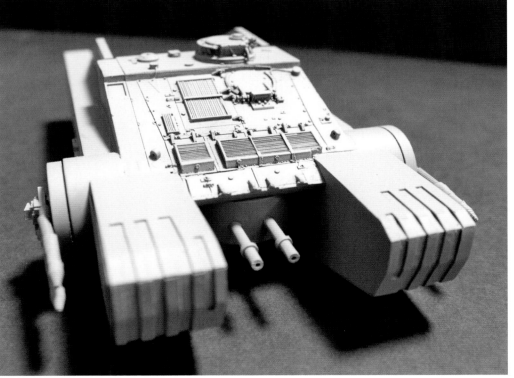

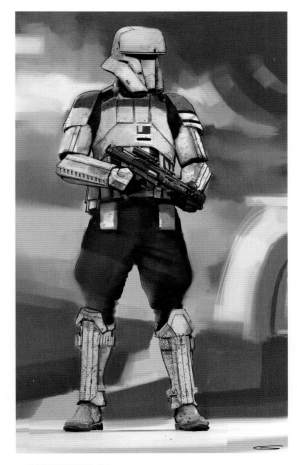

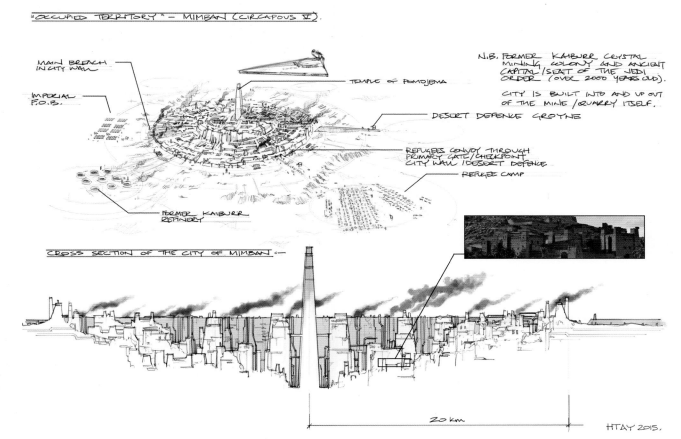

"OCCUPIED TERRITORY" — MIMBAN (CIRCAPOUS V).

MAIN BREACH IN CITY WALL

IMPERIAL F.O.B.

TEMPLE OF POMOJEMA

N.B. FORMER KAIBURR CRYSTAL MINING COLONY AND ANCIENT CAPITAL (SEAT OF THE JEDI ORDER) (OVER 2000 YEARS OLD).

CITY IS BUILT INTO AND UP OUT OF THE MINE / QUARRY ITSELF.

DESERT DEFENCE GROYNE

REFUGEES CONVOY THROUGH PRIMARY GATE / CHECKPOINT CITY WALL / DESERT DEFENCE

REFUGEE CAMP

FORMER KAIBURR REFINERY

CROSS SECTION OF THE CITY OF MIMBAN

20 KM

HTAY 2015.

▲ **TANK TROOPER** Dillon ▲ **JEDHA SKETCH VERSION 1A** Htay ▼ **JEDHA CITY CONCEPT** Church

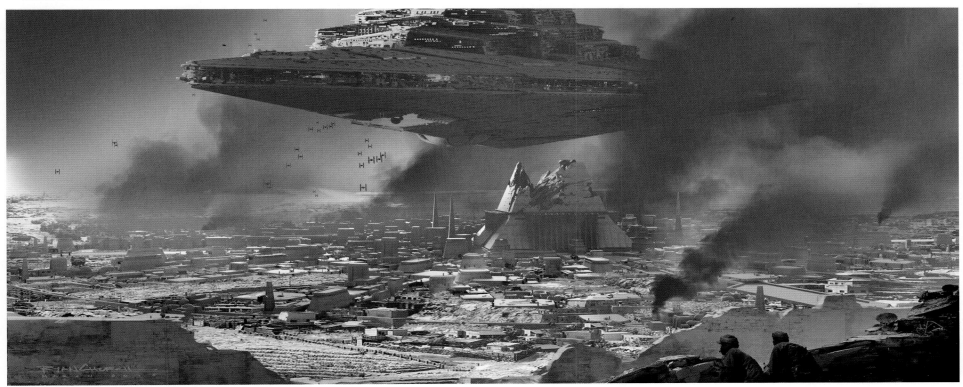

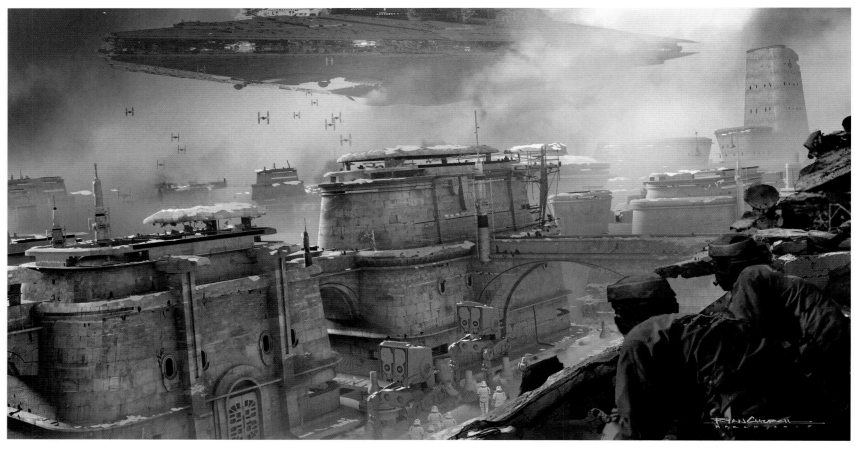

▲ JEDHA EXTERIOR VERSION 4 Church

▼ JEDHA ALLEY EXTERIOR VERSION 1 Tiemens

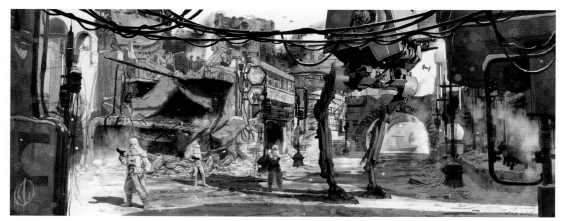

▲ JEDHA ALLEY EXTERIOR VERSION 7G Htay

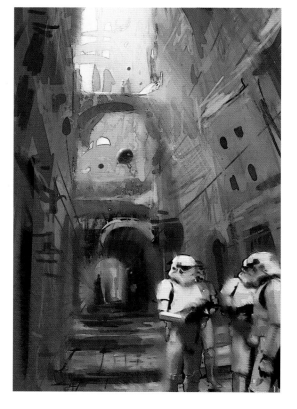

"We used Paris during World War II as inspiration, because of the occupation and how that parallels where we find Jedha in our story. It's an ancient city that has quite a bloody history. It's battle-scarred, and it's been overrun by the Empire. Various battles went on here. There are collapsed buildings and a sort of ragtag population who are being brutalized by the Empire, which is coming in and trying to weed out the rebel militia." Al Bullock

◄ JEDHA SKETCH Htay

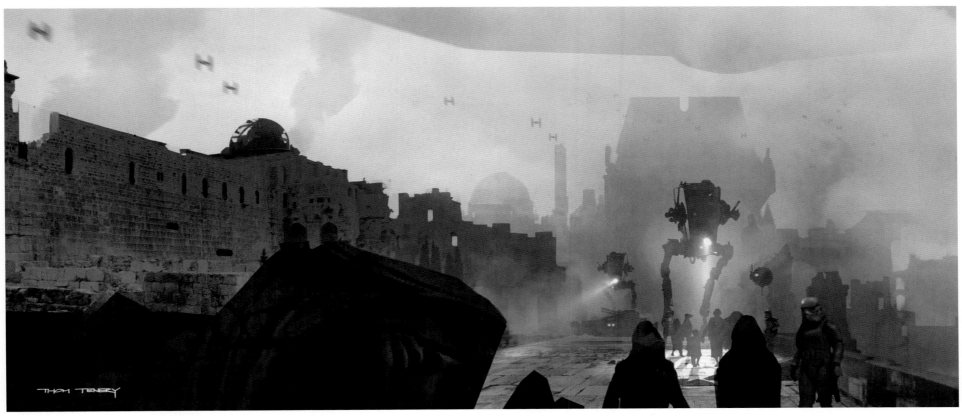

JEDHA SECURITY CHECKPOINT VERSION 2A Tenery

JEDHA POW CAMP VERSION 2C Tenery

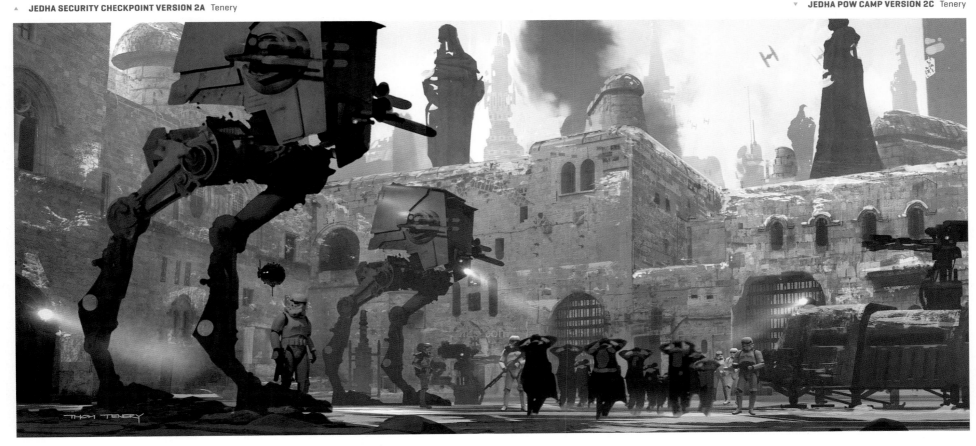

JEDHA 119

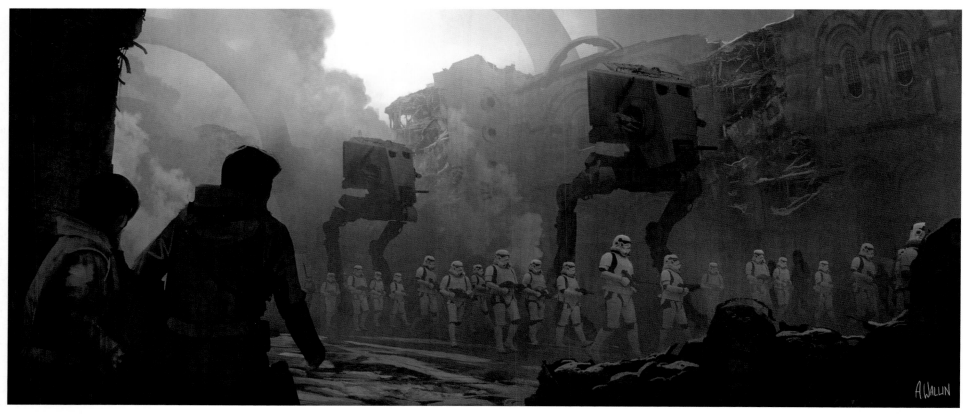

▲ **JEDHA EXTERIOR VERSION 3B** Wallin

▼ **JEDHA EXTERIOR VERSION 5A** Allsopp

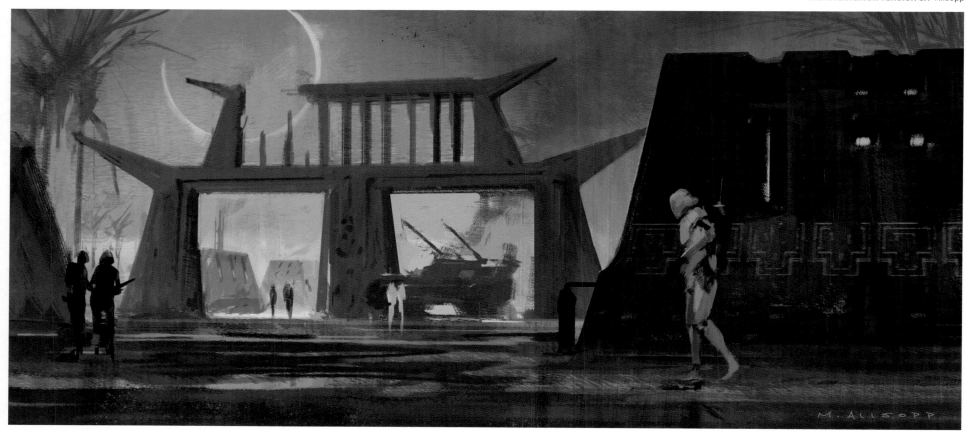

JEDHA CATACOMB PRISON VERSION 3B Wallin

KRENNIC'S JEDHA OFFICE VERSION 2B Wallin

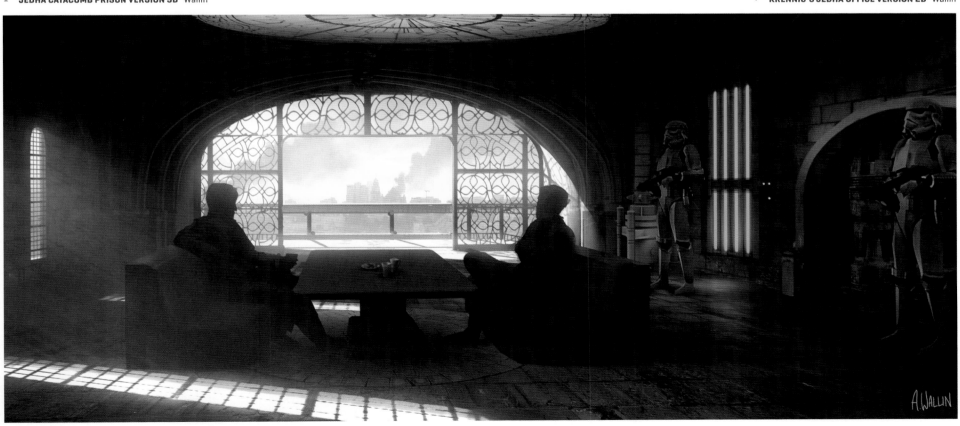

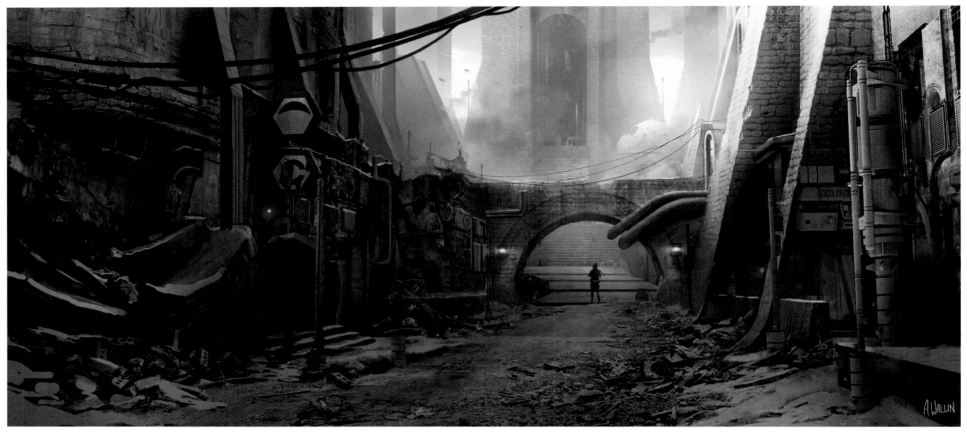

▲ **JEDHA ALLEY VERSION 1C—COLD DESERT** Wallin

▼ **JEDHA ALLEY VERSION 1B—CRASHED X-WING** Htay

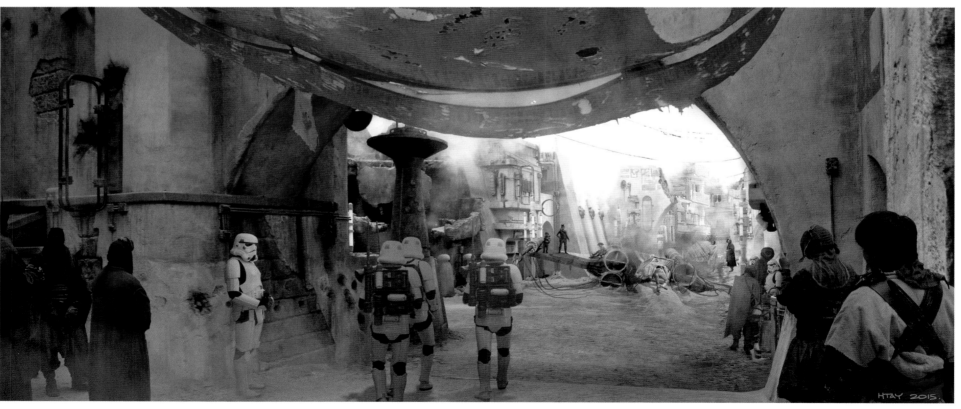

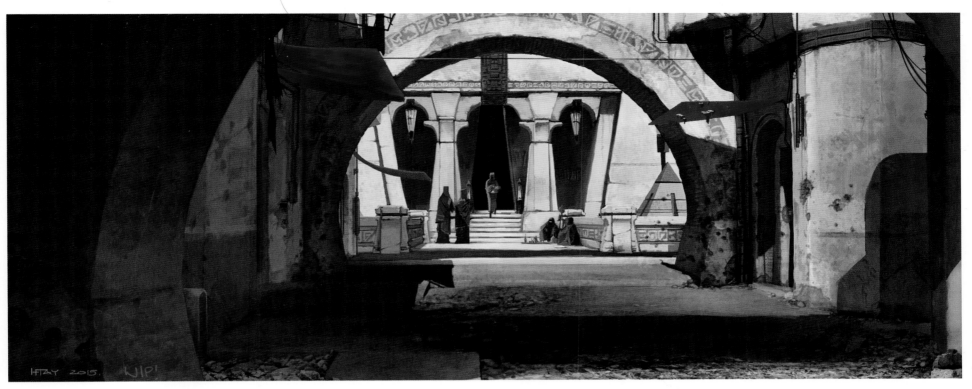

JEDHA TEMPLE OF THE WHILLS ALLEY VIEW VERSION 1A Htay　　　▼ **JEDHA TEMPLE OF THE WHILLS** Allsopp　　　▶▶ **JEDHA EXTRAS VERSION 1A—SECT GROUP** Brockbank

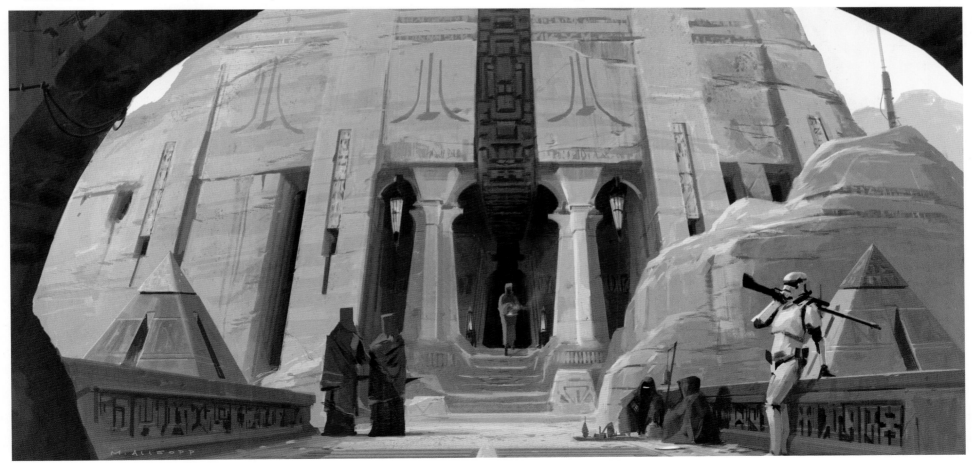

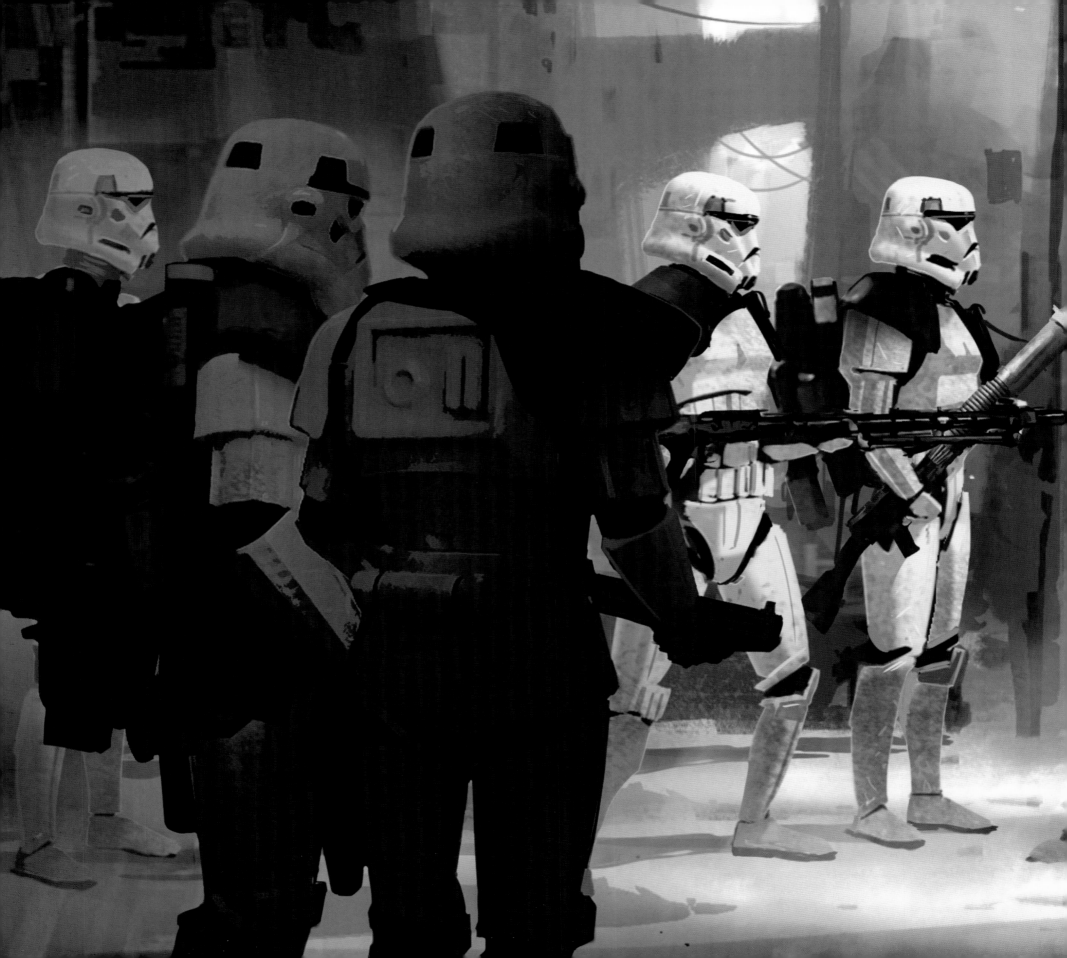

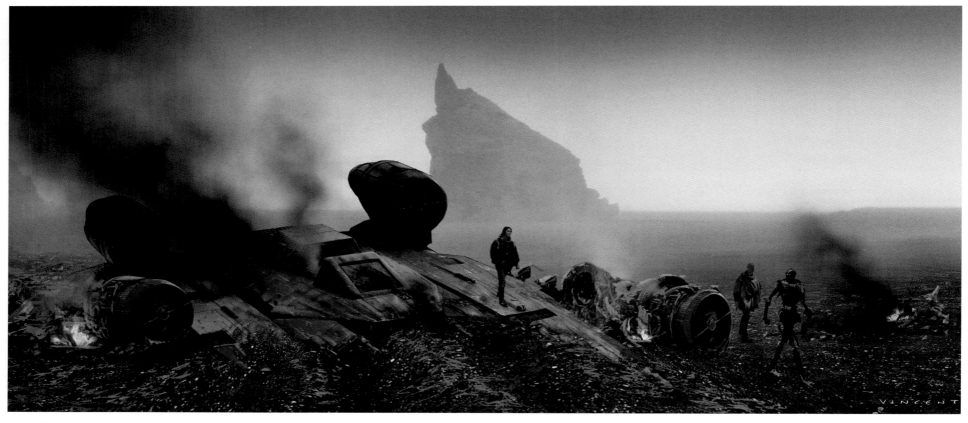

▲ **SAW'S CRASH SITE VERSION 9C** Vincent Jenkins

▼ **SAW'S CRASH SITE VERSION 10A** Vincent Jenkins

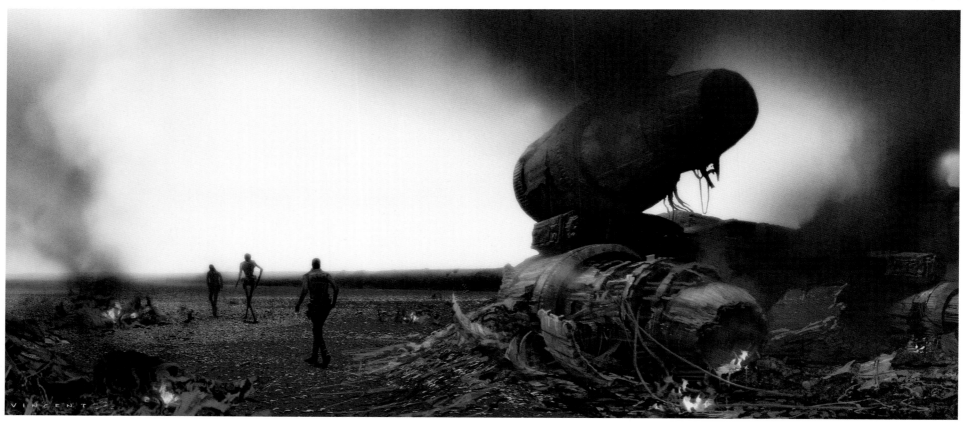

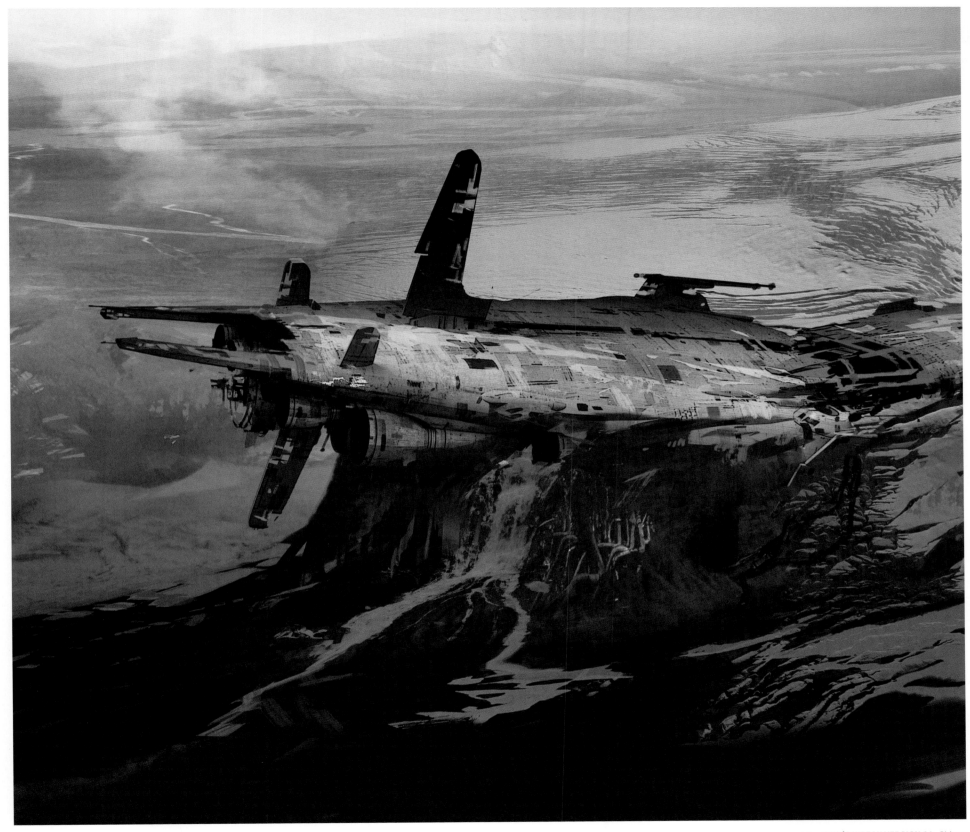

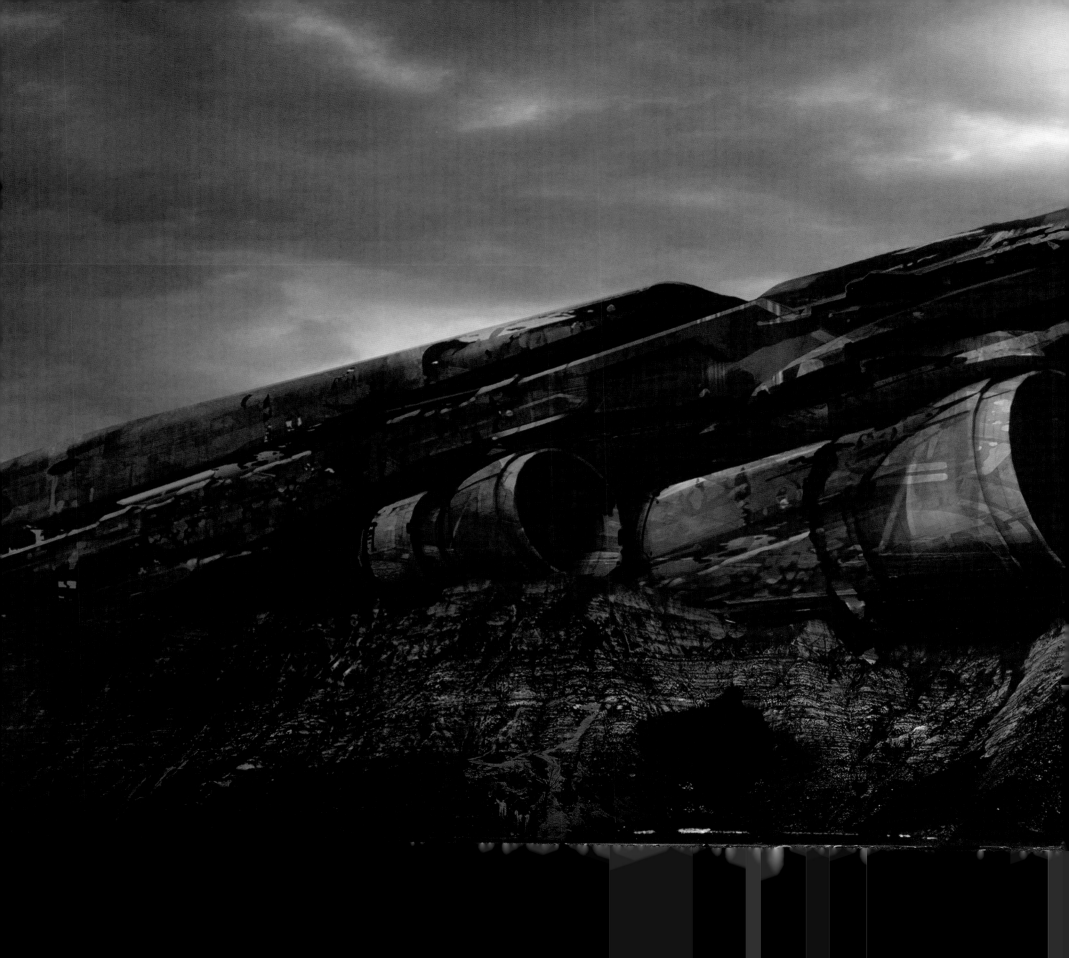

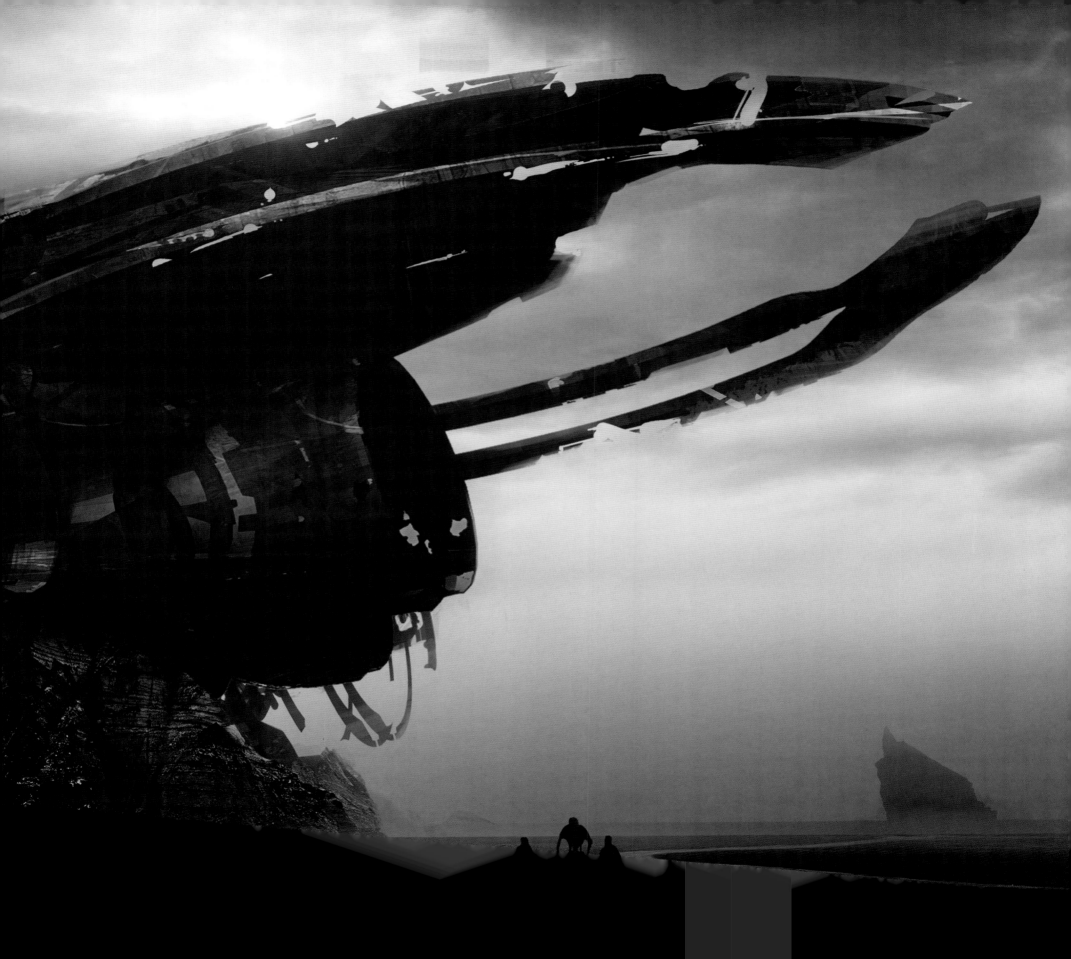

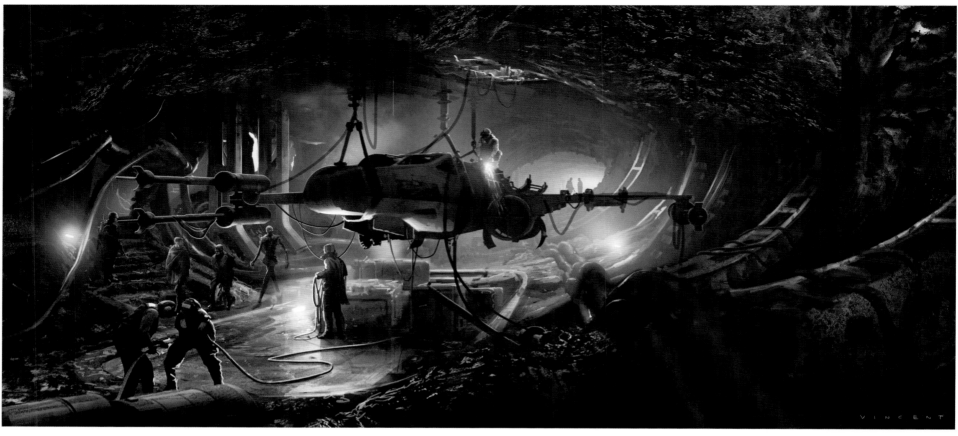

SAW'S CAVE INTERIOR VERSION 12B—JEDHA VERSION Vincent Jenkins ▼ SAW'S CAVE INTERIOR VERSION 7A Vincent Jenkins ▶ SAW'S CAVE INTERIOR VERSION 1A—JEDHA VERSION Vincent Jenkins

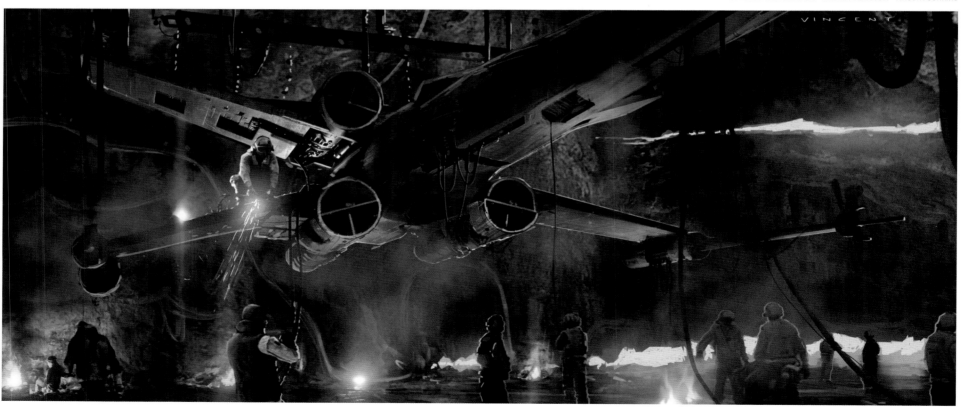

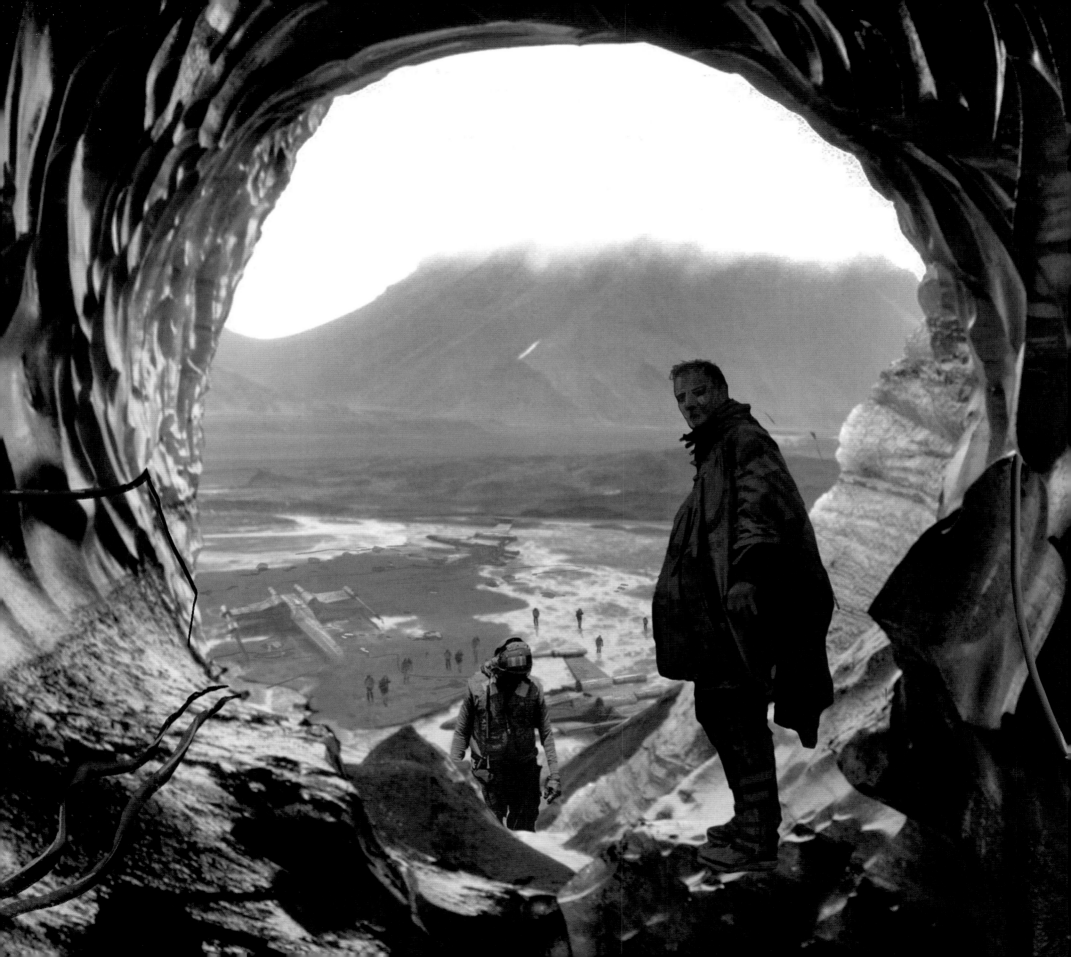

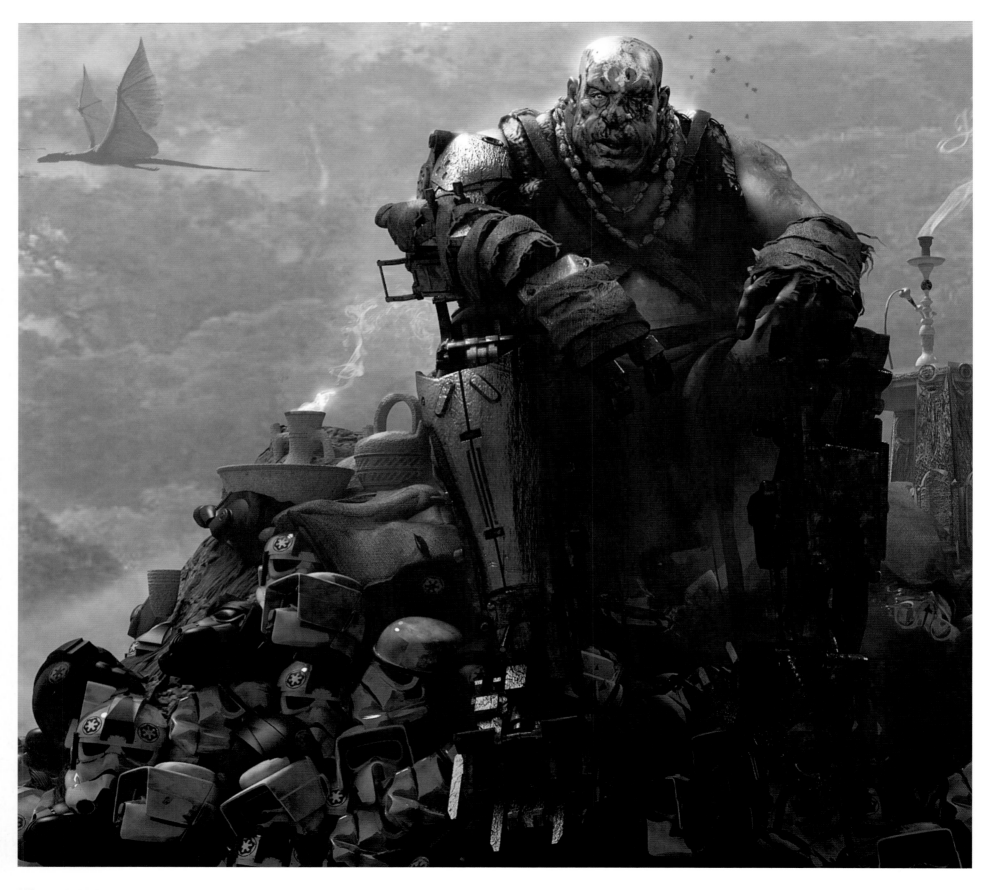

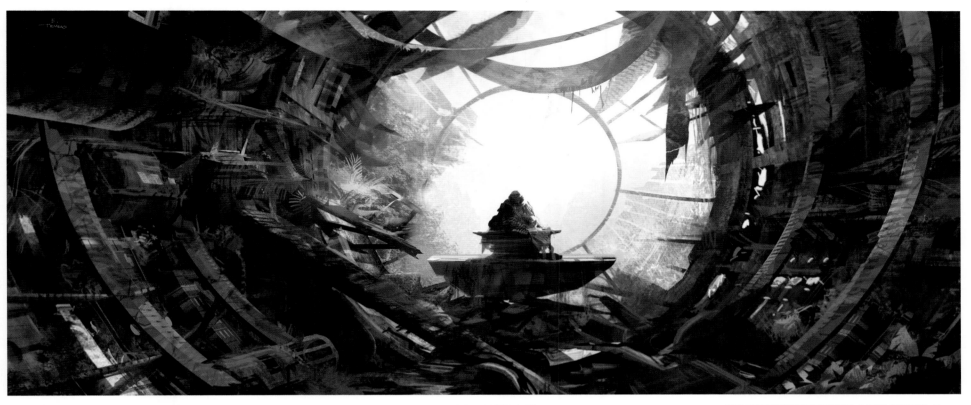

SAW'S THRONE CLOSE-UP McBride ◄ ▲ SAW GERRERA COCKPIT INTERIOR VERSION 4 Tiemens ▼ SAW GERRERA'S ENCAMPMENT—SAW'S CHAMBER Tenery

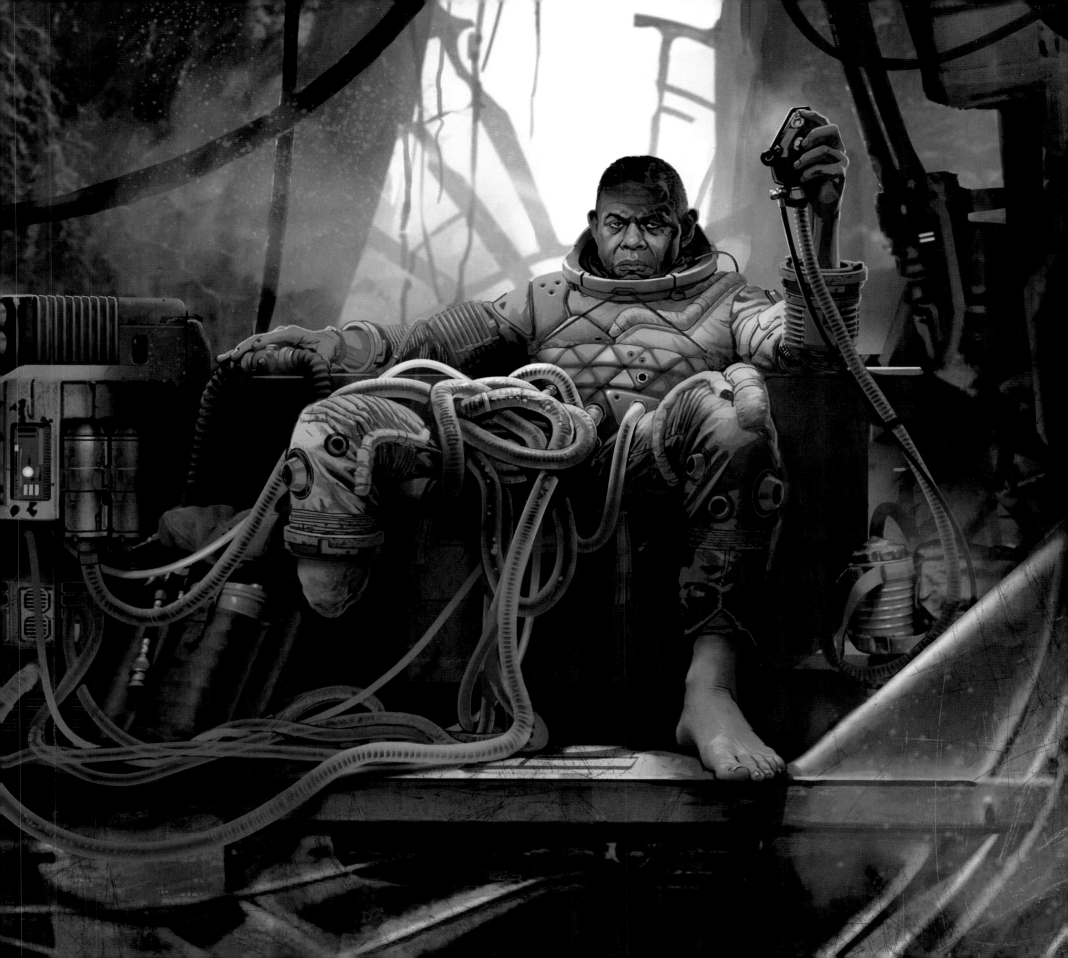

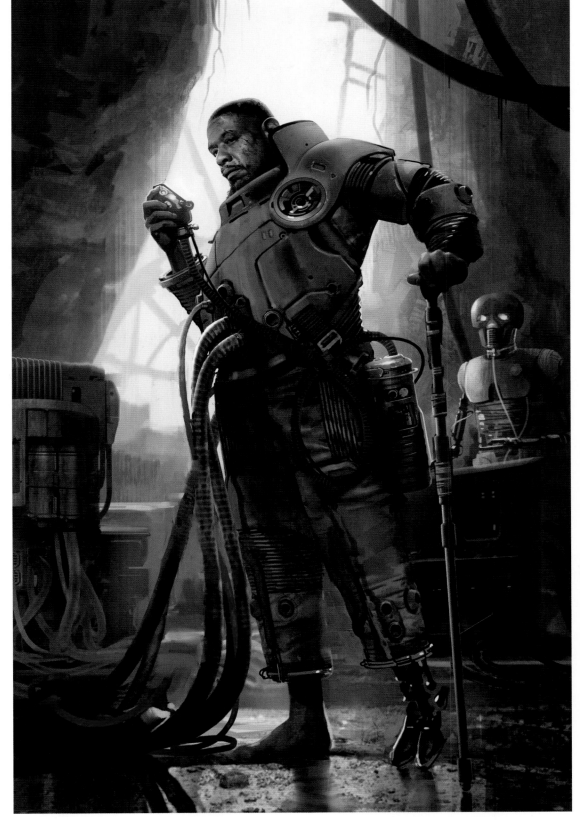

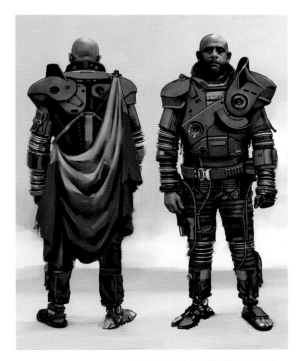

▲ **SAW GERRERA FRONT AND BACK** Dillon

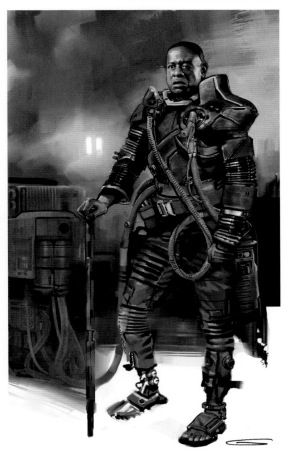

◄ **SAW'S THRONE ROOM VERSION 1C** Brockbank ▲ **SAW GERRERA VERSION 3A** Brockbank and Dillon ▲ **SAW GERRERA NEW DRAFT VERSION 4A** Dillon

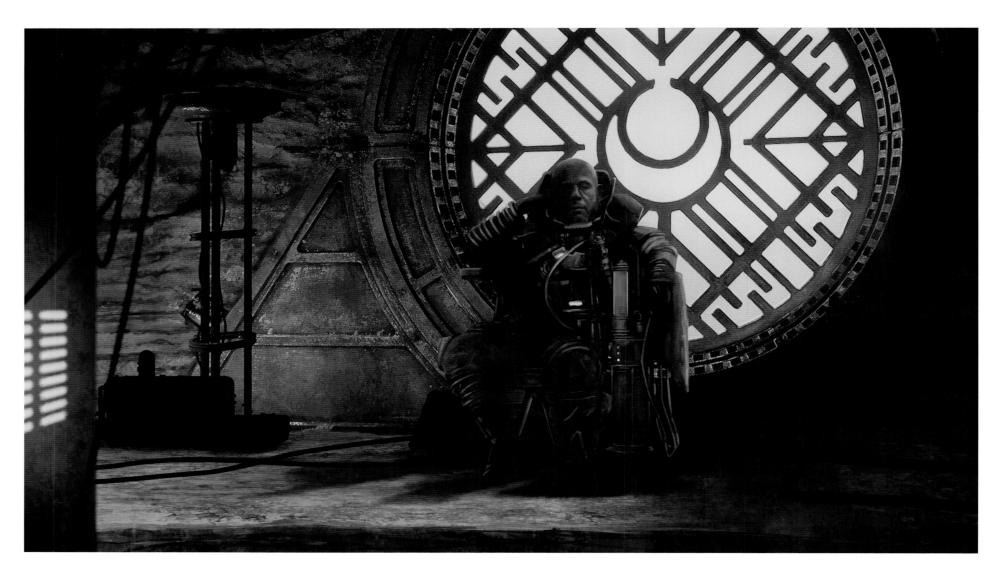

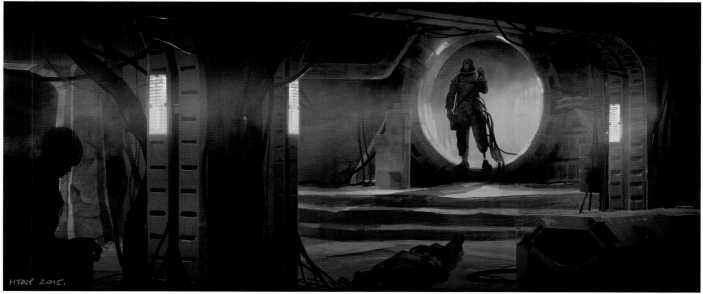

▲ **OCCUPIED CAVE** Htay

◄ **SAW'S LAIR CHAPEL VERSION 1A** Htay

"For Saw's cave, we're incorporating the Jedha aesthetic, bringing in the sandstone, the rock and coloring of Jordan, and a lot of sand. It's a simplicity of form—enhancing the initial architecture with a simple tech dressing and a tribute to Ralph McQuarrie's design. It's very McQuarrie-esque, which of course we love." Lamont

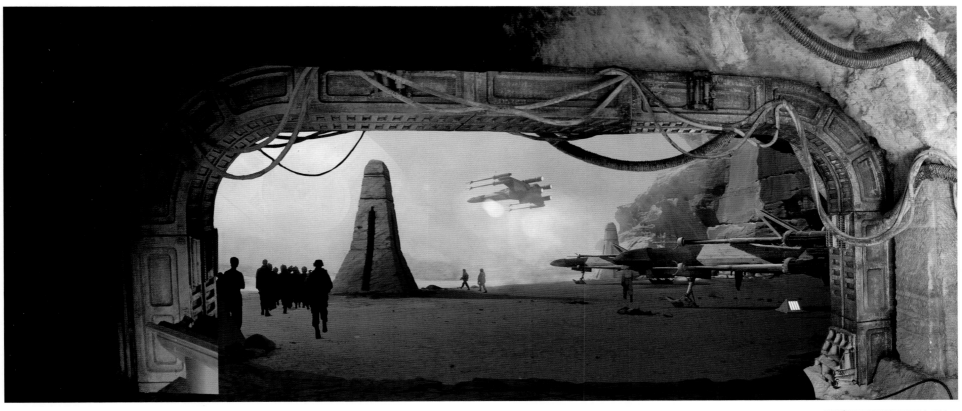

▲ **SAW'S HANGAR EXTERIOR VERSION 1A** Htay

▼ **TWO TUBES** Brockbank

▼ **SAW'S PILOT VERSION 1A** Fisher

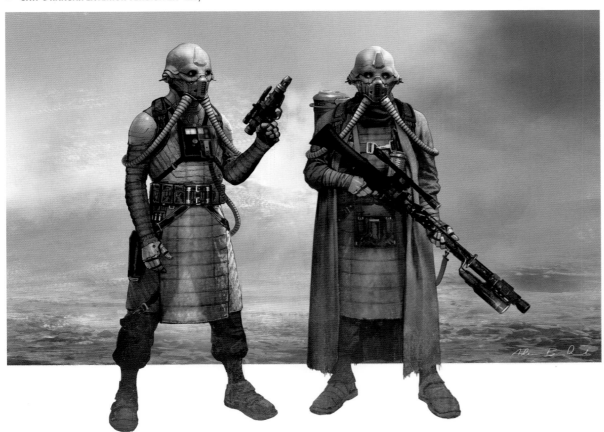

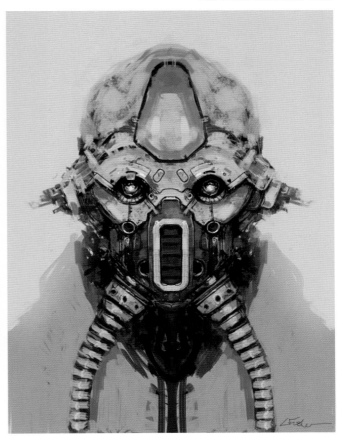

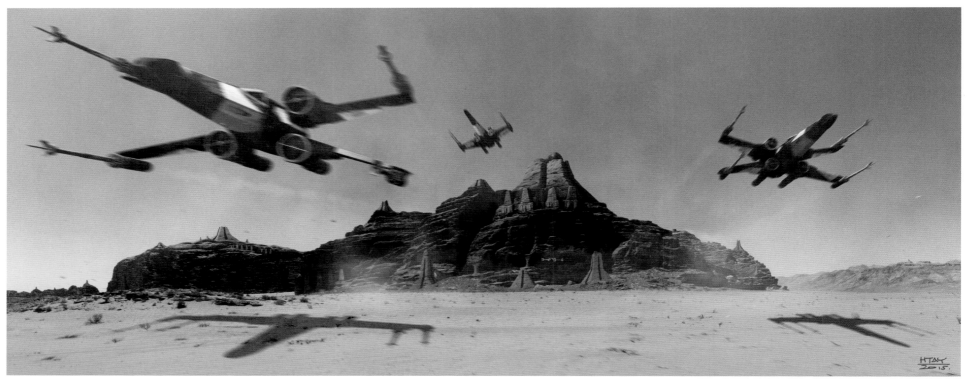

▲ **SAW'S LAIR HANGAR EXTERIOR VERSION 3C** Htay

▼ **JEDHA PLANET DESTRUCTION WITH X-WINGS** Allsopp

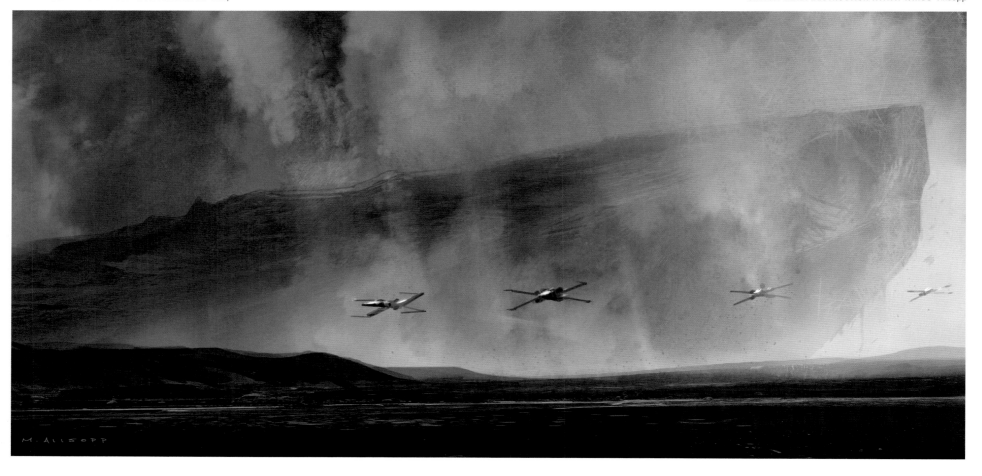

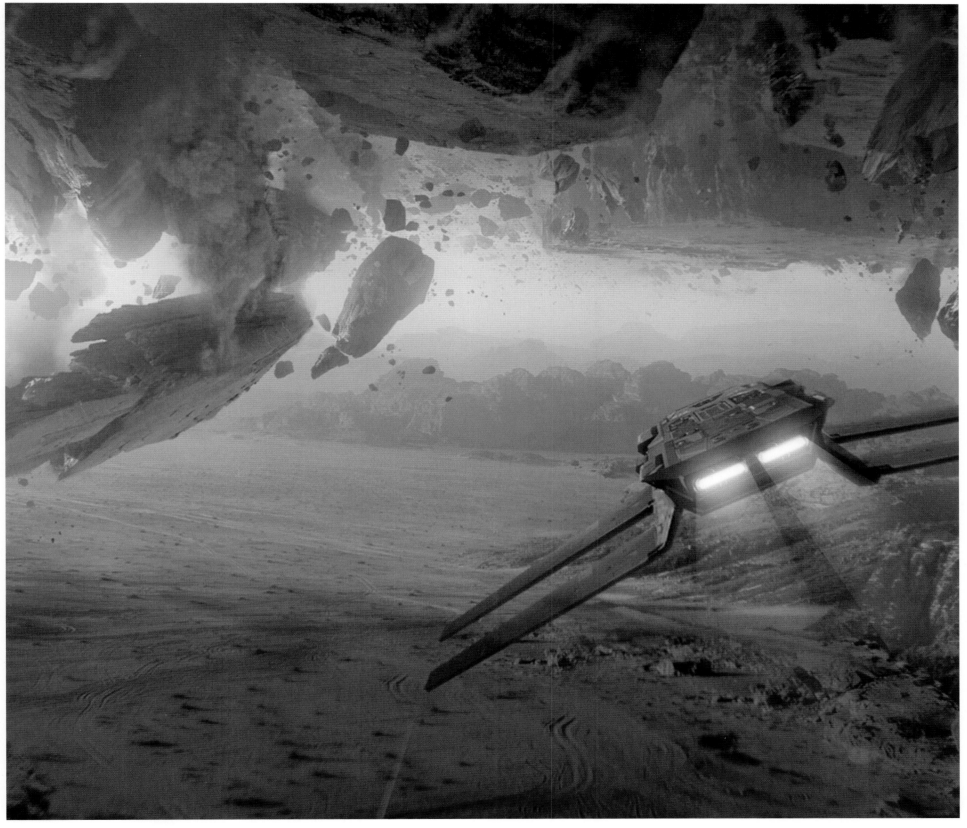

JEDHA DESTRUCTION VERSION 7B Wallin

▸ ▸ JEDHA EXTERIOR VERSION 6A Wallin

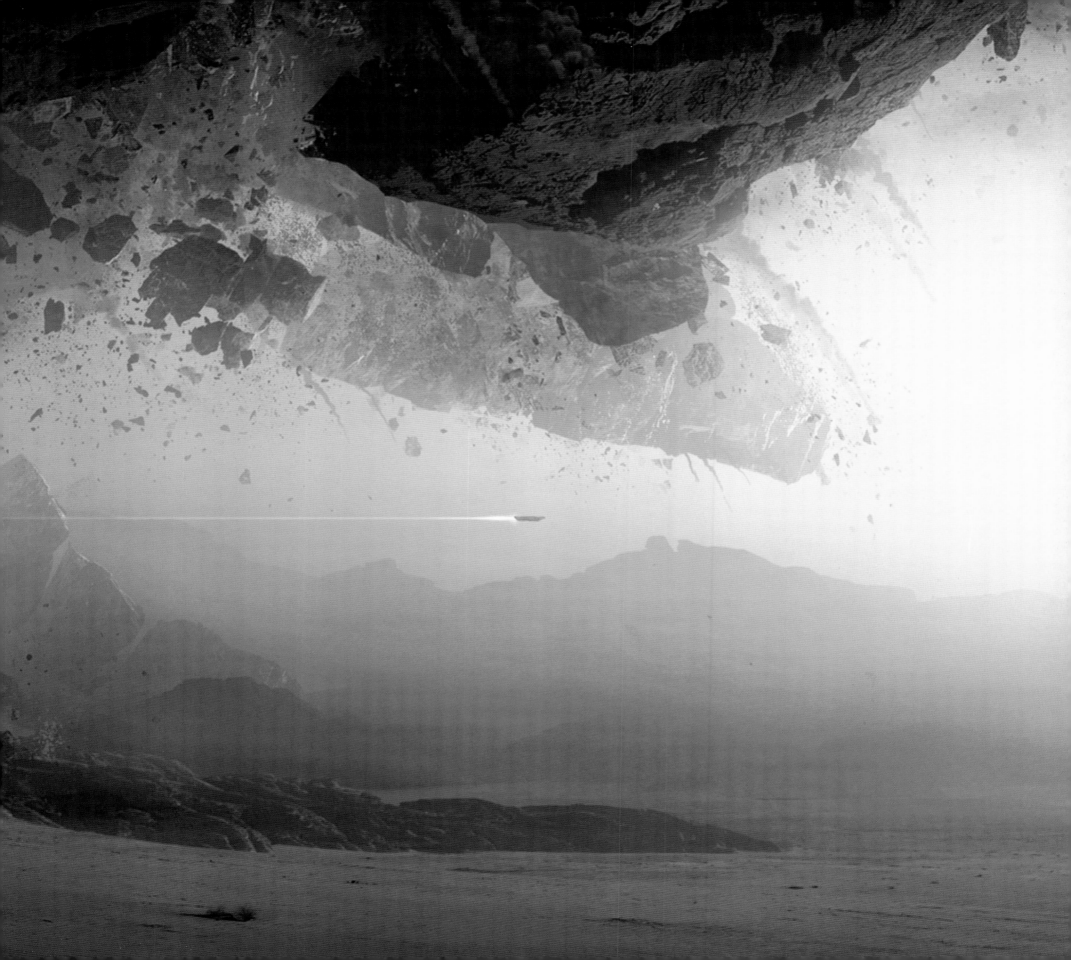

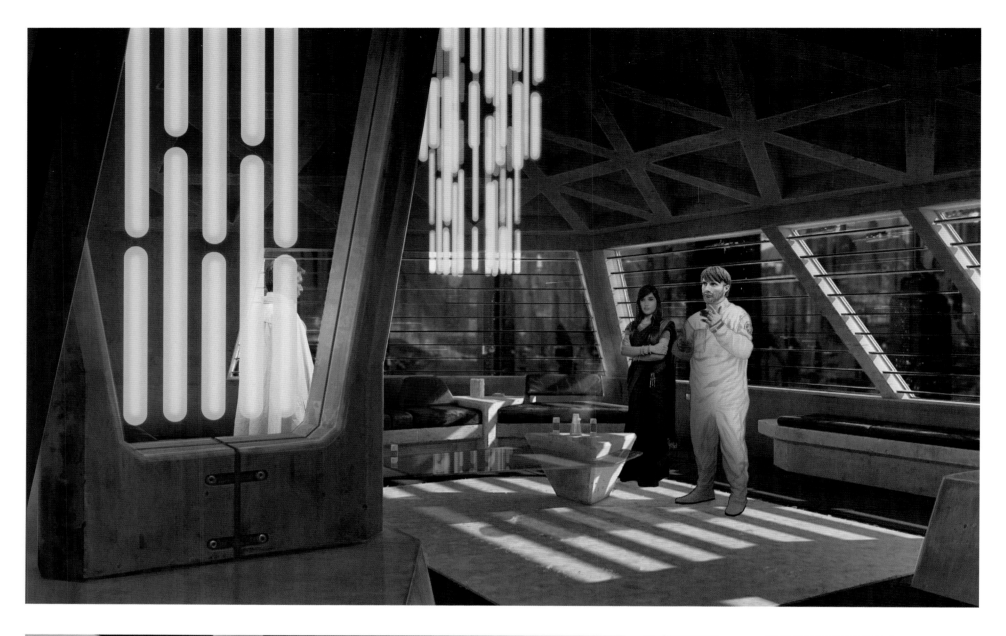

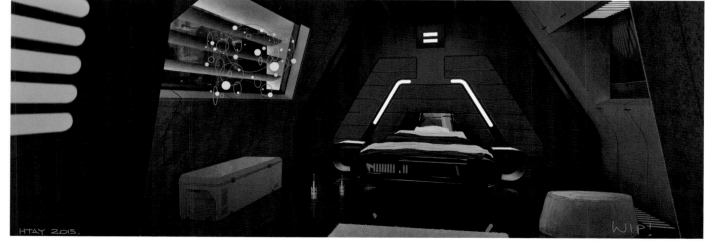

▲ **GALEN ERSO BEDROOM INTERIOR VERSION 4A** Htay

◀ **GALEN ERSO BEDROOM INTERIOR VERSION 1C** Htay

While en route to Jedha, Jyn has a vision of a life half-remembered—a flashback to an early childhood spent on Coruscant, during a time when her father was still working as one of the Empire's prized minds before her family's escape to Lah'mu. The narrative layover to the seat of Imperial power provided an opportunity for the production to evoke emotion from the saga's most distinctive iconography.

"There are certain visual touchstones that you can expect to see when you jump into a *Star Wars* film," said John Swartz. "On any Imperial set, for example, you've got the pill lights and the shiny black floors—but there's more to it than that. It creates an emotional space, a culmination of things that form a *Star Wars* feeling."

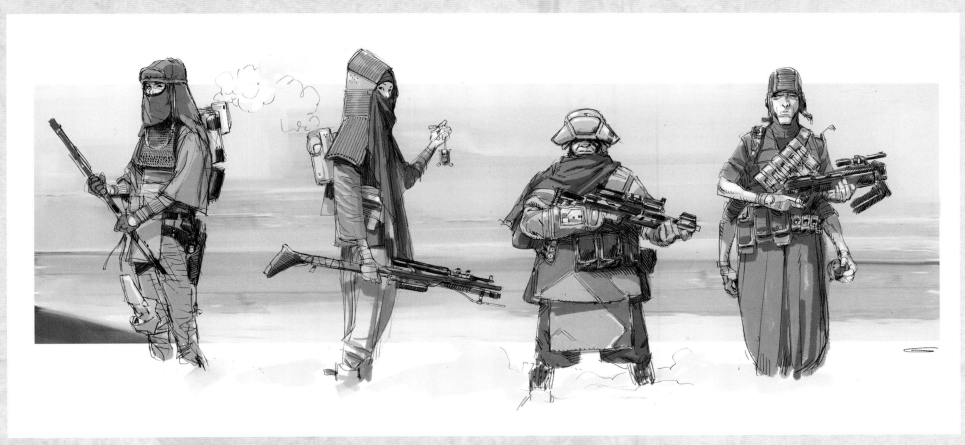

CHIRRUT AND BAZE VERSION 1A—MULTIPLE ANGLES Dillon ▼ CHIRRUT AND BAZE 3 Lunt Davies

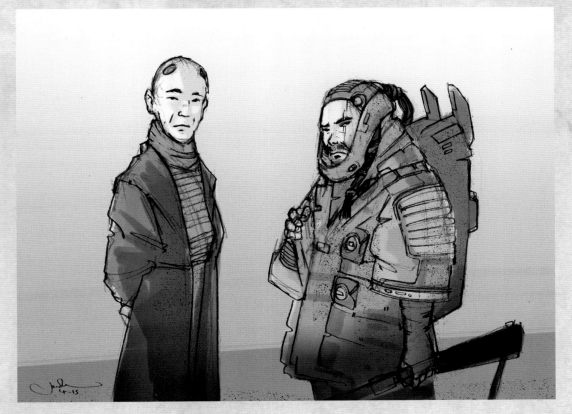

CHIRRUT ÎMWE AND BAZE MALBUS

Two significant additions to the story in Jedha are Chirrut Îmwe, a blind warrior monk, and Baze Malbus. Both are Guardians of the Whills, protectors of the Kyber Temple on Jedha, who join Jyn in her quest to find Saw Gerrera. Pairing an ostensible pacifist with a forceful soldier might seem like an unlikely partnership, but their combative and abiding friendship continues a *Star Wars* tradition of "odd couples" that is at the very heart of the series' appeal.

"*Star Wars* is very good at counterparts," said screenwriter Chris Weitz. "You get these couples—Han and Chewie, R2-D2 and C-3PO. Chirrut and Baze are another one of these dyads. A believer in the Force and a fighter who has no faith. They don't belong together, but they do. I [initially] arrived at this notion that Chirrut was kind of like Baze's father/confessor in a very 'the Force' kind of way. So Baze was able to lay his guilt onto Chirrut, even though he didn't believe in the Force, and Chirrut could believe in Baze's eventual redemption. I think that there's humor there, in these two characters who really seem completely at odds with one another but are tied together."

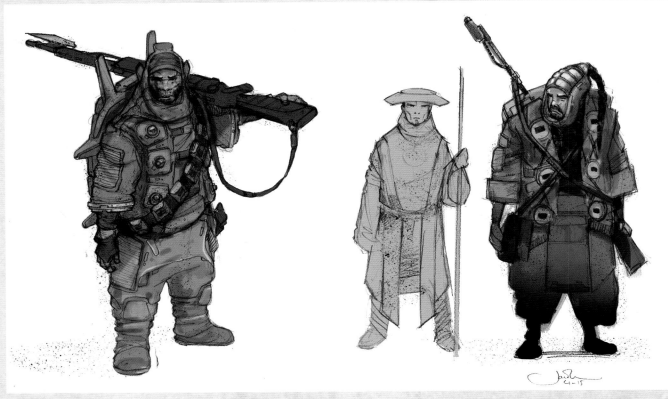

▲ CHIRRUT AND BAZE 2 Lunt Davies

▼ CHIRRUT AND BAZE VERSION 2A Brockbank

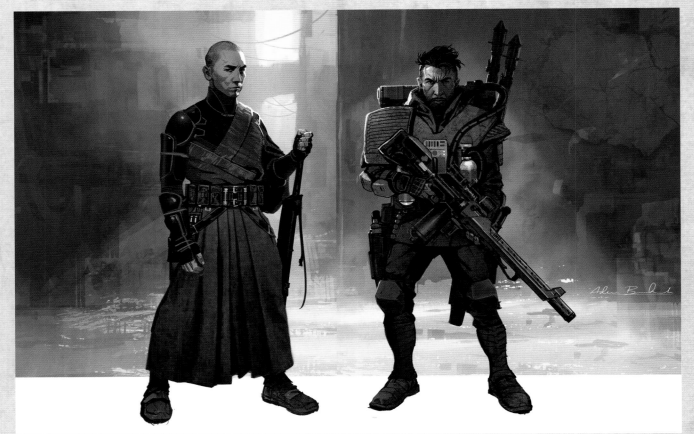

▶ CHIRRUT AND BAZE VERSION 1A Brockbank

"We originally thought that Baze would have a normal gun—one of the new rebel guns we designed for the movie. But from wardrobe to concept, he became much more of a spaceman-like character, with a breathing apparatus like an astronaut, so we went in a completely different direction. I had been trying to introduce the *Star Wars* version of a mini-gun, and Gareth liked the imagery of a belt-to-backpack—kind of a power pack out of the side of the gun." Jamie Wilkinson

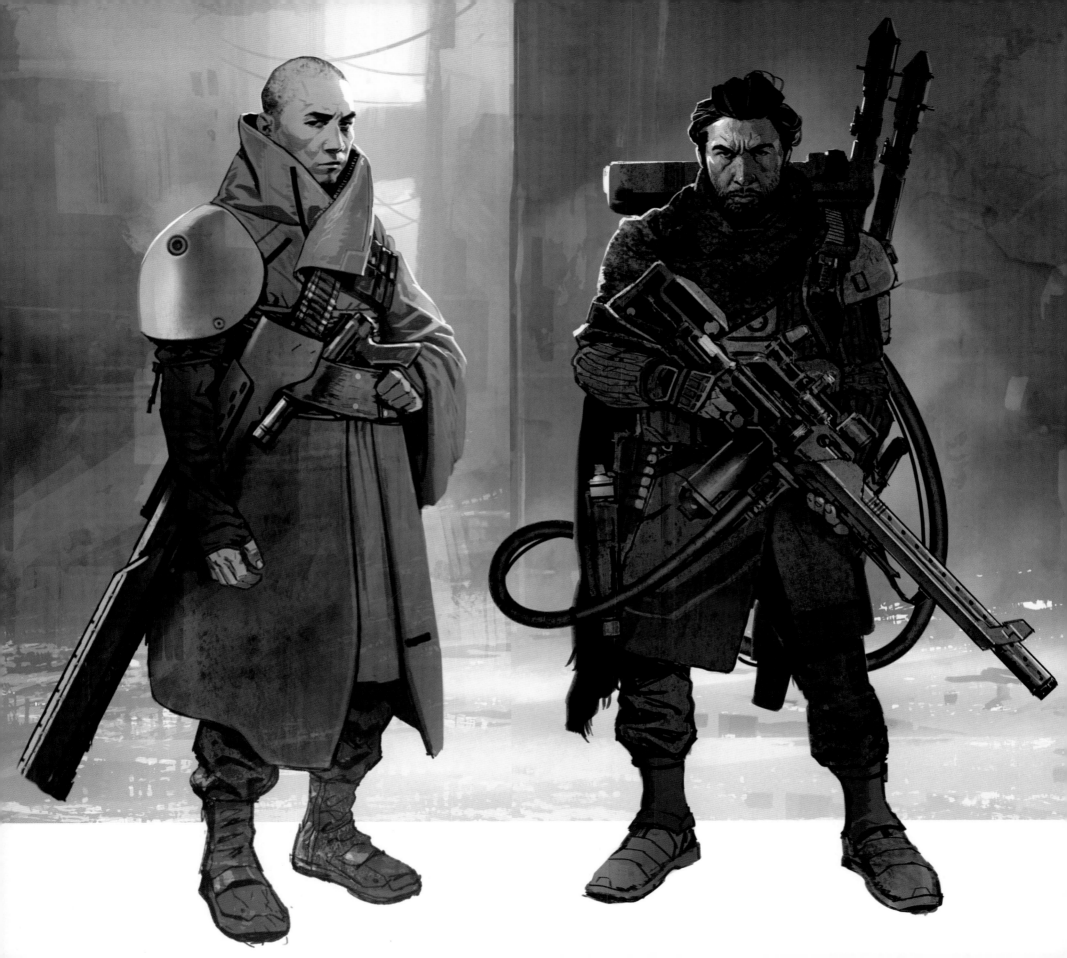

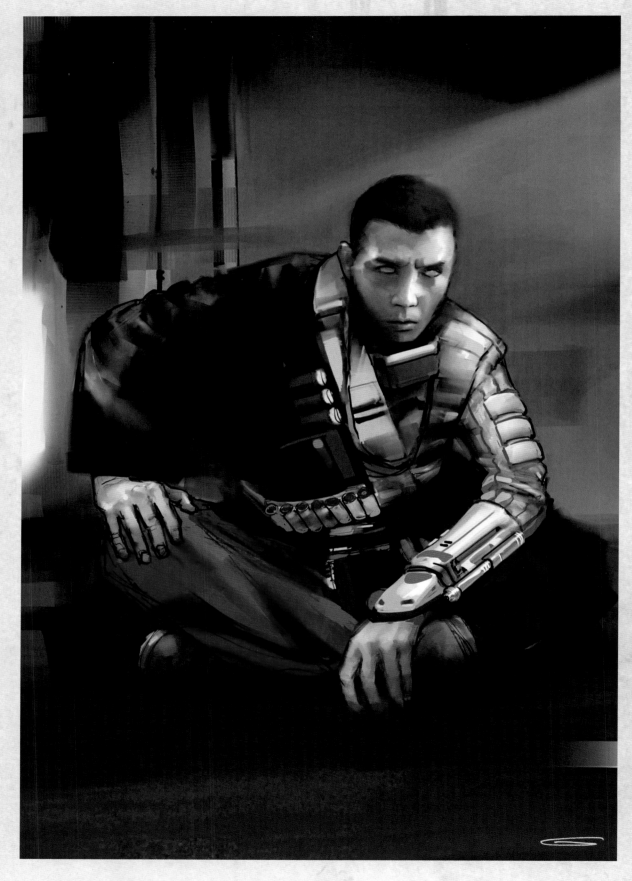

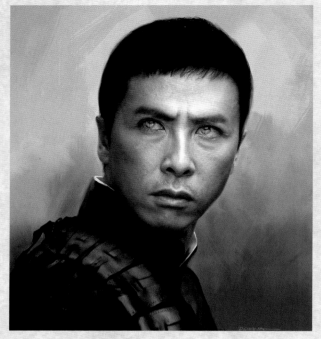

▲ **CHIRRUT EYE LOOKS VERSION 2A** Chiang

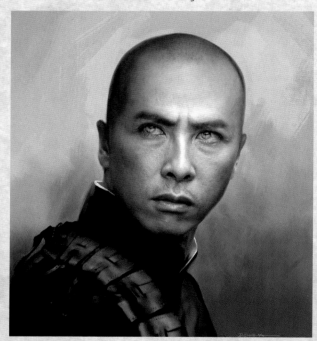

▲ **CHIRRUT EYE LOOKS VERSION 2B** Chiang

◄ **CHIRRUT VERSION 26A** Dillon

"At first, we were going for a look that someone with actual cataracts might have—pure whiteness—but it's *Star Wars*, and you also want your character to look cool. Different. *Star Wars* can't be a reality show! There were debates and discussions, but I said that seeing a Chinese character with blue eyes would be so spectacular. A Caucasian or a European—not a big deal. But for a Chinese character, that is so fresh." Actor Donnie Yen [Chirrut Îmwe]

▲ **CHIRRUT VERSION 1A** Dillon

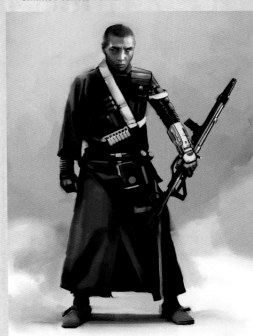

▲ **CHIRRUT COSTUME VERSION 34A** Dillon

▶ **BAZE WITH BEARD 23** Dillon

"Baze is like a combination of all your favorite elements of
Star Wars characters. The partial armor, the boiler suit,
the cool gun, the backpack. It was really driven by what we
thought audiences would like—what you'd want to see in
a mercenary character like this. Gareth really responded
well to the red, so we put some red in Chirrut as well."
David Crossman

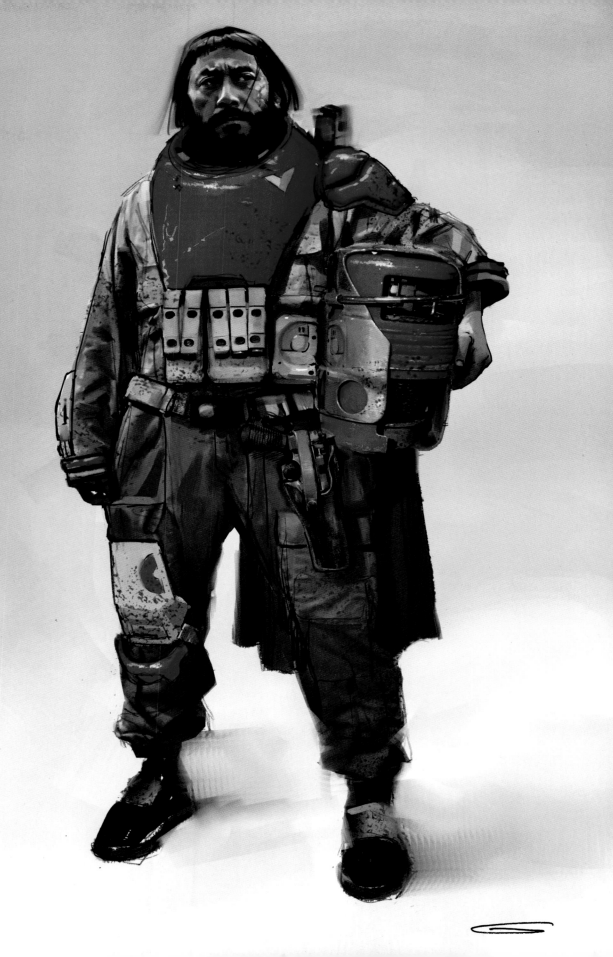

▲ **BOR GULLET VERSION 1A** Manzella

BOR GULLET

Emblematic of Saw's ruthless tactics is his use of Bor Gullet, a telepathic cephalopod the extremist uses to extract information from his prisoners. As a character, Bor is notable not only for his outlandishly misshapen physicality, but also for introducing a new *meta*physicality to the *Star Wars* universe, previously the sole purview of its Force-users.

"I love characters that allow *other* characters to plainly state what's bothering them, in part because I don't believe that people ever say exactly what they mean unless they're under very extreme conditions. I invented this character as a way to get into Jyn's head," said Chris Weitz. "He's an empath; he can understand exactly what you're thinking, but he also feeds off emotions. He likes things like fear and sorrow and sadness. And joy, too. That was really fun—to just play with these weird metaphysical, psychological things with this character. I wanted a form that freaks people out but that still feels familiar. So, it was either insect or octopod. We decided that an octopod worked best because his tentacles could go around people's necks and heads and into their ears."

Gareth Edwards brought the creative brief to Neal Scanlan and his creatures team, and they jumped at the opportunity to design something so monstrous.

"Sometimes, you just need a few words to fire everybody's imagination. With Bor Gullet, we ran wild with a *question*: 'What would be *the most*—?' It was always going to be extreme," said Scanlan. "Gareth liked the idea of tentacles, and he also envisaged Gullet as incapable of mobility. He'd be sustained by life support—this immobile product of the deep dark. It was also very informative for Gareth to characterize him as hampered by physicality but still this brilliant thing with telepathic virtues."

The license to let loose with their most bizarre artistic sensibilities struck a chord with the team, particularly with creature concept designer and senior sculptor Ivan Manzella (*Doctor Who*, *Prometheus*, *Edge of Tomorrow*). "Gareth's got his own sensibilities, but I generally know where he's coming from. I like his ideas—weird and creepy. That's really my bag. The looks he likes are darker, kind of mischievous—with a dark sense of humor. I like all that stuff—odd and bizarre," said

"Bor Gullet is like a sort of blob-ulous, pulsating oyster-octopus; there's some vulgarity in there, as well. It's subtle; you just have to stand on your head to see it." Neal Scanlan

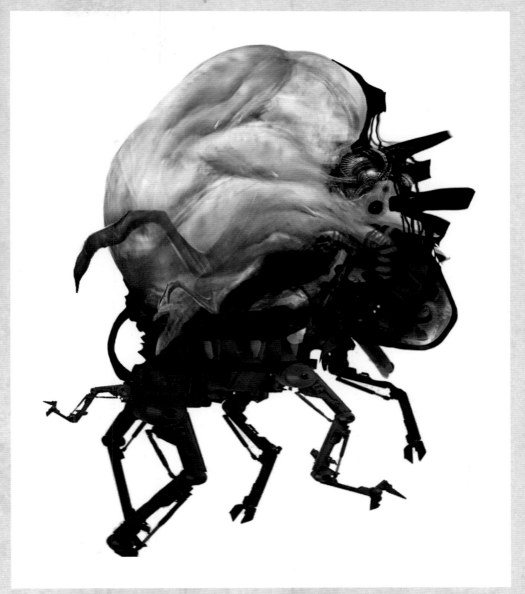

Manzella. "So when he described the octopus creature, this image just popped into my head, and I couldn't wait for the meeting to be over. I just had to get it down. I went straight to my desk and worked into the night, starting with a sketch and embellishing it a bit more over the next few days."

"Bor Gullet was designed in a moment of inspiration—but God knows where Ivan gets his inspiration from," said Scanlan. "He's in therapy, or should be. He went away, and what he came back with just jumped off the page. There are certain designs that you massage and build on, and then there are the ones that are home runs from the start. Ivan's initial sketch was abstract, but it was all there from the start.

"There's a feeling that you're visiting a character that is within the *Star Wars* world—one would expect to see something like Bor Gullet, even though we've never actually seen anything like him. We're always feeding off our legacy and everything that's come before us; it's important to draw from that. With Bor Gullet, I'd say we definitely have a bit of Jabba in him, but he's still so unique. And repulsive."

The unlucky subject of Bor's unique interrogative abilities is defecting Imperial pilot Bodhi Rook—who becomes the final member of Jyn's team when he bravely passes along an important piece of intel that could help the Rebellion stave off the Empire.

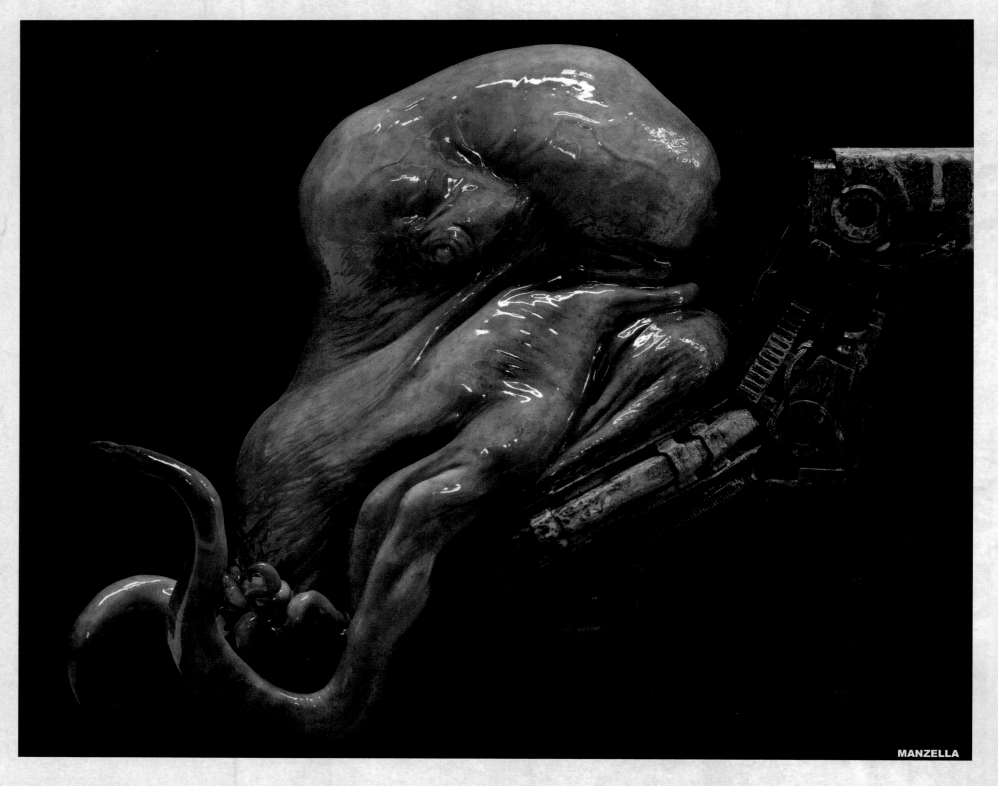

MANZELLA

▲ **BOR GULLET 1** Manzella

"Maquettes are everything in our world—the small-scale sculptures that we produce once a concept's been drawn to a point where we're confident with it. Someone like Ivan [Manzella] is brilliant at conceptualizing and then bringing the design into three dimensions, model-making it, and then painting it to illustrate our ultimate intention." Scanlan

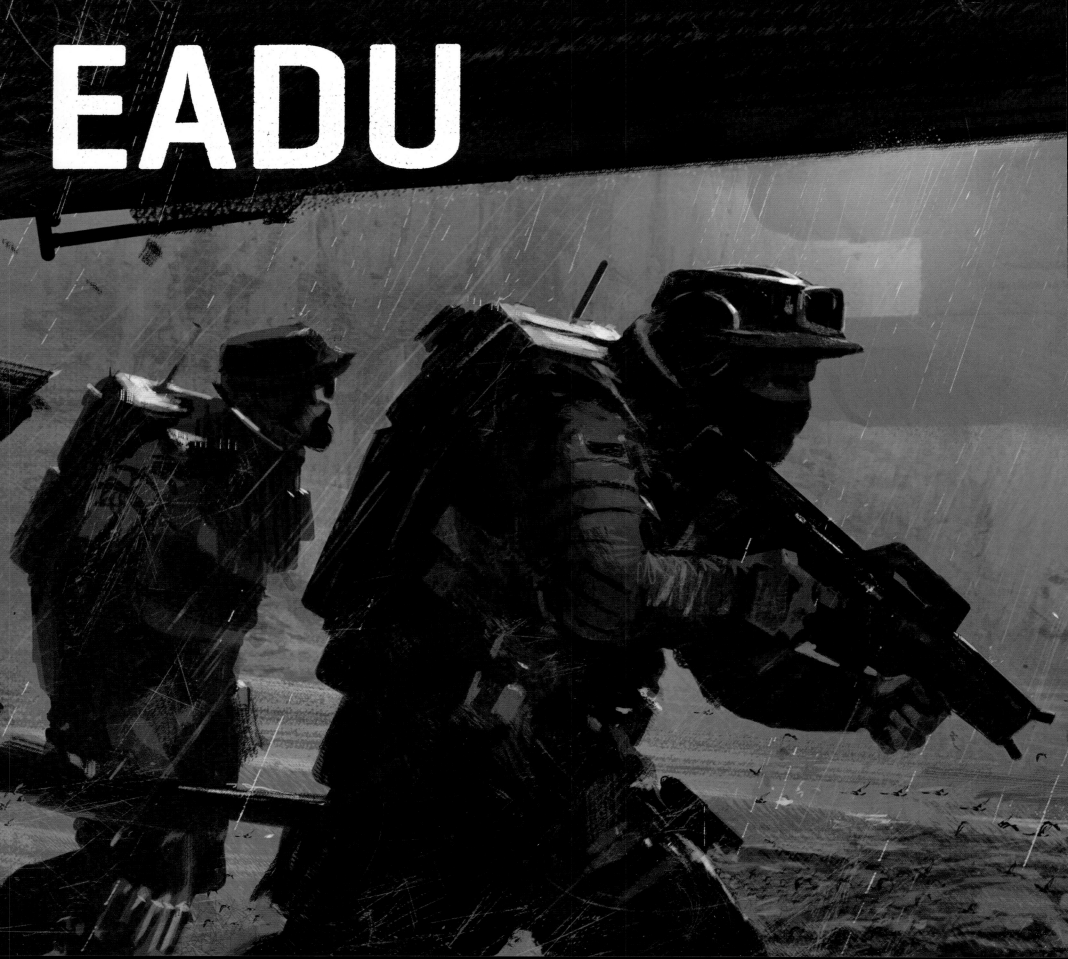

EADU

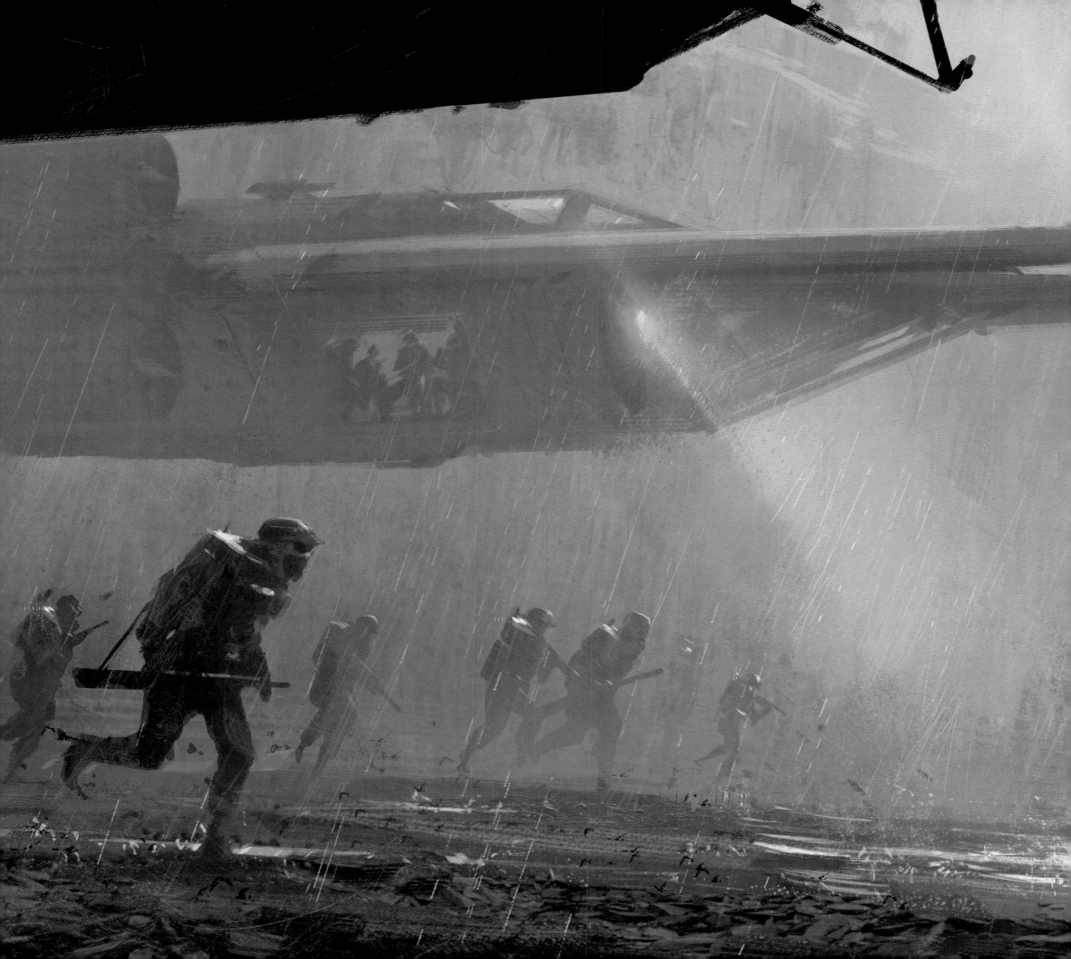

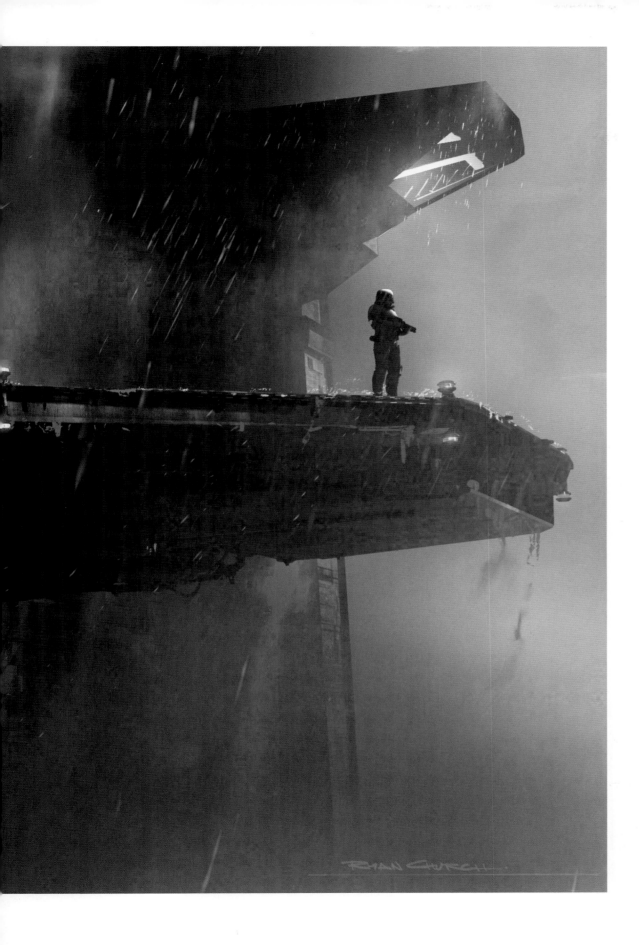

Imperial Installations

The only hope for the Rebellion, and the key to discovering the Death Star's weakness, is Galen Erso, Jyn's estranged father and one of the engineers behind the Empire's ultimate weapon. Galen is revealed to still be alive and in the employ of the Empire against his will. Though she has conflicted feelings for the father she hasn't seen since her childhood, she accepts the mission and follows Galen's trail to the planet Eadu, where Galen leads a team of engineers at an isolated Imperial installation nestled into the planet's inhospitable terrain.

Visual precedents established in the original *Star Wars* films included iconic sets, locations, costumes, vehicles, and more from both the Rebellion and the Empire—all of which would have to be reverse-engineered, interpreted, and adapted for use in *Rogue One*. Tasked specifically with realizing *Rogue One*'s Imperial influences that include the iconic Death Star control room itself, art director Alex Baily (*Rush*, *Game of Thrones*, *The Force Awakens*) explored seemingly fractal resources available in order to discover the unifying visuals that would pin down the production aesthetic.

"It's a lot of detective work; everything is pieced together from reviewing the films, looking at photographs, even scouring fan sites—we're always looking for ways to glean any information on what something looked like or how it was made," he said. "Any little detail—color, size, proportion—because in *A New Hope*, everything was cobbled together."

"For us, the design task was really to come up with something that looked very Imperial—that was not set on the Death Star or on a Star Destroyer, but that still felt of the same family, like it was the same architect," said Doug Chiang. "What Gareth really wanted to do was create a *Star Wars* version of a James Bond supervillain set—kind of a secret base, so our design task was really to take the Imperial aesthetic and then find a way to hide it. The planet Eadu was conceived as a dark and mysterious planet on the Outer Rim—constantly raining, always overcast, enshrouded in mist—and the story point actually helped with our design brief. Slowly, as our characters enter this world, they start to see lights as the base is revealed to them. They're discovering it almost at the same time that the audience is."

But the real discovery on Eadu is the one made by Jyn, who at last comes face-to-face with her father—the culmination of her mission, but also a poignant moment for a hero who has built her own adult identity on a foundation of emotionally detached independence.

◄ **IMPERIAL BASE PLANET—HANGAR IN FOG** Church

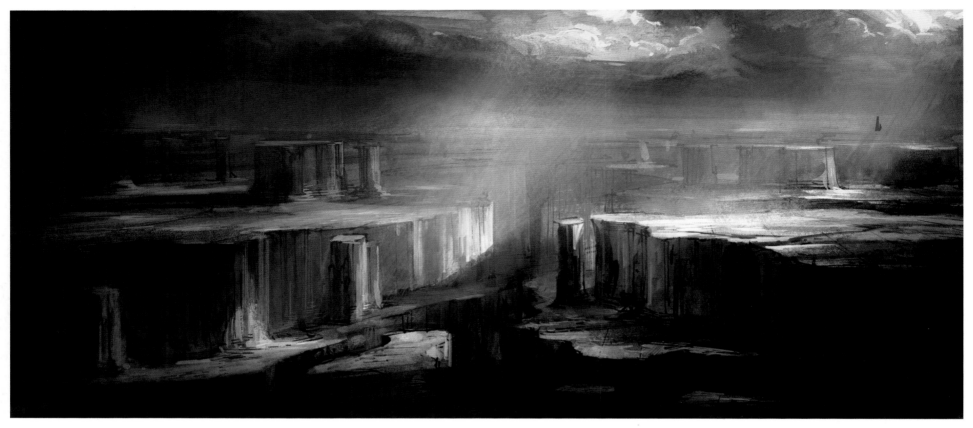

MOUNTAIN PLANET EXTERIOR VERSION 11A Tiemens

MOUNTAIN PLANET EXTERIOR VERSION 1A Tiemens

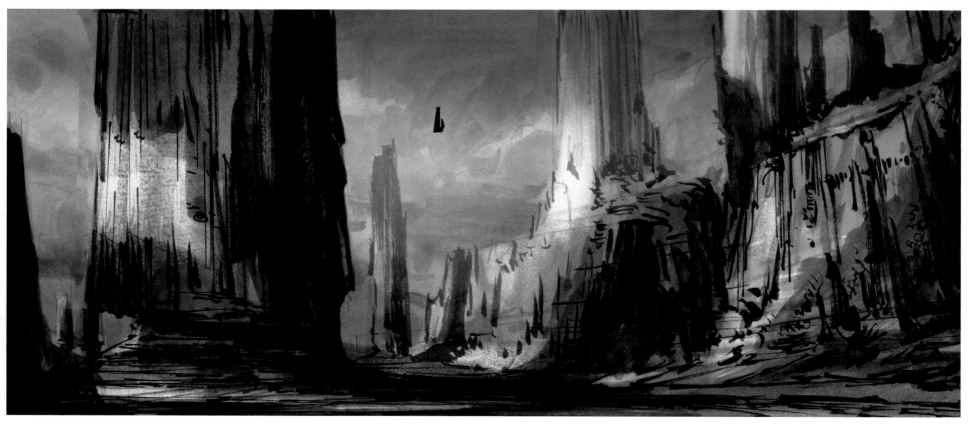

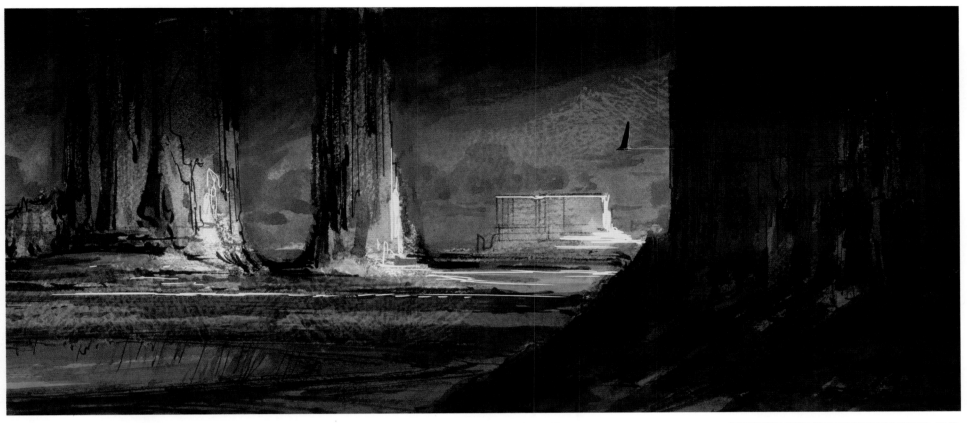

▲ **MOUNTAIN PLANET EXTERIOR VERSION 3A** Tiemens ▼ **MOUNTAIN PLANET EXTERIOR VERSION 2C** Tiemens ▶▶ **MOUNTAIN PLANET AERIAL EXTERIOR VERSION 1G** Wallin

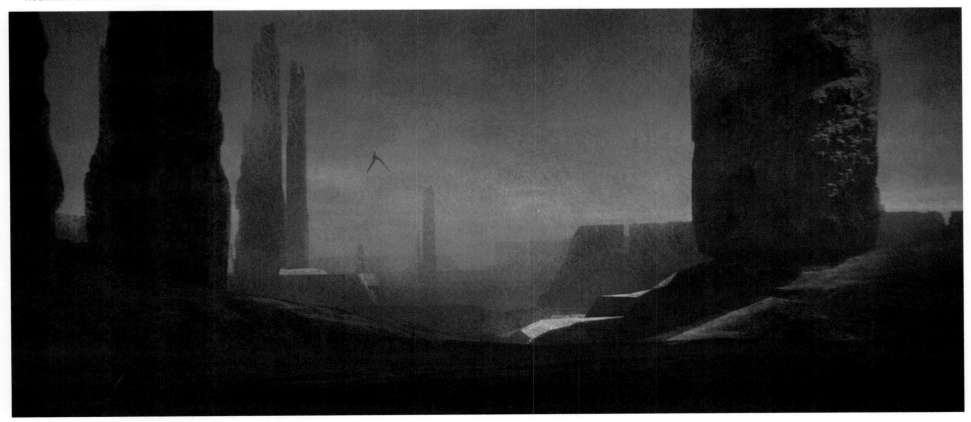

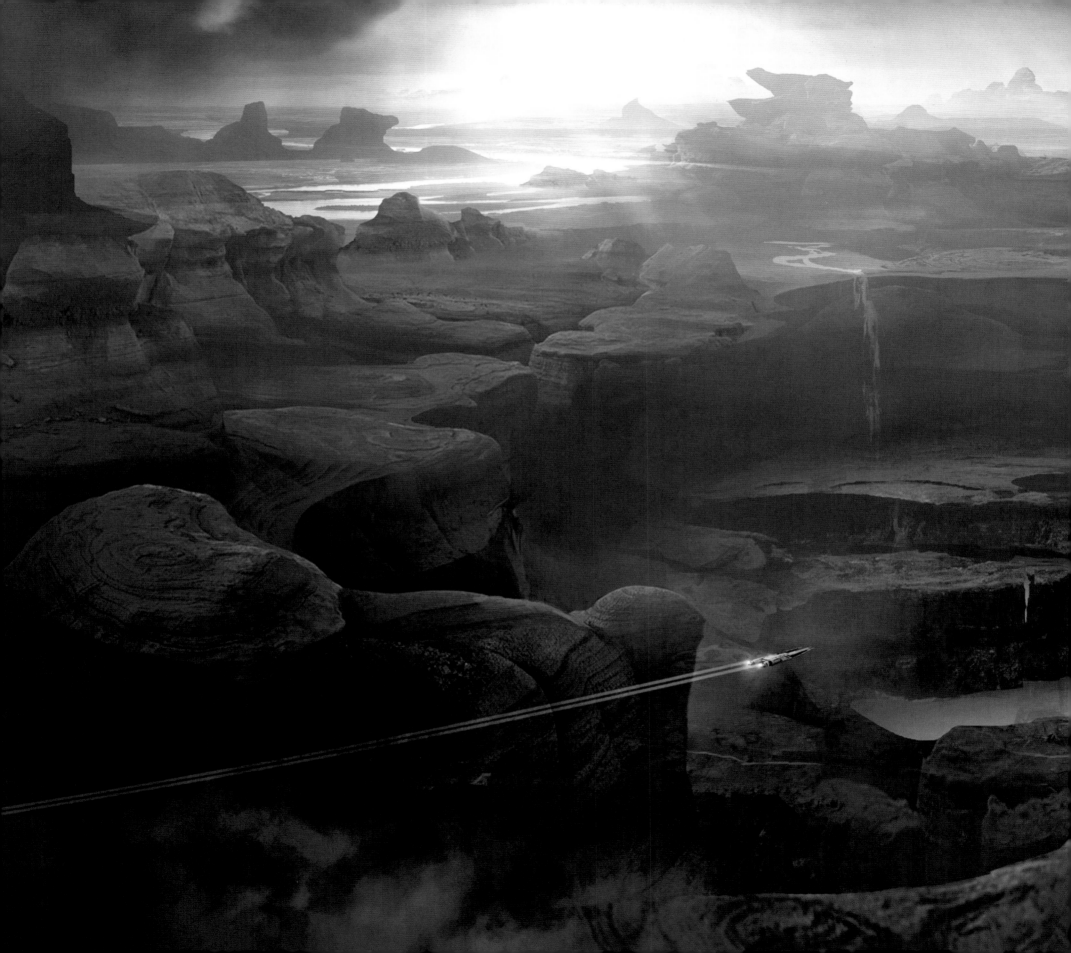

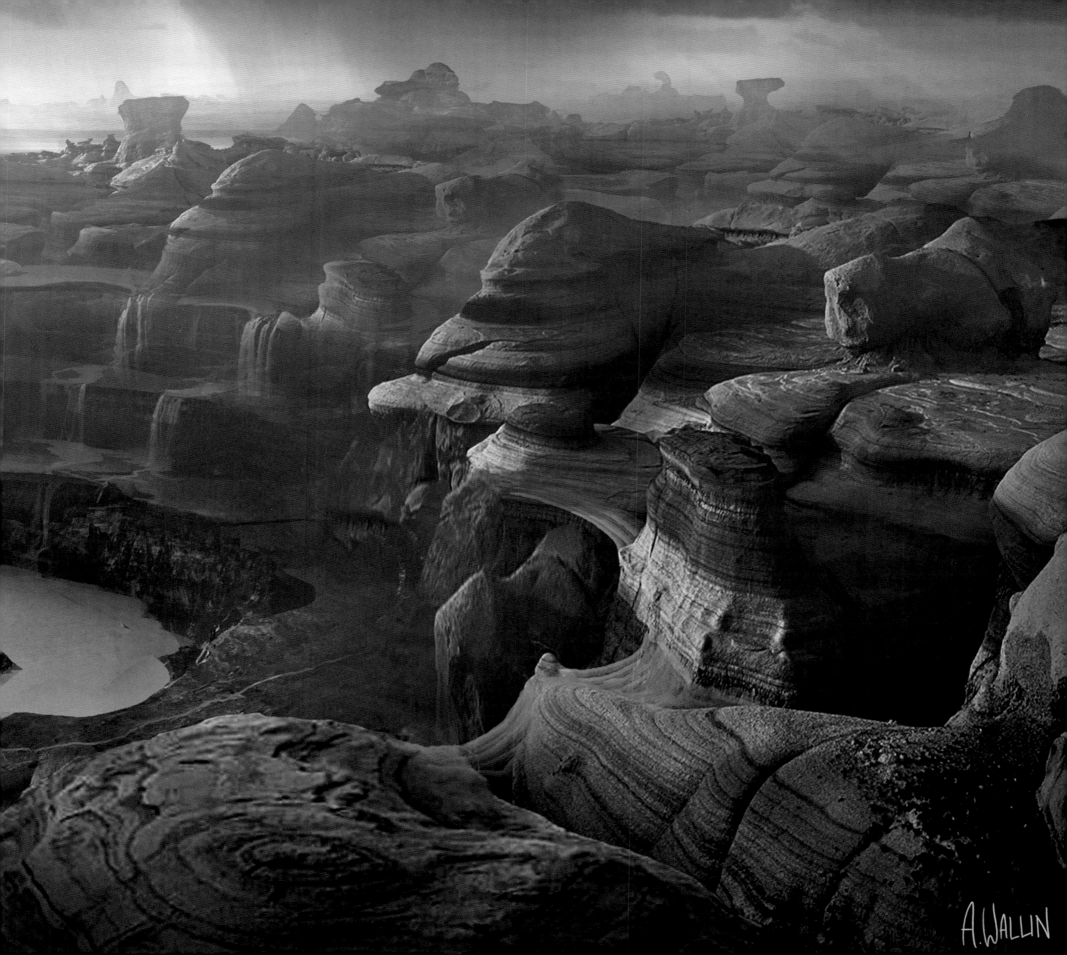

A. Wallin

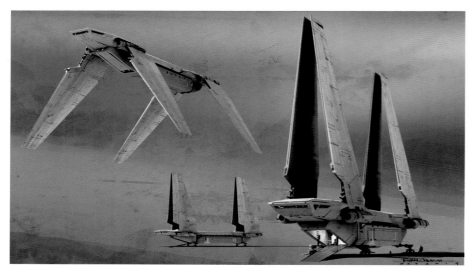

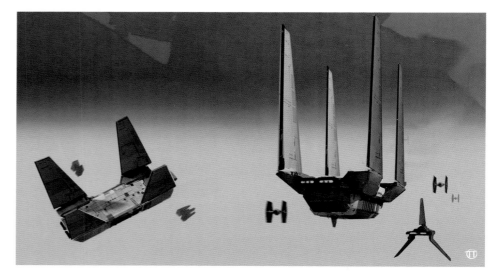

▲ **STOLEN CARRIAGE VERSION 1** Church

▲ **STOLEN CARRIAGE VERSION 4B** Tenery

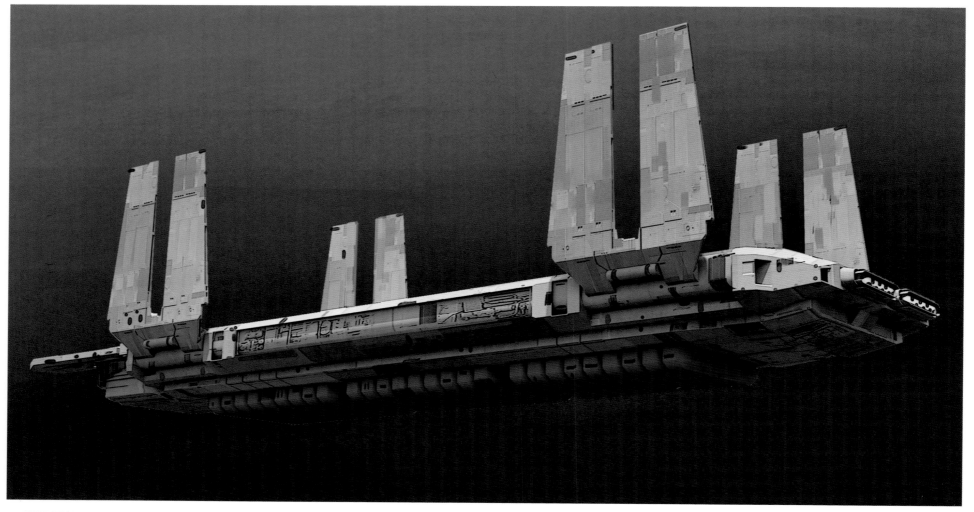

▲ **SUPER TANKER** Tenery

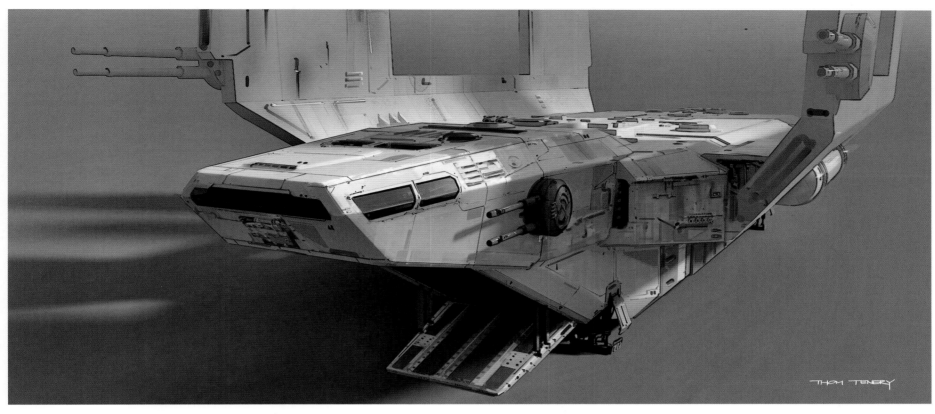

STOLEN SHUTTLE VERSION 1A—FRONT DETAIL VARIANT Rene Garcia and Tenery

STOLEN SHUTTLE VERSION 1A Clyne and Tenery

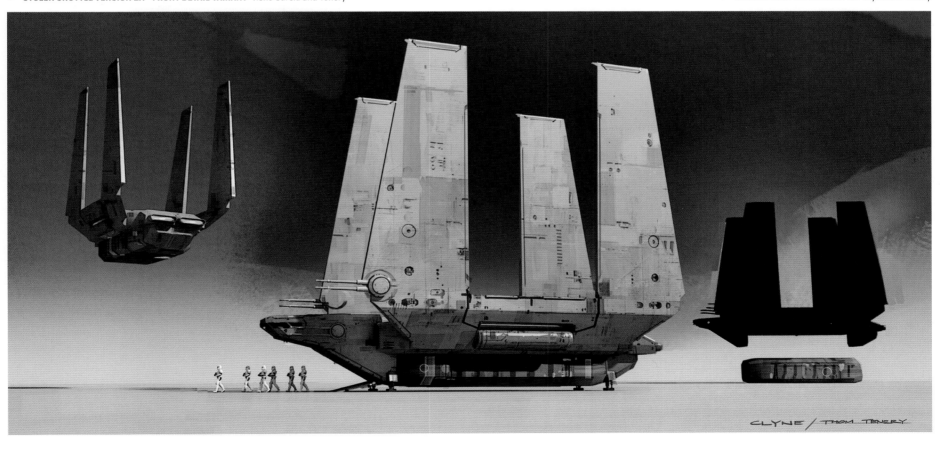

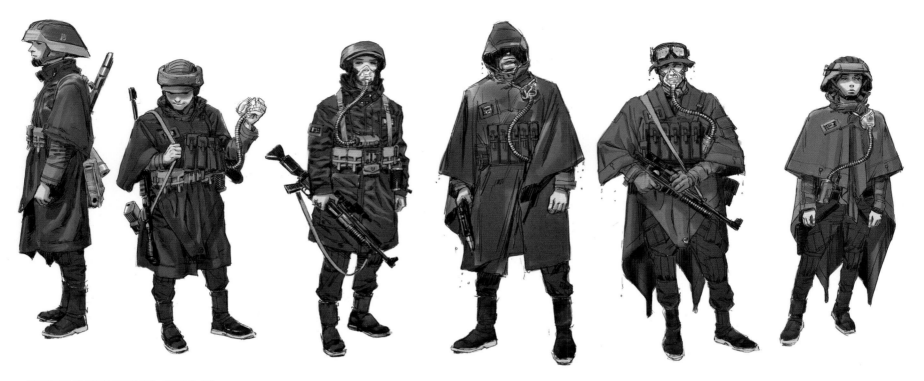

MOUNTAIN MARINES VERSION 1—LINEUP Dillon

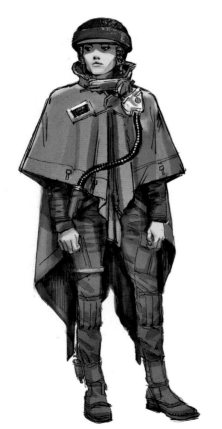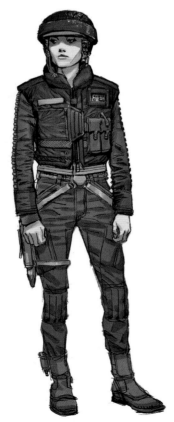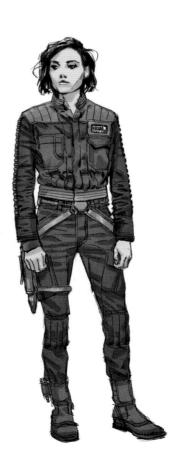

JYN ERSO VARIATIONS Dillon

ENGINEER VERSION 1X Brockbank

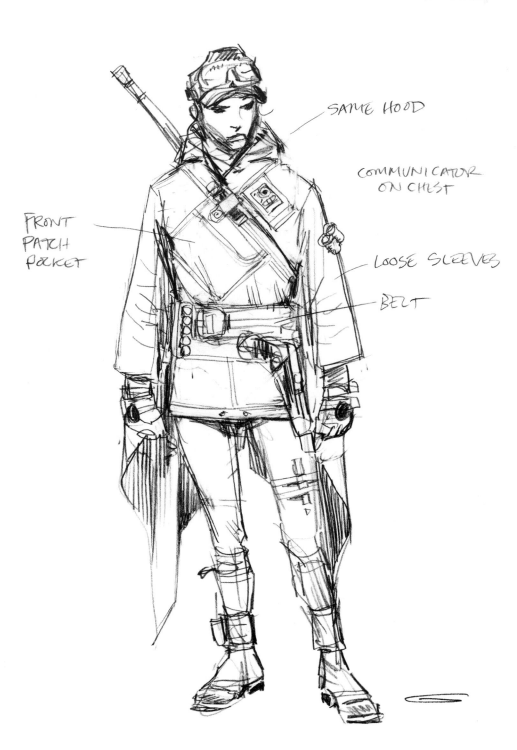

SAME HOOD

COMMUNICATOR ON CHEST

FRONT PATCH POCKET

LOOSE SLEEVES

BELT

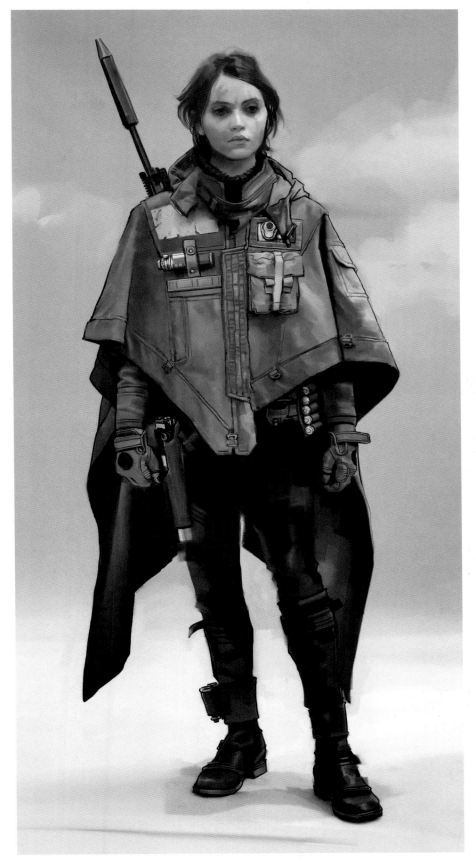

▲ **JYN IN "CONCHO" VERSION 1A** Dillon

▶ **JYN IN "CONCHO" VERSION 2A** Dillon

"Felicity [Jones] wanted Jyn to have an Eastern influence—which is appropriate for *Star Wars*, with so many Japanese influences. The mountain mission on Eadu was going to be a completely wet, freezing cold environment, so we tried to combine some Eastern looks with a poncho, and we ended up with this thing that we called the 'concho,' because it's a crossover coat mixed with a batwing poncho." David Crossman

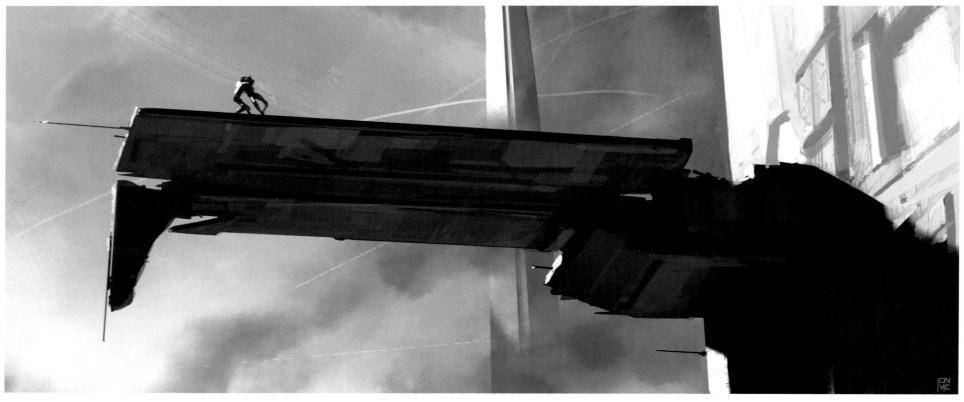

▲ **IMPERIAL LANDING PLATFORM EXTERIOR** McCoy

▼ **EADU PLATFORM EXTERIOR VERSION 1A** Tenery

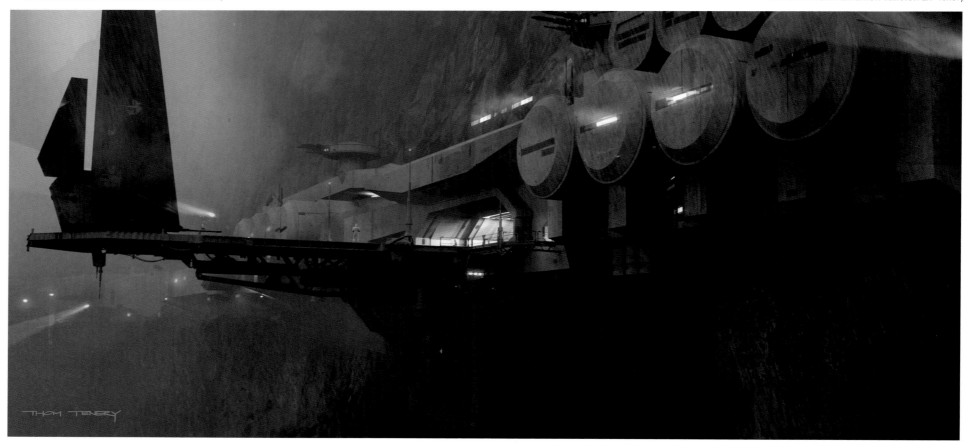

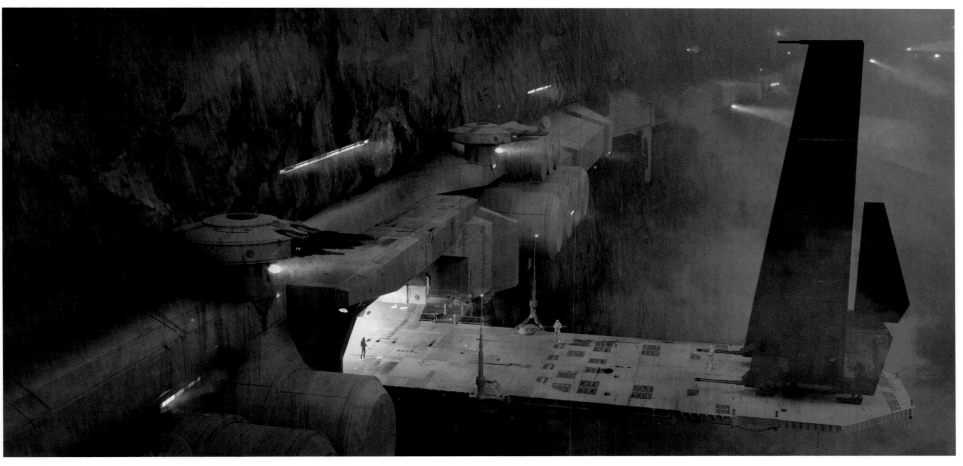

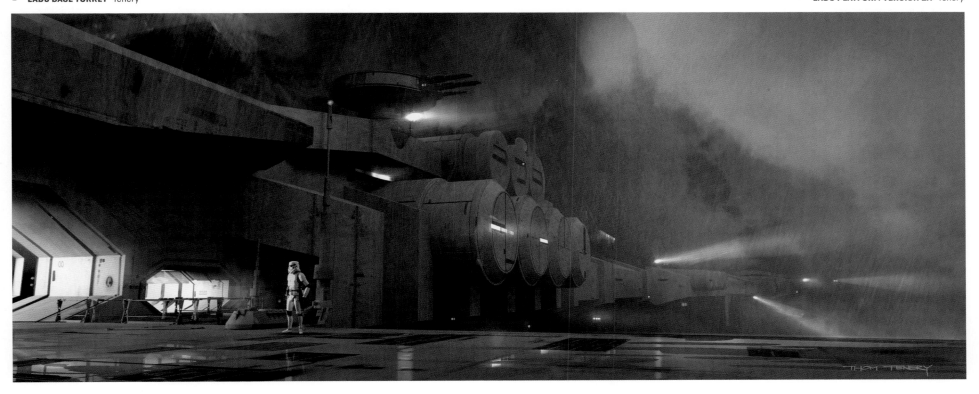

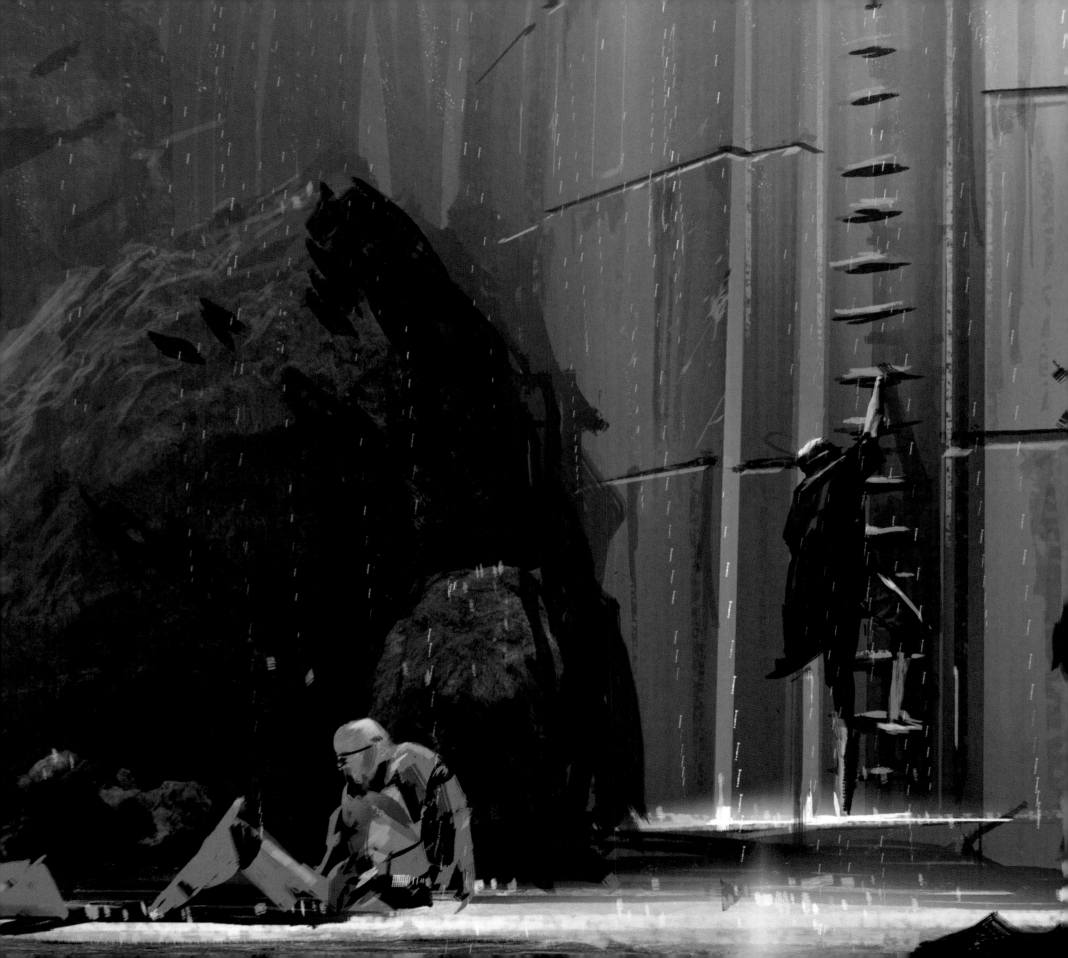

M. ALLSOPP

▲ **MOUNTAIN LANDING EXTERIOR VERSION 1A—KRENNIC'S ARRIVAL** McCoy

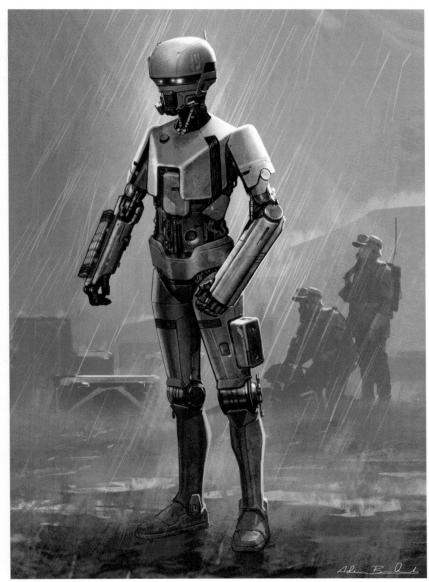

◄ **EADU LADDER** Allsopp

▲ **L1 PROTOCOL DROID VERSION 2I** Brockbank

U-WING LANDING CONCEPT BOARDS Allsop, McCoy, and Tappin

CLOSE ENCOUNTER ON EADU

One short sequence, ultimately excised from *Rogue One*'s final cut, was notable solely due to its behind-the-scenes inspiration: an adventure enjoyed by Matt Allsopp and Gareth Edwards during a brief weekend *away* from development. Allsopp recalled:

"I like to put just a bit of color into my storyboards—usually just one color, which is how we'd come up with the red flares for the HALO jump in *Godzilla* [2014]. I had the same idea on this—to add some green to the black-and-white boards. We had a nice moment where the U-wing is landing on Eadu, and as they descend into the canyon, they use a laser grid to measure the edge of the canyon—like whiskers from the ship, emanating out. The idea was influenced by a trip that Gareth and I took to Area 51.

"Gareth always promised me that we'd go to Area 51 during *Godzilla*. We just never had a chance to do it. But when we were in San Francisco working on *Rogue One*, we rented a big SUV and drove out to Area 51 [in Nevada]. It was a long drive and there weren't many cars on the road, because you're really in the middle of nowhere. Of course, you can't get onto the base, so we drove down this little dirt track toward the entrance. About half-way, we stopped and turned the engine off. It was really amazing,

sitting there in silence and looking up at the stars—though Gareth started playing the *Close Encounters of the Third Kind* soundtrack just to wind me up a little.

"Suddenly, there was this bright light in the desert—very low, in the distance. And then it just went out, and this massive *bang*—like an explosion—filled the air. It freaked us out, and right about then, a red light appeared ahead of us on the road. We figured it was security, so we turned around to head back to the road. But he started following us. So, we got to the highway and then turned to see what he was doing.

"Well, he got to the edge of the highway, and just turned his lights out. Disappeared entirely into the night. A second later, his car lit up green inside, flashing a grid-like laser light show onto the road. Gareth wanted to turn around to check it out, but then he turned his lights back on and started following us again—and then he starts scanning *us* with this laser!

"I'm sure he was just some guy trying to scare us, but what struck me was seeing this flashing green grid hitting the side of the rock canyons we were driving through. But the next day, we talked about it and we decided that we had to try to get that green laser into the film."

U-WING LANDING CONCEPT BOARDS Allsop, McCoy, and Tappin

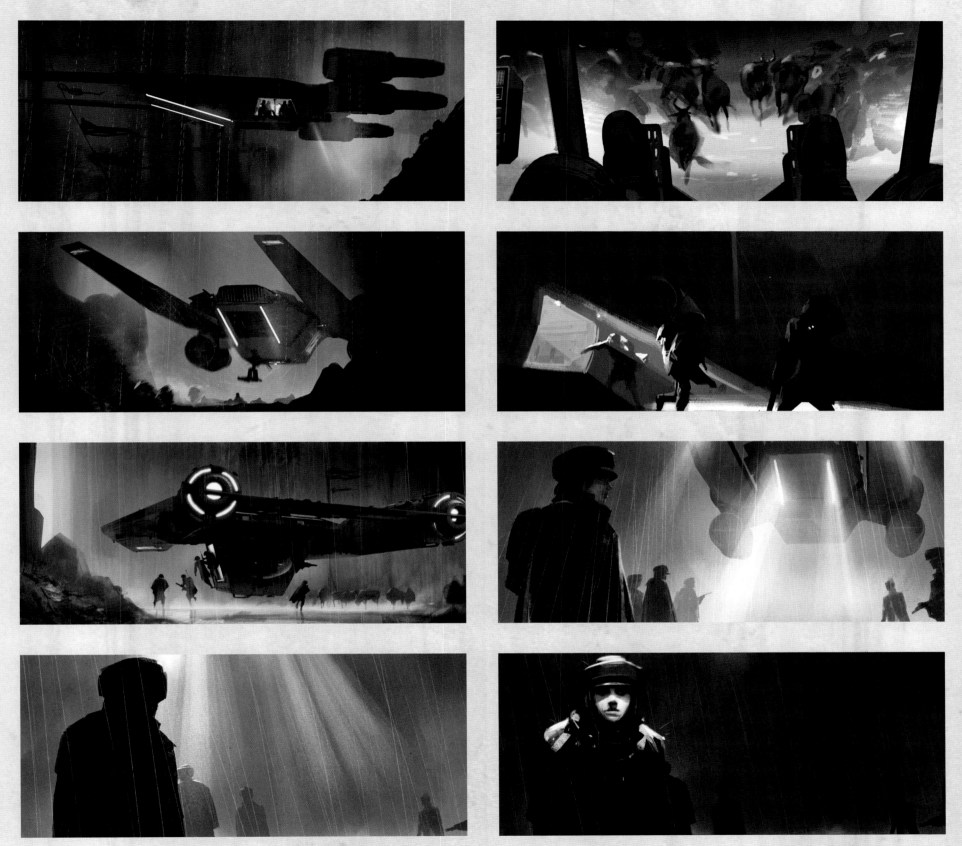

▶▶ **VADER'S LAIR EXTERIOR VERSION 1A** McCoy

MUSTAFAR

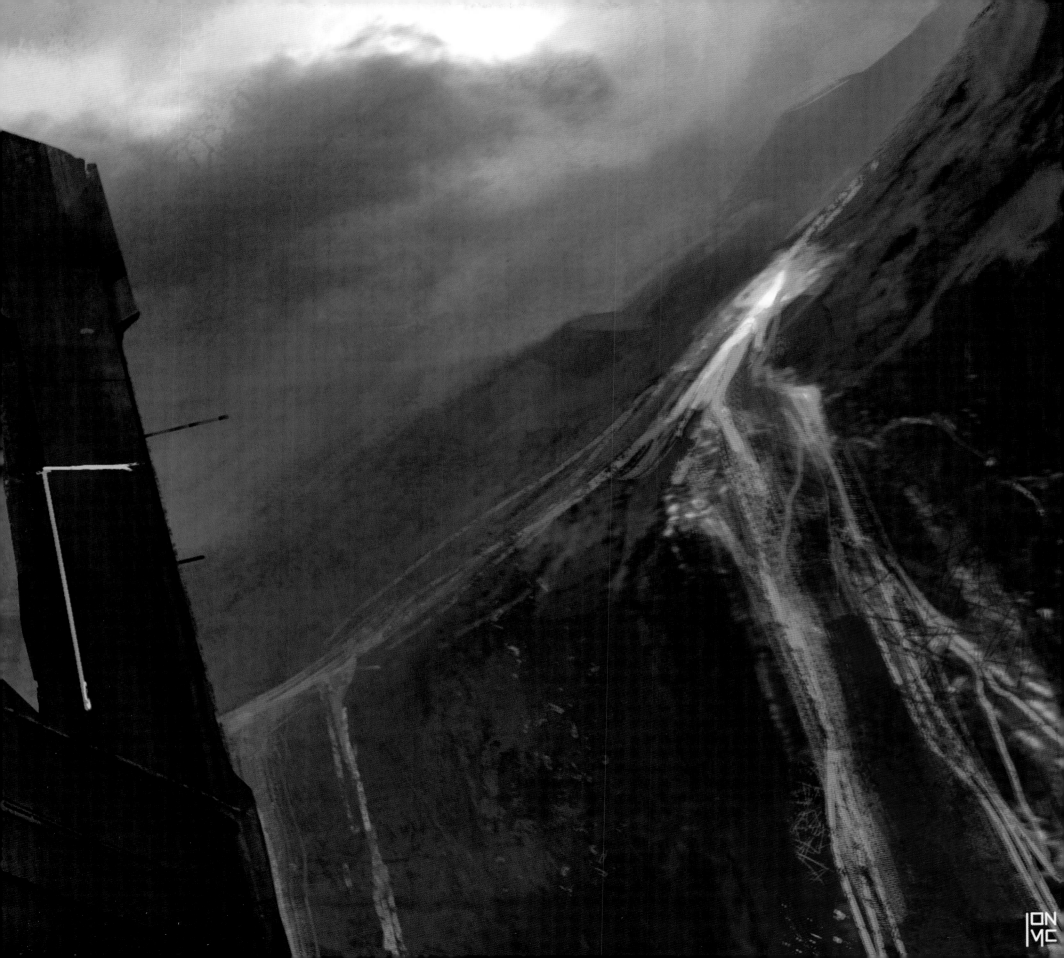

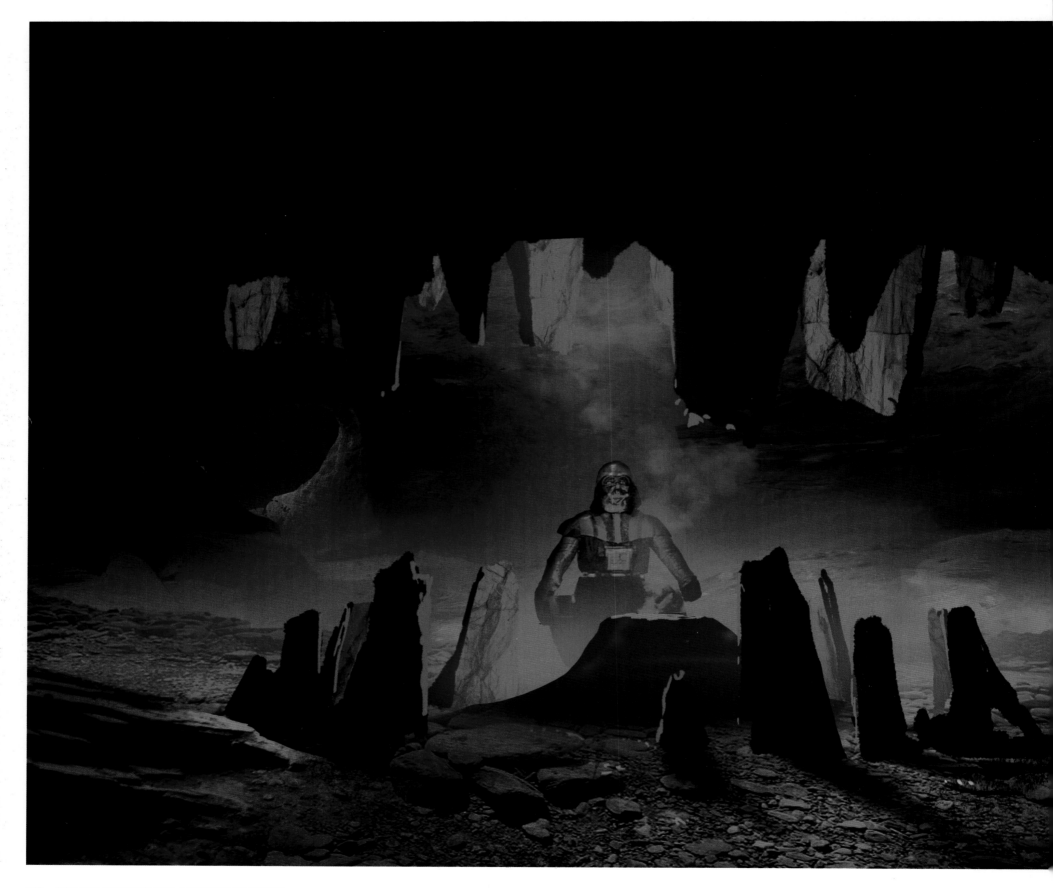

Vader's Lair

At this point in the general *Star Wars* timeline, Darth Vader reigns supreme as an avatar of evil—and the fact that the Dark Lord was still stalking around the galaxy provided not only the opportunity to make use of him in *Rogue One*'s narrative, but also to explore previously unseen aspects of his character and his place in the Empire.

When developing initial designs for *The Empire Strikes Back*, celebrated *Star Wars* artist Ralph McQuarrie had imagined a nightmare castle for Darth Vader—a domicile, asylum, and audience chamber to match the character's own visual menace. Though *Empire*'s story development took a different turn and eventually moved away from depicting the Sith lord's lair, McQuarrie's vision of a lava hellscape would find its way on screen a quarter century later as Mustafar in *Revenge of the Sith*.

"There were all these original designs, early development art from Ralph McQuarrie, that never made it into the films," said Doug Chiang. "A lava planet, Mustafar, finally showed up in *Revenge of the Sith*. When we established Mustafar as Vader's home for *Rogue One*, we then needed more interiors and a bigger picture. So it was really fun to dig up those old McQuarrie designs, to figure out how to blend them with our aesthetic, as well as the aesthetic from *Revenge of the Sith*."

Described in the script as "a towering, monolithic obsidian fortress of stark, brutalist design," Vader's Mustafar castle in *Rogue One* would be concepted, designed, and explored beyond the few images originally envisioned by McQuarrie—and beyond even the narrative needs of *Rogue One* itself.

"We were building worlds, so we always had to keep in mind the broad strokes and the big picture, in case they were ever needed for the story," said Chiang. "We don't see it all right now, but the idea was that Vader's castle was built over a natural cave—a Sith cave deep down below, in the lava field."

Staged atop an unseen, cavernous Sith sanctuary amid the fire and brimstone of Mustafar's infernal lava flow, the foreboding setting is a place of refuge for Vader—the violence and turmoil of the roiling purgatory outside the castle walls providing scenery appropriate for a Dark Lord, while also illustrating the evil of his own twisted soul.

"The castle on Mustafar is this insanely uninviting place— a really evil place, deeply uncomfortable. But this is where Vader stays, because it's the only place *he* feels comfortable,"

◄ **MUSTAFAR MEDITATION CHAMBER 1** Church

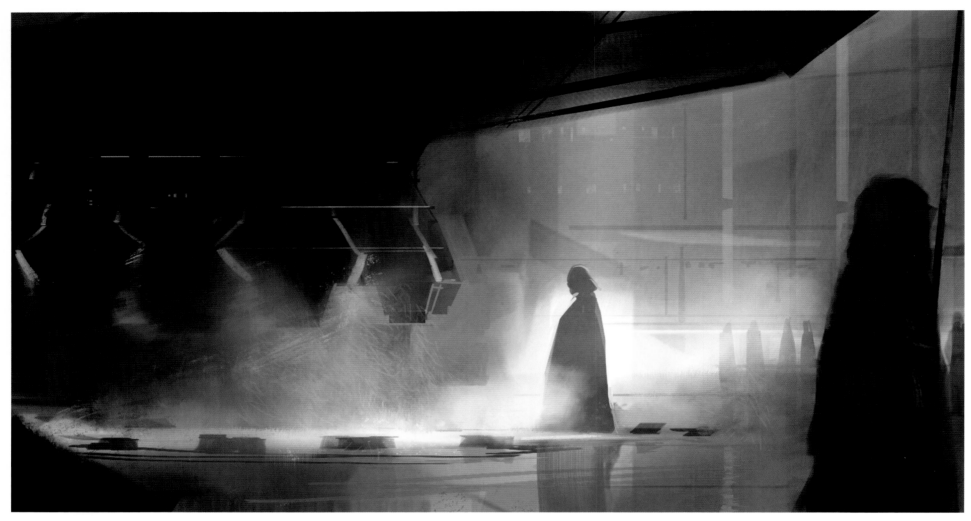

said Christian Alzmann. "The idea is that he would have a massive cylindrical machine in the center of his room—and in the center of that machine is a one-person bacta tank that looks out through a window onto the lava fields of Mustafar. It's both a meditation and a healing chamber."

Serenity for one such as Vader, however, provided the artists opportunities for indulging their wildest fantasies of the macabre. Twisted and evil, the former Skywalker's notions of relaxation conjured images of horror for those tasked with imagining his dark haven.

"There's a lava river underneath, bottom-lighting the room eerily. These arms would come down to pull apart the chamber the way you might separate a pill capsule, and the bacta would leak out on the hot grills to create steam—partially because steam is so atmospheric and awesome, and partially because you don't really want to see a naked Vader," said Alzmann. "But there would be hints and glimpses of his twisted body breaking

through the steam. And then, at the end, you might barely read a silhouette of the helmet as it comes down."

The images emerging from the art department aligned perfectly with those imagined by Gary Whitta, whose draft of the *Rogue One* script featured the first appearance of Vader's lair.

"It would be like seeing something you might find in a jar at a carnival freak show—this really unsettling and unidentifiable naked form just floating in the bacta tank—and then realizing it's Vader, that this is all he is with the armor off, that there's very little of him left," Whitta said. "You realize that he's this crippled, broken, tragic figure—and that what he's looking at through his window is the location where his duel with Obi-Wan took place. The fact that he'd chosen to build his living mausoleum here is a nod to the conflict in him—that he would go back to this place to reflect on what happened to the man he once was. At the same time, it's also terrifying, and when he emerges with all of his armor, he's Darth Vader."

▲ **MUSTAFAR WIDE VERSION 11** Allsopp

▲ **MUSTAFAR EXTERIOR VERSION 9** Allsopp

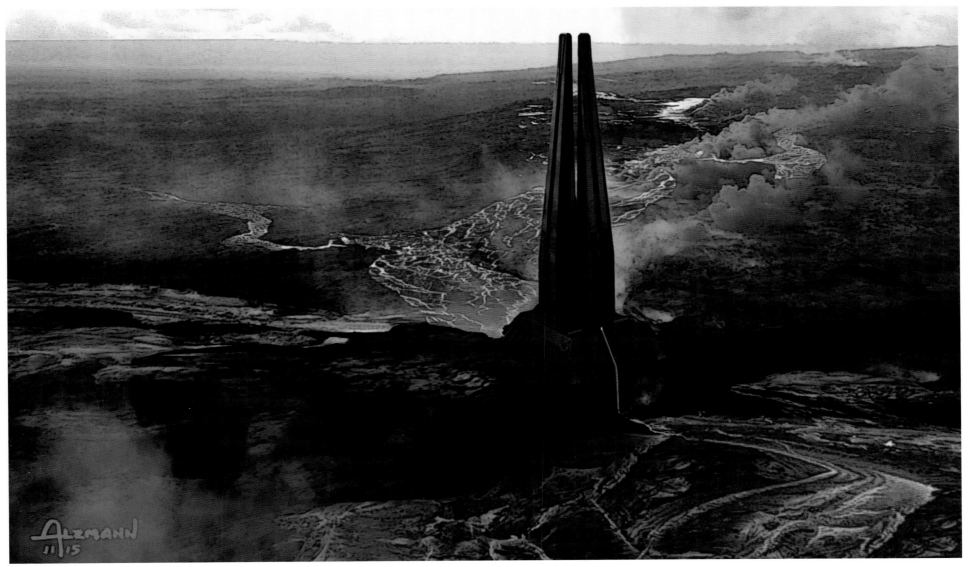

▲ **VADER'S CASTLE EXTERIOR VERSION 5** Alzmann

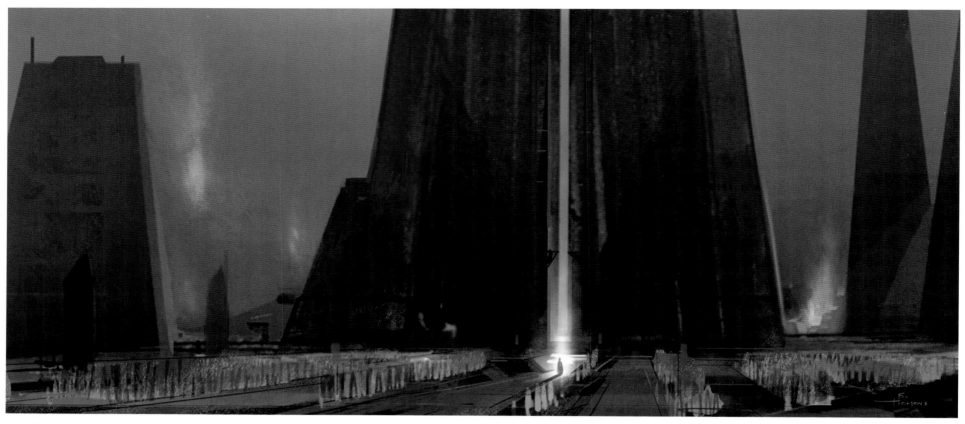

MUSTAFAR LONG LENS EXTERIOR VERSION 1 Tiemens

MUSTAFAR WIDE EXTERIOR VERSION 4 Tiemens

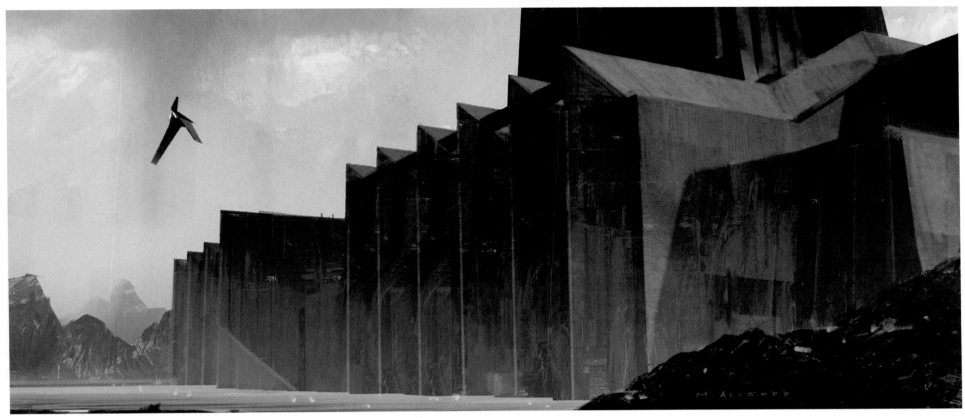

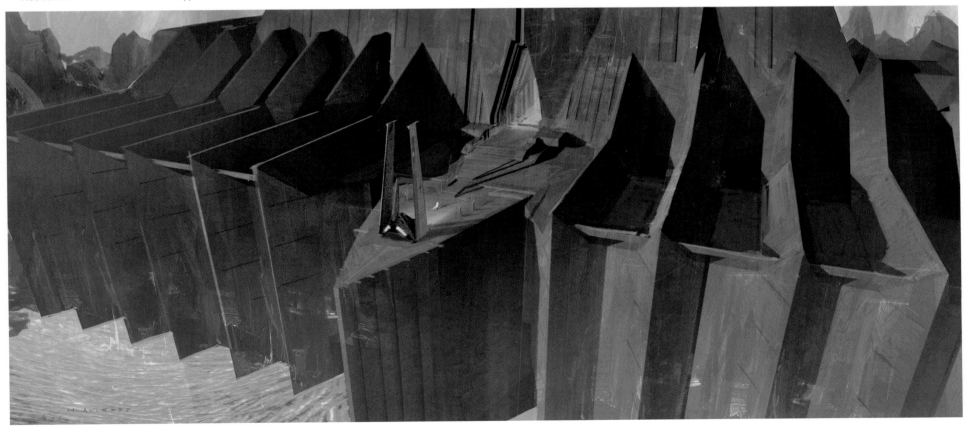

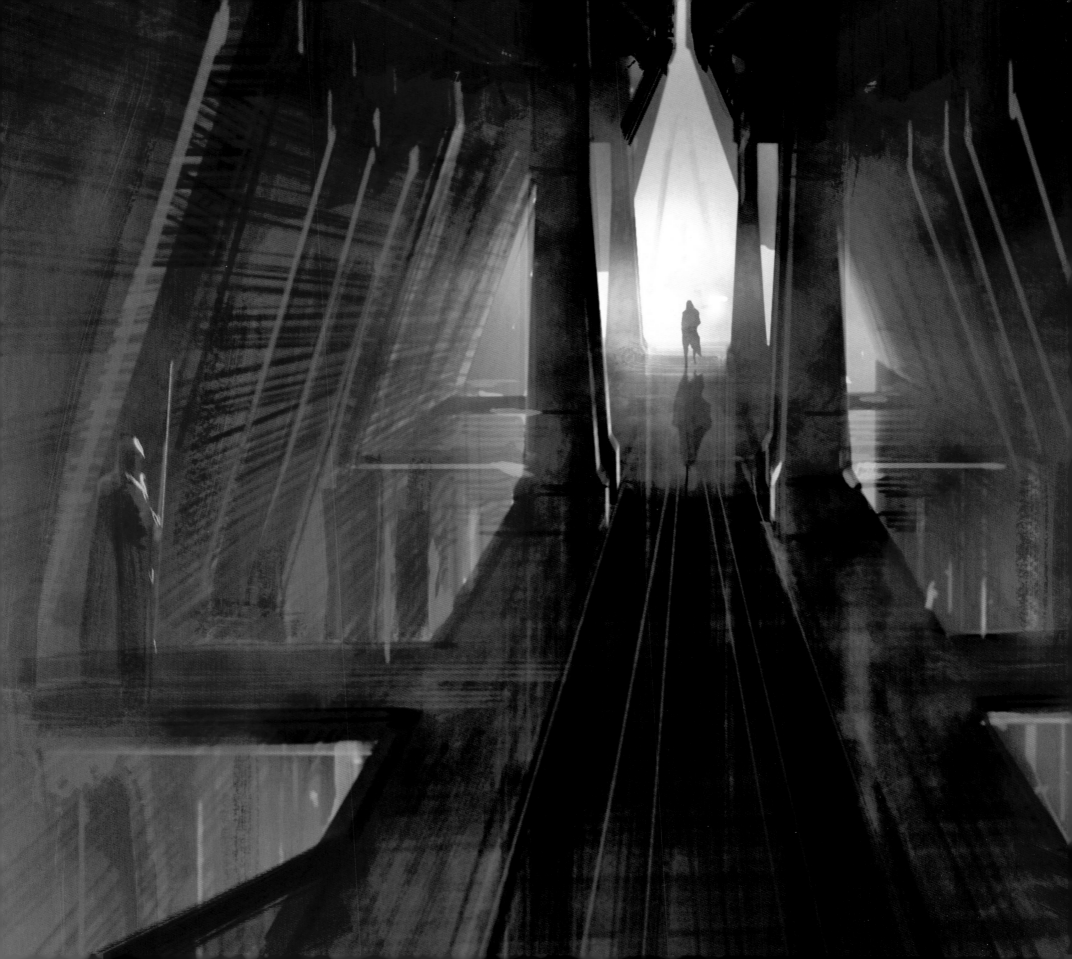

SITH RELIEFS VERSION 2 "Krennic's a pretty bad guy, but I wanted to put that in context when he visits Vader. In the design, he's forced to walk down this scary, imposing, lava-lit hallway with religious Sith reliefs on the wall. Sith lords use fear to their benefit, and I think Vader knows he's putting Krennic in his place, throwing him off: 'I know you're important, but you're not *this* bad.' It's definitely a little *Temple of Doom*, but you can't go wrong with that approach. I can definitely see darts coming out of the reliefs if he steps in the wrong place." Alzmann

VADER'S CASTLE INTERIOR Allsop

BACTA CHAMBER ANTEROOM VERSION 1 Alzmann

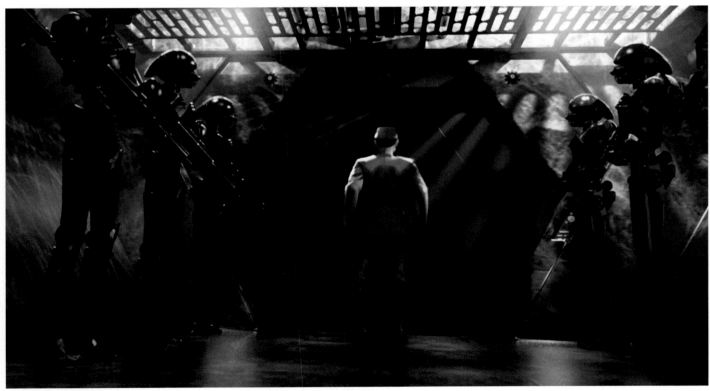

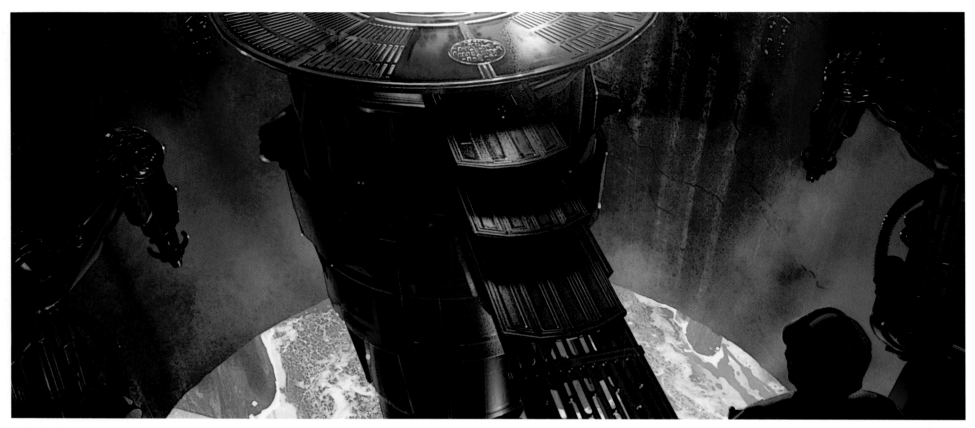

BACTA TANK MECHANICAL ARMS VERSION 34 Alzmann

BACTA CHAMBER VERSION 27 Alzmann

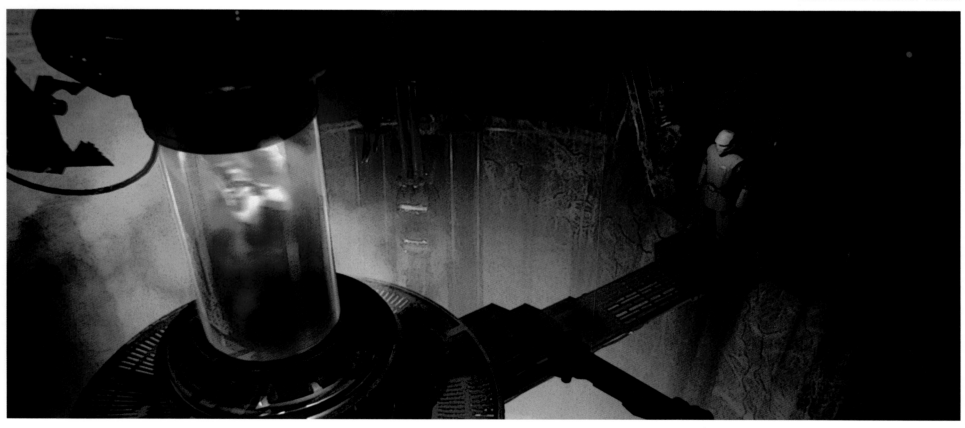

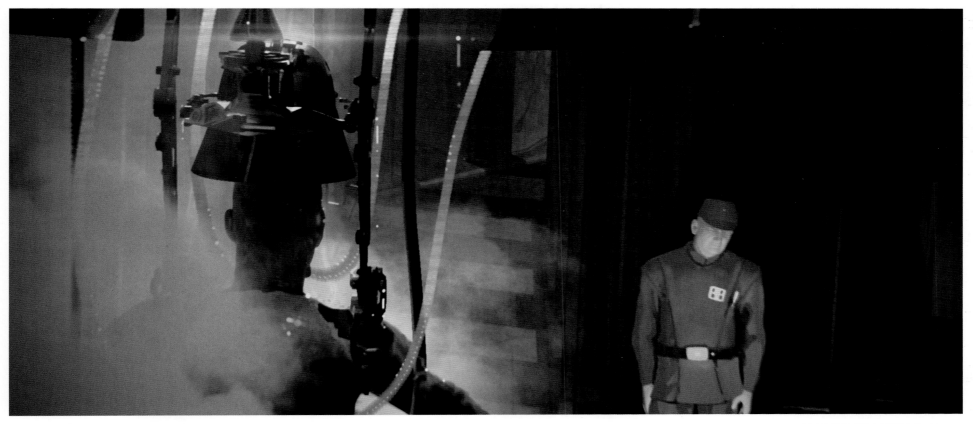

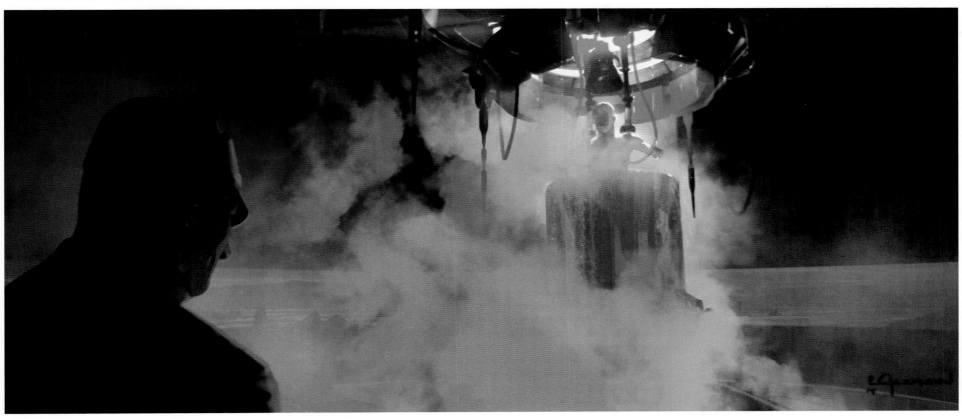

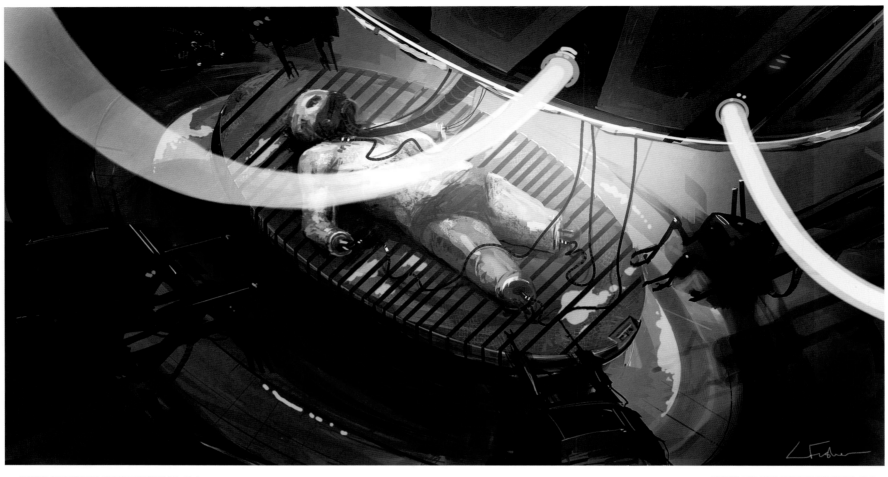

▲ **VADER ON MEDICAL TABLE VERSION 1A** Fisher ▼ **VADER IN BACTA TANK VERSION 1B** Fisher

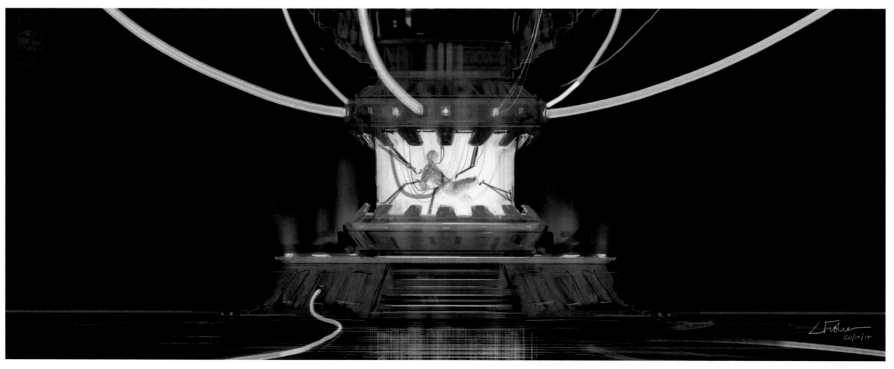

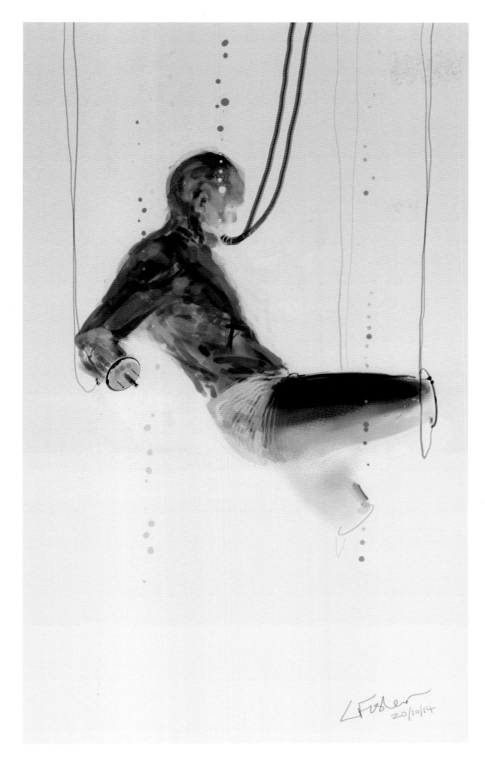

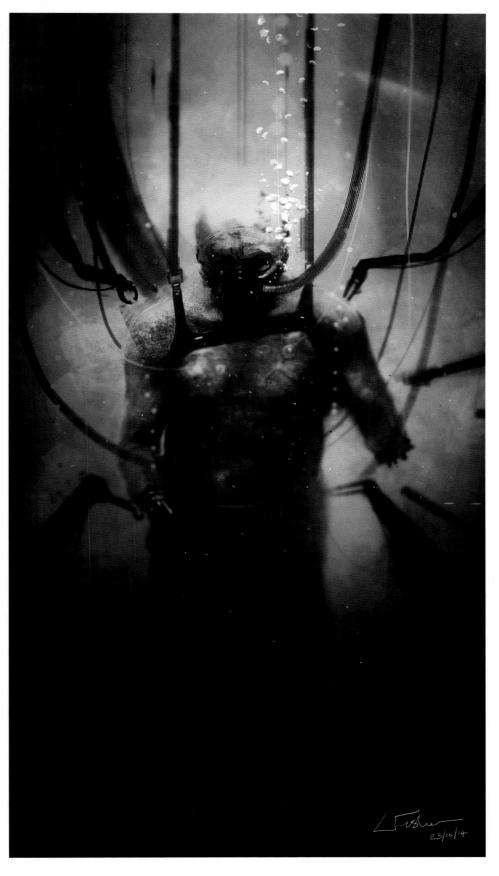

▲ **VADER IN BACTA TANK VERSION 3A** Fisher

▶ **VADER IN BACTA TANK VERSION 6A** Fisher

"When I saw the concept art for Vader's lair, I knew it was going to kill. I knew everyone was going to love it. I wasn't in the room when she saw it, but I was told that Kathy Kennedy really responded to it and the idea that Vader would choose for himself such a hellish kind of chamber." Gary Whitta

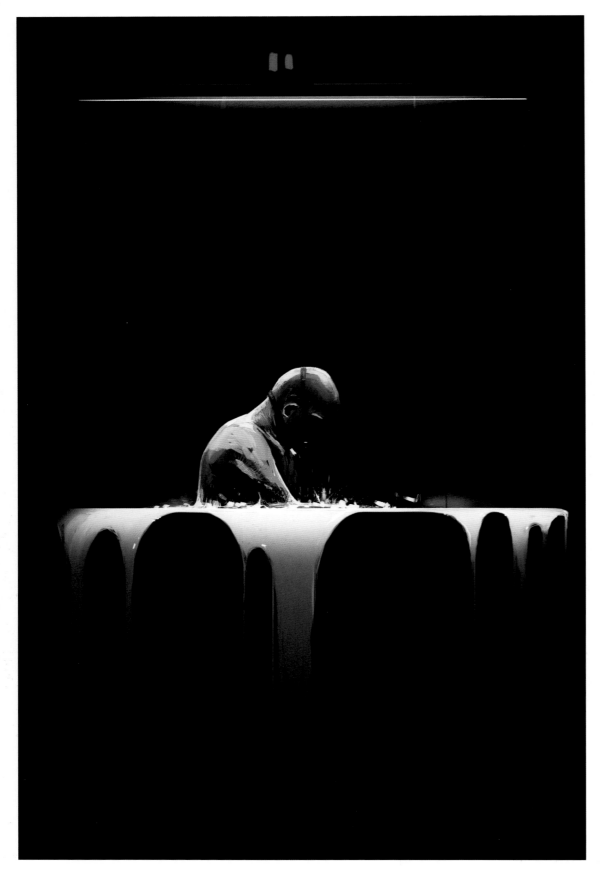

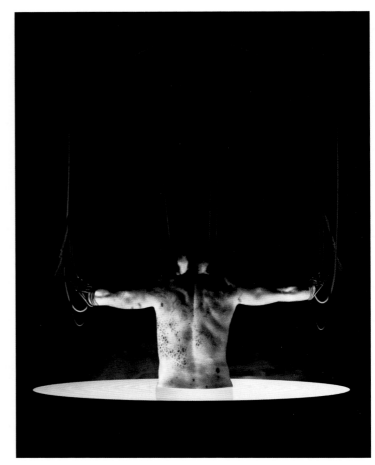

▲ **VADER RISES FROM BACTA VERSION 1A** Fisher

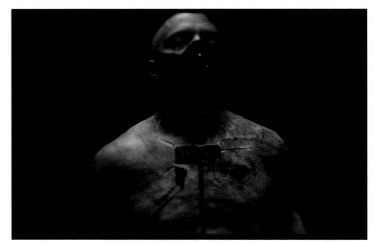

▲ **VADER IN BACTA VERSION 2A** Fisher

◄ **VADER IN BACTA VERSION 1B** Fisher

"The idea was that Vader would need to sometimes remove all of his armor to completely replenish his depleted body, but that his private place wasn't actually an Imperial location. We called it Vader's spa, Vader's crib, Vader's relaxation center—but we pictured it as this really dreadful place with Albert Speer-like brutalist architecture." Whitta

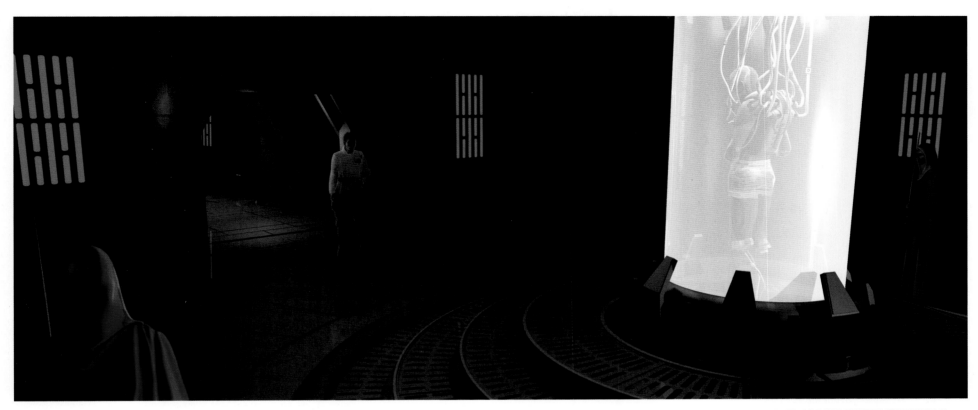

▲ **BACTA CHAMBER INTERIOR VERSION 1A** Julian Caldow

▼ **BACTA CHAMBER INTERIOR VERSION 2B** Tenery

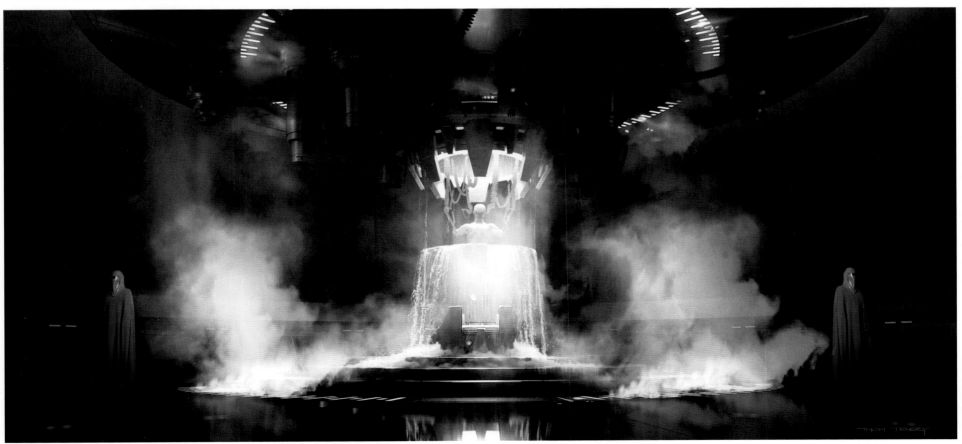

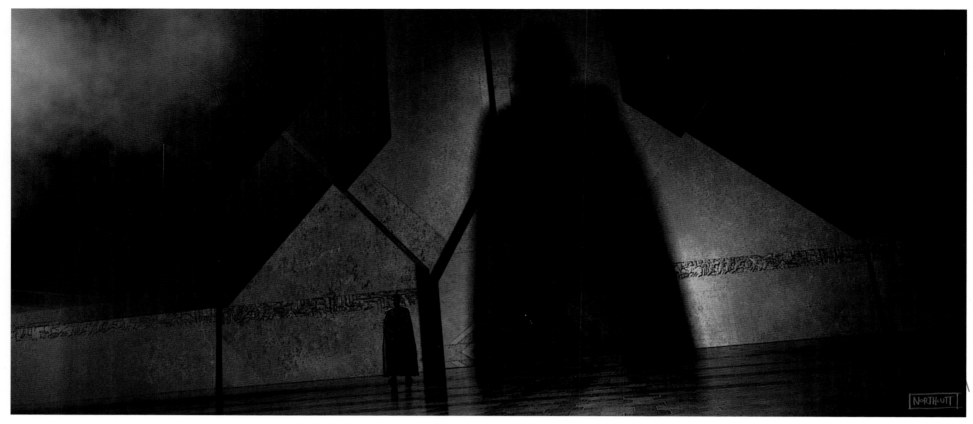

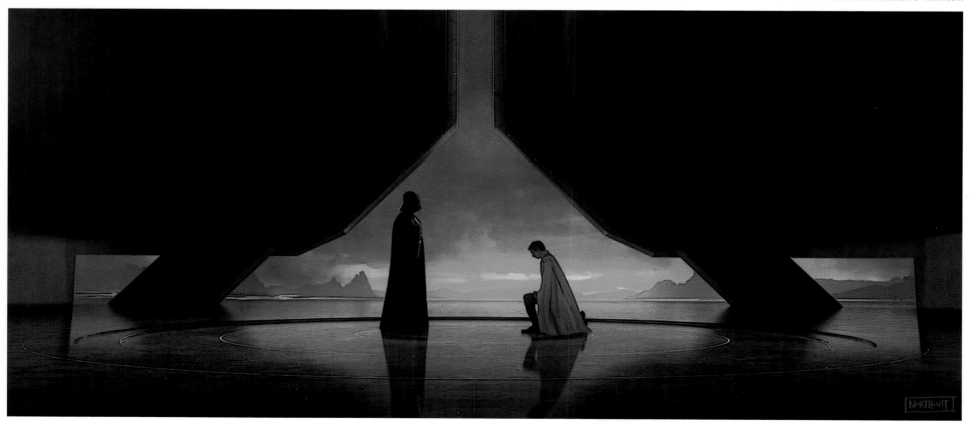

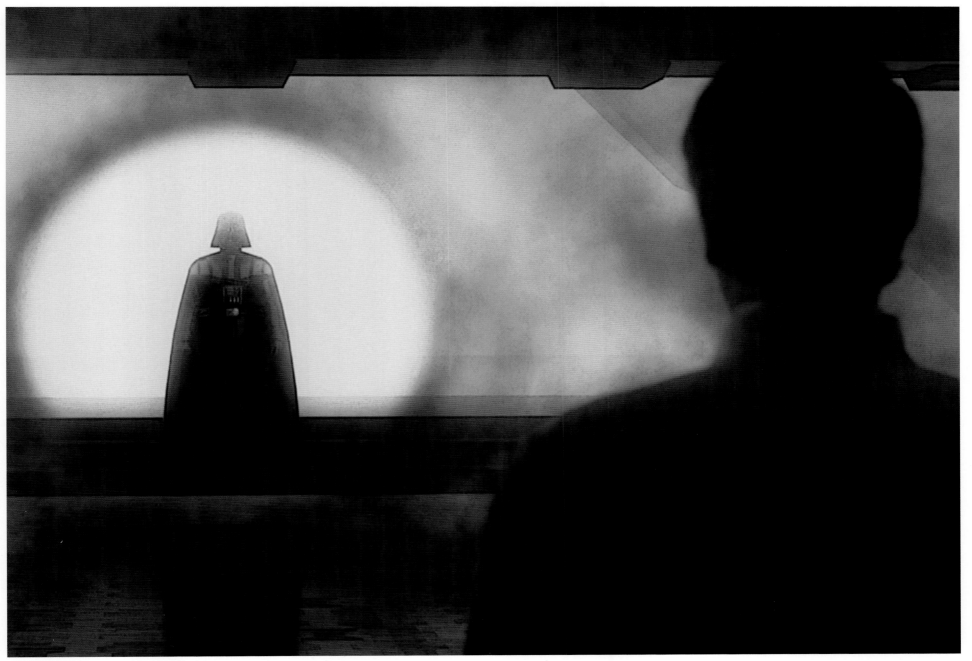

▲ **VADER'S CHAMBER VERSION 4** Northcutt

▸▸ **SCARIF EXTERIOR VERSION 1A** Tenery

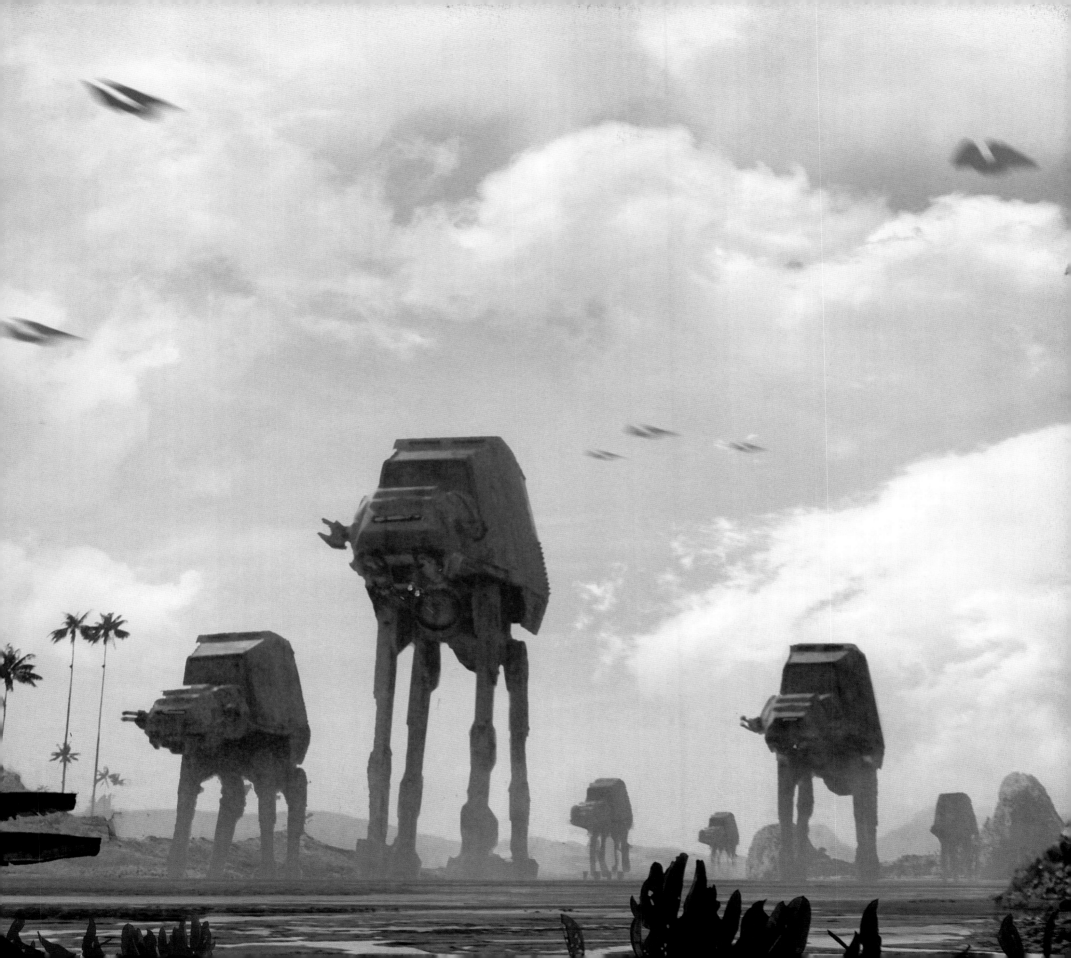

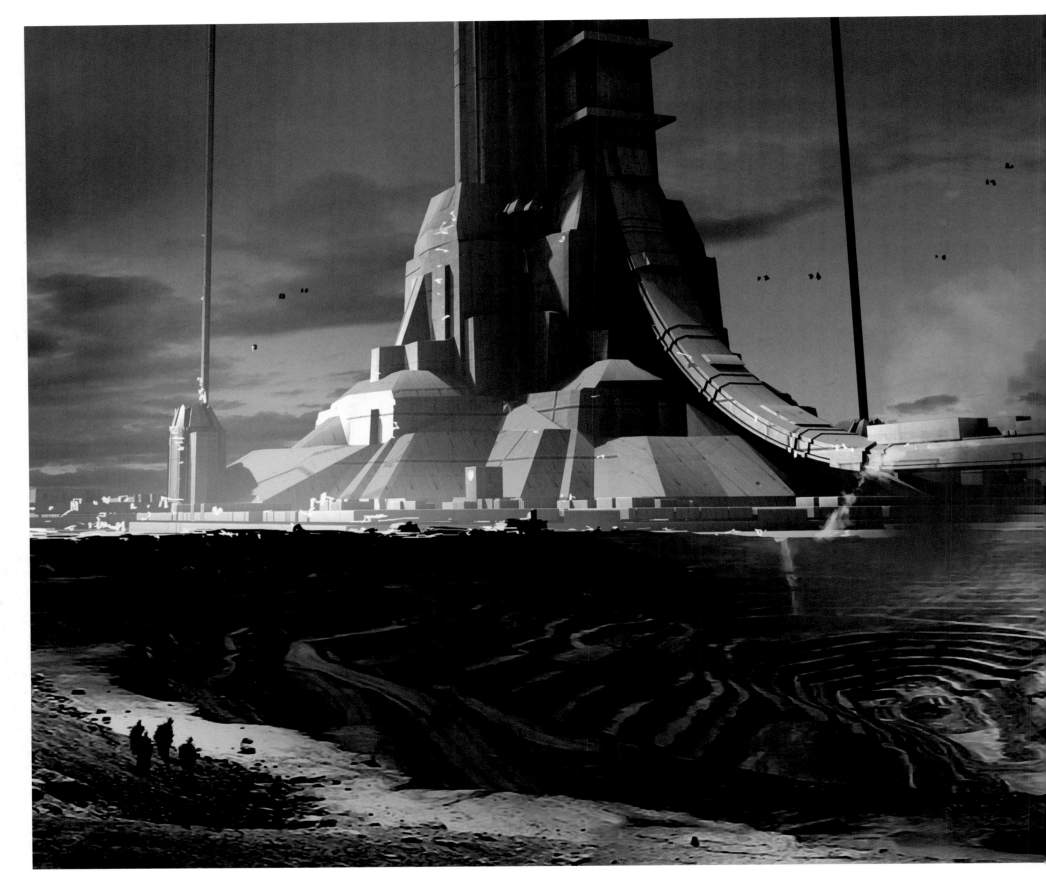

The Final Battle

The existence of the Death Star proven, there remains only the question of how the rebels can combat it—and with Alliance leadership locked in debate over how best to resist the Empire in light of this new intelligence, Jyn and her team are forced to take matters into their own hands. Going rogue from even the Rebellion itself, they launch their own secret infiltration on the Empire's secret base on Scarif—a desperate suicide mission to the heart of Imperial space, and a last-ditch effort to find a way to stop the ultimate weapon before it can wreak havoc upon the galaxy.

"Very early on, Gareth [Edwards] wanted to set the end battle in a very dramatic place—visually dramatic," said Doug Chiang. "He wanted to create a tropical paradise, because he wanted Jyn's story arc to land her in a bright and crystal clear location, to show that she's now completely clear about her mission."

Even beyond its service to the emotional color trajectory of *Rogue One*'s hero's journey, the setting for the film's finale excited the artists' sense of visual novelty, standing as it does in stark contrast to the conventional approach to climactic blockbuster settings.

"You see a lot of movies where the third act—the final battle—is gloomy, cloaked in shadow and darkness. I really liked the flip on that, that we were doing something that felt so different in this tropical location. I'm not even sure how Gareth came up with the idea for Scarif—that it was going to be a paradise—but as soon as he said it, I could see the whole thing," said Matt Allsopp. "It also worked with the idea that the Empire was destroying this beautiful location—trenches ripped out of the ground as they've strip mined the surface. Everything about the Empire's presence on Scarif would create this digital, industrial feel that would radiate outward. It all focuses down to our story there."

Jon McCoy agreed, emphasizing that the location's setting heightened the climactic action of the finale. "You *see* the Empire eating the landscape. You can *feel* that it's wrong. The contrast of that beautiful landscape to that brutal industrialism sets a really nice juxtaposition for the end of the film," he said. "You get that feeling of the loss of paradise and the loss of the environment itself to these industrialized canyons of the Empire. You don't want to see that, to see this landscape ruined. It tells you what the Empire is, what they are all about—so it becomes that much more rewarding when the rebels find a way to fight them, when they get the Death Star plans."

◄ **DEATH STAR BASE PLANET—SPACE ELEVATOR** Church

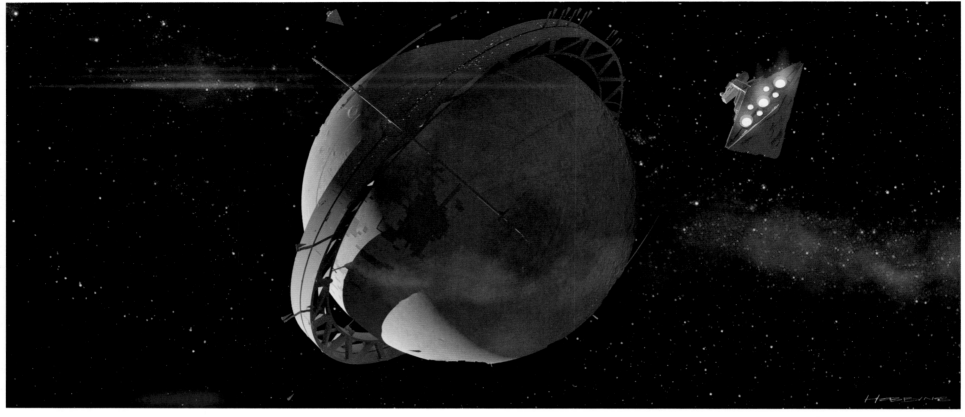

▲ **DEATH STAR BASE PLANET—IMPERIAL MINING WORLD VIEW A** Hobbins

▼ **DEATH STAR EXTERIOR—IMPERIAL INTELLIGENCE CENTER VERSION 1** Northcutt

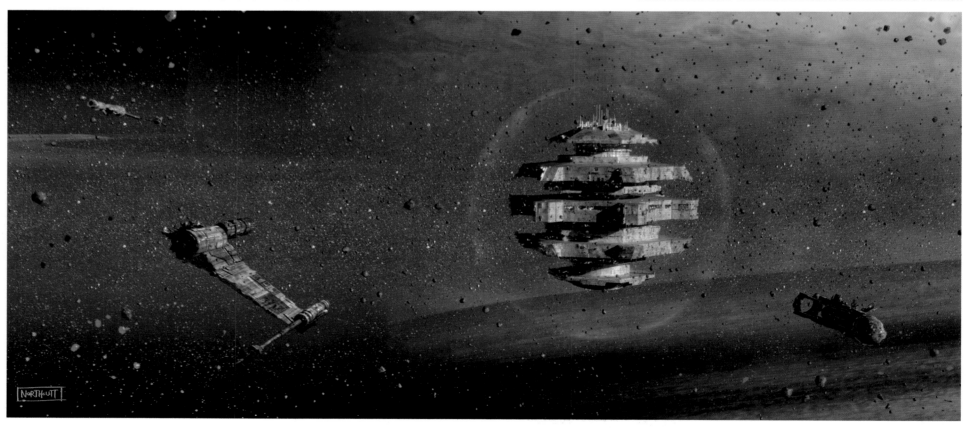

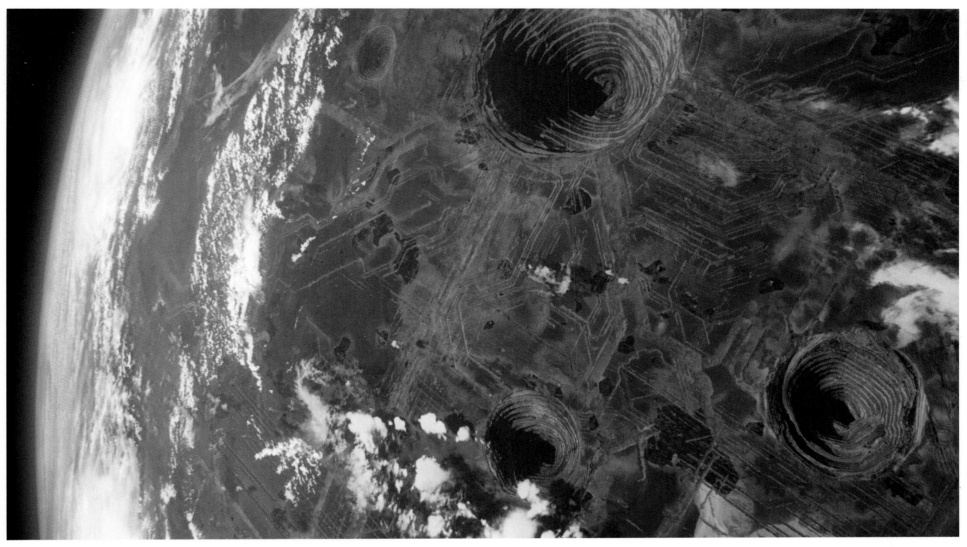

In addition to illustrating the major themes of *Rogue One*—the Empire's corrosive effect on the galaxy, the need for heroes willing to stand against their encroaching evil—Chiang points out the narrative utility of Scarif's idyllic settings, which distinguish the film from previous *Star Wars* installments while also maintaining a visual cohesion.

"It's visual storytelling, imbued in the location," he said. "And it's also a great staging place for an action battle. You have shallow water, palm trees, blue skies—but slowly over the course of the action sequence, it's scarred by explosions and smoke and you are able to see the tone shift, visually. Gareth wanted a rich palette for that, for this grittier action film—an infantry ground battle with rebels and troopers running through bright sand. It was a visual image he'd had from early on, and something we hadn't seen yet in a *Star Wars* world, and yet it fits really well."

But fans familiar with the opening crawl for the original *Star Wars* film know to expect more from *Rogue One*'s climactic finale than just the theft of the Death Star plans—that in addition to the covert activities of the spies audiences will come to know as Rogue One, rebel spaceships will also win their first victory against the evil Galactic Empire. High above the ground assault, in space above Scarif, there is another battle raging.

"What Gareth wanted to do was to have a classic *Star Wars* approach to the third act, with a three-pronged battle—one in space at an Imperial docking facility, one in the atmosphere, and one on the ground," said Chiang. "And the fourth thread would follow our heroes intimately, as they sneak onto the base itself to steal the plans."

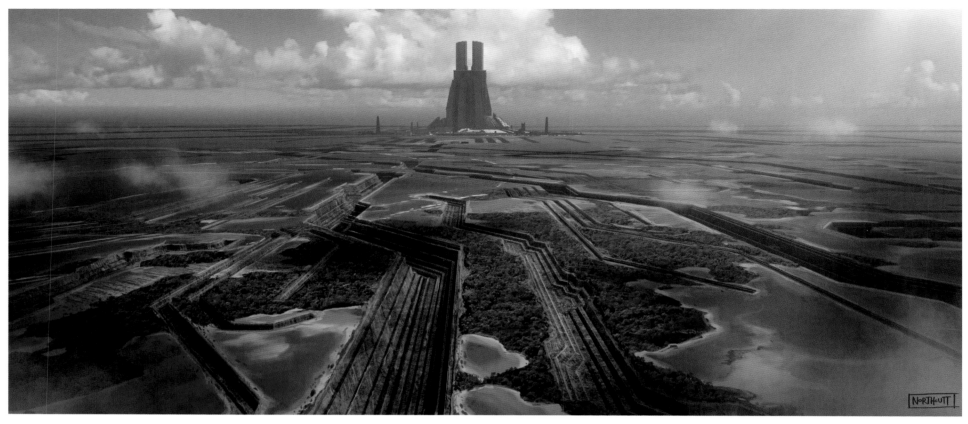

▲ **SCARIF ISLAND AERIAL VIEW VERSION 5** Northcutt

▼ **IMPERIAL BASE PLANET—SPACE ELEVATOR** Church

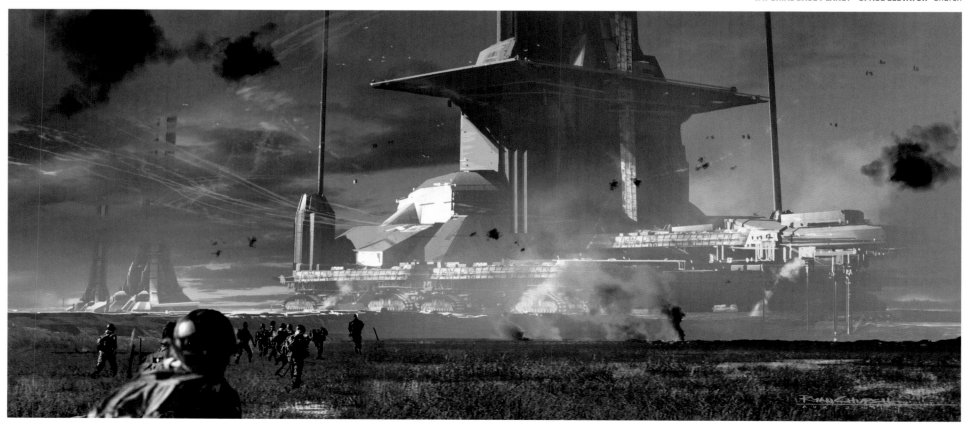

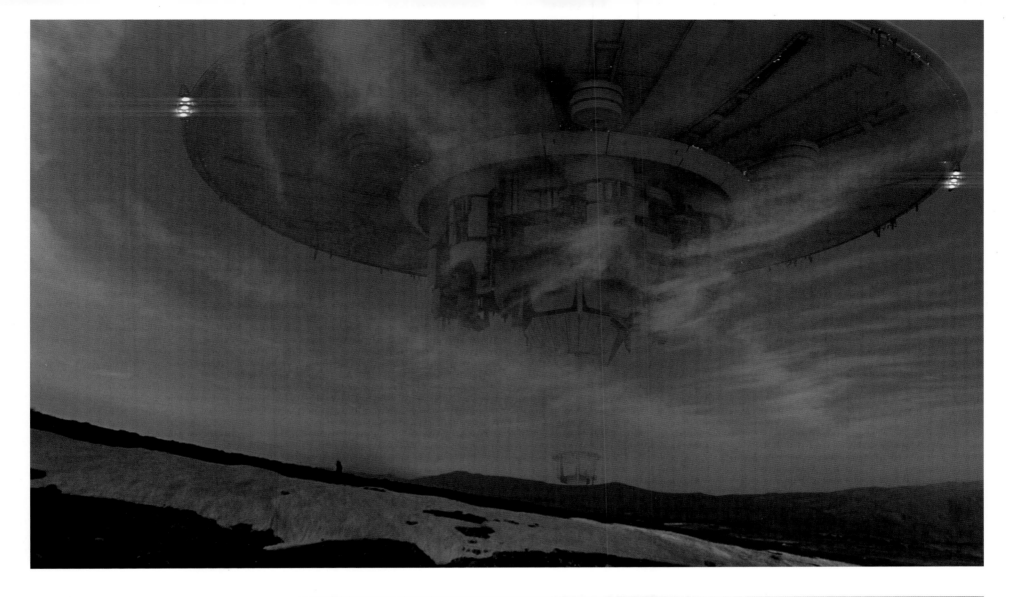

▲ **FACTORY PLANET—DEATH STAR DISH** Church

▶ **IMPERIAL BASE PLANET—DEATH STAR DISH (SUBTERRANEAN)** Church

"At one point, a mountain planet with a hidden base was going to house the inner dish of the Death Star, and we had to give it a sense of scale. There was an idea that it would rise up out of a mountaintop lake to ultimately attach to the Death Star as it was being built—but that was just crazy. It's way too big! Even just the navel was far too massive." **Tiemens**

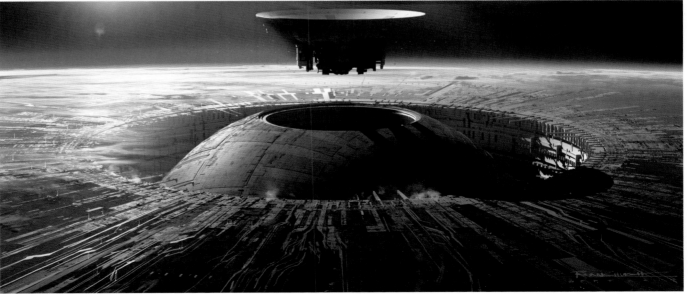

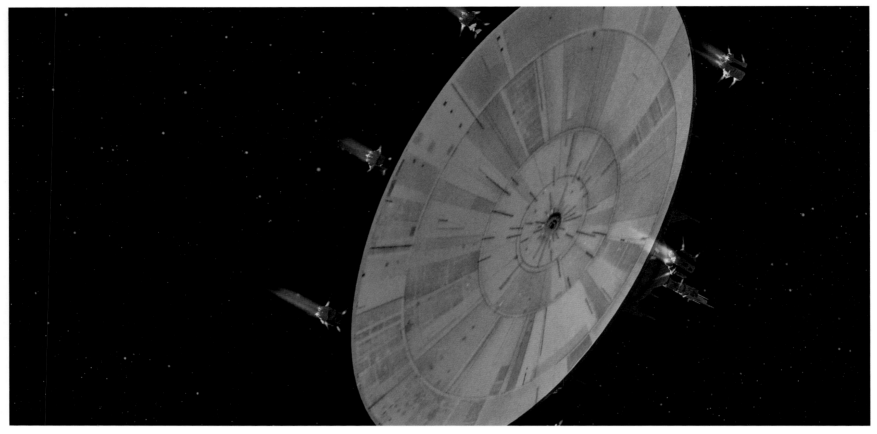

▲ **DEATH STAR DISH VERSION 3** Hobbins

▼ **STAR DESTROYER DOCK VERSION 2A** Tenery

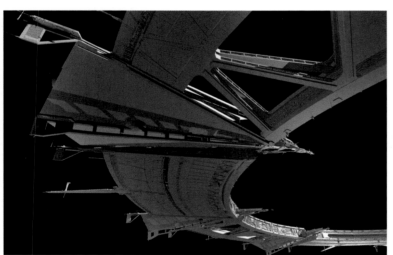

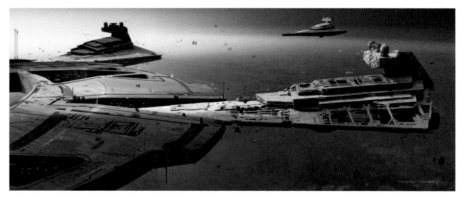

▲ **STAR DESTROYER SPACE DOCK EXTERIOR VERSION 5E** Church, Garcia, and Tenery

▶ **STAR DESTROYER DOCK VERSION 2A ALTERNATE** Tenery

"Gareth loves the idea of creating symbolic graphics, and here we were dealing with the idea of channeling all the visuals to our finale. The idea for the space battle was that it would focus on an Imperial docking facility above the planet Scarif—channeling through a ring to the planetary shield and down to the surface. It was all aligned, with the citadel directly below the shield; that was where the heroes were going to steal the plans. Graphically, it directed the story." Chiang

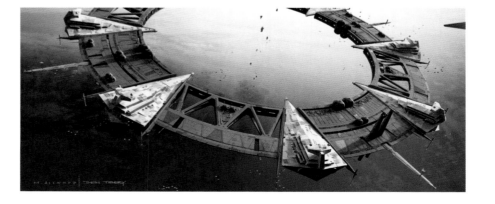

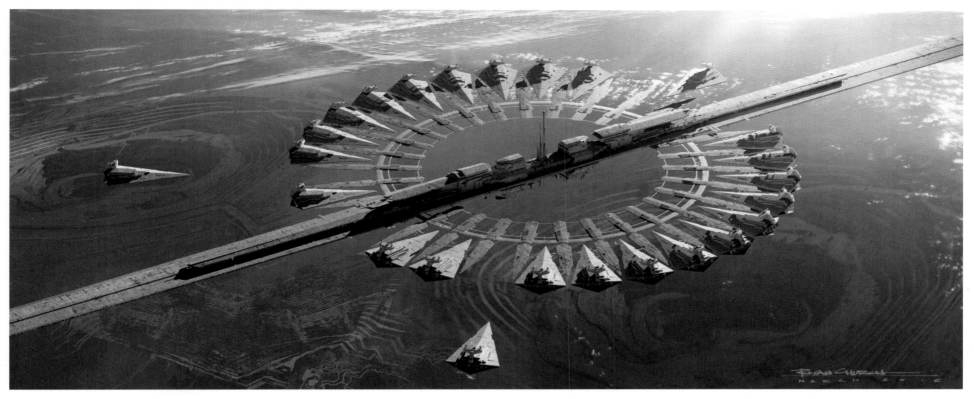

IMPERIAL BASE PLANET—STAR DESTROYER DOCKING BASE Church ▾ STAR DESTROYER SPACE DOCK VERSION 7 Church ▶▶ STAR DESTROYER SPACE DOCK VERSION 8 Church

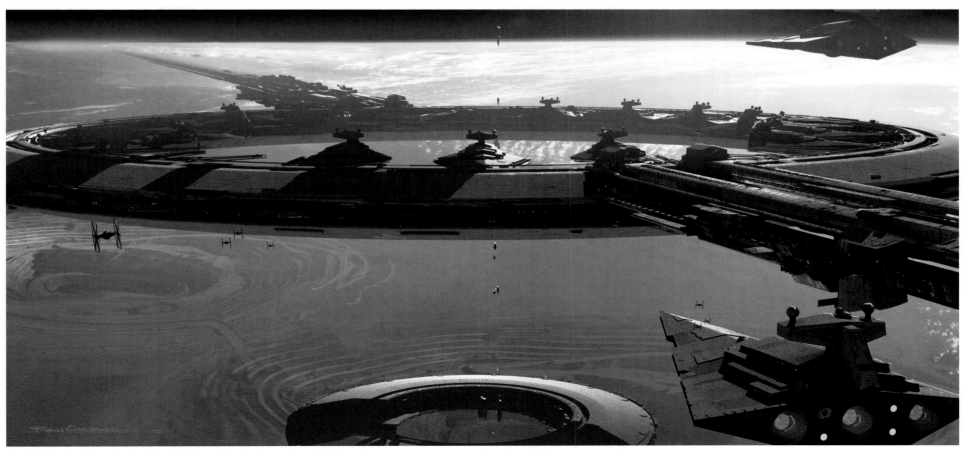

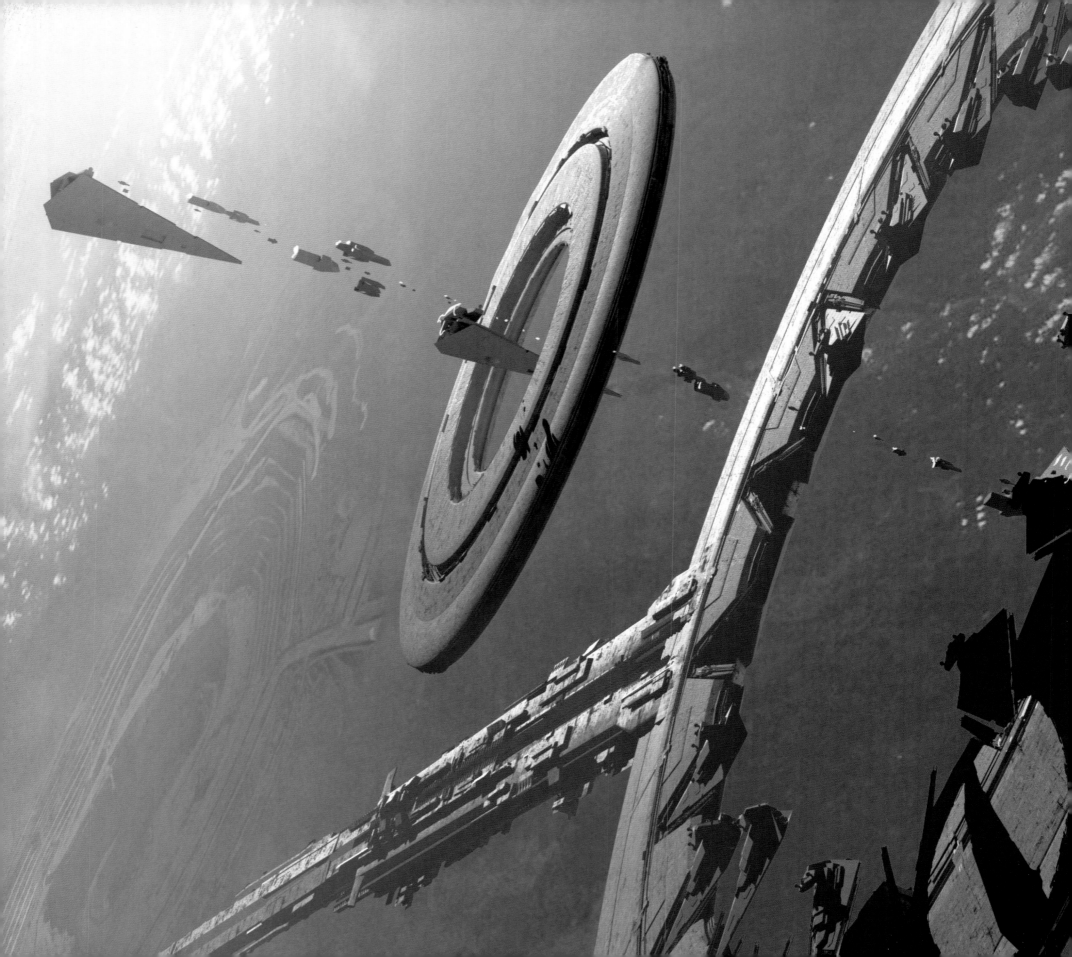

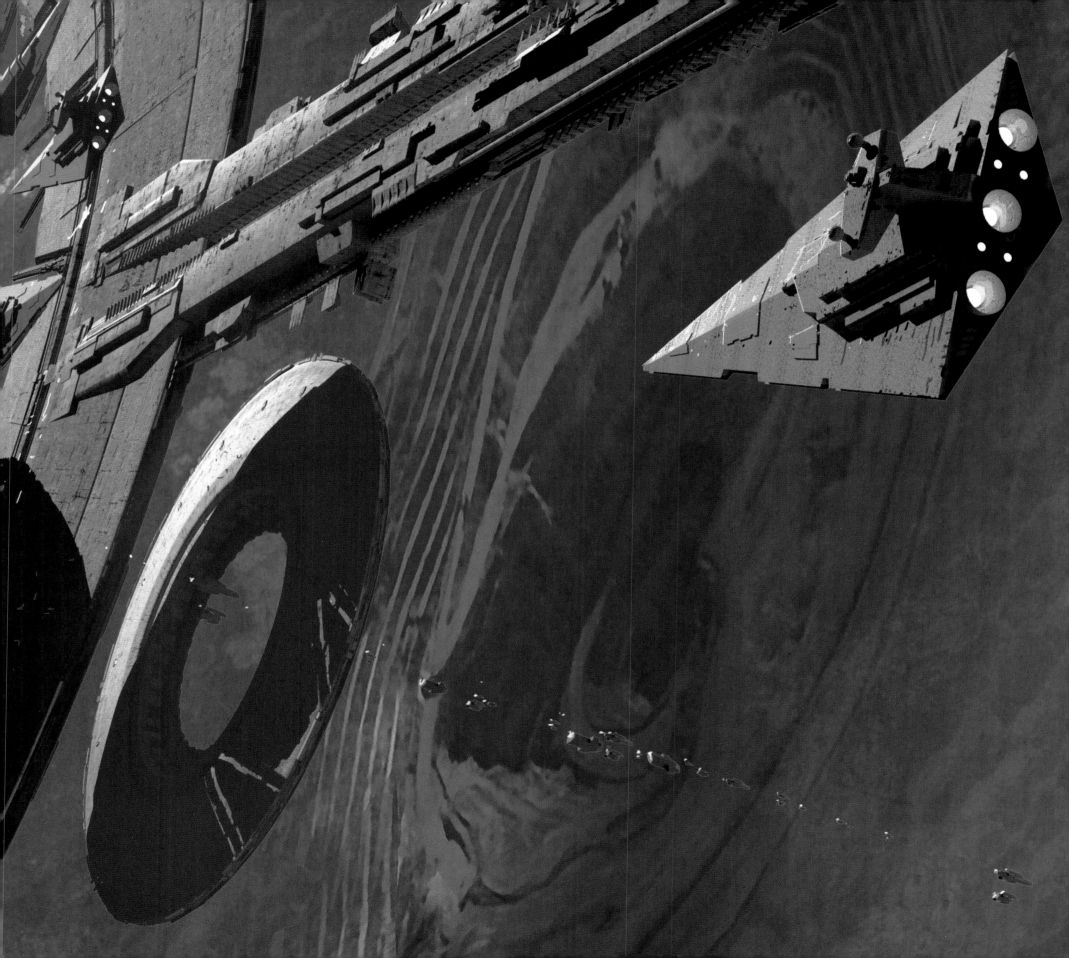

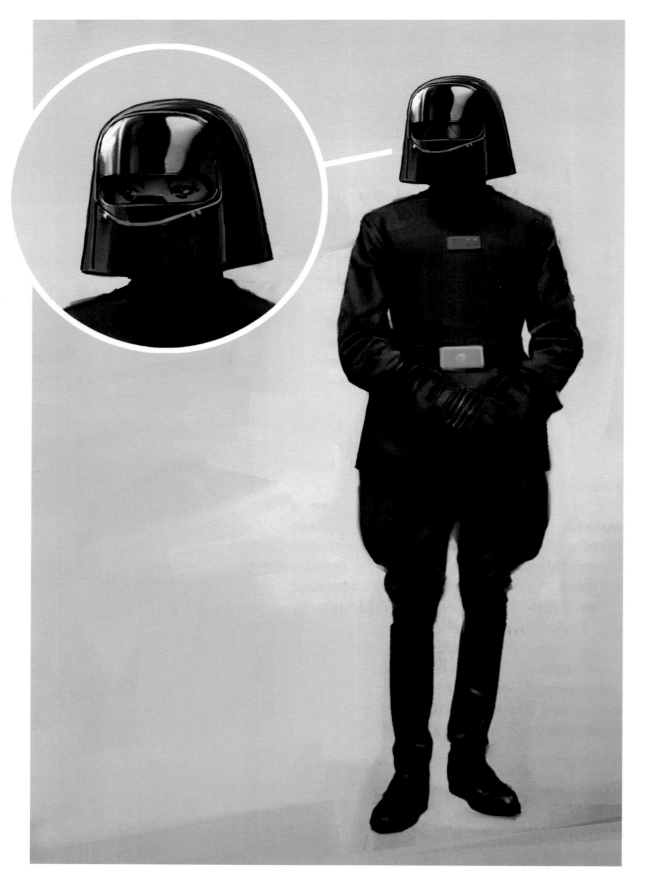

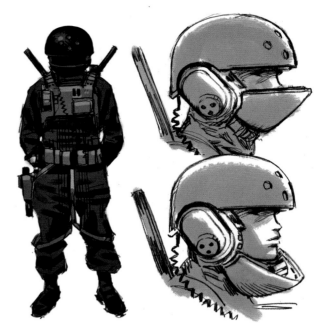

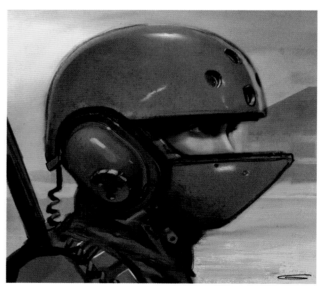

"Toward the end of the film, when they land at the Imperial base, Jyn and Cassian have to put on disguises. We put her in this very cool outfit: an Imperial landing-pad guard. This is how she manages to get through the Imperial base. It's three looks together—a play on the Imperial gunner's helmet but with a movable visor and an underbite." Crossman

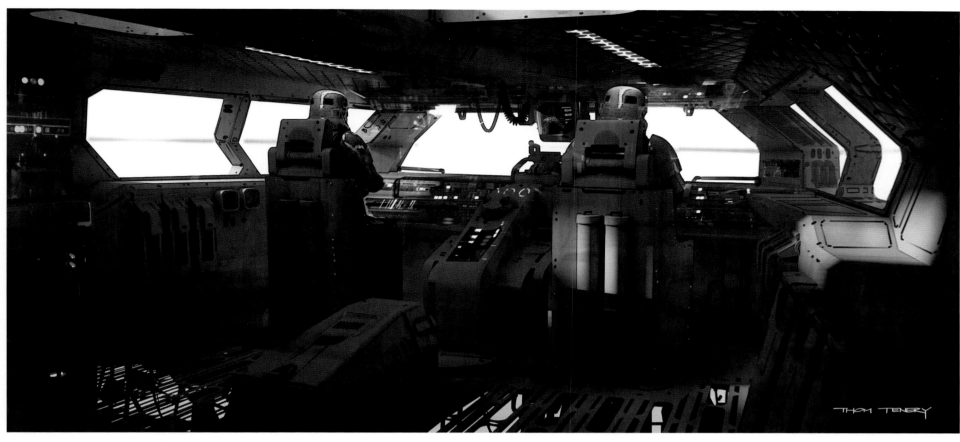

STOLEN SHUTTLE VERSION 1A—COCKPIT Tenery

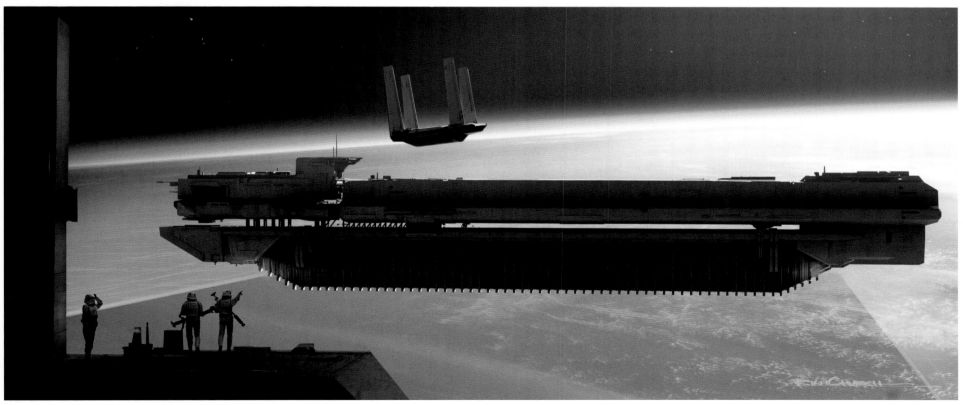

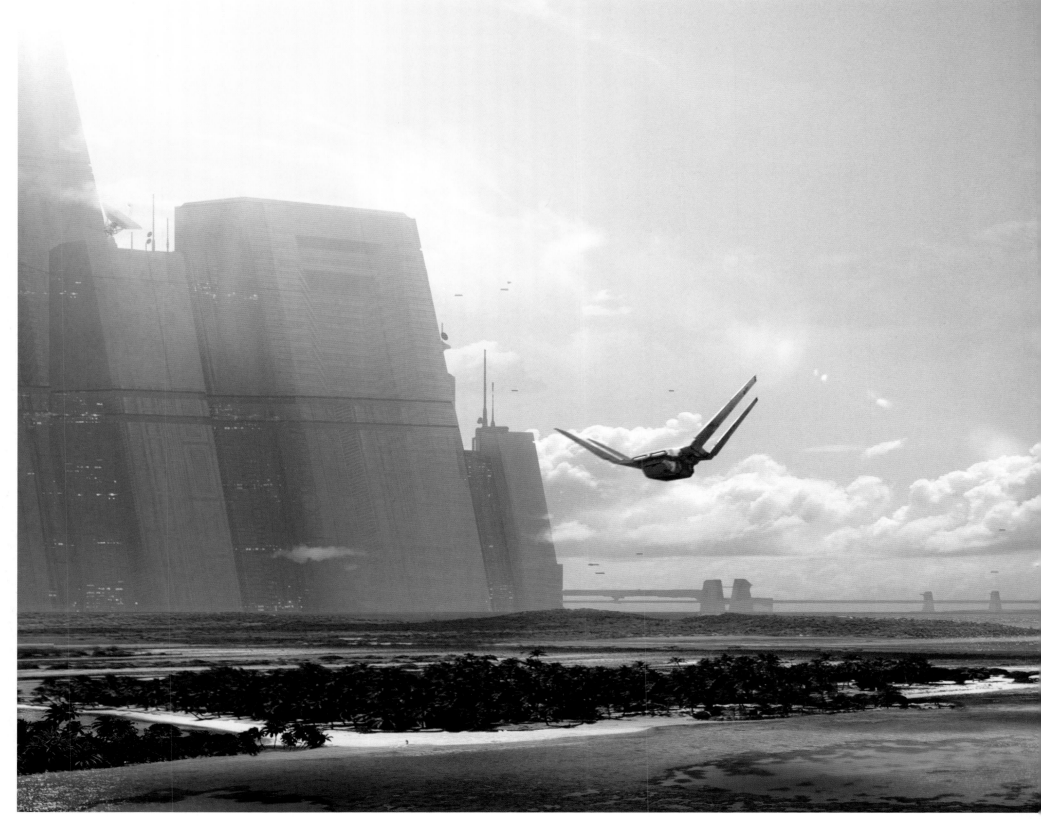

▲ **SCARIF COMMUNICATIONS TOWER EXTERIOR VERSION 1B** Wallin

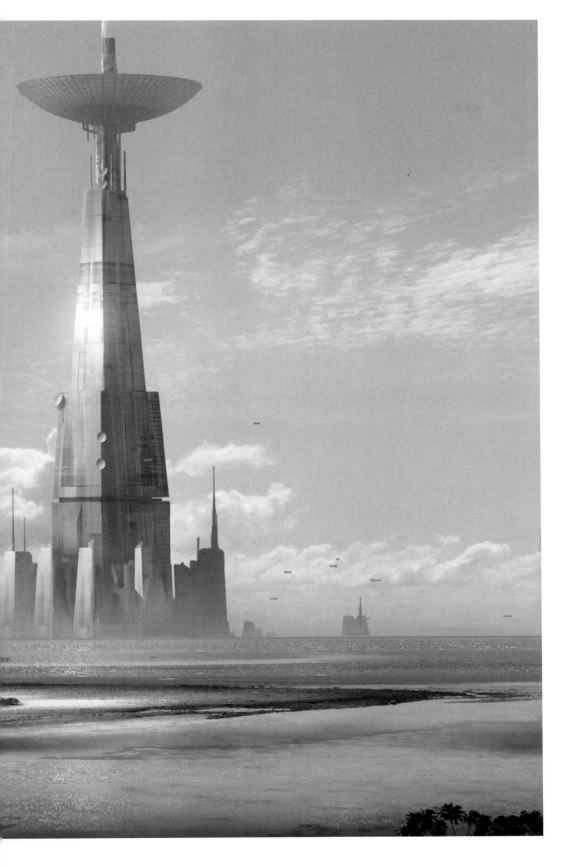

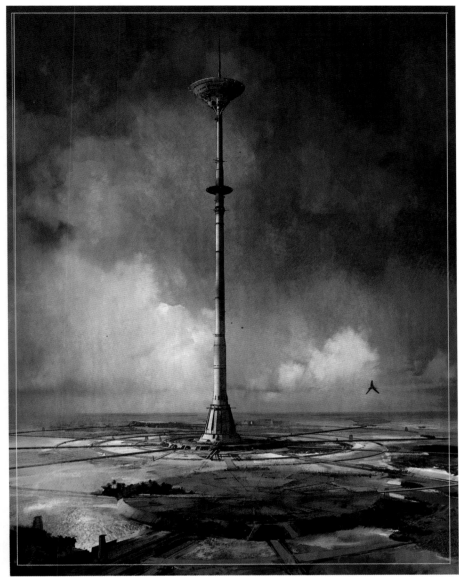

▲ **IMPERIAL COMMUNICATIONS TOWER EXTERIOR VERSION 1** Tiemens

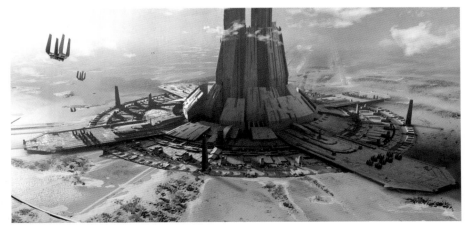

▲ **SCARIF COMMUNICATIONS TOWER VERSION 1A** Church

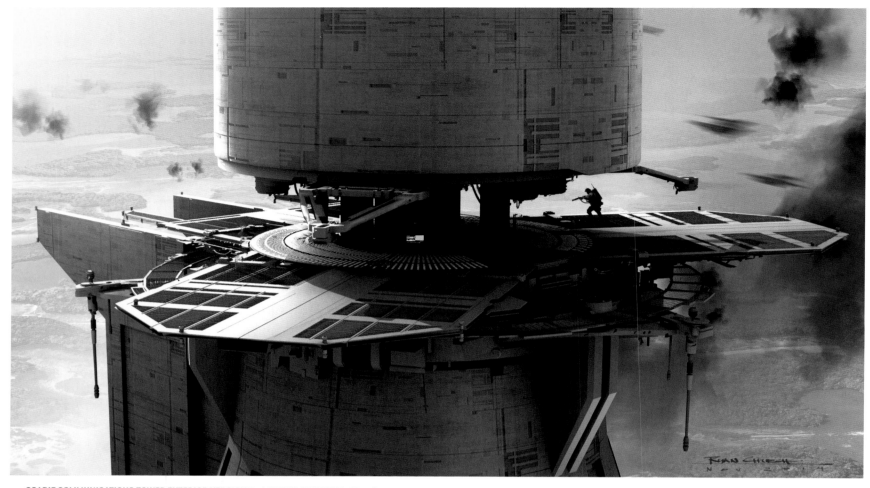

▲ SCARIF COMMUNICATIONS TOWER EXTERIOR VERSION 1—LANDING PLATFORM Church

▼ IMPERIAL COMMUNICATION TOWER VERSION 1A Church

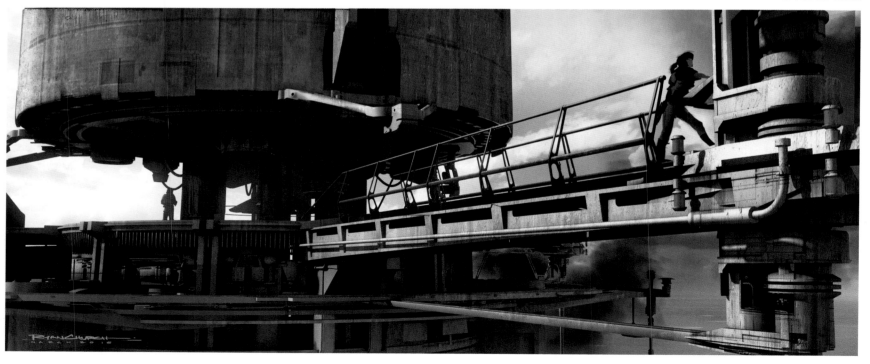

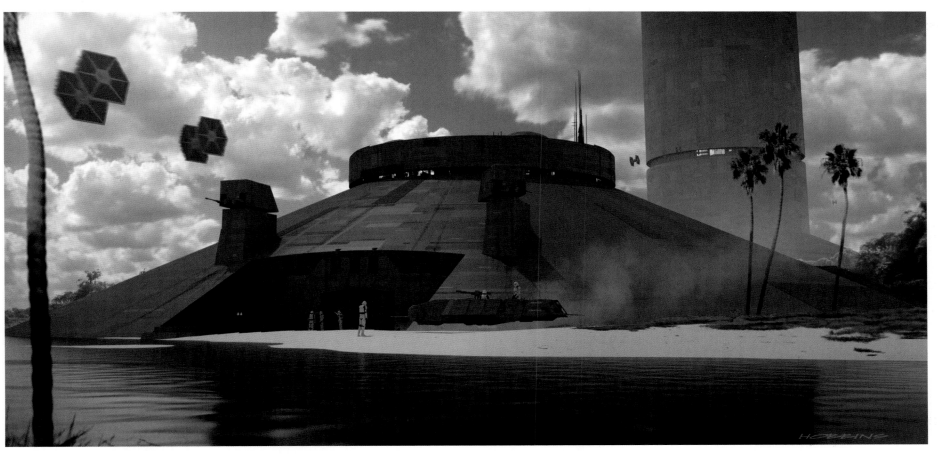

SCARIF COMMUNICATIONS TOWER EXTERIOR VERSION 1—BUNKER REVISION Hobbins

BUNKER MAIN ENTRANCE VERSION 11—DOORS OPEN REVISION Hobbins

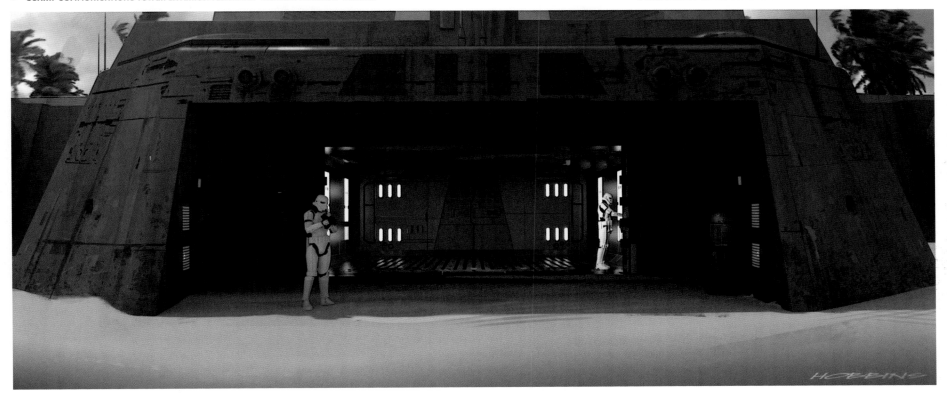

SCARIF LANDING CONCEPT BOARDS Allsop, McCoy, and Tappin

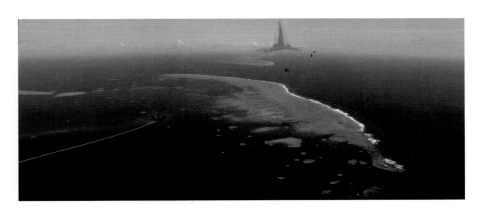

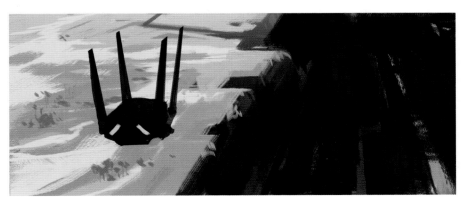

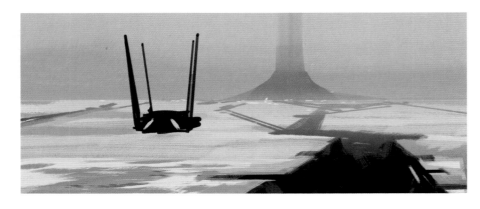

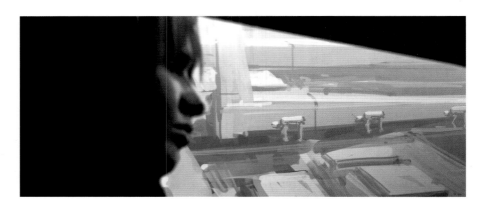
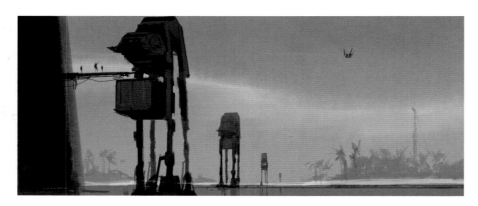
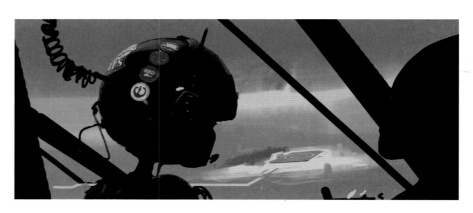
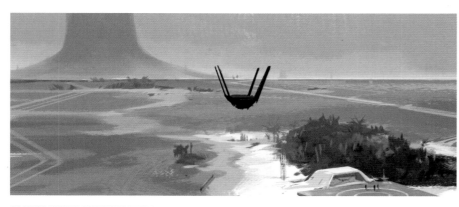
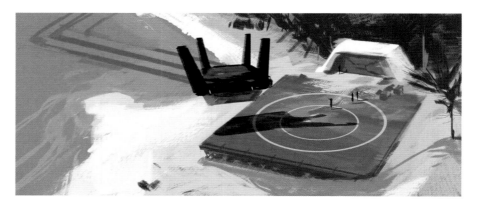

SCARIF LANDING CONCEPT BOARDS Allsop, McCoy, and Tappin

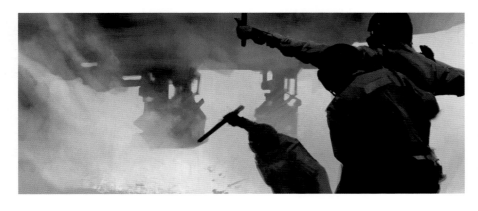

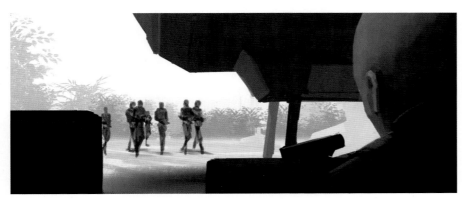

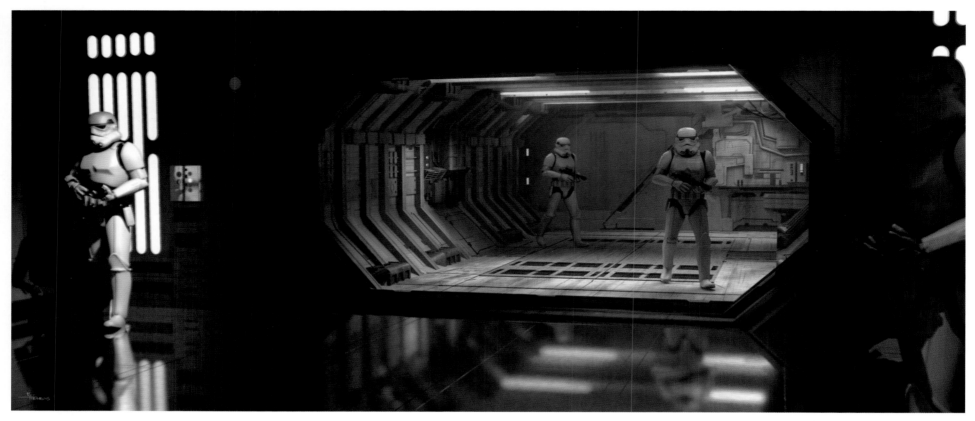

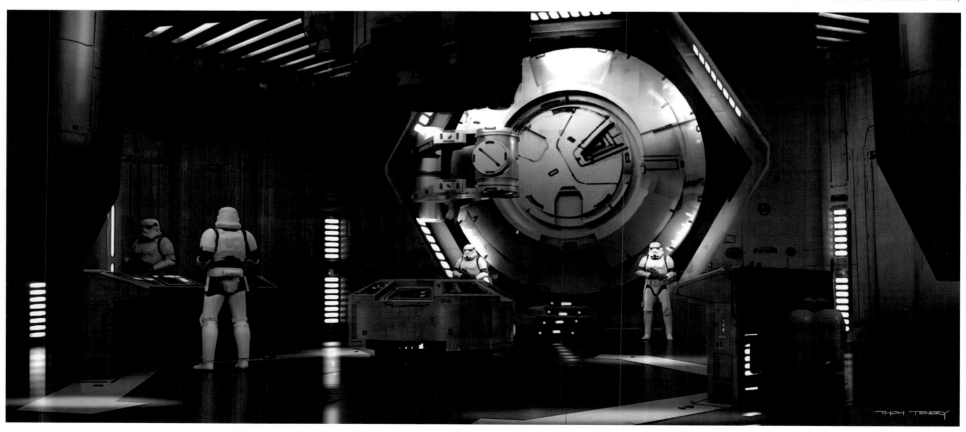

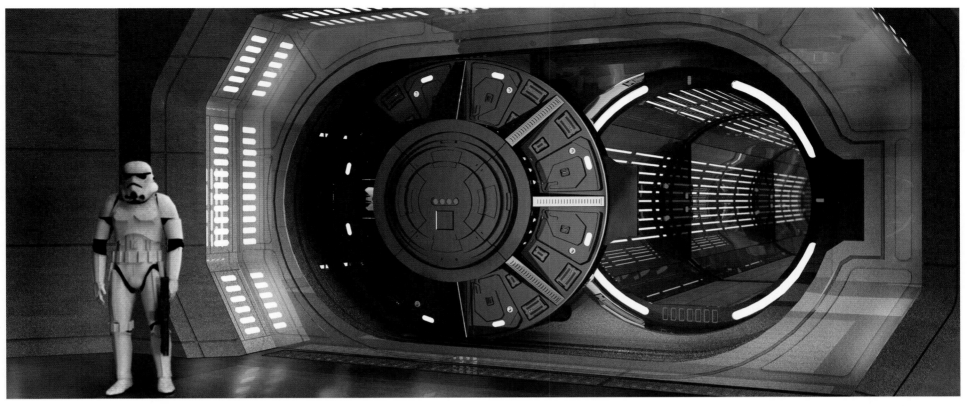

IMPERIAL COMPUTER VAULT INTERIOR VERSION 3B Julian Caldow

IMPERIAL COMPUTER VAULT INTERIOR VERSION 20 Hobbins

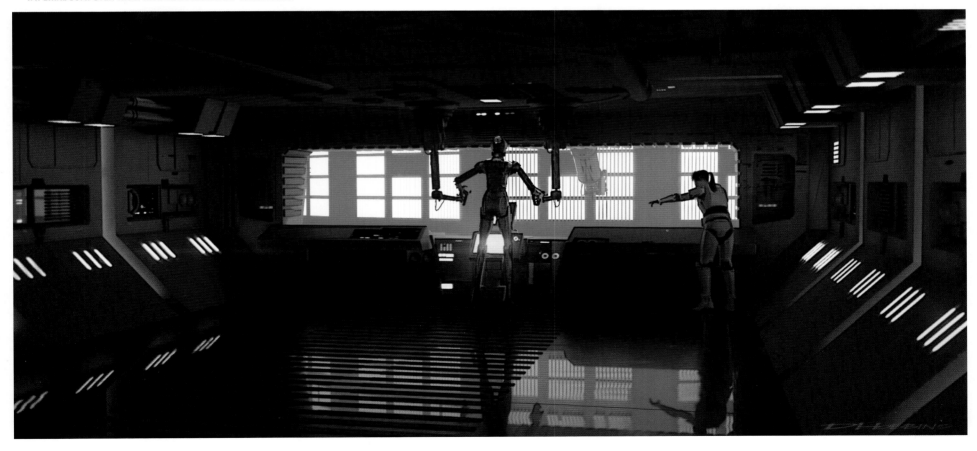

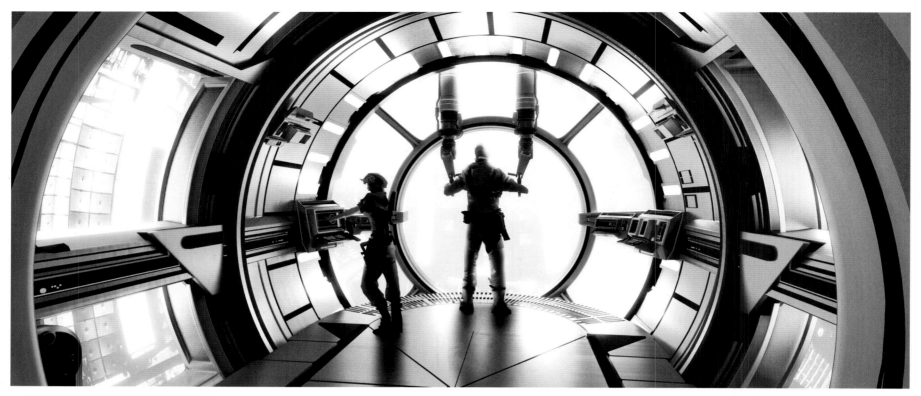

▲ **SCARIF INTERIOR COMPUTER VAULT VERSION 1** Church

▼ **COMPUTER VAULT INTERIOR VERSION 1** Church

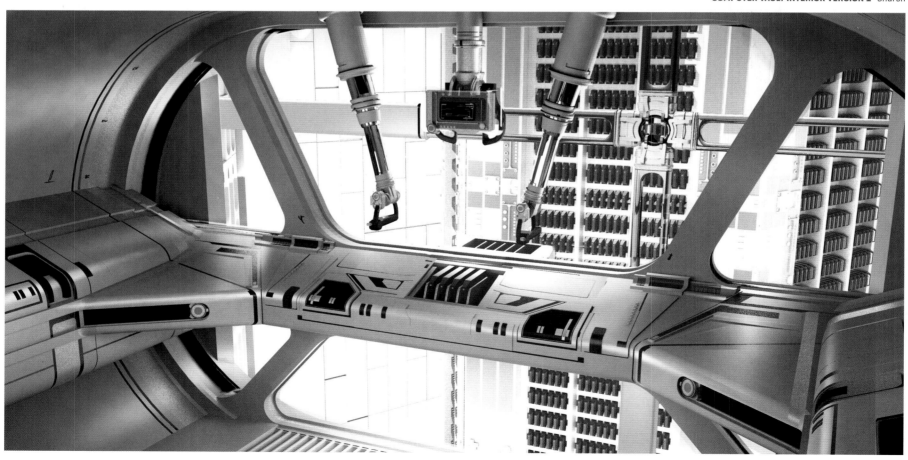

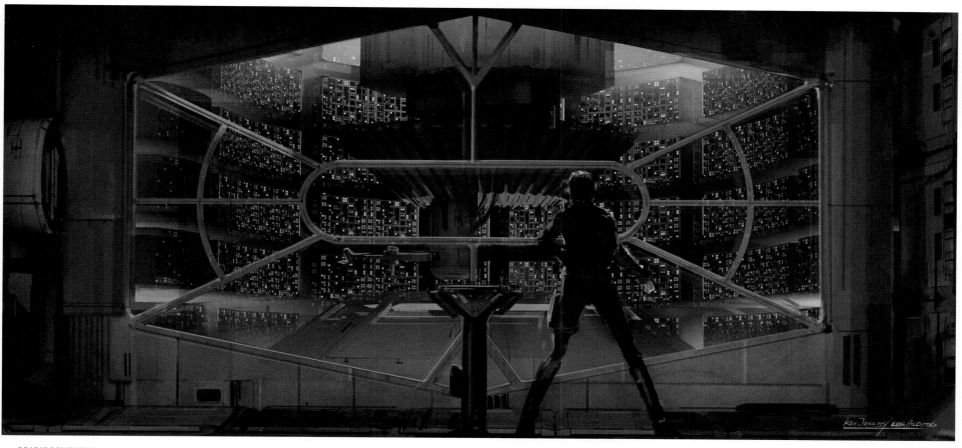

SCARIF COMPUTER VAULT Kevin Jenkins

▼ DATA CORE TOWER DROID Vincent Jenkins

▶▶ DATA CORE TOWERS Vincent Jenkins

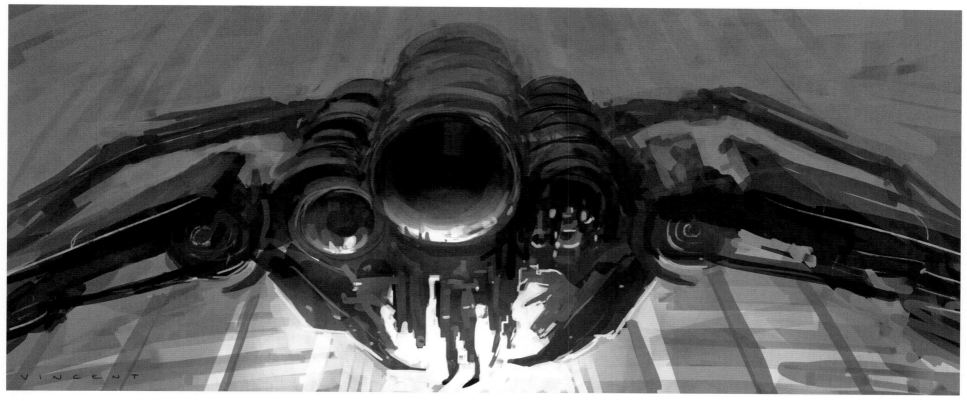

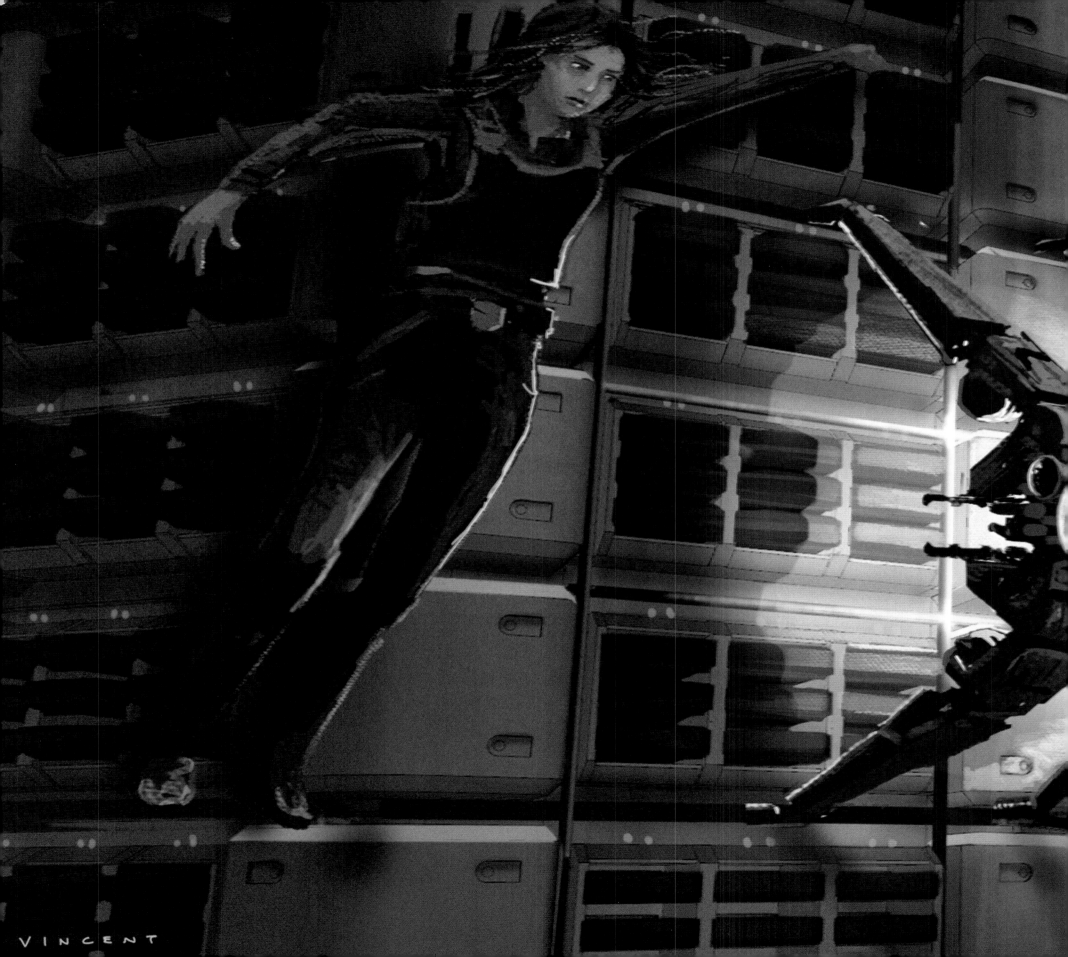

VINCENT

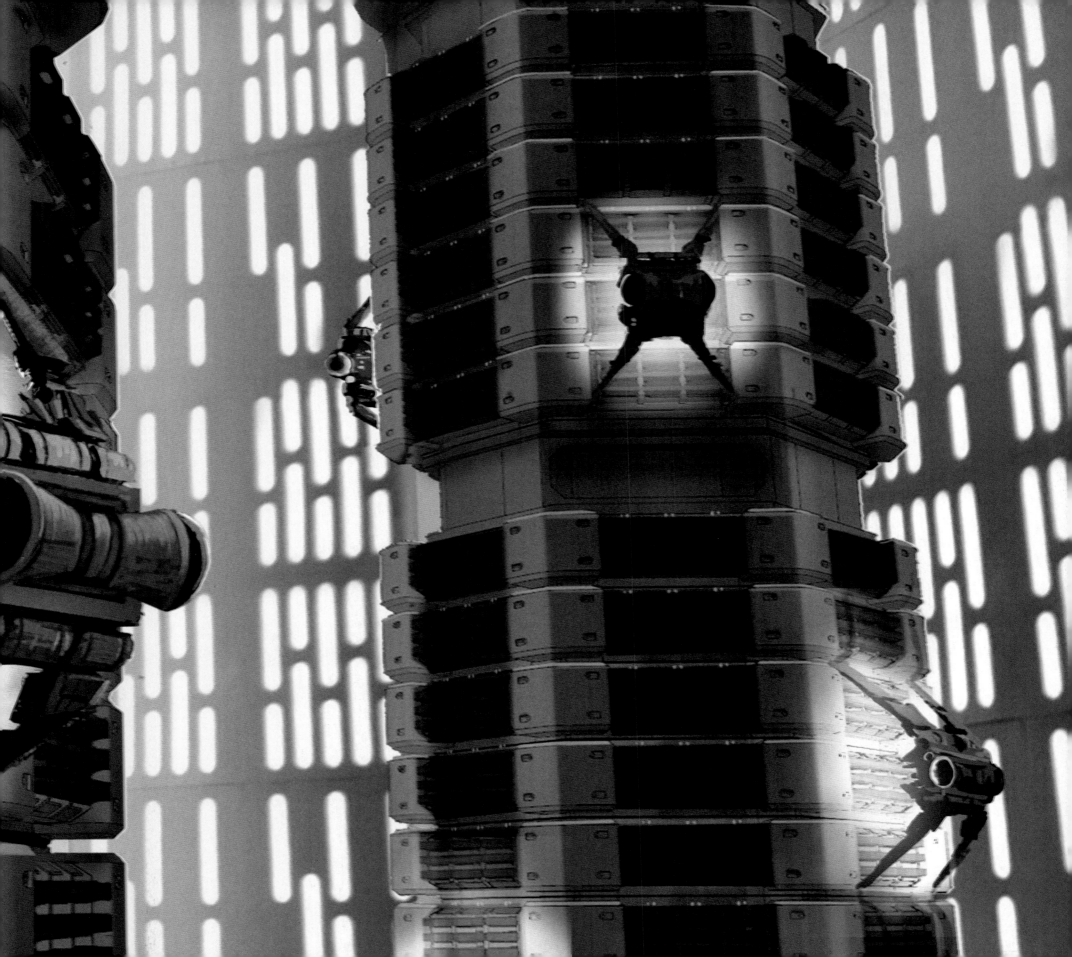

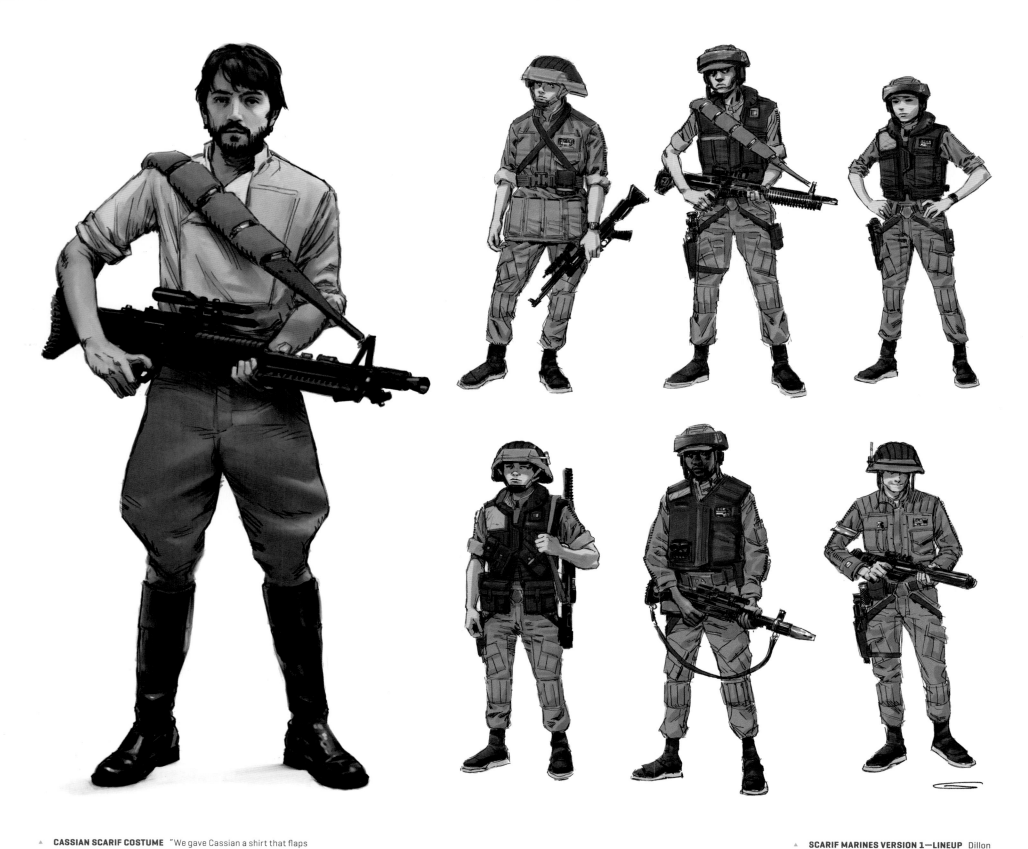

▲ **CASSIAN SCARIF COSTUME** "We gave Cassian a shirt that flaps open like Luke Skywalker's in *Return of the Jedi*. It's very much a classic kind of *Star Wars* look." Dillon

▲ **SCARIF MARINES VERSION 1—LINEUP** Dillon

▲ **REBEL MARINES VERSION 5A** Dillon

◄ **REBEL MARINE—*RETURN OF THE JEDI* HELMET VERSION 1** Dillon

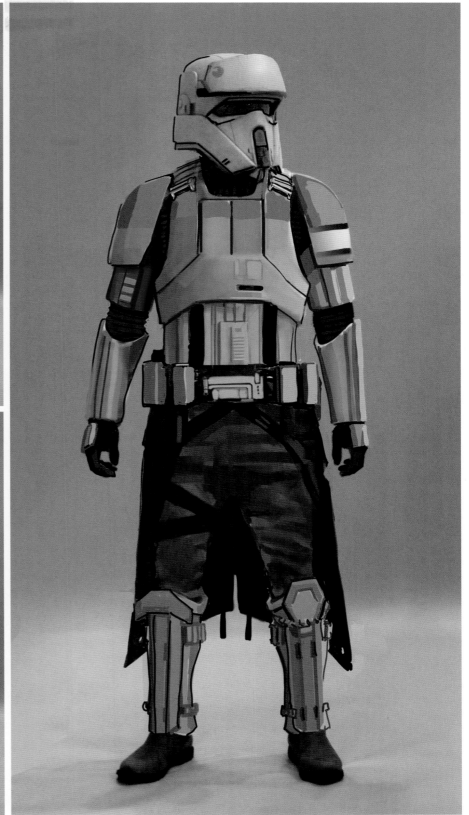

▲ **SCARIF TROOPER** Dillon

▲ **U-WING PILOT VERSION 2X** Dillon

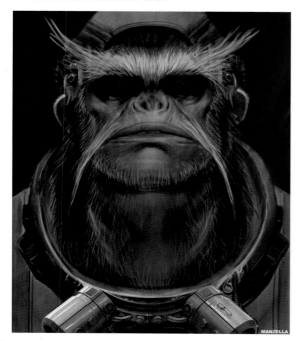

▲ **SPACE MONKEY** Manzella

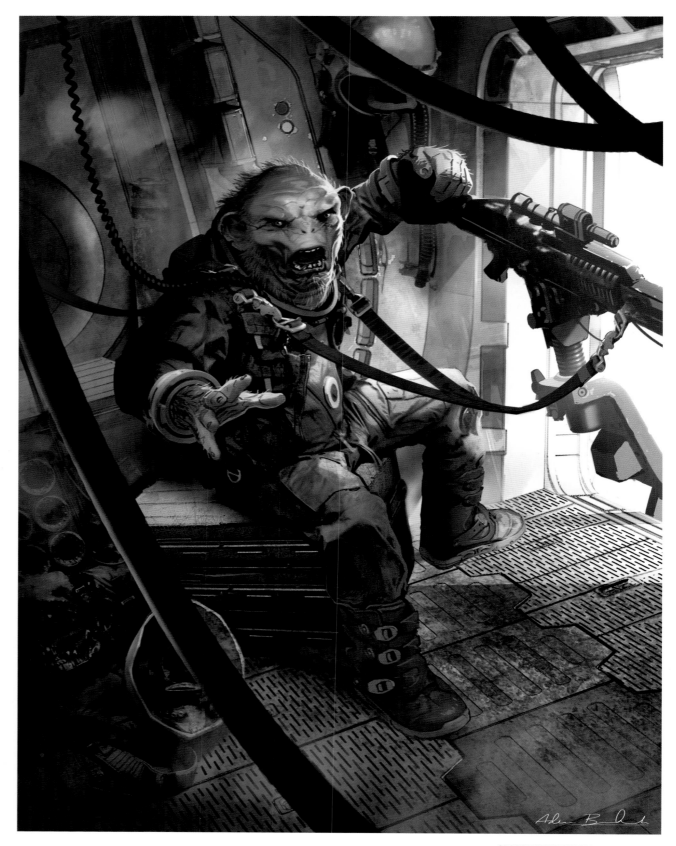

▲ **SPACE MONKEY VERSION 1B** Brockbank

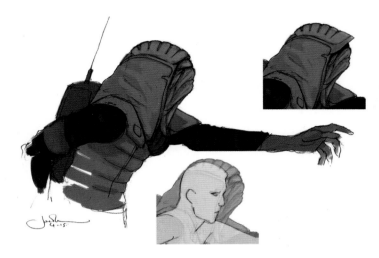

▲ **PAO (MOUTH CLOSED) VERSION 1A** "Pao originated as a sketch for *The Force Awakens*—just a one-off drawing from a creative brief that never made it into the movie. He started as a guy with loads of long, spiky hair—glam-rock hair, to give you a sense of volume—who is basically just a mouth. For *Rogue One*, that didn't work with the military angle, so I replaced the hair with a kind of kepi but kept the big mouth. Gareth liked the idea of him in the battle, turning to his comrades and yelling *'Come on!'*—but his mouth opens far beyond what you'd expect." Lunt Davies

▼ **PAO (MOUTH OPEN) VERSION 1B** Lunt Davies

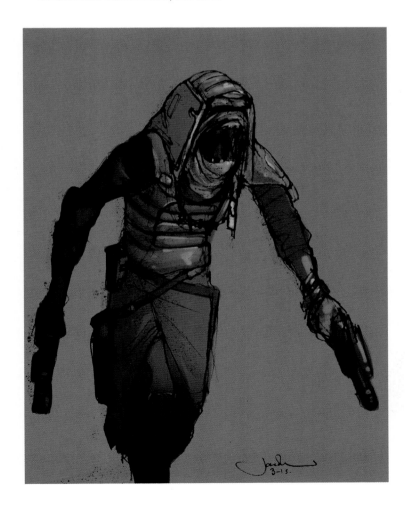

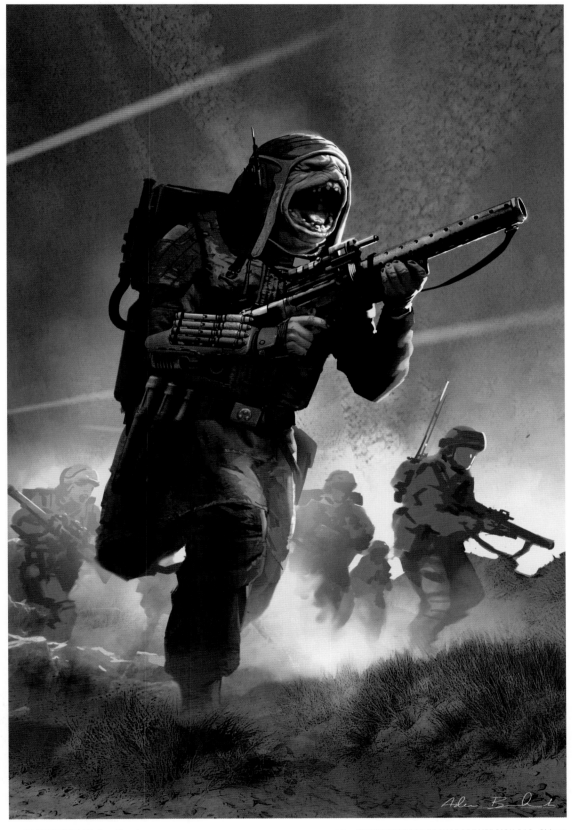

▲ **PAO VERSION 1B** Brockbank ▶▶ **DEATH TROOPER TRANSPORT VERSION 010** Chiang

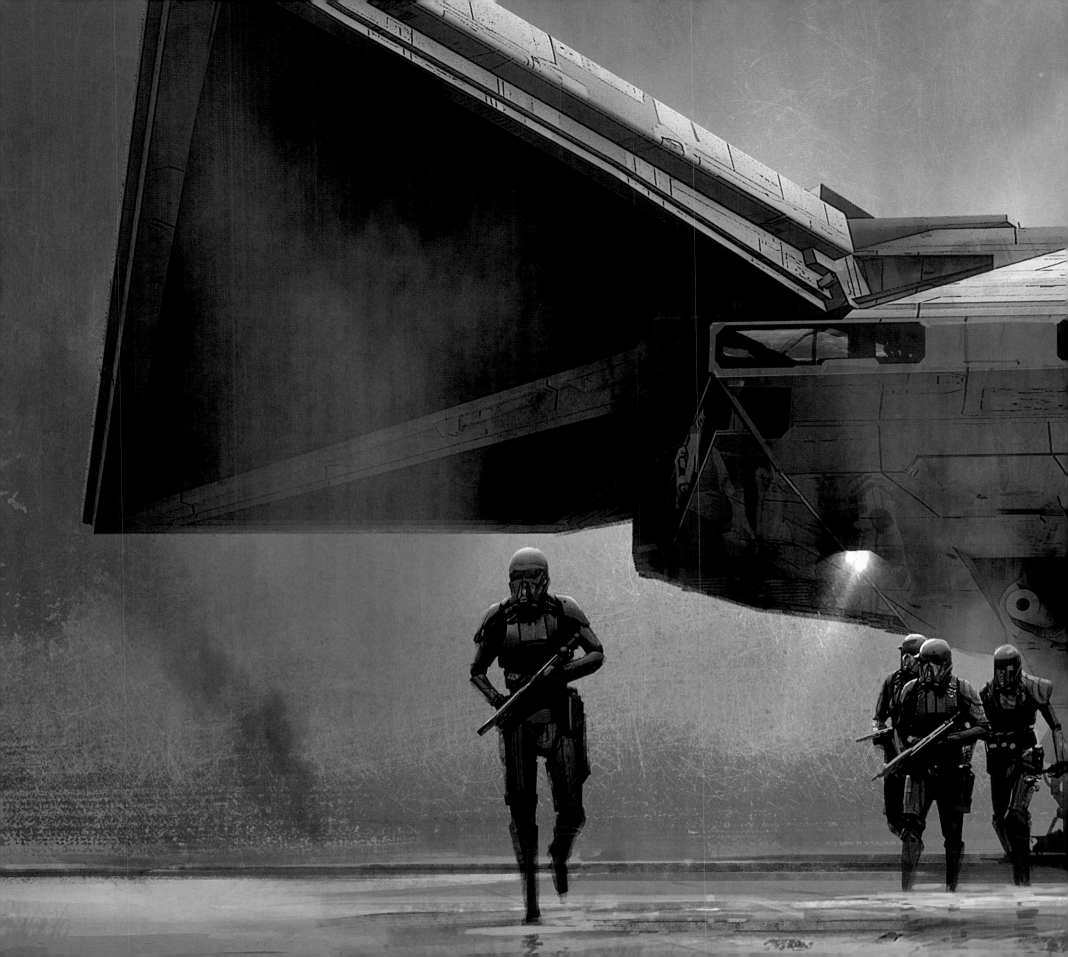

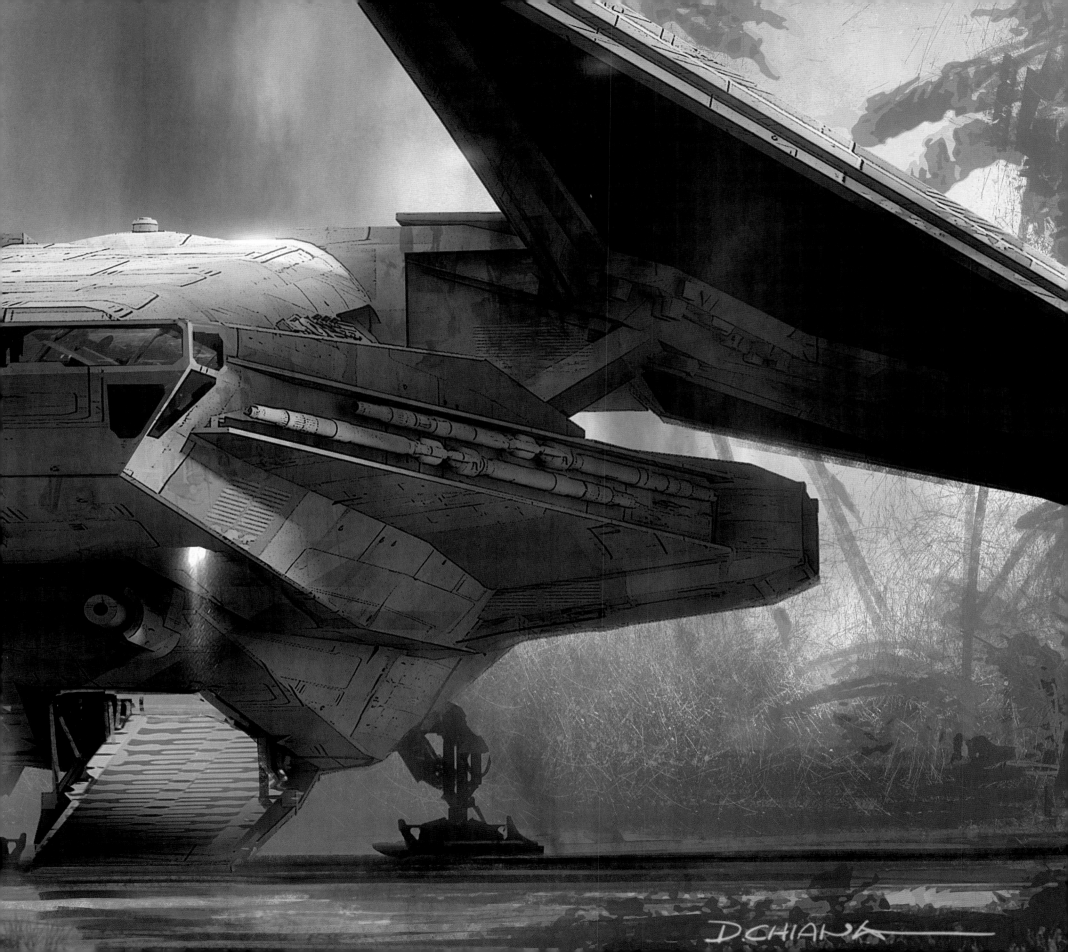

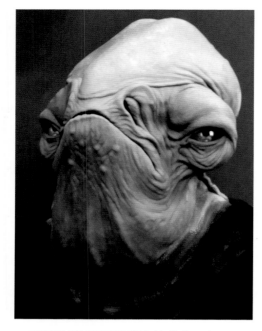

▲ **ADMIRAL RADDUS EYE TEST 2** Martin Rezard

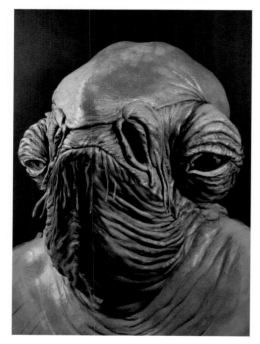

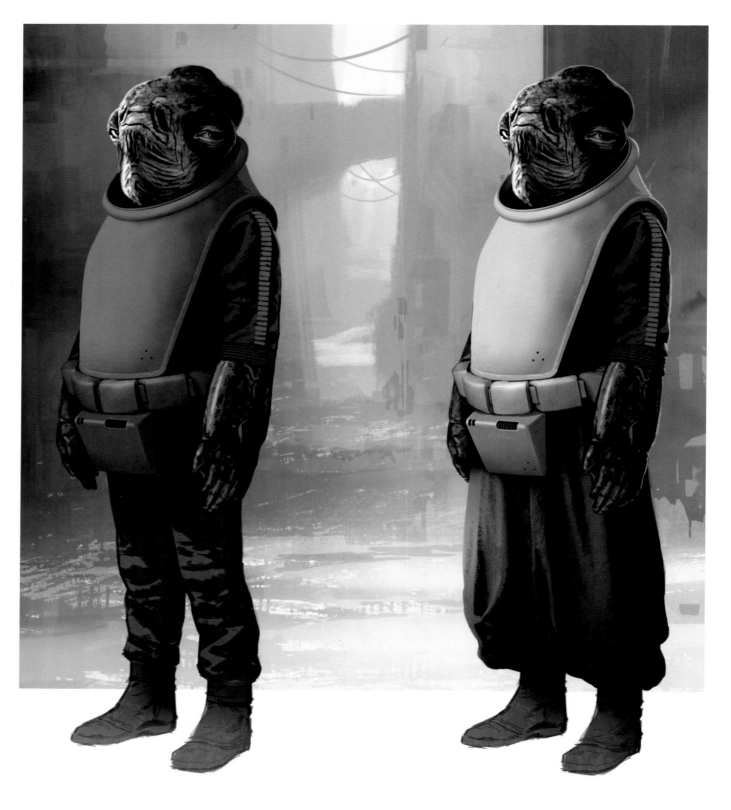

▲ **ADMIRAL RADDUS VERSION 2A** Rezard

▶ **ADMIRAL RADDUS COSTUME VERSION 1B** Brockbank

"The inspiration for Admiral Raddus was a company major or captain smoking a cigar, mixed in with a bulldog. Winston Churchill was perfect; he's very jowly." Gustav Hoegen

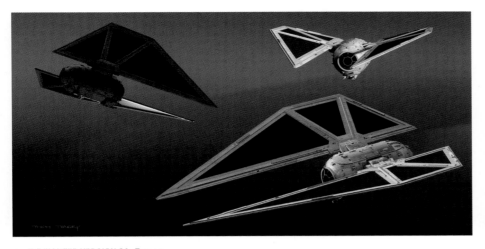

▲ **TIE FIGHTER VERSION 2A** Tenery

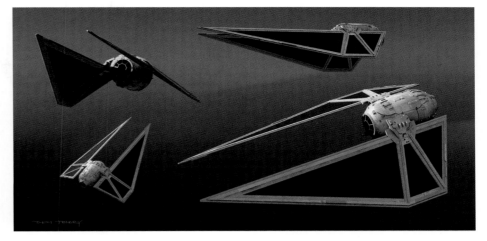

▲ **TIE FIGHTER VERSION 4A** Tenery

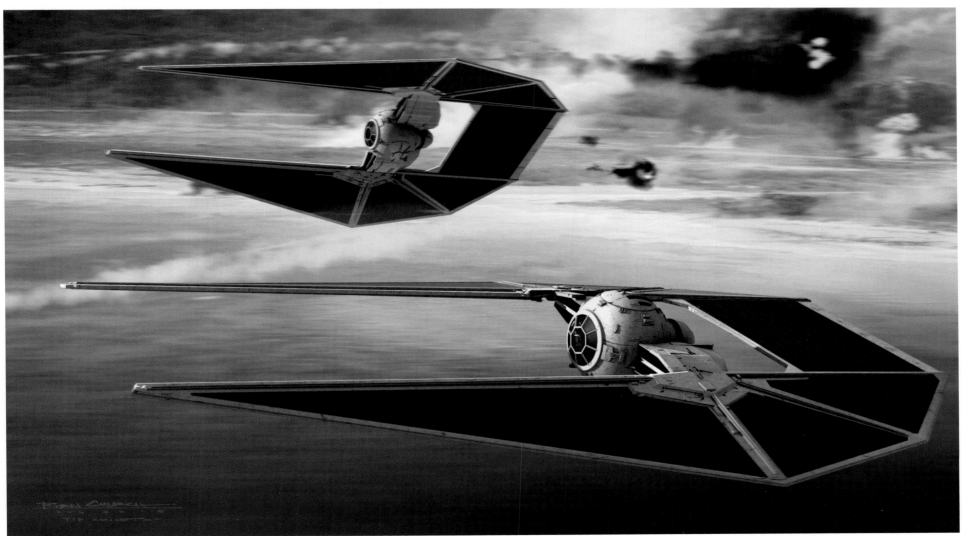

▲ **TIE FIGHTER IN ATMOSPHERE VERSION 1** Church

▶▶ **IMPERIAL BASE PLANET EXTERIOR—TIE FIGHTER ATTACK VERSION 1** Tenery

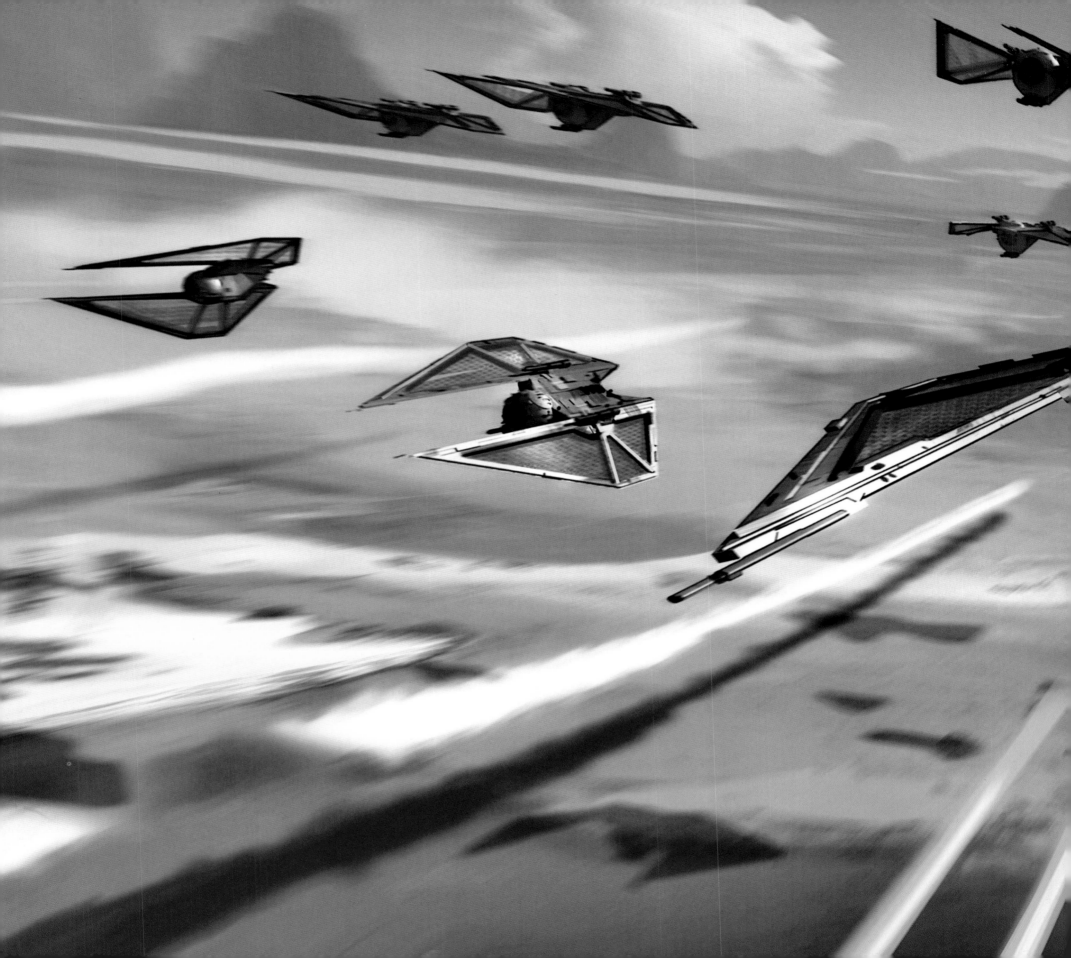

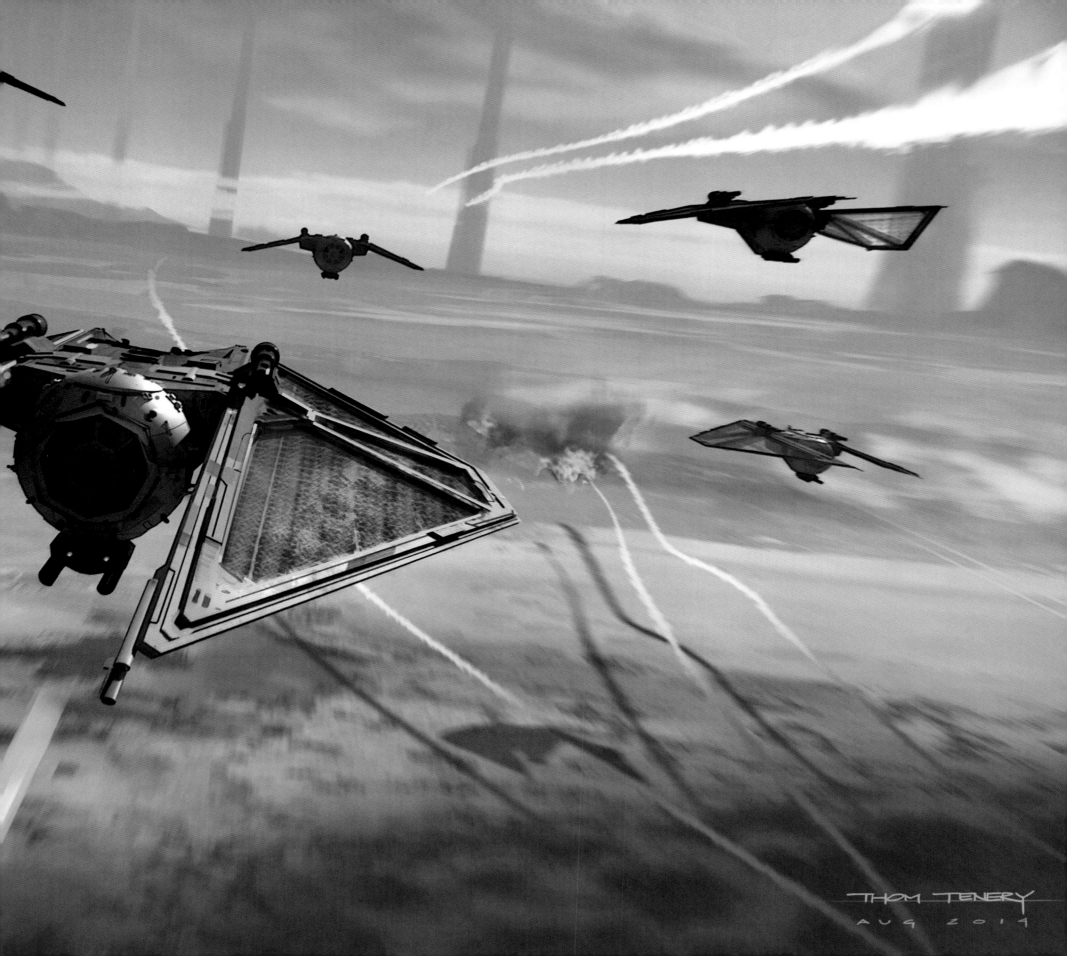

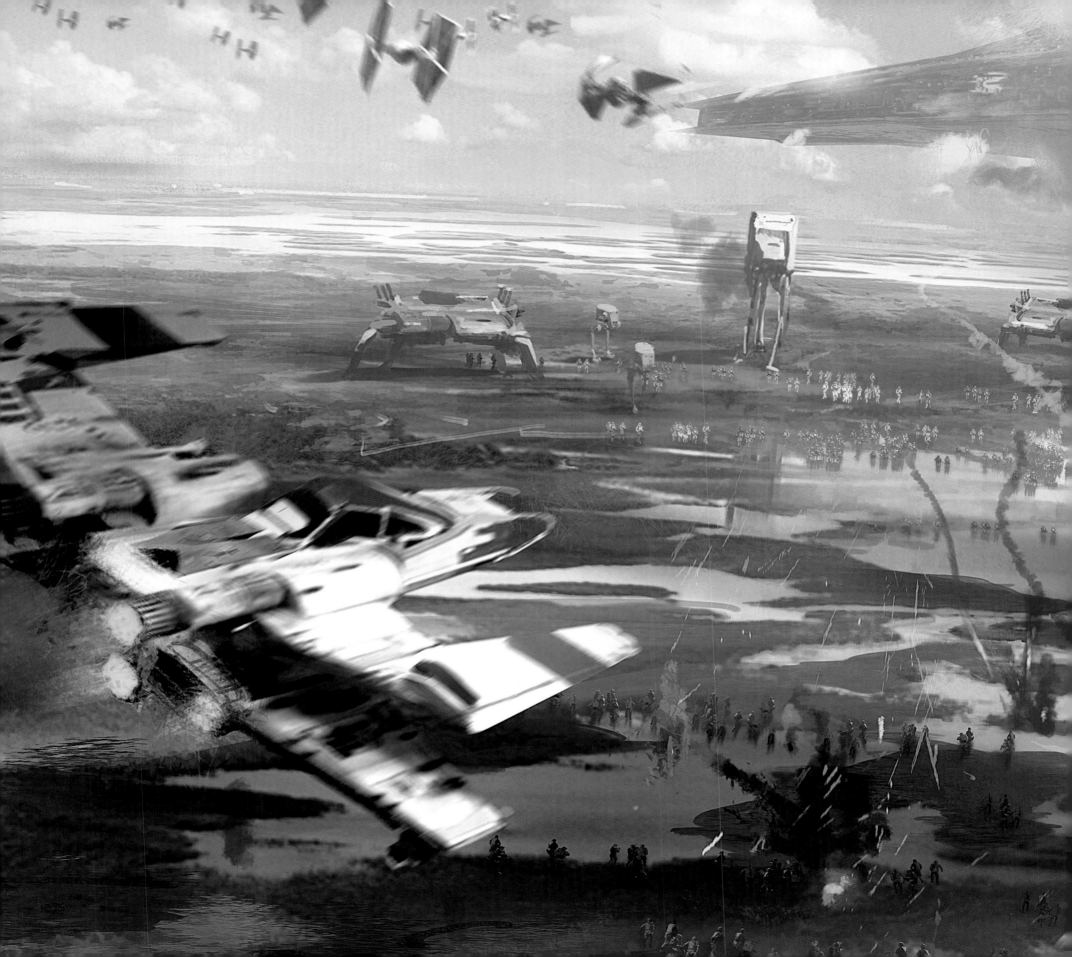

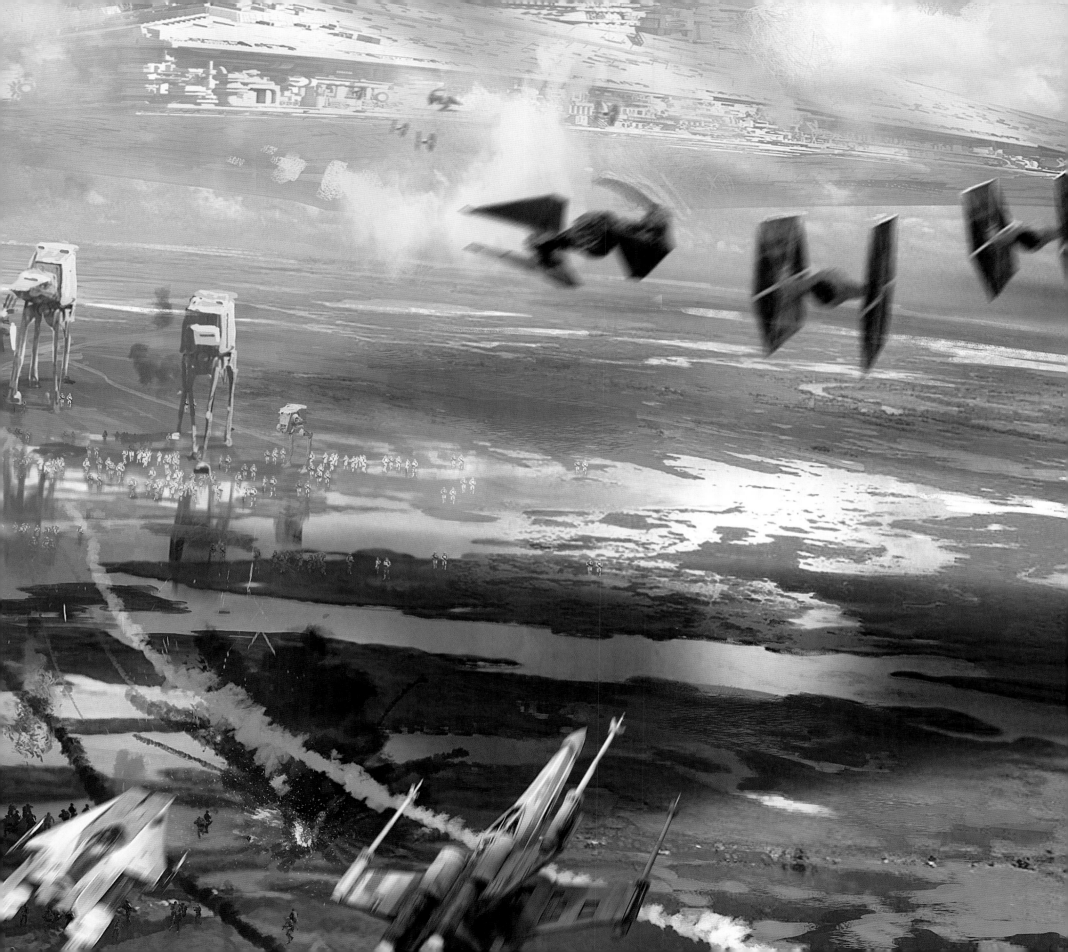

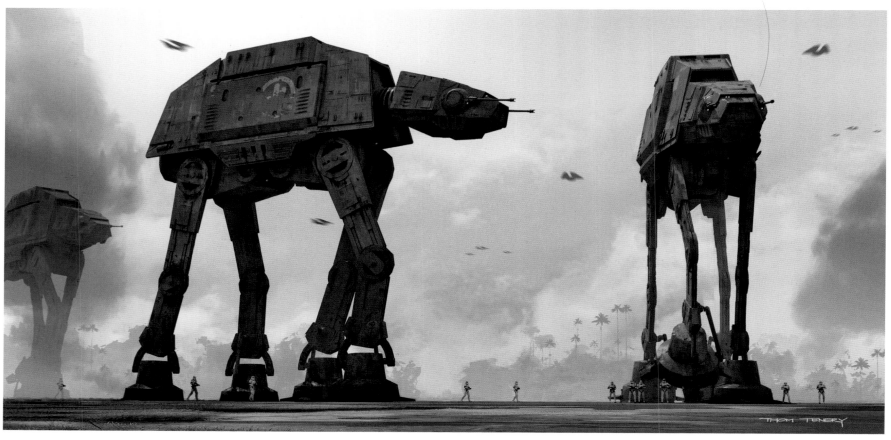

◄ ◄ **MARSH BATTLE VERSION 1** Khang Le ▲ **CARGO AT-AT VARIANT VERSION 1A** Tenery ▼ **CARGO AT-AT VARIANT VERSION 2A** Tenery

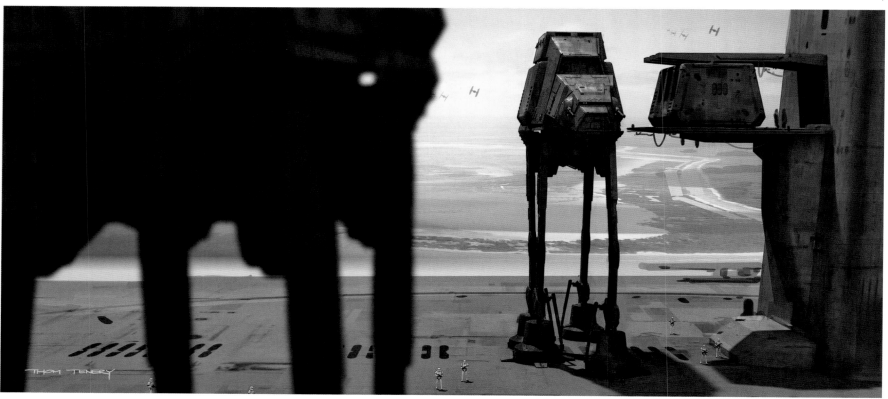

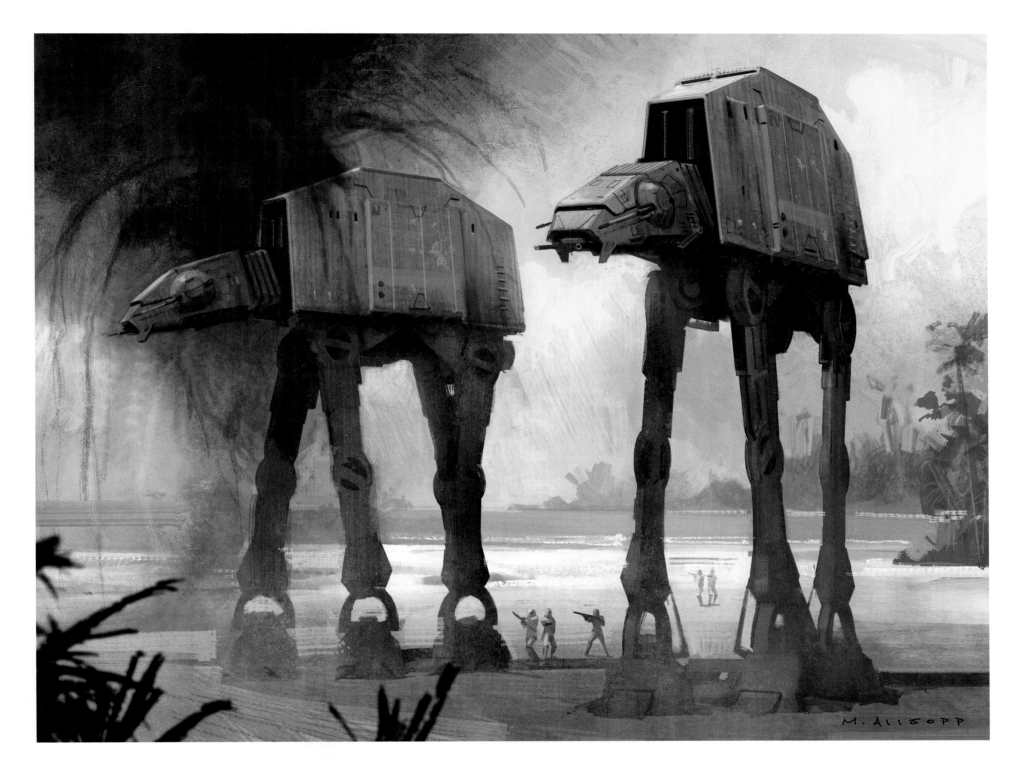

▲ **CARGO AT-AT VERSION 1B** Allsopp

"Gareth wanted AT-ATs for the end sequence, so we were brainstorming about why there would be AT-ATs there. I suggested that maybe they were modified to be used as beasts of burden—that these were transport machines instead of war machines, whose height would allow them to wade in the water." McCoy

"The AT-AT was an interesting design challenge, because I have a different memory of how it appeared in *The Empire Strikes Back* than what it actually looked like. Gareth suggested that we design our AT-AT to feel more like our memory— with the excuse that this is a new version, serving a different function on a different planet. So we reinterpreted it, made it a little more stylized, a little bit more romantic—scaled it up, narrowed it, made it a little bit more sexy." Chiang

▶ ▶ **SCARIF AT-AT ASSAULT** Allsopp

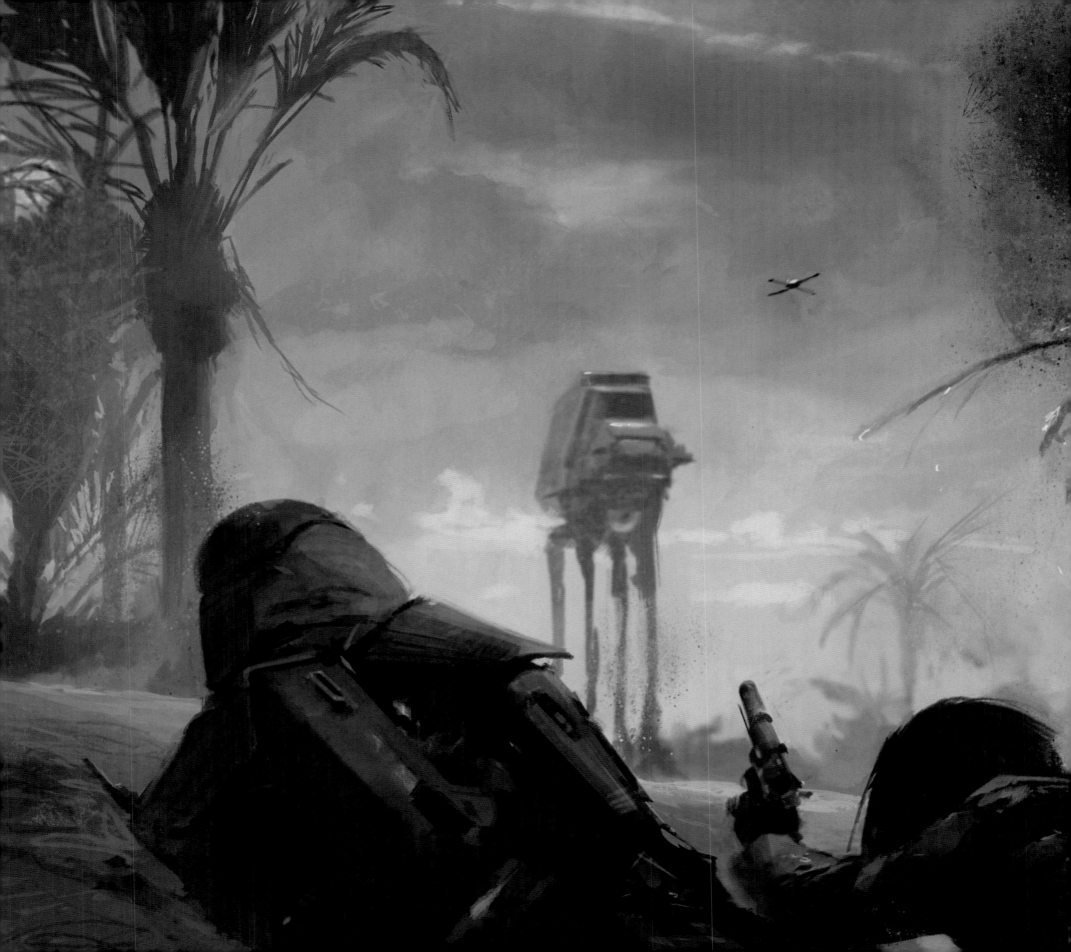

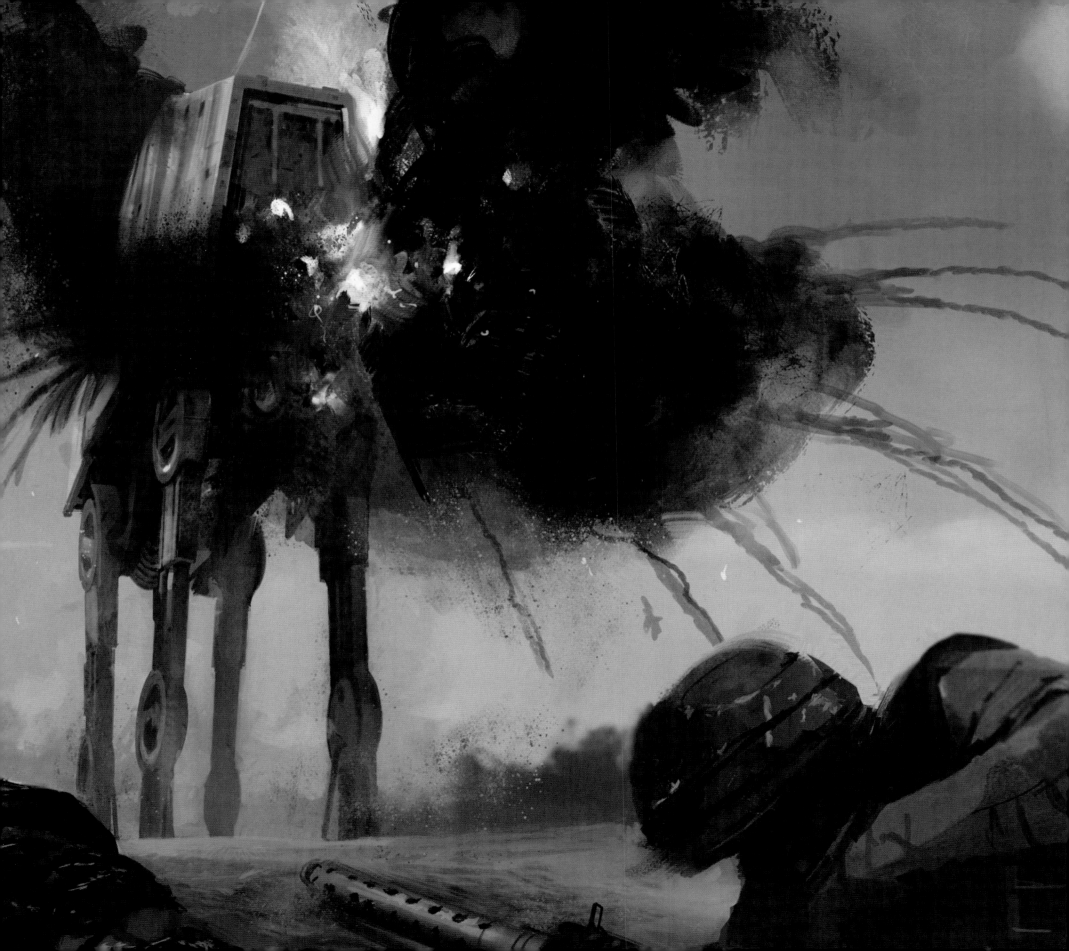

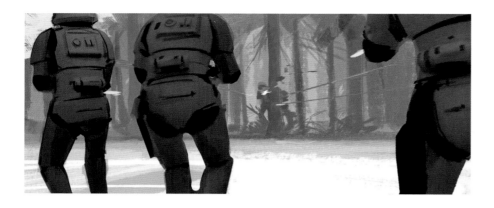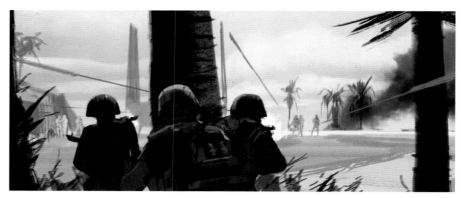
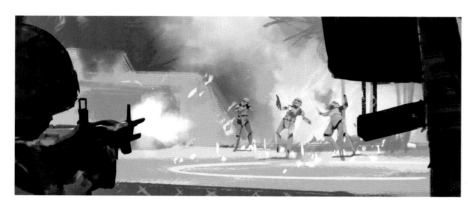

SCARIF BATTLE CONCEPT BOARDS Allsop, McCoy, and Tappin

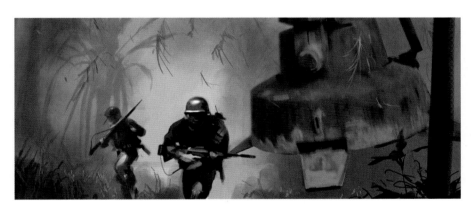

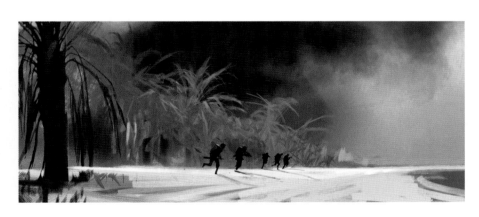

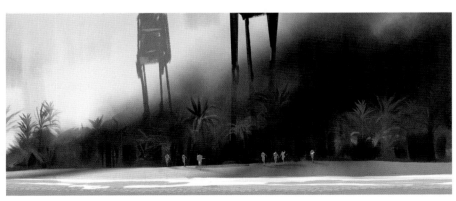

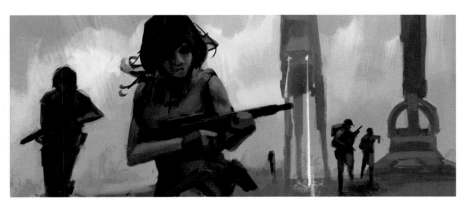

▶▶ **STAR DESTROYER DOCKING FACILITY BOMBING RUN** Church

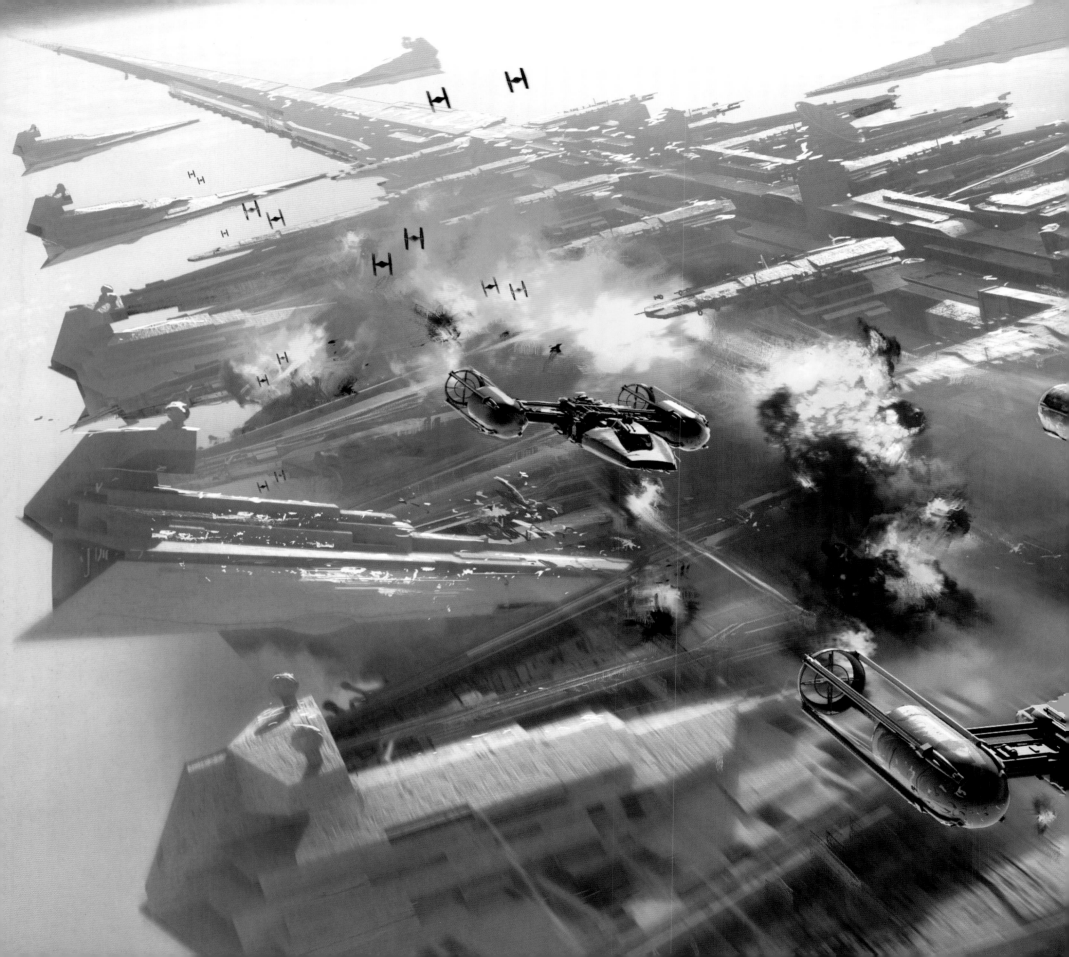

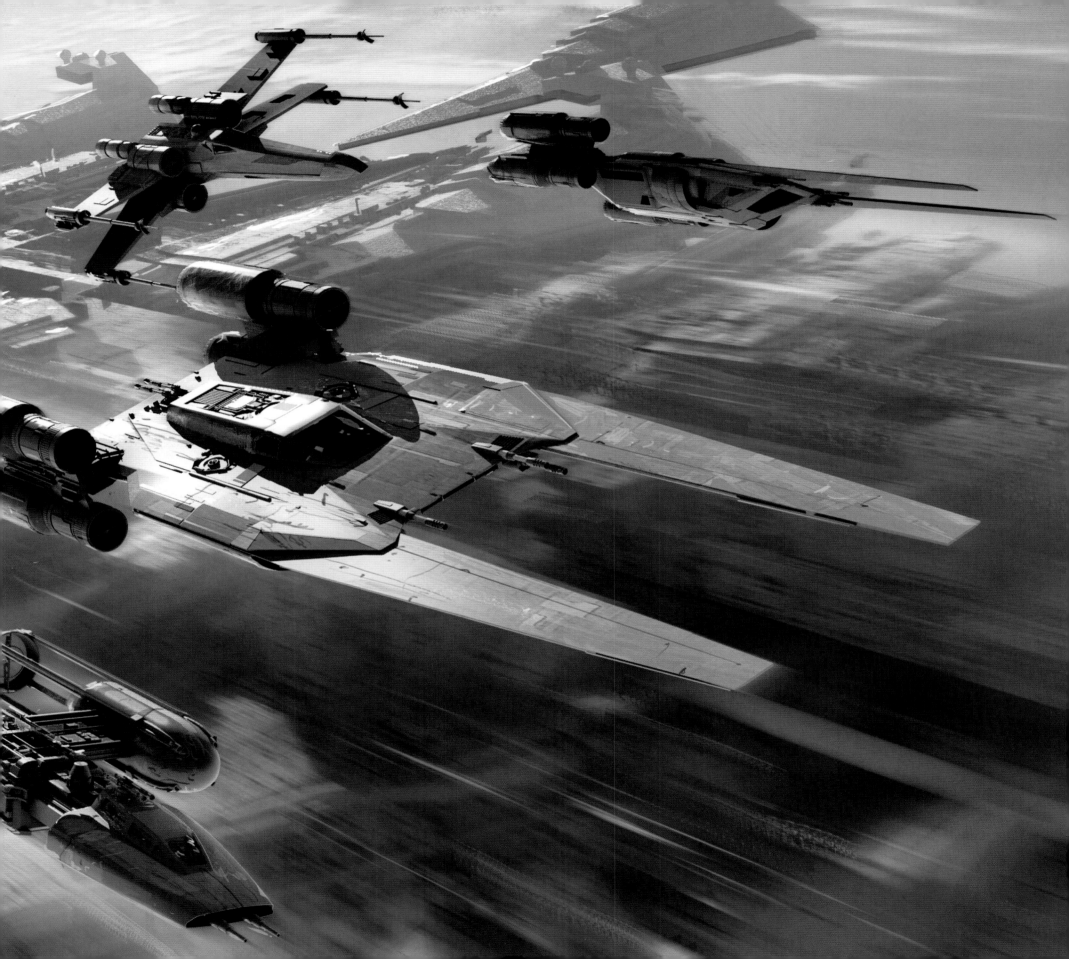

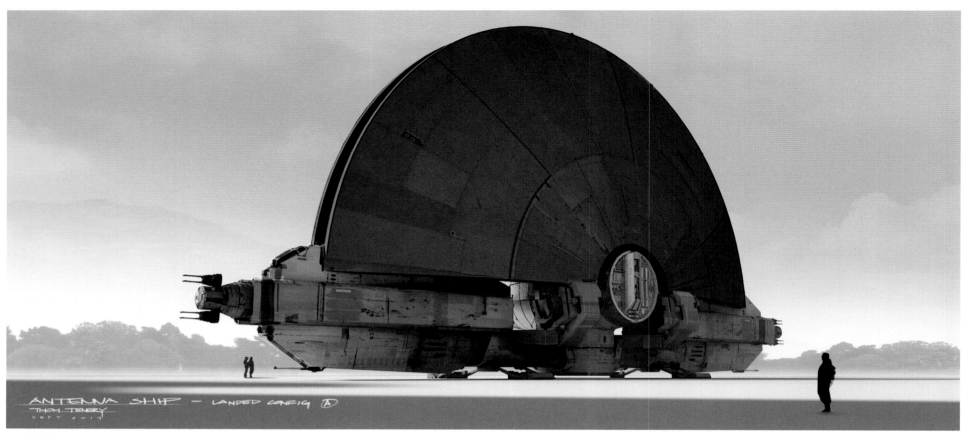

ANTENNA SHIP 1 Tenery

IMPERIAL BASE PLANET EXTERIOR BATTLE VERSION 1 Allsopp and Church

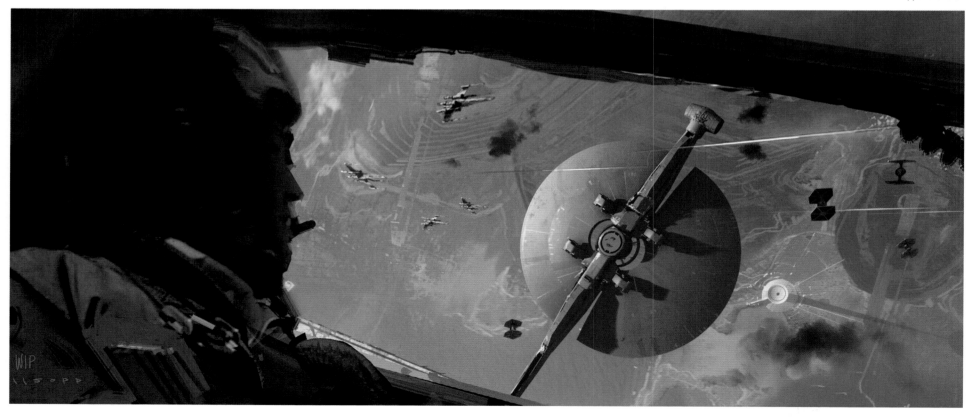

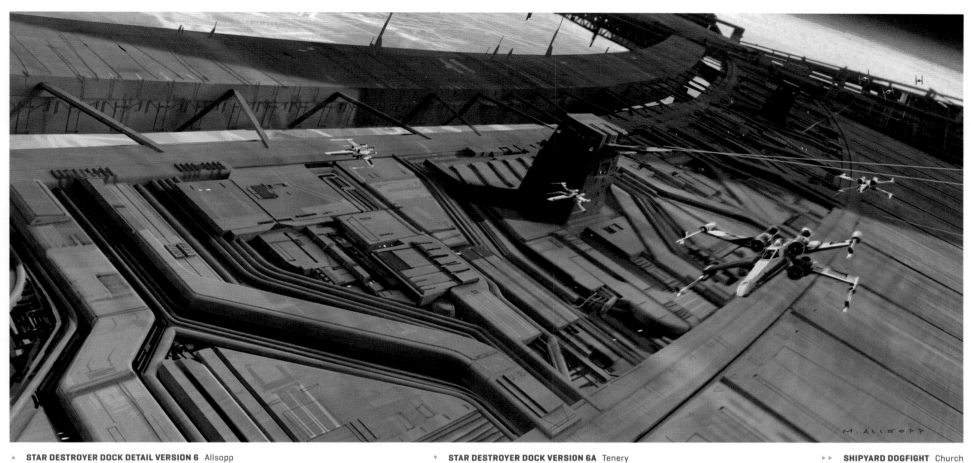

▲ **STAR DESTROYER DOCK DETAIL VERSION 6** Allsopp ▼ **STAR DESTROYER DOCK VERSION 6A** Tenery ▶▶ **SHIPYARD DOGFIGHT** Church

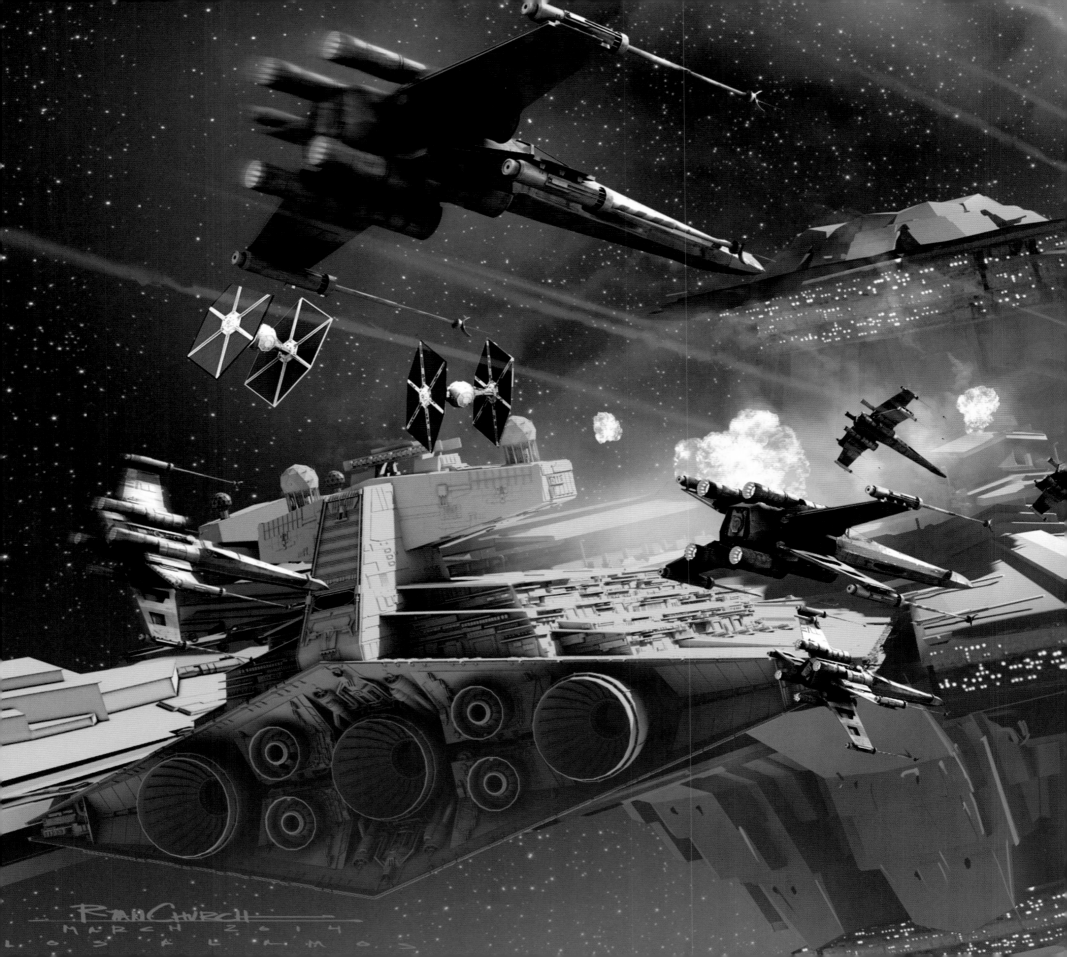

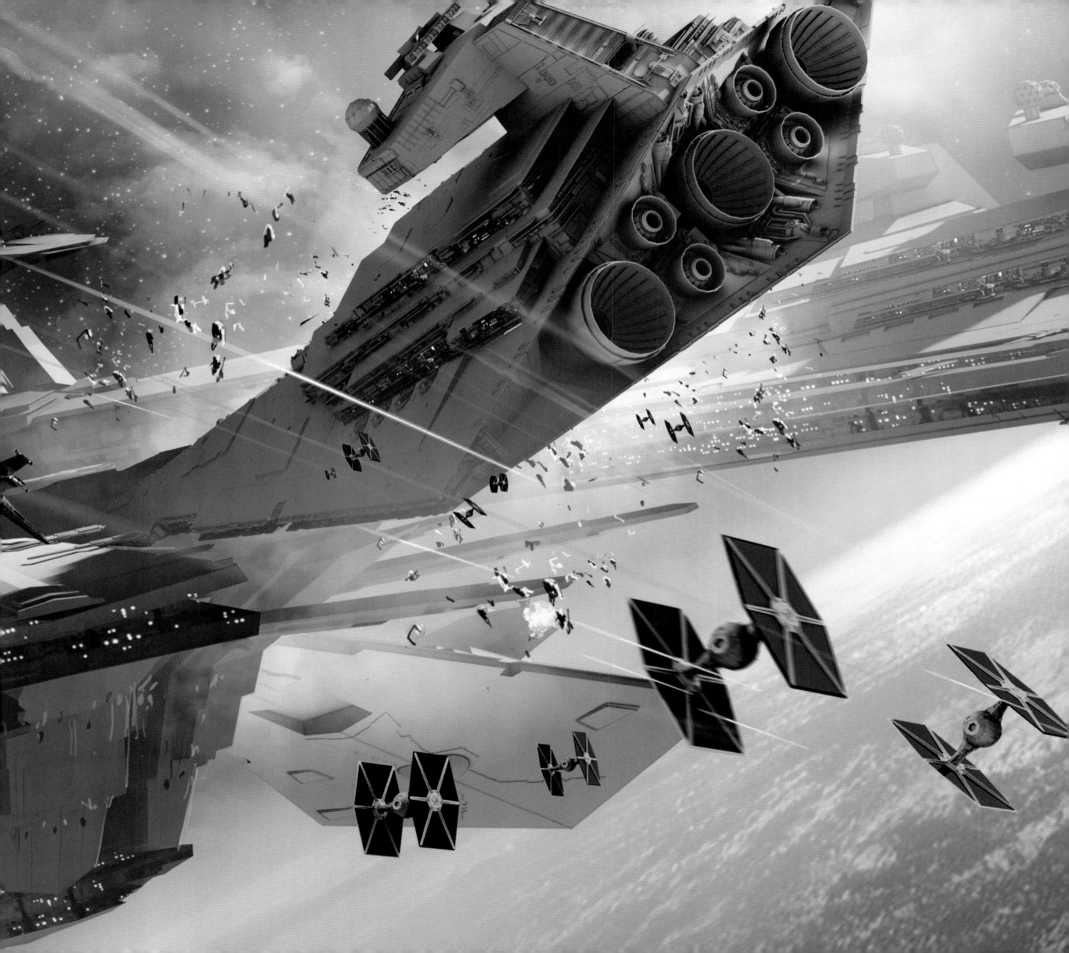

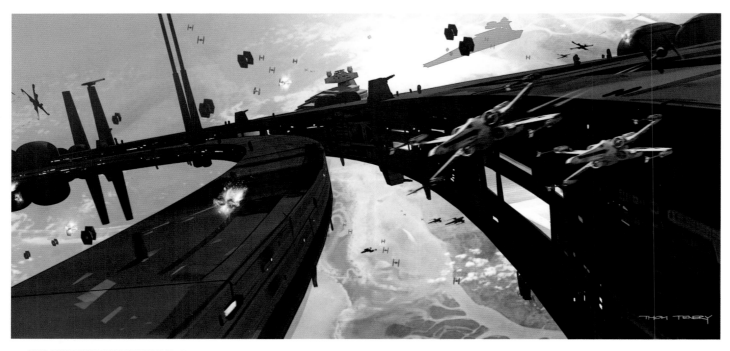

▲ **STAR DESTROYER DOCK VERSION 4A** Tenery

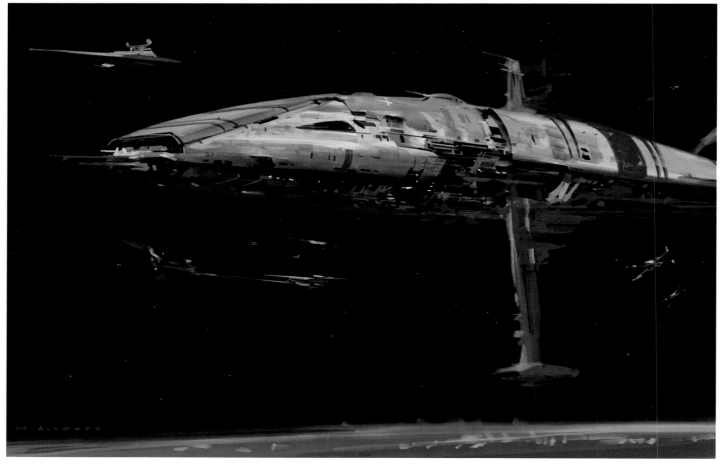

▲ **REBEL TRAWLER VERSION 1A** Allsopp

▶ **REBEL TRAWLER VERSION 6A** Allsopp

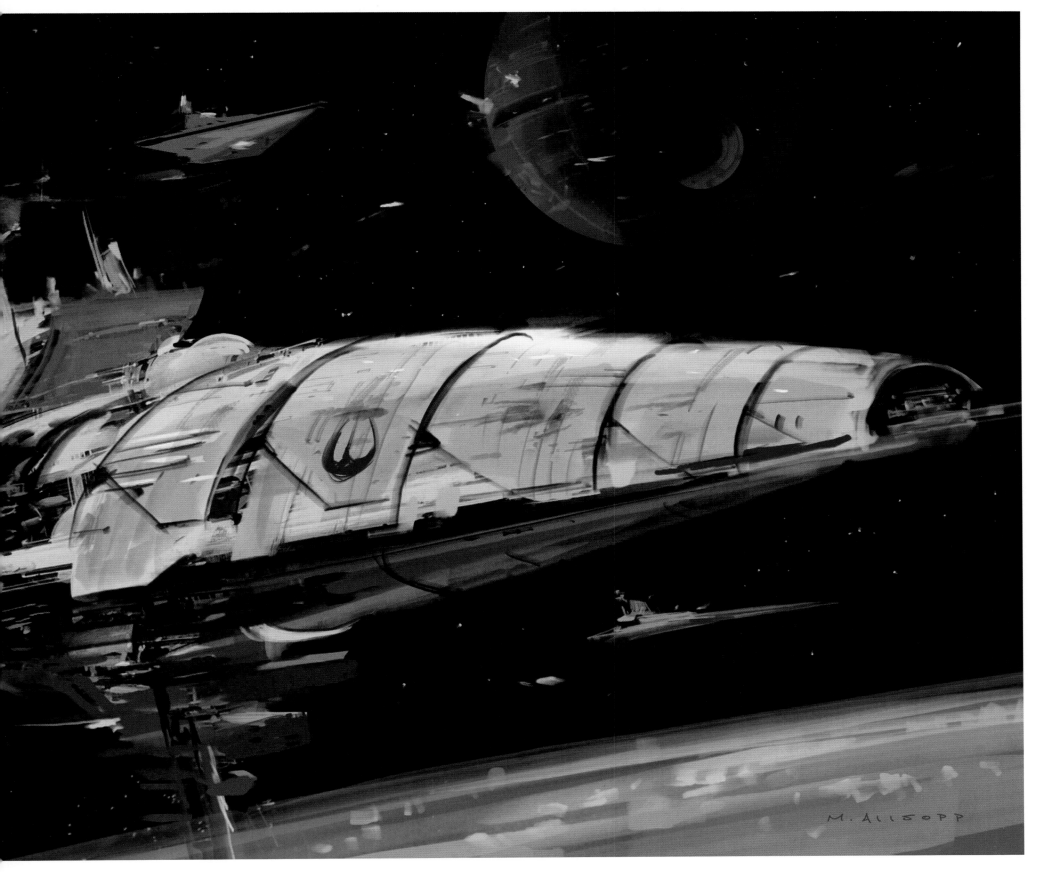

M. ALLSOPP

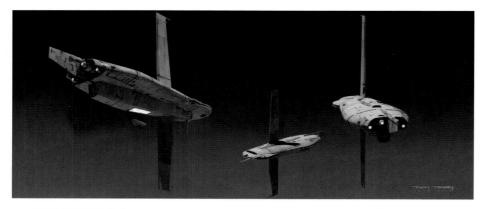

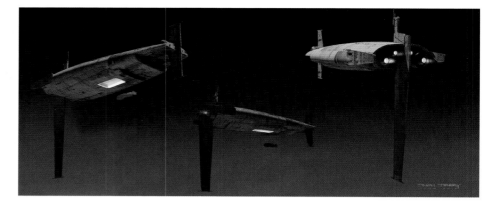

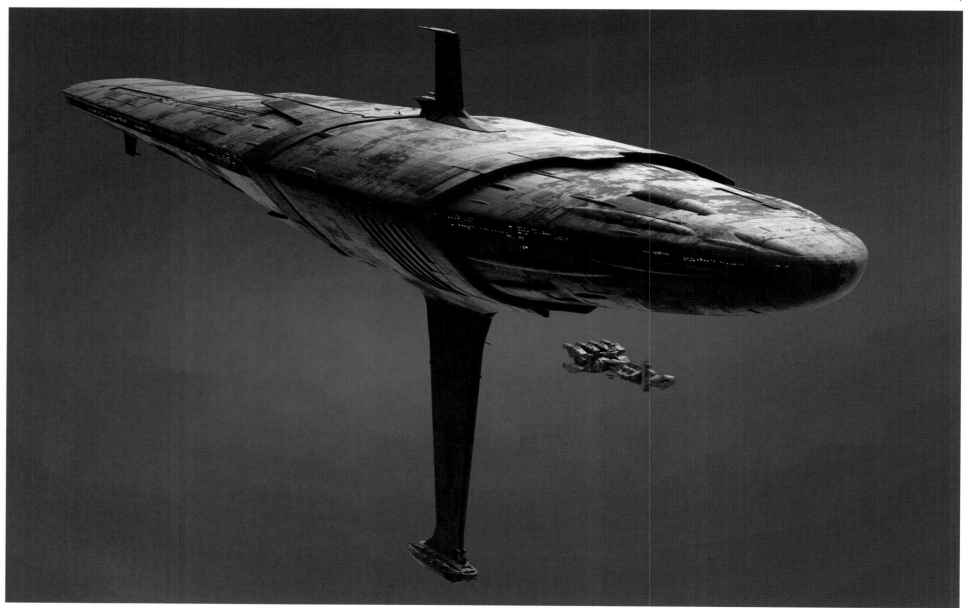

▲ **RADDUS'S SHIP FRONT—MON CALAMARI CRUISER VERSION 1A** Church

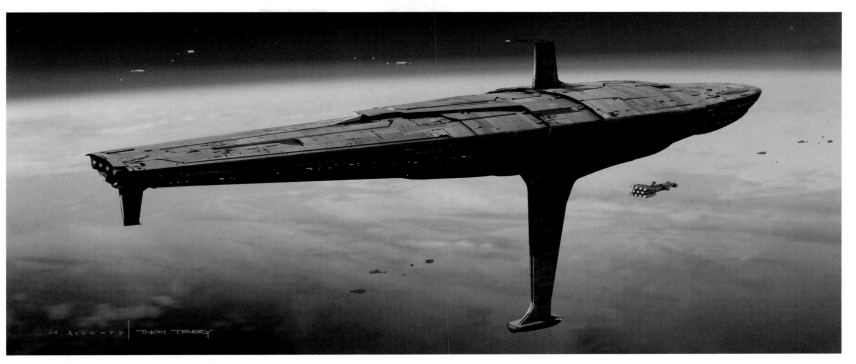

▲ **REBEL CRUISER VERSION 2A** Tenery

▼ **RADDUS'S SHIP—MON CALAMARI CRUISER VERSION 1A** Church

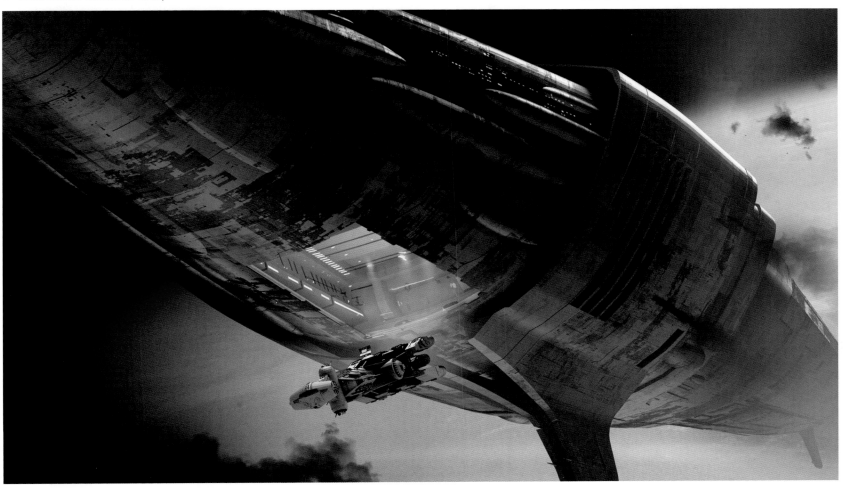

"HOW YOU REMEMBER IT..."

With many of the artists coming to *Rogue One* having just finished work on *The Force Awakens*—and many on the production personally invested in the franchise as *fans*—nearly everyone joined the production already fluent in *Star Wars*'s visual vocabulary. But even with *A New Hope* as a fixed starting point for design, and even—as with any *Star Wars* production—with Ralph McQuarrie's influences as an unofficial style guide, they were challenged with finding ways to innovate within these essential limitations, as well as with updating those designs for audiences used to more sophisticated visuals.

"You'd think that a good percentage of our designs would have been locked before we even started, because they'd ultimately have to blend seamlessly with Episode IV," said Doug Chiang. "Gareth [Edwards] was definitely respectful of that and tried to stay true to that, but there was another interesting component to his approach. Because we're coming into the story earlier, he always wanted to add a little bit, to give some backstory to the designs that we've seen in Episode IV."

The driving mantra for the film—not just in the art departments, but across all areas of production—became "how you remember it, not how it was," promoting the notion that remaining true to the *feeling* of the original movies did not necessarily require draconian fidelity to visual details four decades dated. It was a tricky balance between nostalgia and innovation, guided by emotional memory as much as rigorous research.

"*Rogue One* literally has to dovetail with *A New Hope*," said Ryan Church. "It has to look and feel right—like we'd just gone to the archives and found some unused Episode IV design on a scrap of paper. It's a period piece, and we all know exactly where it takes place in *Star Wars* history, so it has to fit perfectly . . . but it also takes place almost forty years later than that in real history."

Finding that balance was the quintessential dilemma for Edwards, for whom *A New Hope* had been the creative inspiration that first motivated his interest in filmmaking.

"I'd watched it every day as a kid for years," he said. "And yet, if we copied that style, I think it would feel out of place in today's cinema—a little bit slow and a little bit too classical. Stylistically, imitating *A New Hope* with just a karaoke version felt pointless—borderline sacrilegious—but ours still *has* to connect. It has to have that vibe. We worked back from that, and we worked separately from that—asking ourselves what viewers would want to see in a *Star Wars* movie that they've not seen before. It's a hard balance—stressful and very difficult—but you dream about hitting the bull's-eye in the exhaust port, and I felt a bit like a version of Luke."

▶ **JYN WITH DEATH STAR HOLOGRAM VERSION 2D** Vincent Jenkins

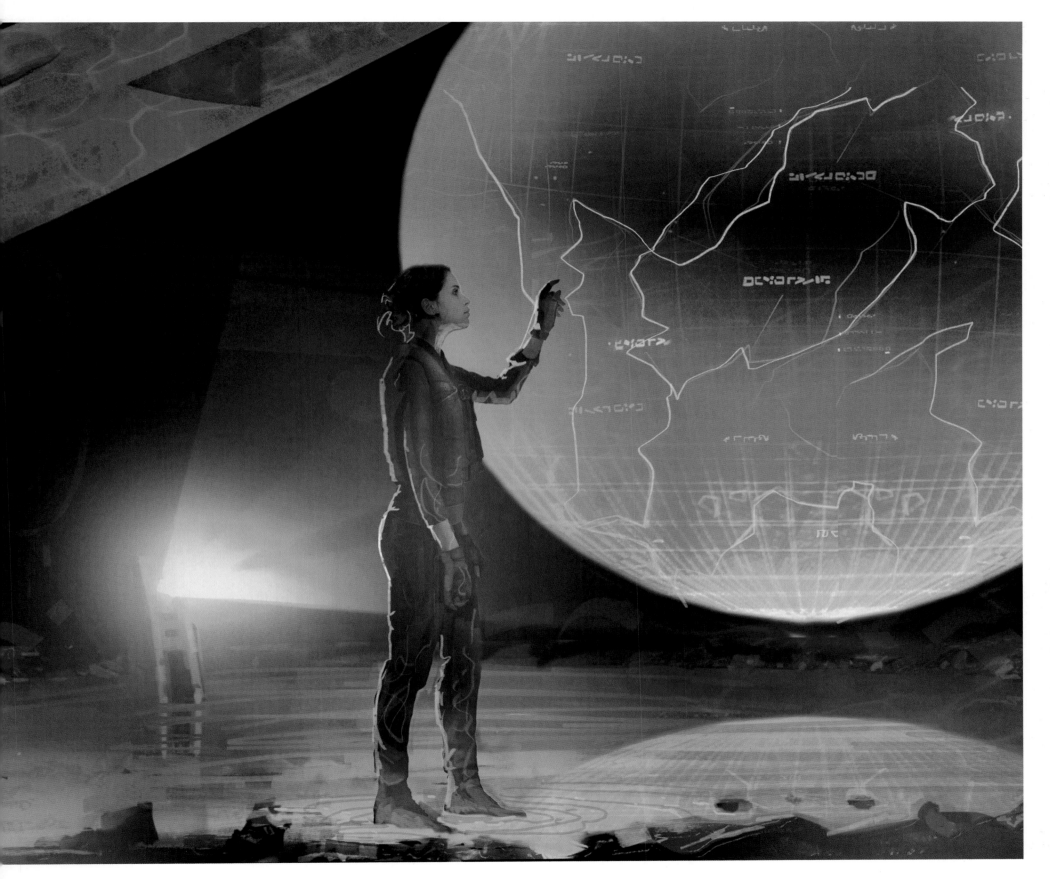

Index

Admiral Raddus 224
agricultural droids 40
alien portrait 109
Alliance 14, 61, 193, 199
Allison Shearmur 61
Allsopp, Matt 8-9, 12-13,
 23, 38, 42, 43, 44, 49,
 54-55, 56, 84, 85, 86,
 97, 100-101, 102, 111-
 112, 116, 120, 123, 138,
 152-153, 166-167, 168,
 169, 170, 177, 179, 180,
 181, 193, 208, 210,
 232-233, 234, 238,
 239, 242-243
Andromeda Strain, The 93
Alzmann, Christian 20, 23,
 24-25, 26, 48, 71, 100,
 102, 176, 177, 181-183
antenna ship 238
Area 51 169
Art of Star Wars, The
 10, 14
assault ship 18-19
AT-AT commander (*see
 also* cargo AT-AT,
 Scarif AT-AT assault)
 76
Attack of the Clones (*see
 also Star Wars*:
 Episode II *Attack of
 the Clones*) 20, 23

bacta chamber (*see also*
 Darth Vader) 181,
 182-183, 187
bacta tank (*see also* Darth
 Vader) 182, 184, 185,
 186
Baily, Alex 155
BB-8 68
Baze Malbus 2-3, 143, 144,
 145, 147
Bell, John 72
Blue-Sky Development 21
Bespin 38
Bib Fortuna 109
BLIND LTD. 92, 93
Bonura, Chris 68, 69
Booth, Andrew 92, 93
Bor Gullet 148, 149, 150,
 151
Brockbank, Adam 70,
 106, 107, 108, 109,

124-125, 134, 135,
 137, 144, 145, 162, 167,
 220, 224
Bullock, Al 32, 118
bunker 207

Caldow, Chris 110
Caldow, Julian 187, 213
cargo AT-AT (*see also*
 AT-AT commander,
 Scarif AT-AT assault)
 230, 231
Cassian Andor 2-3, 68, 69,
 78, 97, 99, 202, 218,
 252
Chan, Kinman 69, 109
Chiang, Doug 10-11, 14,
 18-19, 27, 30, 31, 32,
 38, 40-41, 54, 62,
 63, 68, 80, 87, 97, 98,
 128-129, 146, 155,
 175, 193, 195, 198,
 222-223, 231, 246
Chirrut Îmwe 2-3, 143, 144,
 145, 146, 147
Church, Ryan 14-15, 20,
 21, 27, 45, 78, 79, 80,
 85, 86, 88, 89, 116,
 117, 118, 154-155, 160,
 174-175, 192-193, 196,
 197, 198, 199, 200-
 201, 203, 205, 206,
 214, 225, 236-237,
 238, 240-241, 244,
 245, 246
Churchill, Winston 224
*Close Encounters of the
 Third Kind* 169
Cloud City 48
Clyne, James 22-23, 28-
 29, 161
computer theft 20
concept boards 54-57,
 168, 170-171, 208-211,
 234-235
Crossman, David 48, 147,
 163, 202
cruiser 244
C-3PO 68
Cuba, Larry 93

Darth Vader (*see also*
 bacta tank, bacta
 chamber Mustafar

castle) 4-5, 14, 68,
 172, 175, 179, 180, 181,
 184, 185, 186, 188,
 189
Darth Vader's chamber
 188-189
data core tower droid 215
data core towers 216-217
Death Star 23, 36, 38, 47,
 92, 93, 155, 193, 194,
 197, 198, 246-247,
 250-251
Death Star Base Planet
 192-193, 194
death trooper helmets 51
death trooper transport
 222-223
death troopers 49, 52, 53
Destroyer of Worlds
 (treatment) 20, 23
 (*see also* Knoll,
 John)
Dillon, Glyn 17, 42, 46-47,
 48, 49, 50, 51, 53, 64-
 67, 70, 109, 117, 135,
 143, 146, 147, 162,
 163, 202, 218, 219,
 220, 252, 256
Dray Nevis 23, 24-25
drop ship 84, 89
Dusseault, Yanick 27, 48

Eadu 155, 163, 165, 166-
 167, 169
Edwards, Gareth 10, 14-15,
 30, 32, 36, 38, 39, 40,
 48, 54-55, 69, 74, 78,
 79, 85, 98, 99, 144,
 148, 155, 169, 193,
 195, 198, 221, 231,
 246
Empire Strikes Back, The
 38, 76, 175, 231
engineer 162
Erso family 42
escape from mountain
 planet 27

factory planet 197
Finkel, Jordana 100
Fisher, Luke 4-5, 6, 33, 68,
 69, 72, 73, 74-77, 107,
 108, 109, 137, 184,
 185, 186

Force Awakens, The (*see
 also Star Wars*:
 Episode VII *The
 Force Awakens*) 20,
 21, 23, 30, 31, 32, 38,
 48, 63, 68, 93, 221,
 246
Force 10 from Navarone 23
Ford, Harrison 14
Ford, John 19

Galen Erso 36, 39, 42, 155
Galen Erso bedroom 142
Garcia, Rene 161, 198
Giang, John 78
Godzilla (2014) 15, 30, 54,
 169
Grand Moff Tarken 63
Grass (planet) 34-35, 43

Haley, Christian 57, 58-59,
 60-61, 103
Hart, Kiri 20, 21, 99
Hefferman, Toby 39
hero blaster rifle 67
hero ship 30, 79, 80, 85,
 86, 87, 89
Hobbins, David 80, 82-83,
 194, 198, 207, 213,
 250-251
Hoegen, Gustav 224
homestead 36-37, 38, 39,
 40-41, 42, 43, 48,
 49, 84
homestead droid 40
homestead graphic 92
Horey, Mungo 92, 93
Htay, Will 96, 98, 104-105,
 114, 116, 117, 118, 122,
 123, 136, 137, 142
Hutchings, Alex 116

IceBlink Studios 11
Iceland 39
ILM (*see also* Industrial
 Light & Magic) 21,
 32, 68
Imperial base planet 154-
 155, 196, 197, 199,
 226-227, 238
Imperial communications
 tower 205, 206, 212
Imperial computer vault
 212-213

Imperial hovercraft 115,
 116
Imperial landing platform
 164
Imperial-occupied Jedha
 (*see also* Jedha) 1
*Indiana Jones and the
 Temple of Doom* 181
Industrial Light & Magic
 (*see also* ILM) 11,
 14, 20

James Bond 155
Jedha (planet) (*see also*
 Imperial-occupied
 Jedha) 1, 8-9, 11,
 94-95, 96, 97, 98,
 100-101, 102-103,
 104-105, 111, 112-113,
 114, 116, 117, 118, 119,
 120, 122, 130, 138,
 139, 140-141, 142
Jedha alien 108
Jedha "camel" 100
Jedha catacomb prison
 121
Jedha City 99, 117
Jedha droid 109, 110
Jedha extras 106, 107, 108,
 109, 124-125
Jedha market 110
Jedha POW camp 119
Jedha tank 116
Jedha temple 111, 123, 143
Jedi 97
Jedi Force 97
Jenkins, Kevin 111, 215
Jenkins, Vincent 36-37,
 104-105, 115, 126,
 130, 131, 215, 216-
 217, 246, 252-253,
 254-255
Jerris Kestal 23, 24-25
Johnston, Joe 10
Jones, Felicity 64, 163
Jyn Erso 2-3, 6-7, 10, 17,
 23, 24-25, 36, 38, 39,
 40, 42, 61, 63, 64-67,
 78, 97, 99, 143, 148,
 149, 155, 162, 163,
 193, 202, 256
Jyn's ship 80, 82-83, 84,
 85, 86, 87, 88, 89,
 90-91, 246-247

Kennedy, Kathleen 19, 20, 185

Khang, Le 81, 228-229

Knoll, John (*see also Destroyer of Worlds*) 20, 21, 23, 27, 32, 36, 93

Krennic 23, 36, 39, 46-47, 48, 181

Krennic's arrival 167

Krennic's Jedha office 121

Krennic shuttle 44-45

Krennic sidearm 47

K-2SO 2-3, 16, 23, 24-25, 26, 36, 68, 69, 70, 71, 72-77

Kurosawa, Akira 19

Lah'mu 39, 142

Lamont, Neil 11, 14, 31, 98, 136

Legendary Pictures 15, 30

Letaw, Nicole 86

Lindberg, Karl 25, 26

Lobot 48

L1 protocol droid 167

Lucas, George 10, 14, 19, 23, 31, 32, 99

Lucasfilm Ltd. 10-11, 19, 21, 36, 38

Luke Skywalker 14, 38, 97, 218

Lunak 23, 24-25, 36

Lunt Davies, Jake 40, 71, 72, 74, 143, 144, 151, 221

LV teeth 108

Lyra 42

Manzella, Ivan 26, 33, 72, 73, 108, 148, 149, 150, 220

marine fighter (*see also* mountain marines) 78, 80

marsh battle 228-229

McBride, Aaron 69, 70, 74, 132

McCoy, Jon 2-3, 6-7, 38, 39, 40, 54, 56, 99, 164, 167, 168, 170, 171, 172, 208, 210, 231, 234

McGatlin, Jason 30

McQuarrie, Ralph 10, 14, 136, 175, 246

militia 107

Millennium Falcon 14, 78, 93

mining concept 21

mining shuttle 93

mining vehicle radar 92

mining vehicle tractor beam 92

Mon Calamari cruiser 244, 245

Mon Monthma 61

Monsters 15, 30, 54

mountain marines (*see also* marine fighter) 162

mountain planet 22-23, 152-153, 156, 157, 158-159

Mustafar (planet) 177

Mustafar castle (*see also* Darth Vader) 174-175, 176, 177, 178, 179, 180

New Hope, A (see also Star Wars: A New Hope) 10-11, 20, 23, 36, 38, 61, 63, 93, 97, 98, 246

Northcutt, Brett 34-35, 43, 188-189, 194, 195, 196

Obi-Wan Kenobi 98

occupied cave 136

Pao 221

Phantom Menace, The (see also Star Wars: Episode I The Phantom Menace) 31

Pinewood Studios 11, 68

Planet X 252-253, 254-255

Princess Leia 63

prisoner transport painting 12-13

production design 11

protocol droid 70, 71

Raddus's ship 244, 245

RA-7 model protocol droid 36

rebel cruiser 245

rebel fighter (ship) 80

rebel marines 219

rebel trawler 242-243

reconnaissance ship/ marine fighter 27

Return of the Jedi 32, 38, 61, 218, 219

Revenge of the Sith (see also Star Wars: Episode III Revenge of the Sith) 20, 38, 175

Rezard, Martin 224

Ria Talla 23, 24-25

Roberts, Rayne 36

Rogue One: A Star Wars Story ensemble 2-3

R2-D2 68

Sandales, Lee 98

Savage, Matthew 47, 52

Saw Gerrera 99, 135, 143

Saw Gerrera cockpit 133

Saw Gerrera encampment 133

Saw's cave 127, 130, 131

Saw's crash site 126

Saw's hangar 137

Saw's lair 136, 138

Saw's pilot 137

Saw's throne 132

Saw's throne room 134

Saw's wreck 128-129

Scanlan, Neal 68, 148, 149, 150

Scarif 190-191, 193, 194, 195, 198, 208-211

Scarif AT-AT assault (*see also* AT-AT commander, cargo AT-AT) 232-233

Scarif battle concept boards (*see also* concept boards) 234-235

Scarif communications tower 204-205, 206, 207

Scarif computer vault 214, 215

Scarif dish alighment 92

Scarif Island 196

Scarif marines 218

Scarif shield ship 203

Scarif tower aerial exterior 15

Scarif trooper 219

Scarlet, Tyler 31

senator droid 70

Senna 23, 24-25, 24-25, 26, 31, 32, 33, 36

set design and decoration 11

shipyard dogfight 240-241

Sith reliefs 181

Skull Beard 108

space monkey 220

Speer, Albert 186

Spielberg, Steven 32

Star Destroyer 92, 94-95, 198, 199, 200-201, 236-237, 239, 242

Star Wars: A New Hope (see also A New Hope) 10, 36, 48, 69, 78, 93

Star Wars design and technical aspects 10

Star Wars: Episode I *The Phantom Menace (see also The Phantom Menace)* 11, 31

Star Wars: Episode II *Attack of the Clones (see also Attack of the Clones)* 11, 20, 23

Star Wars: Episode III *Revenge of the Sith (see also Revenge of the Sith)* 20

Star Wars: Episode IV *A New Hope* 10-11, 14, 20, 23, 48, 246

Star Wars: Episode V *The Empire Strikes Back* (see *The Empire Strikes Back*)

Star Wars: Episode VI *Return of the Jedi* (see *Return of the Jedi*)

Star Wars: Episode VII *The Force Awakens* (see also *Star Wars: The Force Awakens, The Force Awakens*) 11, 20

Star Wars prequel trilogy 10

Star Wars: The Clone Wars 63, 99

Star Wars Rebels 63

storyboards (see concept boards)

Strange Magic 30

stolen carriage 160

stolen shuttle 161, 203

super tanker 160

Swartz, John 20, 31, 53, 97, 142

Swartz, Kristen 63

tank trooper 117

Tappin, Stephen 54, 56, 168, 170, 208, 210, 234

Tatooine 97

telescope ship 27

Tenery, Thom 1, 15, 44, 52, 87, 88, 89, 90-91, 119, 127, 133, 160, 161, 164, 165, 187, 190-191, 198, 203, 212, 226-227, 230, 238, 239, 242, 244, 245

Thang, Li 21

THX 1138 93

TIE fighter 28-29, 92, 93, 225

Tiemens, Erik 14, 38, 40, 118, 133, 156-157, 176, 178, 197, 205, 212

Tivik 252

Triangle Face 109

trooper helmets 50

trooper pistol 52

trooper with kilt 50

2001: A Space Odyssey 93

underworld alien 107

underworld extra 108

U-wing 168, 170

U-wing pilot 220

Wallin, Andrée 63, 94-95, 103, 120, 121, 122, 139, 140-141, 158-159, 204-205

The Walt Disney Company 19

Weitz, Chris 97, 143, 148

Wertz, Colie 62

Westworld 93

Who's Who 17

Whitta, Gary 30, 36, 99, 176, 185, 186

Wilkinson, Jamie 144

Williams, John 14

Williams, Sam 50, 51

Willix Cree 23, 36

World War II 19, 99, 118

X-wing 78, 79, 92, 122, 138

Yavin 4 57, 58-59, 60-61, 62, 63, 93

Yen, Donnie 146

Yoda 68

Yue, Shaun 92

Y-wing 78, 79

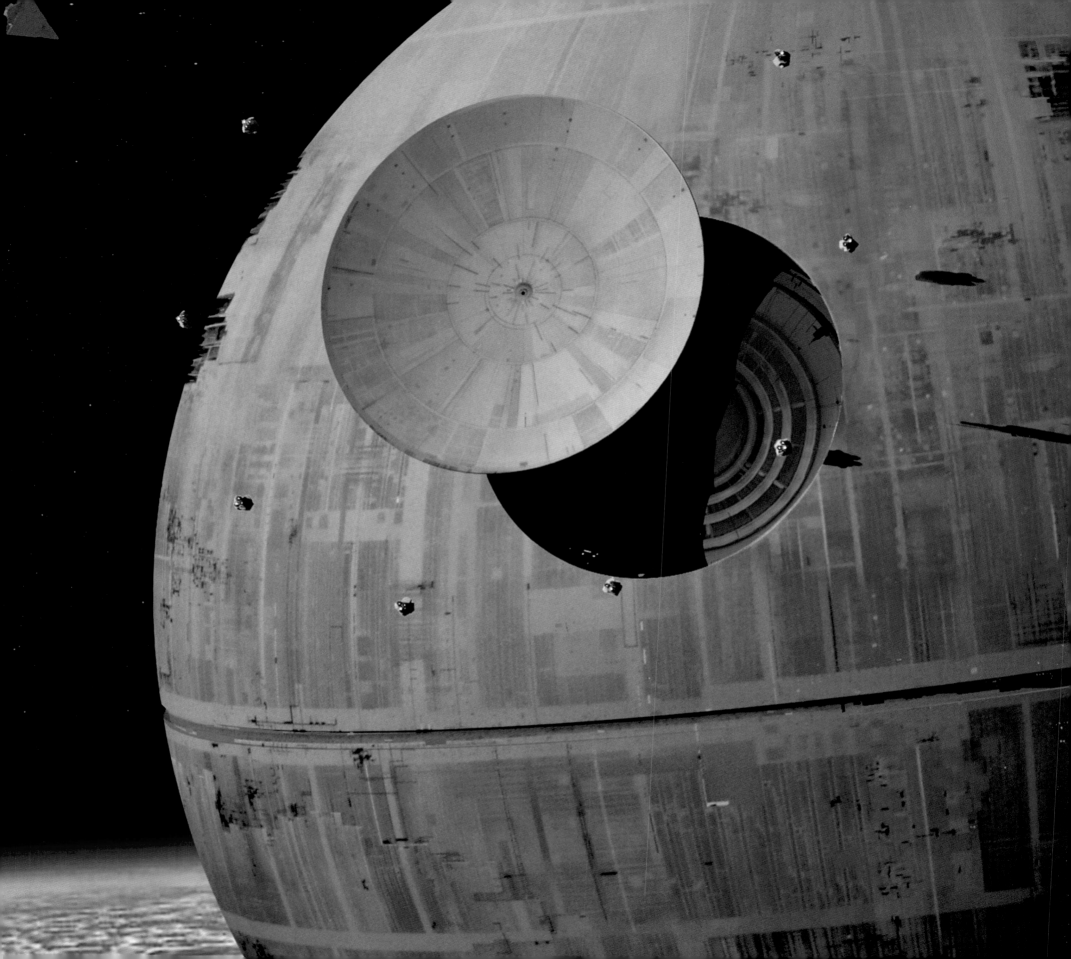

Acknowledgments

There are, of course, far too many people to thank.

To the current custodians of *Star Wars*—Gareth Edwards, Kathleen Kennedy, and all the remarkable artists on *Rogue One*—thank you for shepherding this mythology so beautifully into the future. To all of the same—and specifically Doug Chiang, Neil Lamont, John Swartz, and Kristen Swartz—for welcoming me into your worlds and onto your production. And to George Lucas, for inspirations too many to count.

To my editors, Eric Klopfer (at Abrams) and Frank Parisi (at Lucasfilm), whose good humor was as welcome and as valuable as your guidance, your institutional knowledge, and your infinite patience. To Phil Szostak, whose curatorial contributions to this book deserve so much more credit than a mere inclusion in the acknowledgments. And to Jonathan Rinzler, who first accepted me into the fold and whose past examples set the gold standard for *Star Wars* production reporting.

To Rayne Roberts—my "spiritual guide." Whenever navigating these processes seemed more complicated than dusting crops, your wisdom is what kept me from flying right through a star or bouncing too close to a supernova.

To Chris Argyropoulos, Lynne Hale, and Bob Gazzale—three whose omission from any expression of inspiration and gratitude would be a crime against both.

To everyone whose support was invaluable along the way—my mom and my sister, my dad and Terry, Angela Araujo, Matt Palmquist, April Word, Aly Pierce, Trish Brunner, and so many more fine folks.

And finally, thank you to Dr. Janet Tomiyama—my long-suffering wife and constant source of inspiration, who endured (and endures) a whole lot of *Star Wars* with nary a complaint.

Josh Kushins

◄ **DEATH STAR DISH VERSION 4** Hobbins

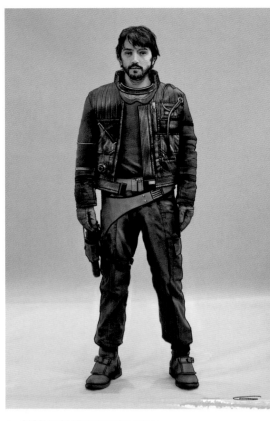

▲ **CASSIAN COSTUME STUDY** Dillon

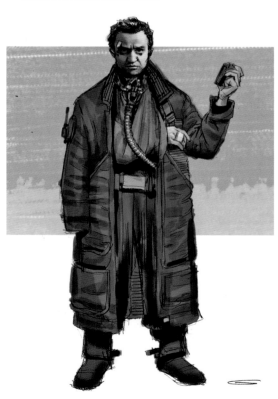

▲ **TIVIK** Dillon ▶ **PLANET X** Vincent Jenkins

▸ **PLANET X ALLEYWAY** Vincent Jenkins

▸▸ **JYN ERSO IN COMBAT GEAR VERSION 1** Dillon

FOR LUCASFILM LTD.

SENIOR EDITOR Frank Parisi
CREATIVE EDITOR Michael Siglain
IMAGE EDITOR AND CONSULTANT Phil Szostak
ART DIRECTOR Troy Alders
IMAGE UNIT Erik Sanchez and Newell Todd
STORY GROUP Pablo Hidalgo, Matt Martin, and Rayne Roberts

FOR ABRAMS

SENIOR EDITOR Eric Klopfer
DESIGNER Liam Flanagan
MANAGING EDITOR Gabriel Levinson
PRODUCTION MANAGER Denise LaCongo

Library of Congress Control Number: 2015955627

ISBN: 978-1-4197-2225-7

© & TM 2016 LUCASFILM LTD.

Case **JYN WITH DEATH STAR HOLOGRAM VERSION 2D** Vincent Jenkins

Printed and bound in China

10 9 8 7 6 5 4 3 2

Abrams books are available at special discounts when
purchased in quantity for premiums and promotions as
well as fundraising or educational use. Special editions
can also be created to specification. For details, contact
specialsales@abramsbooks.com or the address below.

ABRAMS The Art of Books
115 West 18th Street, New York, NY 10011
abramsbooks.com

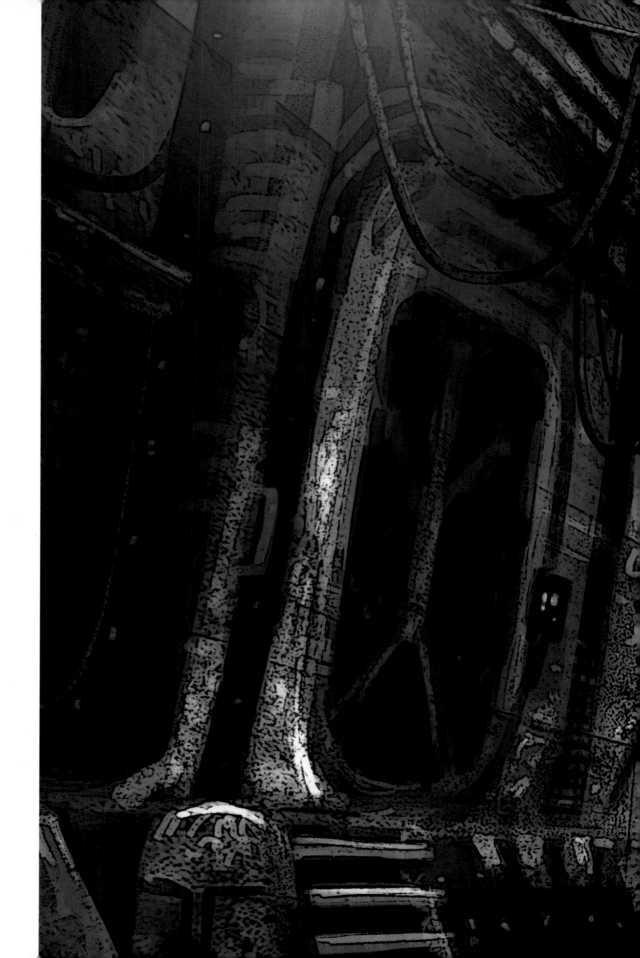

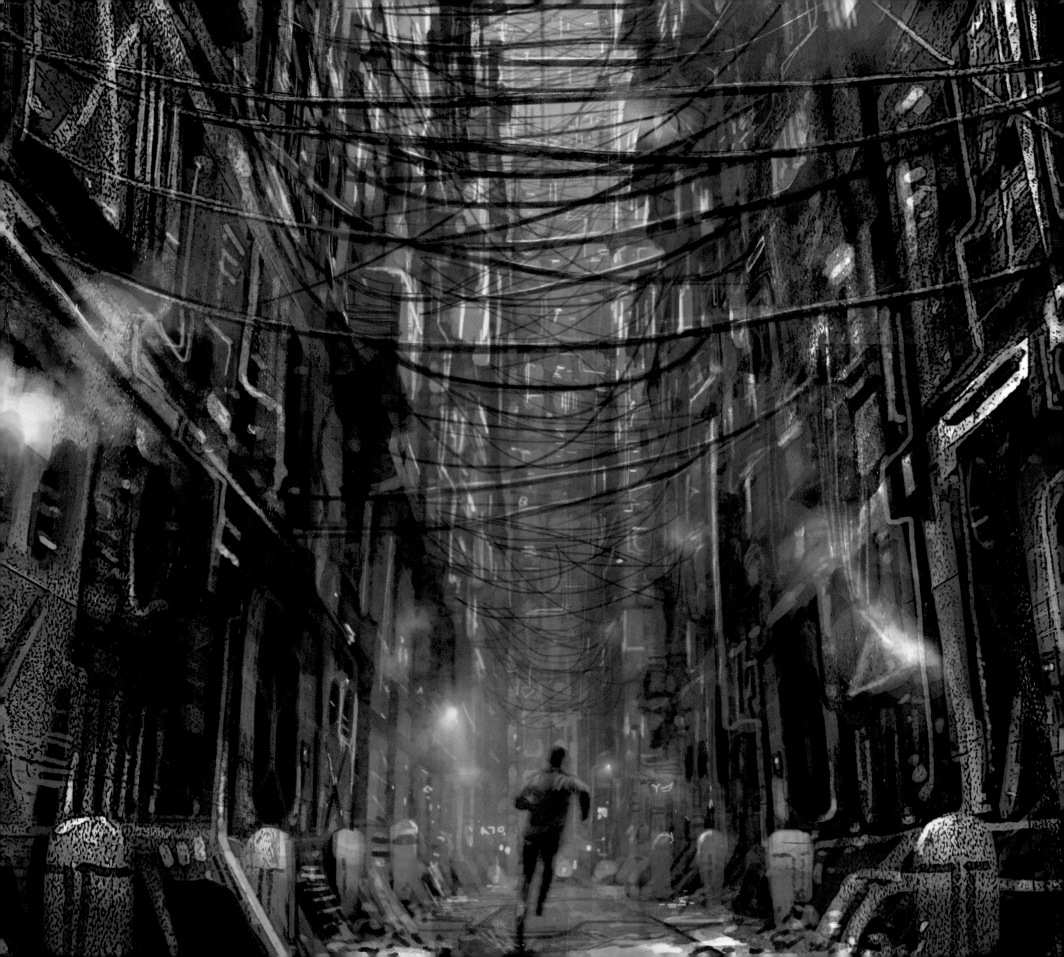

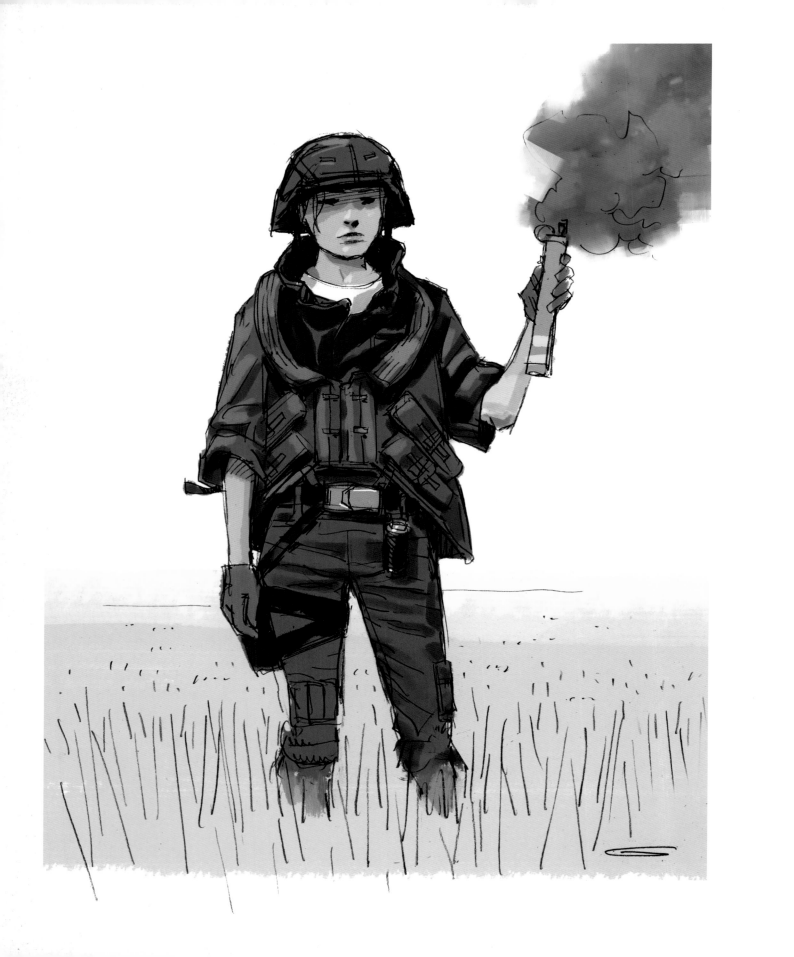